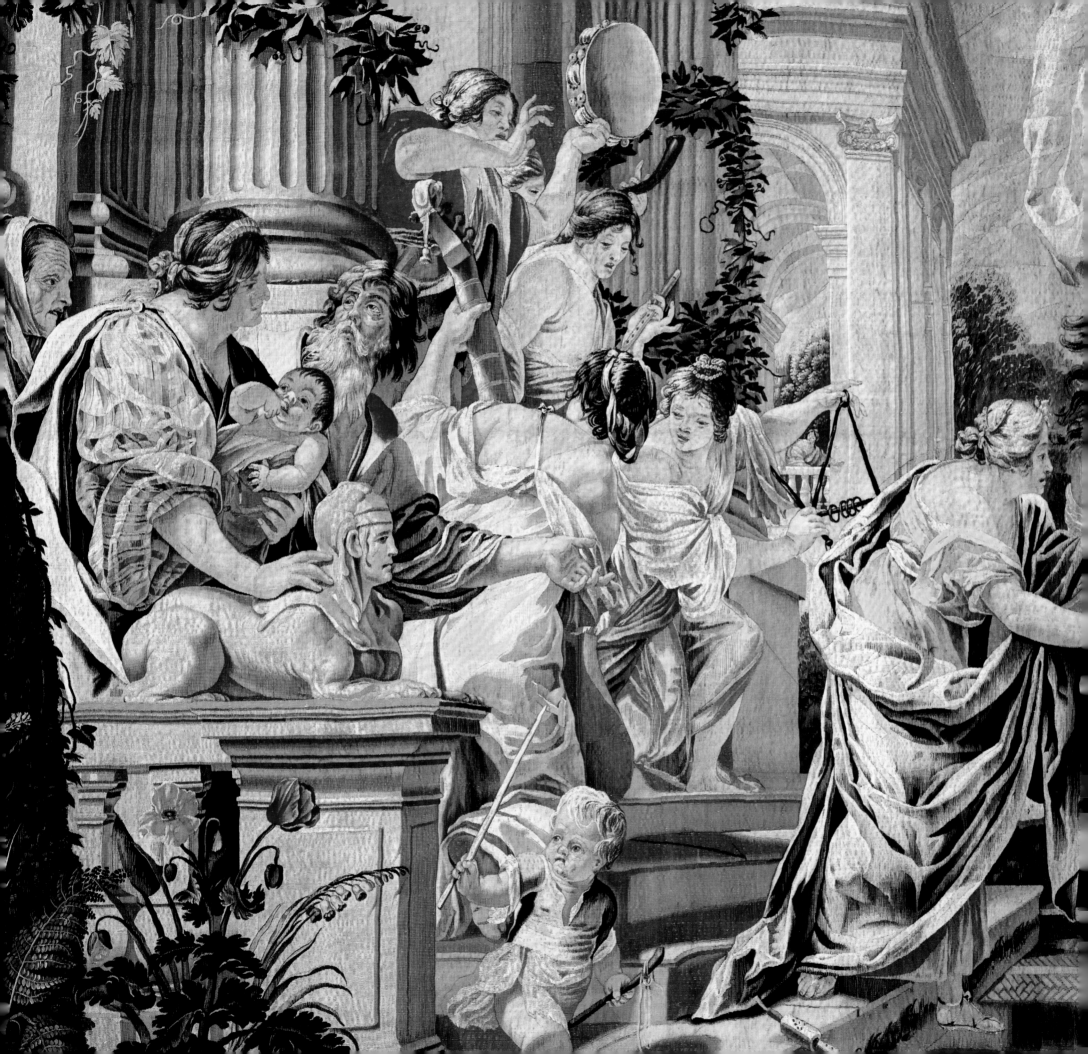

Woven Gold
Tapestries of Louis XIV

Charissa Bremer-David

With essays by
Pascal-François Bertrand, Arnauld Brejon de Lavergnée, and Jean Vittet

The J. Paul Getty Museum, Los Angeles

This publication accompanies the exhibition *Woven Gold: Tapestries of Louis XIV,* on view at the J. Paul Getty Museum at the Getty Center, Los Angeles, December 15, 2015–May 1, 2016.

Published by the J. Paul Getty Museum, Los Angeles
Getty Publications
1200 Getty Center Drive, Suite 500
Los Angeles, California 90049-1682
www.getty.edu/publications

Nola Butler, *Project Editor*
Alexandra Bonfante-Warren and Nola Butler, *Manuscript Editors*
Jeffrey Cohen, *Designer*
Amita Molloy, *Production*

The essays in this catalogue were translated from the French by Sharon Grevet.

Distributed in the United States and Canada by the University of Chicago Press
Distributed outside the United States and Canada by Yale University Press, London

Printed in Hong Kong

Library of Congress Cataloging-in-Publication Data
Woven gold (J. Paul Getty Museum)
 Woven gold : tapestries of Louis XIV / Charissa Bremer-David ; with essays by
Pascal-François Bertrand, Arnauld Brejon de Lavergnée, and Jean Vittet.
 pages cm
 "This publication is issued on the occasion of an exhibition of fourteen examples from
the tapestry collection of Louis XIV, held at the Getty Center from December 15, 2015,
to May 1, 2016"—Provided by the publisher.
 Includes bibliographical references and index.
 ISBN 978-1-60606-461-0 (hardcover)
 1. Louis XIV, King of France, 1638–1715—Art collections—Exhibitions. 2. Louis XIV,
King of France, 1638–1715—Art patronage—Exhibitions. 3. France—Kings and rulers—
Art collections—Exhibitions. 4. Tapestry—France—Paris—History—Exhibitions.
I. Bremer-David, Charissa, editor. II. Brejon de Lavergnée, Arnauld, author. III. Vittet,
Jean, author. IV. Bertrand, Pascal-François, author. V. J. Paul Getty Museum, organizer,
issuing body. VI. Title.
 NK3049.A1W68 2015
 746.3944'09032—dc23
 2015020572

Front jacket: *Autumn* (detail, plate 9a)
Back jacket: *Winter, Cybele Begs for the Sun's Return* (detail, plate 12a)
Page i: *The Daughter of Jephthah* (detail, fig. 55)
Page ii: *The Daughter of Jephthah* (detail, plate 7a)

Neptune and Cupid Plead with Vulcan for the Release of Venus and Mars
(detail, plate 3a)

Contents

Foreword

Woven Gold: Tapestries of Louis XIV is the first exhibition in the United States devoted to the renowned collection of tapestries belonging to the French Crown during the reign of Louis XIV (r. 1643–1715), the Sun King. Organized by the J. Paul Getty Museum in association with the Mobilier National et les Manufactures Nationales des Gobelins, de Beauvais et de la Savonnerie in Paris, this spectacular exhibition is timed to observe the tercentenary of Louis's death, and the selection of fourteen superlative tapestries evokes the grandeur that once graced the walls of his residences. This rare display at the Getty Center, and its accompanying publication, complement the rich holdings of French decorative arts in the Museum's galleries, allowing themes and motifs to be appreciated across different media and forms. Indeed, the exhibition builds upon the interests of J. Paul Getty himself, whose diary recounts his visits in 1938 and 1939 to the Gobelins gallery, where he "saw some magnificent Louis XIV tapestries."

Likened to Apollo, ancient god of the sun and light, as well as protector of the Muses, Louis XIV was celebrated within his lifetime as the shining patron of architecture, garden design, painting, sculpture, printmaking, and tapestry weaving, all arts that flourished under the unifying vision and direction of his talented and versatile court painter Charles Le Brun. The king and the painter were best known for transforming the small hunting lodge at Versailles into the magnificent château that influenced court culture across Europe, and continues to draw visitors from around the world today, and for their revitalization of the famed Gobelins tapestry manufactory in Paris, which is also still in operation.

At the end of Louis XIV's reign, the French royal collection encompassed hundreds of important and valuable hangings, only a portion of which still survive. Ranging in date from about 1470 to 1715 and coming from weaving workshops across northern Europe and France, the tapestries showed scenes from the Bible, history, and mythology, after the designs of the greatest artists, including Raphael, Giulio Romano, Peter Paul Rubens, Simon Vouet, and Le Brun. As this publication demonstrates, the king was more than simply an heir, or even a visionary patron. He was also an extraordinary collector of tapestries, and his agents actively pursued the best of the great sixteenth- and seventeenth-century hangings that survived. Through his acquisition and display of these prestigious old weavings from dispersed princely collections, the king enhanced his status and reputation, as well as that of the monarchy, and appropriated the rank, erudition, and taste of the tapestries' previous owners.

This ambitious endeavor to re-create the splendor of the Sun King's former collection in Los Angeles is made possible through exceptional loans from the Mobilier National, the successor institution to the ancient French royal collection, and the goodwill and generosity of colleagues there, notably Bernard Schotter, former Administrateur Général; Jérôme Poulain, Secrétaire Général; Christiane Naffah-Bayle, Conservateur Général du Patrimoine and Directrice des Collections; and Thomas Bohl, Conservateur du Patrimoine. Other critical loans of works on paper come from the Département des Arts Graphiques, Musée du Louvre; the Département des Estampes et de la Photographie, Bibliothèque Nationale de France; and the Getty Research Institute, Los Angeles. Studies and sketches preceded the weaving of these costly, large-scale textiles, and prints allowed for wider diffusion of their compositions; the presence of these materials in the exhibition greatly enhances our understanding of the tapestries.

Three French colleagues have contributed informative and thought-provoking essays on the king as collector, heir, and patron for this exhibition catalogue. We warmly acknowledge the participation of Jean Vittet, Conservateur en Chef, Musée National du Château de Fontainebleau; Pascal-François Bertrand, Professeur d'Histoire de l'Art, Université de Bordeaux Montaigne; and Arnauld Brejon de Lavergnée, Conservateur Général Honoraire du Patrimoine. We also commend the vision and dedication of Charissa Bremer-David, Curator of Sculpture and Decorative Arts at the Getty, who is the curator of the exhibition and the principal author of this catalogue. Through this project, these scholars have done much to advance the understanding of this important aspect of art history and collecting for both specialists and the general public.

The J. Paul Getty Museum is pleased also to have sponsored the conservation of two tapestries from the Mobilier National for presentation in this exhibition. The careful treatments undertaken by the De Wit Royal Manufacturers of Tapestry in Mechelen, Belgium, and the restoration facilities of the Mobilier National in Paris and Aubusson, ensure the future integrity of these monumental hangings. We are most grateful to the Hearst Foundations, Eric and Nancy Garen, and the Ernest Lieblich Foundation for joining us in funding this important preservation effort.

TIMOTHY POTTS
Director, The J. Paul Getty Museum, Los Angeles

HERVÉ BARBARET
Directeur, Mobilier National et les Manufactures Nationales des Gobelins, de Beauvais et de la Savonnerie, Paris

OPPOSITE:
The Entry of Alexander into Babylon
(detail, plate 10e)

Acknowledgments

The exhibition *Woven Gold: Tapestries of Louis XIV* and this accompanying catalogue are the glorious outcome of a long and fruitful association between the J. Paul Getty Museum, Los Angeles, and the Mobilier National et les Manufactures Nationales des Gobelins, de Beauvais et de la Savonnerie, Paris. Colleagues at both institutions have generously contributed their time and expertise to realize the project. At the Mobilier National, we are particularly indebted to Hervé Barbaret, Directeur; Jérôme Poulain, Secrétaire Général; Bernard Schotter, former Administrateur Général; Christiane Naffah-Bayle, Conservateur Général du Patrimoine and Directrice des Collections; Marie-Hélène Dali-Bersani, Directrice du Département de la Production des Manufactures and Responsable du Fonds Textile Contemporain; Thomas Bohl, Conservateur du Patrimoine; Marie-Odile Klipfel, Régisseur des Expositions; Marina Le Baron-Sarasa, Service de la Documentation; Véronique Leprette and Céline Méfret, Responsable de la Mission; Liliane Larable, Service des Archives; and Laurence Montlouis, Sylvie Joly, and Catherine Delarbre of the Atelier Restauration Tapisserie. Through their collaborative efforts, twelve monumental tapestries from the collection of Louis XIV have traveled to Los Angeles in observance of the tercentenary of the king's death.

This remarkable event is further enhanced by the temporary reunion of these tapestries with another, a hanging from *The Story of Scipio*, which had been dispersed from the French royal collection at the time of the French Revolution. Thanks to the Hearst San Simeon State Historical Monument, San Simeon, California, the famed *Scipio* piece can be appreciated once again, after an interlude of more than two centuries, in context with other weavings formerly in the Crown's Furniture Warehouse. Mary Levkoff, Museum Director; Hoyt Fields, Retired Annuitant Director; and Beverly Steventon, Assistant to the Director at Hearst Castle, accommodated this request with enthusiasm and supreme goodwill.

Critical loans of complementary works on paper have come from three institutions whose curatorial teams graciously facilitated the process and shared their knowledge. From the Musée du Louvre, Paris: Jean-Luc Martinez, Président-Directeur; Xavier Salmon, Conservateur Général du Patrimoine and Directeur du Département des Arts Graphiques; Séverine Lepape, Conservateur de la Collection Rothschild; Juliette Trey, Conservateur; and Bénédicte Gady, Collaboratrice Scientifique. From the Bibliothèque Nationale de France, Paris: Bruno Racine, Président; Sylvie Aubenas, Directeur du Département des Estampes et de la Photographie; Barbara Brejon de Lavergnée, Bibliothécaire à la Réserve du Département des Estampes et de la Photographie; Jocelyn Monchamp, Conservateur; and Cyril Chazal, Extramural Exhibitions, Service des Expositions. From the Getty Research Institute, Los Angeles: Thomas W. Gaehtgens, Director; Louis Marchesano, Curator; Christina Aube, Curatorial Assistant; Irene Lotspeich-Phillips, Registrar; and Lora Chin Derrien, Associate Registrar.

Special thanks are due to Arnauld Brejon de Lavergnée, Conservateur Général Honoraire du Patrimoine, former Directeur des Collections du Mobilier National, Paris. His vision and generosity of spirit have been fundamental to the success of this exhibition from the earliest stages. Jean Vittet, Conservateur en Chef, Musée National du Château de Fontainebleau, and Pascal-François Bertrand, Professeur d'Histoire de l'Art, Université Bordeaux Montaigne, have contributed to this catalogue not only significant essays but also insights gained by decades of focused study. The depth and breadth of their scholarship on the place of tapestry in French royal arts' patronage have led us to a more informed and nuanced understanding of this complex subject. The field of French tapestry studies, in general; this volume, in particular; and the present author, especially, have benefitted tremendously from their research and intellectual vigor.

Woven Gold is an ambitious undertaking, involving the visionary leadership, invaluable support, unflagging effort, and creative talent of dozens of colleagues from across the Getty Trust, the J. Paul Getty Museum, and Getty Publications. Principal among these are, from the Getty Trust: James Cuno, President and Chief Executive Officer; Eileen Savage, Associate Vice President of Development; Amy Hood, Senior Communications Specialist; and Lynette Haynes, Manager, Procurement and Contract Services; from the J. Paul Getty Museum: Timothy Potts, Director; Thomas Kren, Associate Director for Collections; Quincy Houghton, Associate Director for Exhibitions; John Giurini, Assistant Director for Museum Communications and Public Affairs; Anne Woollett, Curator, and Scott Allan, Associate Curator, from the Paintings Department; Elizabeth Morrison, Senior Curator, and Christine Sciacca, Assistant Curator, from the Manuscripts Department; Lee Hendrix, Senior Curator, Julian Brooks, Curator, and Ketty Gottardo, Associate Curator, from the Drawings Department; Yvonne Szafran, Senior Conservator, and Laura Rivers, Associate Conservator, from Paintings Conservation; Marc Harnly, Senior Conservator, and Nancy Yocco, Conservator, from Paper Conservation; Amber Keller, Principal Project Specialist, and Kirsten Schaefer, Exhibitions Coordinator Associate, from Exhibitions; Merritt Price, Manager, and Irma Ramirez, Designer, from Exhibition Design; Betsy Severance, Chief Registrar, Carole Campbell, Registrar for Collections Management, Cherie Chen, Registrar, Leigh Grissom, Assistant Registrar, Jacqueline Cabrera, Associate Registrar, and Marit Coyman-Myklebust, Assistant Registrar for Exhibitions, from the Registrar's Office; Stanley Smith, Manager, Michael Smith, Assistant Manager, Rebecca Vera-Martinez,

Senior Photographer, Erik Bertellotti, Senior Media Producer, Anne Martens, Writer, and Chris Keledjian, Associate Editor, from Collection Information and Access; Tuyet Bach, Exhibition Liaison, Peter Tokofsky, Education Specialist, and Cathy Carpenter, Education Specialist, Artist-Based Programs, from the Education Department; Laurel Kishi, Performing Arts Manager, Public Programs; Kevin Marshall, Manager and Head of Preparations, Michael Mitchell, Lead Preparator, and the outstanding team of art handlers from the Preparations Department; from Getty Publications: Kara Kirk, Publisher; Elizabeth Nicholson, Acting Editor in Chief; Jeffrey Cohen, Senior Designer; Amita Molloy, Senior Production Coordinator; Pam Moffat, Senior Project Management Coordinator; Nola Butler, Project Editor; Rachel Barth, Assistant Editor; Alexandra Bonfante-Warren, freelance copy editor; Sharon Grevet, freelance translator; Dianne Woo, freelance proofreader; and Harvey Lee Gable, Jr., freelance indexer.

Members of the Sculpture and Decorative Arts Department and of the sister department of Decorative Arts and Sculpture Conservation extended key support and constructive advice over the many months of preparation. My thanks to Anne-Lise Desmas, Associate Curator and Department Head; Jeffrey Weaver, Associate Curator; Ellen South, Senior Staff Assistant; Philippe Halbert, Graduate Intern; Brian Considine, Senior Conservator; Jane Bassett, Conservator; and Deni Bernhart, Senior Staff Assistant. Words cannot adequately acknowledge their collective contribution.

With grateful appreciation, I wish to acknowledge colleagues from across the United States and around the globe who graciously shared ideas, responded to requests for information, or granted access to collection materials: Koenraad Brosens, Professor of Art History, and Guy Delmarcel, Professor Emeritus, the Catholic University of Leuven, Leuven; Yvan Maes, President, and An Volckaert, Academic Advisor, De Wit Royal Manufacturers of Tapestry, Mechelen; Bruno Ythier, Conservateur, Cité Internationale de la Tapisserie et de l'Art Tissé, Aubusson; Patrick Michel, Professeur d'Histoire de l'Art Moderne, Université Charles-de-Gaulle–Lille 3, Lille; Dominique Chevalier and Nicole de Pazzis-Chevalier, Galerie Chevalier, Paris; Lawrence Perquis, Lawrence Perquis Photographies, Paris; Beatrix Saule, Directrice Générale, Pierre-Xavier Hans, Conservateur en Chef, Elizabeth Caude, Conservatrice en Chef, and Noémie Wansart, Collaboratrice Scientifique, Musée National des Châteaux de Versailles et de Trianon; Florian Knothe, Director of the University Museum and Art Gallery, University of Hong Kong, Hong Kong; Helen Wyld, Curator, National Trust for Scotland, Edinburgh; Edouard Kopp, Maida and George Abrams Associate Curator of Drawings, Harvard Art Museums, Cambridge; Elizabeth Cleland, Associate Curator, European Sculpture and Decorative Arts, the Metropolitan Museum of Art, New York; Lorraine Karafel, Associate Dean, Art and Design History and Theory, and Assistant Professor of Art History, Parsons School of Design, the New School, New York; Darren Poupore, Chief Curator, Biltmore Estate, Asheville; Sharon Shore, Caring for Textiles, Culver City; Noelle Valentino, Academic Programs Coordinator, Hammer Museum, Los Angeles; Yadine Larochette, Larochette Textile Conservation, Los Angeles; Sharon Sadako Takeda, Curator and Department Head, Kaye D. Spilker, Curator, and Clarissa Esguerra, Assistant Curator, Costume and Textiles, Los Angeles County Museum of Art, Los Angeles; Gloria Williams, Curator, Norton Simon Museum, Pasadena; Dr. Miguel Sagesse of Western University of Health Sciences, Pomona; Barbara Gaehtgens, Los Angeles and Berlin; Eric and Nancy Garen, Los Angeles; Ebeltje Hartkamp-Jonxis, Amsterdam; Susan Miller, New York; Michael Osmann, Clarksburg, Ontario; and Diane Webb, Maastricht.

We are deeply grateful that the Hearst Foundations, Eric and Nancy Garen, and the Ernest Lieblich Foundation joined the Getty Trust and the J. Paul Getty Museum in supporting the exhibition and the conservation of two tapestries from the collection of the Mobilier National. By embracing the project, their contributions offered encouragement at a critical moment and ensured the preservation of these fragile textiles for generations to come.

To each and every one who contributed to the exhibition and the catalogue, thank you.

CHARISSA BREMER-DAVID
Curator, Sculpture and Decorative Arts,
The J. Paul Getty Museum

Note to the Reader

Historically, the medium of tapestry was regarded as the preeminent expression of princely status and courtly taste. Extraordinary expenditures of money, time, and talent were allocated to tapestries in order to proclaim the erudition, virtue, and aesthetic sophistication of the patron. Louis XIV, king of France (r. 1643–1715), formed one of the greatest—if not the foremost—early modern European collections of tapestries. The Crown's collection at the end of his reign was staggering, containing some 2,650 pieces. This impressive number was reached by slow accumulation over centuries and by intense phases of opportunistic acquisition and strategic patronage.

At the time of Louis's coronation, the royal holdings were especially notable for the spectacular Renaissance hangings acquired chiefly by one predecessor, François I (r. 1515–47). Many of those weavings were profusely enriched with precious metal–wrapped threads. This valuable inheritance was augmented later in the reign of Louis, after the turbulent mid-seventeenth-century civil wars known as the Fronde, with other significant antique sets of tapestries that became available on the art market. Moreover, beginning in 1661, when Louis assumed the role of supreme patron of the arts, the Crown systematically commissioned new creations from contemporary French manufactories over the course of the next fifty years.

Arnauld Brejon de Lavergnée, in the first essay of this volume, introduces the reader to the medium of tapestry and its place in the hierarchy of French court art during the Baroque. The second essay, by Jean Vittet, summarizes the origin and development of the French royal collection during the long seventy-two-year rule of Louis XIV. The symbolic significance and visual power of the collection are revealed in the final essay, by Pascal-François Bertrand, in which he compares the display of tapestries at two coronations, those of Louis XIV, in 1654, and Louis XV, in 1722.

Following the essays are twelve catalogue entries, corresponding to the tapestries displayed in the exhibition *Woven Gold: Tapestries of Louis XIV*, on view at the J. Paul Getty Museum at the Getty Center, Los Angeles, from December 15, 2015, to May 1, 2016. The entries are arranged in chronological order according to the year of the original designs (rather than order of production). Thus, the entries are divided into three sections, aligning with the three means by which the collection evolved: antique sets of Renaissance tapestries purchased for the royal collection in the seventeenth century, antique sets of tapestries inherited by the king, and new sets of tapestries ordered by the Crown. These three sections reveal Louis XIV as collector, heir, and patron.

Specific information pertinent to each individual hanging and related works on paper in the exhibition appears in the Checklist and Endnotes (pp. 128–38), grouped according to the sequence of tapestry series presented in the entries.

With regard to woven marks, note that regulations varied. In Brussels, tapestries over a certain size had to bear the woven mark of the city, twin Bs flanking a plain shield, as well as the mark of the weaver or the entrepreneur. This civic ordinance of May 1528 was later confirmed by the higher authority of a Spanish imperial edict of May 1554. In seventeenth-century France, weavers operating under royal privilege in the Parisian workshop at the Louvre did not have to mark their work produced for the Crown, but from 1607 tapestries produced for the open market in other workshops did have to be identified with particular marks—usually a fleur-de-lis and the first letter of the city of origin—in order to distinguish them from hangings illegally imported and sold in the realm. For instance, the immigrant entrepreneurs Marc de Comans (1563–1644) and François de La Planche (1573–1627), who operated the manufactory in the Faubourg Saint-Marcel, a suburb then southeast of the city wall of Paris, were obligated to comply with this directive. Often, optional secondary symbols or monograms were added to the hanging by the responsible master weaver or entrepreneur. The absence or presence of a woven mark was no guarantee of origin, however, as the perimeter selvages containing such marks could be easily replaced without damage to the border or narrative field; see Delmarcel 2000, 362; Denis 2007b, 124; and Brosens 2011b, 39. Nevertheless, given the meaning and significance of authentic and extant marks, their absence or presence has been recorded in the Checklist for each tapestry in the exhibition.

Similarly, contemporary measurements of tapestry dimensions also varied over time and region. The most common unit of linear measurement was called an ell, or *aune* in French. Gradually, the Flemish ell standardized to a length of 68.53 cm (27 in.) whereas the French *aune* in use at the Royal Tapestry Manufactory at the Gobelins equaled 118.8 cm (customarily rounded to 46¾ in.). The basic French unit of currency at that time was the livre. As a point of reference, thirty livres in 1664 covered the annual cost of food and lodging for one apprentice at the Royal Tapestry Manufactory at Beauvais; see Bremer-David 2007, 409, 419n11.

Throughout this volume, the names of historic agencies, institutions, and inventories have been rendered in English, per the adjacent key. Note that the preeminent tapestry manufactory at the Hôtel of the Gobelins, situated in the Faubourg Saint-Marcel, was restructured in November 1667 and its name changed from the Manufacture Royale de Tapisserie des Gobelins to the Manufacture Royale des Meubles de la Couronne.

Académie de France à Rome / French Academy in Rome

Académie des Inscriptions et Belles-Lettres / Academy of Inscriptions and Belles-Lettres

Académie Royale de Peinture et de Sculpture / Royal Academy of Painting and Sculpture

Accademia di San Luca (Roma) / Academy of Saint Luke (Rome)

Bâtiments du Roi, Jardins, Arts et Manufactures / Office of Royal Buildings, Gardens, Arts and Manufactories

Corps et Communauté des Maîtres et Marchands Tapissiers / Guild of Master Weavers and Tapestry Merchants

Garde-Meuble de la Couronne / Crown's Furniture Warehouse

Inventaire Général des Meubles de la Couronne / General Inventory of the Crown's Furniture

Journal du Garde-Meuble de la Couronne / Journal of the Crown's Furniture Warehouse

Manufacture Royale d'Aubusson / Royal Manufactory of Aubusson

Manufacture Royale des Meubles de la Couronne / Royal Furniture Manufactory of the Crown

Manufacture Royale de Tapisserie de Beauvais / Royal Tapestry Manufactory at Beauvais

Manufacture Royale de Tapisserie des Gobelins / Royal Tapestry Manufactory at the Gobelins

Petite Académie / Petite Academy

Brussels, workshop of Willem (?) Dermoyen
(Flemish, act. 1529–after 1544), after the
design by Bernard van Orley (Flemish,
ca. 1488–1541). *March*, from *The Hunts of
Maximilian*, 1531–33. Tapestry: wool,
silk, and gilt metal–wrapped thread, 440 ×
750 cm (173¼ × 295¼ in.). Paris, Musée
du Louvre, Département des Objets d'Art,
OA 7314

Louis XIV, Patron and Collector of Painting and Tapestry

Arnauld Brejon de Lavergnée

KINGS WERE BUILDERS, and this was particularly true of Louis XIV (1638–1715, r. from 1643). No one summed up the king's ambition better than his minister Jean-Baptiste Colbert (1619–1683), when he said, "Your Majesty knows that, apart from brilliant military exploits, nothing better demonstrates the grandeur and spirit of princes than buildings, and all posterity measures them in light of those superb mansions that they erected during their lifetimes."[1] And—as was always the case with Louis XIV—art collections went hand in hand with architectural projects. The genesis, development, and augmentation of these collections were chief among his lifelong interests. Colbert, superintendent of the Office of Royal Buildings, Gardens, Arts and Manufactories from 1664, formulated and pursued the policy of making Louis XIV the greatest collector in Europe. He was well aware of the costs incurred.

A Major Collection

To get an idea of the scope of the painting and tapestry acquisitions made during the reign of Louis XIV, we need cite only the purchases of the Everhard Jabach (1616–1695) collections (which contained the finest paintings by Correggio [ca. 1489–1534] and Titian [ca. 1488–1576]) or the tapestry collections of Cardinal Jules Mazarin (1602–1661, first minister of France from 1642), the duc d'Épernon (1592–1661), the duc de Guise (1614–1664), and Nicolas Fouquet (1615–1680, superintendent of finance 1653–61). From among the finest purchases, we will mention the two acquisitions from the duc de Mazarin (1632–1713), the cardinal's heir: the beautiful *Hunts of Maximilian* tapestry set (figs. 1, 14), formerly the jewel of the Hôtel de Guise, acquired in 1662 for the sum of 83,400 livres, and, three years later, in 1665, nine other tapestry sets for the considerable sum of 235,677 livres. There was, too, the famed set acquired from the duc d'Épernon, *The Triumphs of the Gods*, with its gold and silver thread, believed at the time to be after designs by the esteemed Renaissance master Raphael (1483–1520; see plate 2a). Painted works by the same artists—Raphael, Correggio, and Titian—were also avidly sought, notably Raphael's masterful *Portrait of Baldassare Castiglione*, acquired by the Crown from the duc de Mazarin in 1661. A single painting, at the time, could be worth between 200 and 4,000 livres.[2]

Tapestry makes up one of the most prestigious holdings of the French royal collections. We will emphasize the obvious: The numbers we have from royal inventories are extremely impressive. The French Crown acquired nearly five hundred easel paintings between 1662 and 1685 and more than a thousand paintings for decorative projects.[3] By contrast, with regard to the tapestry collection, the *General Inventory of the Crown's Furniture* of 1716 lists 304 tapestry sets, consisting of 2,566 individual pieces, plus an additional 85 single hangings.[4] It is difficult to determine how many of these were "old" tapestries, as old pieces and more recent productions from the Gobelins and Beauvais manufactories are listed together in the same document. Moreover, "old" could refer both to sets that Louis XIV inherited and to antique sets he purchased.

"Homeless Paintings": Walls without Tapestries

A work of art takes on life only if it is seen. What is the point of acquiring a work of art, if it is not displayed? Can a parallel be drawn between the two fields of artistic creation—painting and tapestry—that constitute so much of the king's enduring legacy? Tapestry is mobile, tapestry is

decorative; it is folded and then folded again, while easel painting is (in theory) an object of delectation and contemplation. Let us study, at least briefly, the role assigned to both in a few royal palaces in the latter half of the seventeenth century.

The phrase "homeless paintings" was coined by the modern art historian Antoine Schnapper (1933–2004), one of the first to consider the question of how the paintings newly acquired by the young Louis XIV beginning in 1662 were displayed.[5] One room after another in the Louvre and Tuileries Palaces served as the royal picture *cabinet* from the early 1660s until 1683, when much of the collection was transferred to Versailles. Schnapper laid out the major stages: first, the architect Louis Le Vau (1612–1670) created a *cabinet*, that is, a small room, for the nascent picture collection near the Small Gallery in the Louvre in 1664; there was its transitory placement with the triumphal exhibition of Italian masterpieces in the Ambassadors' Gallery (also known as the Gallery of Diana) in the Tuileries Palace from 1668 to 1671; then the picture *cabinet* (now comprising seven rooms) migrated to a location near the Gallery of Apollo in the Louvre, which the king honored with a visit in 1681. However, these were merely stages, just so many deinstallations and reinstallations, betraying a hesitancy to commit to a final placement. Paintings were transported to Versailles in late 1673 and then again in January 1683. The situation became more stable at Versailles in the 1690s, with permanent *cabinets*, such as the Oval Salon and the Shell Cabinet, where this time it was the lovely small works by Francesco Albani (1578–1660) and his Bolognese contemporaries that carried the day.

The situation was quite different, we surmise, for tapestries, which are, by their very nature, movable decor. There is no record of their exhibition or use in the Louvre and the Tuileries in the years from 1660 to 1680, except that they were stored in a warehouse—a fact that the scholar Henri Sauval happened to mention about 1665. The tapestries shipped to the Château of Versailles were primarily intended as furnishings.[6] Jean Vittet reviewed the facts in a seminal article.[7] After the first, relatively modest installations in the years 1666–68, one stunning display followed another, made possible by successive expansions of the château. Starting in 1669, Le Vau created the Grand Apartments of the king and queen. The former housed—albeit for only a few months—*The Hunts of Maximilian* while the latter probably contained the first set of *The Royal Residences / The Months of the Year*, a very recent creation after an initial concept by the director of the Royal Tapestry Manufactory at the Gobelins and first painter to the king, Charles Le Brun (1619–1690). "It is easy to imagine," wrote Vittet, "the splendor of this exhibition, where the goldsmiths' handiwork, already depicted in the tapestries, sparkled in the apartments."[8]

This Golden Age began to decline in the 1680s, when embroideries replaced the masterpieces created by the Gobelins weavers. Starting in 1693, a few tapestries were hung at the smaller Trianon Palace, situated in the grounds of Versailles, with, once again, the de Guise family's prized *Hunts* and, especially, the newly woven *Portieres of the Seasons* after Claude III Audran (1658–1734). The logic behind the shipments from the Crown's Furniture Warehouse and the Gobelins manufactory escapes us today, but we note that, from time to time, the tapestry subjects were chosen based upon a room's occupant. Tapestries were put to other uses as well—as diplomatic gifts and specific furnishings for visits by foreign rulers, as well as in processions during religious festivals (particularly the one in 1677 described in great detail in the court circular *Le Nouveau Mercure Galant*)—uses that merit further study.[9]

The King's Taste

There is little recorded information concerning the king's personal taste in painting and for art in general, except to say that he knew and loved architecture; Schnapper wrote somewhat harshly that "Louis XIV's taste does not seem particularly original."[10] Regarding tapestry, however, it is known that Louis XIV appreciated *The Hunts of Maximilian* (their design is quite pleasing, he observed) and the *[Old] Indies* tapestries. The latter was a series he asked to see several times (figs. 2, 28).[11]

Gradually, the context changed, the patron supplanted the collector, and Louis XIV would henceforth live surrounded by works of art that contributed to making the most beautiful palace in Europe even more magnificent.

The Getty Museum had the idea of devoting an entire exhibition—a first—to the tapestry collection of Louis XIV. It is our hope that visitors to the exhibition at this beautiful American museum—and readers of this accompanying catalogue—will discover the spirit of this textile art that always strives for greatness, in size, material, and subject matter, and that is synonymous with splendor.

NOTES

1. Colbert and Clément 1861–82, 5:269.
2. By way of comparison, in 1665, Armand Jean de Vignerot du Plessis, duc de Richelieu (1629–1715), sold the king twenty-two paintings, including thirteen by Nicolas Poussin (1594–1665), for the sum of 50,000 livres. It is true that it was Colbert who set the purchase price.
3. The painter Charles Le Brun (1619–1690) compiled an inventory of the easel paintings; see Brejon de Lavergnée 1987; and Engerand and Bailly 1899.
4. Vittet and Brejon de Lavergnée with de Savignac 2010.
5. Schnapper 1993.

6. We will focus only on the Château of Versailles. Displays—sometimes spectacular ones—of tapestries were also held at the Châteaux of Saint-Germain and Fontainebleau in the latter half of the seventeenth century.
7. Vittet 2011c.
8. Vittet 2011c, 186. See also entry 11, this catalogue.
9. *Le Nouveau Mercure Galant* (July 1677), 50–54.
10. Schnapper 1987, 10.
11. For a much more complete study of the king's taste for tapestry, see Vittet and Brejon de Lavergnée 2014.

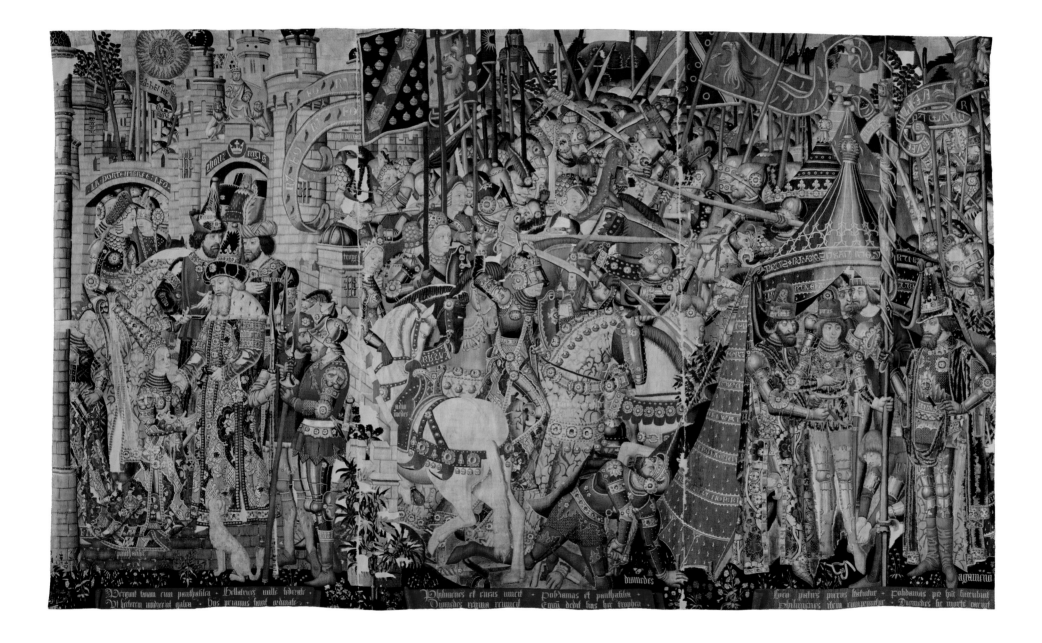

FIG. 3

Tournai workshop, after the design by
the Master of Coëtivy or Colin d'Amiens
(French, act. 1461–95). *The Queen of the
Amazons, Penthesilea, Aids the Trojans*,
from *The Story of Troy*, 1470–80. Tapestry:
wool and silk, 416 × 737 cm (163¾ ×
290³⁄₁₆ in.). London, Victoria and Albert
Museum, 6-1887

The French Royal Collection of Tapestries at Its Zenith

Louis XIV as Heir, Collector, and Patron

Jean Vittet

I

N 1716, ONE YEAR AFTER THE DEATH of Louis XIV, the French royal collection comprised 304 different tapestry sets, totaling 2,566 individual hangings, plus another 85 single pieces.[1] The only assemblage in history to rival it was the one assembled in the previous century by Henry VIII, king of England (1491–1547, r. from 1509), the greatest collector of Renaissance tapestries, who had gathered a similar number of pieces.[2] To put this in perspective, at the death of Philip II, king of Spain (1527–1598, r. from 1556), the renowned collection of the Spanish Habsburgs consisted of only seven hundred pieces, according to an inventory of 1598.[3] The variety of themes and subjects evoked by the sets in the French royal collection—biblical, religious, ancient, and contemporary history; mythology; allegory; medieval romances; and genre scenes—never fails to surprise, even though *verdures*—green landscape scenes—accounted for nearly one-third of the total. We are also struck by the international character, with weavings from very geographically diverse sources: Paris, including the illustrious Gobelins manufactory, Beauvais, Aubusson, Felletin, Tours, Amiens, Cadillac, Antwerp, Brussels, Oudenaarde, Delft, and Surrey, with the Mortlake Tapestry Works. Of this considerable collection, some seven hundred tapestries survive, six hundred of them in French collections. Three centuries after his death, we honor Louis the Great for putting together this fabulous treasure, whose magic amazes us still.

The Inheritance

The French royal collection of tapestries inherited by Louis XIV was rich and expansive, yet it had already suffered many significant dispersals before his coronation in 1654. Medieval tapestries, rare and precious now, have sometimes been viewed as disposable property. A notable case in point occurred on September 15, 1645, when Louis XIV was only seven years old. On that day at Fontainebleau, he signed letters patent conferring reward and favor to "Sieur Ratabon…, steward and officer of His buildings, in consideration of the good and pleasing services that he renders daily to His Majesty…, [the king] has granted and gifted to said Sieur Ratabon thirteen fragments of old tapestry, of high warp,…depicting the wars of the English against the Bretons."[4] From this description, we can easily recognize the famous and splendid set of the *Battle of Formigny* tapestries, a set woven with gilt-metal thread, originally measuring fifty-five running ells (or French *aunes*, a unit of linear measurement that varied according to time and place) in combined width, which Charles VII (1403–1461, r. from 1422) had commissioned to commemorate the French victory in the reconquest of Normandy at the end of the Hundred Years' War (1450). But had anyone explained to young Louis that this masterpiece of French art celebrated one of the greatest military feats France had ever known? Did his contemporaries remember that its models had been painted by Jean Fouquet (ca. 1420–ca. 1480), the greatest French artist of the fifteenth century?[5] Finally, was the king aware of the irreparable mistake that, under the guise of generosity, he was making by signing away this gift? This significant set never returned to the royal collection; after its acquisition by Bernard de Nogaret de La Valette, second duc d'Épernon (1592–1661) in 1656, it passed to the princes de Conti, who were still known to own it in the eighteenth century.[6]

FIG. 4

France or Flanders, unknown workshop, after the design by a French or Flemish artist. *The Judgment of Paradise*, also called *The Judgment of Wisdom*, from *The Family Father*, ca. 1500–1520. Tapestry: wool and silk, 160 × 185 cm (63 × 72¹³⁄₁₆ in.). Present location unknown

FIG. 5

Brussels, unspecified or undetermined workshop, probably after the design by Perino del Vaga (Italian, 1501–1547). *Apollo with the Signs of the Zodiac*, from *Apollo and the Four Seasons*, ca. 1545. Tapestry: wool, silk, and gilt metal–wrapped thread, 394 × 585 cm (155⅛ × 230⁵⁄₁₆ in.). Saint Petersburg, State Hermitage Museum, T 15623

Prestigious Ancestral Collections

Such routine disposal of tapestries, to which, as an adult, Louis XIV soon put an end, explains why his immediate inheritance dated back no further than the reign of Charles VIII (1470–1498, r. from 1483). Indeed, the oldest pieces still present among the Crown's assets in the seventeenth century almost all came down from this king;[7] Louis XII (1462–1515, r. from 1498), his immediate successor;[8] or Anne of Brittany (1477–1514), who married them in turn.[9] When Louis XII ascended to the throne, however, he brought with him a number of pieces from his own lineage, the ducs d'Orléans, including an extraordinary set of the *Sacraments*, from the early fifteenth century, which had belonged to Louis I d'Orléans (1372–1407).[10] Today, only two fragments of this medieval collection are still in existence: a tapestry from *The War of Troy* series in the Victoria and Albert Museum, London (fig. 3), and a fragment of a *Story of Hercules* in the Mobilier National, Paris. Two more medieval weavings survive, which can be related to a tapestry known in the seventeenth century as *The Family Father* but actually intended to evoke the theme of the Battle between the Virtues and Vices (fig. 4).[11]

The largest legacy, in both breadth and quality, to come down to Louis XIV descended from François I (1494–1547, r. from 1515), who was unquestionably one of the greatest tapestry patrons of all time.[12] This inheritance consisted of magnificent tapestries woven with gilt metal–wrapped thread in Brussels after cartoons by some of the most famous masters of the Renaissance—Raphael (1483–1520), Giulio Romano (ca. 1499–1546), and Pieter Coecke van Aelst (1502–1550), among others—but their excessive richness was unfortunately their downfall: this treasure has disappeared, most of it lost during the French Revolution. A notable exception is the admirable set of *Apollo and the Four Seasons*, now conserved in the State Hermitage Museum, Saint Petersburg (fig. 5).[13] Though the full legacy of François I has been sadly diminished by dispersal and destruction, much of its former splendor is conjured by other, extant editions of the same series made specifically for the Habsburgs, such as *The*

FIG. 6

Brussels, unspecified workshop, after the design by Hieronymus Bosch (Netherlandish, ca. 1450–1516). *The Tribulations of Life*, from *The Vision of Saint Anthony*, 1550–70. Tapestry: wool, silk, and gilt metal–wrapped thread, 291 × 372 cm (114⁹⁄₁₆ × 146⁷⁄₁₆ in.). Madrid, Patrimonio Nacional, A.364.12297

FIG. 7

Paris, Faubourg Saint-Germain manufactory, under the direction of Sébastien-François de La Planche (French, d. 1694 or later), after the design by an artist in the circle of Pieter Coecke van Aelst (Flemish, 1502–1550). *Psyche's Meal*, from *The Story of Psyche*, ca. 1660. Tapestry: wool, silk, and gilt metal–wrapped thread, 390 × 390 cm (153⁹⁄₁₆ × 153⁹⁄₁₆ in.). Fontainebleau, Musée National du Château de Fontainebleau, F 768 c/4

Acts of the Apostles, The Story of Scipio, The Story of Saint Paul, The Vision of Saint Anthony (fig. 6), and *The Story of Joshua*, sets preserved in Madrid and Vienna, and by tapestries rewoven in Paris, particularly at the Gobelins manufactory, after originals still in the French royal collection, such as *The Story of Psyche* (fig. 7), *The Lucas Months* (fig. 8), *The Bacchanalia*, and *The Seven Ages of Man*. The contributions of the last Valois kings to the royal tapestry collection remain a mystery, but the wars of religion must have discouraged the amassing of collections. More research is needed to better understand the patronage of Henri II (1519–1559, r. from 1547), Charles IX (1550–1574, r. from 1560), and Henri III (1551–1589, r. from 1574) (fig. 9).[14]

The legacy of the Bourbons, the direct ancestors of Louis XIV, was as important as that of François I—in quantity at least, if not in quality. It seems Henri IV (1563–1610, king of Navarre from 1572 and king of France from 1589) added to the royal collection a single set, inherited from the kings of Navarre, a *Story of Saint John the Baptist*.[15] Instead, he had shipments of magnificent embroideries sent from Pau to Paris. He did, however, enrich the Furniture Warehouse with new tapestry commissions from the Parisian workshops, intended to encourage the French weaving industry.[16] Essentially, three series remain from this era: a complete set of *The Story of Coriolanus* (fig. 10)[17] and two sets from *The Story of Queen Artemisia*,[18] one of which was divided before the reign of Louis XIV and miraculously reunited in 2007. The reign of Louis XIII (1601–1643, r. from 1610) also produced innovative achievements, particularly the famous *Story of Constantine* after Peter Paul Rubens (1577–1640).[19] In addition, Simon Vouet (1590–1649) appears to have been the most important creator of tapestry designs destined for the royal Furniture Warehouse. His sense of harmonious nature and poetic narrative explains the success his designs enjoyed, then and now (see plate 7a).[20] Despite the revolts and disturbances of the Fronde, the regency of Anne of Austria (1601–1666, queen regent of France 1643–51) also contributed to the royal collections: the set of *Rinceaux with the Elements and the*

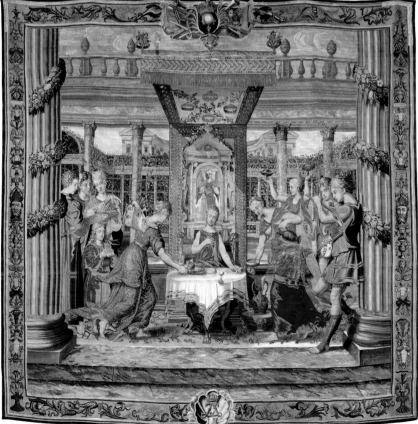

FIG. 8

Paris, Gobelins manufactory, in the low-warp workshop of Jean-Baptiste Mozin (French, d. 1693), after the design by the Master of the Lucas Months (Flemish, sixteenth century). *February*, from *The Lucas Months*, 1688–89. Tapestry: wool and silk, 300 × 320 cm (118⅛ × 126 in.). Pau, Musée National du Château de Pau, P 109 C

FIG. 9

Brussels, undetermined workshop, after the design of Antoine Caron (French, 1521–1599). *Tournament of Breton and Irish Knights at Bayonne*, from the *Valois Tapestries*, ca. 1575–81. Tapestry: wool, silk, silver- and gilt metal–wrapped thread, 384 × 605 cm (151⅛ × 238¼ in.). Florence, Galleria degli Uffizi, Deposito Arazzi, inv. 1912-25, no. 495

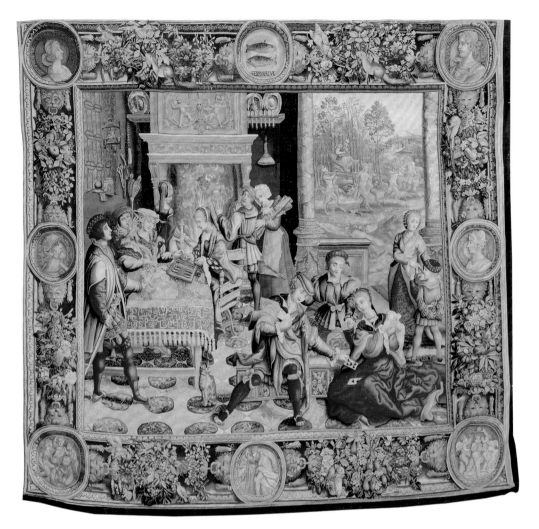

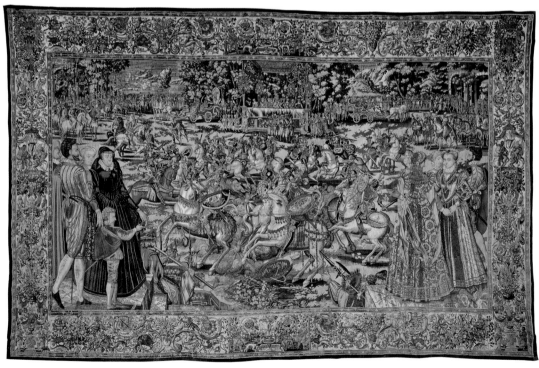

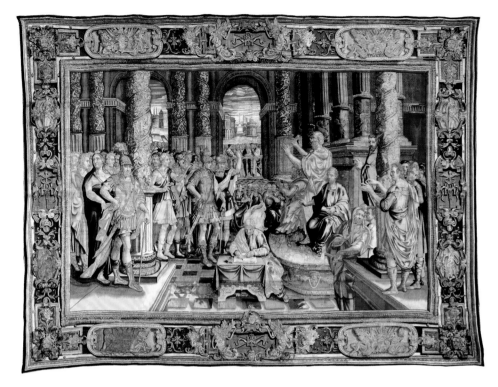

Seasons, attributed to Charles Errard (1606/1609–1689), stands out for its often-cited decorative elegance (fig. 11).[21]

Major Acquisitions of the Reign

In enriching the royal collection, the role of the king, who was focused on governing, could not suffice, and several leading ministers of France strove to remedy this shortcoming. Cardinal Richelieu (1585–1642, first minister of France from 1624), who owned a very notable collection of tapestries, bequeathed the best of them to the king, including a rich *Story of Diana* after Toussaint Dubreuil (1561–1602) (fig. 12) and an extraordinary set, *The Grotesques*, suggestive of hunting and dating back to the Renaissance.[22] The importance of the latter has been obscured due to its destruction, but, thanks to the discovery of an equivalent weaving (fig. 13), its merits can be appreciated once again.[23] Cardinal Jules Mazarin (1602–1661, first minister of France from 1642) followed the example of collecting set by Richelieu, and he attempted to give his entire collection to Louis XIV. But the king and his then new minister Jean-Baptiste Colbert (1619–1683) cautiously refused the controversial gift, as portions of the collection had been acquired under dubious circumstances. Finally, only two sets bequeathed by Mazarin in 1661 were accepted by the Crown: the *Sabine Women* and *Fructus Belli* (Fruits of war). The cardinal had been given these sets by the king of Spain during the negotiations for the marriage of Louis XIV to Maria Teresa of Spain (1638–1683, queen of France from 1660).[24]

Collectors: Ministers, Peers, and the King

Letters of appointment signed by Louis XIV on December 31, 1663, affirmed Gédéon Berbier du Metz (1626–1709) as steward and comptroller general of the Crown's Furniture Warehouse. The document alluded to "the experience of the last century, during which there was prodigious dissipation of all that was most beautiful and most rare in our [royal] furniture warehouse." The king therefore tasked the new royal furnishings manager "to search for furniture of our Crown that may have been diverted or

FIG. 12

Paris, Faubourg Saint-Marcel manufactory, in the workshop of Hans Taye (Flemish, act. France ca. 1627), after the design by Toussaint Dubreuil (French, 1561–1602). *Diana and Apollo Slaying the Children of Niobe*, from *The Story of Diana*, ca. 1630. Tapestry: wool, silk, and gilt metal–wrapped thread, 397 × 580 cm (156⁵⁄₁₆ × 228³⁄₈ in.). Paris, Mobilier National, GMTT 15/3

FIG. 13

Brussels, possibly workshop of Hans (Jan) Mattens (Flemish, act. 1613, d. 1633/34), after the design by an unknown artist (Flemish?, sixteenth century). *Combat between a Serpent and a Leopard Who Devours a Monkey*, from *The Grotesques*, ca. 1600, with later reweaving. Tapestry: wool and silk, 430 × 694 cm (169⁵⁄₁₆ × 273¼ in.). Paris, Drouot Richelieu, April 5, 2013, no. 198

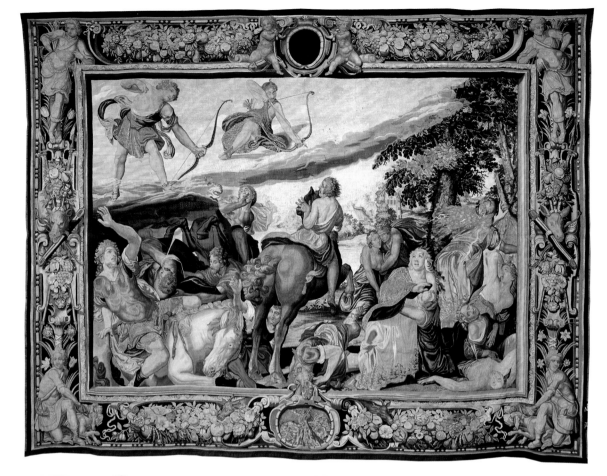

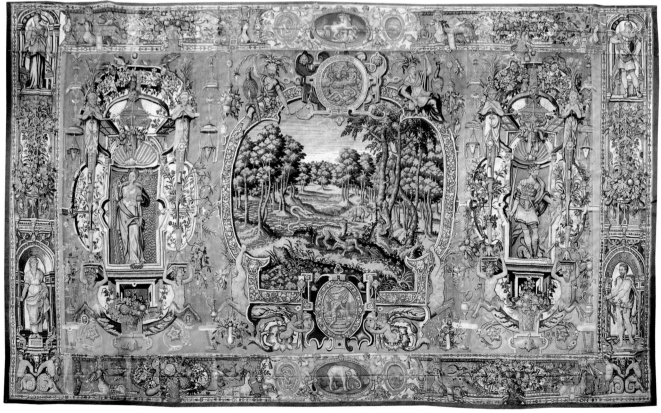

FIG. 14

Brussels, workshop of Willem (?) Dermoyen (Flemish, act. 1529–after 1544), after the design by Bernard van Orley (Flemish, ca. 1488–1541). *July*, from *The Hunts of Maximilian*, 1531–33. Tapestry: wool, silk, and gilt metal–wrapped thread, 430 × 570 cm (169⅝ × 224⅞ in.). Paris, Musée du Louvre, Département des Objets d'Art, OA 7318

pledged" away from the collection.[25] Colbert, who promoted a policy to glorify the monarchy, supported Berbier du Metz in this endeavor. The latter administrator fulfilled the assignment by making several prestigious purchases of tapestries from large estates in the early years of the reign. Thus, at the death of the second duc d'Épernon (1592–1661), the Furniture Warehouse recovered several exceptional royal tapestry sets for the Crown, some of which had left the royal collection as a result of Henri III's largesse to the first duc d'Épernon (1554–1642).[26] In 1665, Colbert sealed a spectacular deal, the purchase of the greatest weavings from Cardinal Mazarin's collection, which had passed meanwhile to his heir and nephew, the duc de Mazarin. In this way, Colbert brought some of the most stunning and most admired tapestry masterpieces of all time into the French collections: *The Hunts of Maximilian* (figs. 1, 14), *The Acts of the Apostles*, originally from Charles I of England (1600–1649, r. from 1625) (see plate 1a), and *The Story of Scipio* from the marshal d'Albon de Saint-André (see plate 4a). This last set had been at the center of unexpected international issues when Cardinal Mazarin pledged it in 1648 to support the army of Modena.[27]

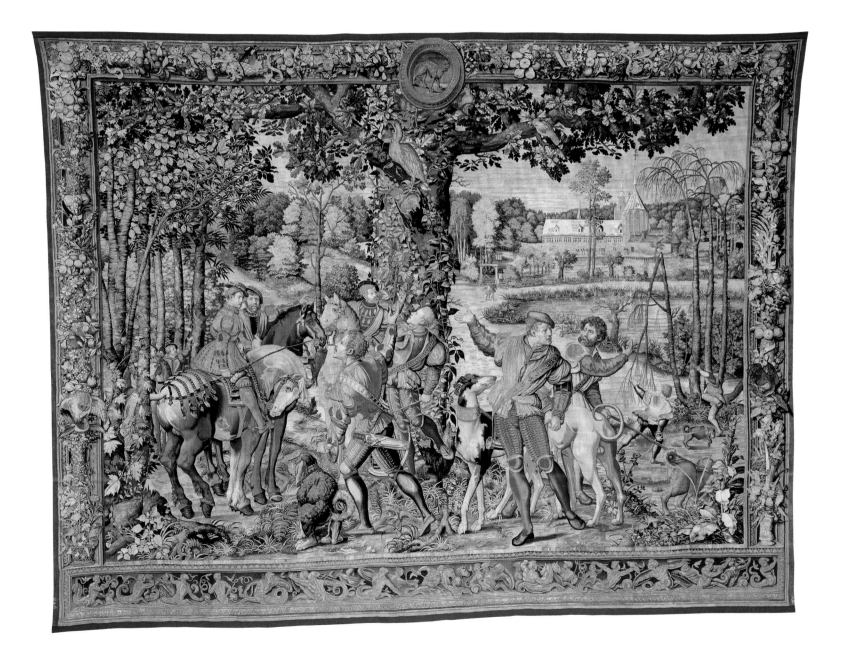

Some of these famous tapestries had, since the sixteenth century, figured in the collection of the powerful de Guise family of Lorraine, including an astonishing *Actaeon* set, a portion of which has been identified in a private collection.[28] The last representative of the de Guise line even bequeathed to the king a set of *The Five Ages of Life* that François I had owned a century earlier. The preparatory drawings for that series, which had come into the possession of the banker and collector Everhard Jabach (1616–1695), were identified thanks to information provided about them by the historian André Félibien (1619–1695) and the architect Nicodemus Tessin the Younger (1654–1728) (fig. 15).[29]

Shortly after, in 1666, the Crown finalized the confiscation of the collection of Nicolas Fouquet (1615–1680), the disgraced superintendent of finance. That seizure was an actual act of preemption before there was a name for such a thing.[30] The goods were stored at the Parisian townhouse of the Mazarin family until the king made financial compensation in order to satisfy Fouquet's creditors. Abundant and varied, the collection included the Renaissance series mentioned above: *Apollo and the Four Seasons*, which apparently had come from François I; a small, rare set of the life of Saint John (fig. 16); and a valuable reproduction, woven at the English Mortlake Tapestry Works in Surrey, of a sixteenth-century series, *The Story of Vulcan* (see plate 3a).[31] Its cartoon painter, a master of very elegant design, has still not been identified.[32] Mortlake also created another astonishing panel in the Fouquet collection, *The Supper at Emmaus*, after Titian (ca. 1488–1576).[33] The final years of the reign also witnessed the purchase of several sets from Anne-Marie-Louise d'Orléans, known as La Grande Mademoiselle (1627–1693), none of which have been seen since.[34]

All these spectacular acquisitions during the reign were rounded out with generally more modest purchases from numerous merchants, mostly Parisian, whose names are given in the *Journal of the Crown's Furniture Warehouse* and the royal accounts (Dame Petit, Foucanie [or Soucagne], Henri, Michel, Méteils, Lescot, Bastier, Prozelle, Duru, Doublet, Béhagle, Dame Devoulges, Pasquier).[35] In 1671, Jabach sold the king a few elegant Aubusson "landscape with perspectives" tapestries, one of which still exists (fig. 17).[36]

Royal Displays of Antique Tapestries and the King's Taste

As early as 1654, on the occasion of Louis XIV's coronation in Reims, the interior of the cathedral had been entirely decorated with tapestries from the royal collection. The occasion was recorded visually

for posterity in several engravings by Jean Le Pautre (1618–1682). For certain reasons, the views
were not entirely accurate (see the essay by Bertrand, this catalogue) (see fig. 38).[37] The Treaty of the
Pyrenees, signed in 1659 on Pheasant Island to end the long-running war with Spain, was another
occasion for a grand display of tapestries, descriptions of which have been preserved.[38] The Fête-Dieu
(Feast of Corpus Christi), instituted in the Middle Ages, was also an opportunity for massive displays of
the richest royal tapestries. They were hung on the walls of the royal residences, as well as along
the streets of the cities and towns where the observances took place. Impressive lists of such displays
have sometimes been preserved, particularly for the years 1666, at the Château of Fontainebleau;
1668, at the Château of Saint-Germain-en-Laye; and 1677, at the Château of Versailles.[39]

But these events only continued the ancestral traditions of the French monarchs. More sig-
nificant to us is how tapestries were used in the king's private spaces. On this subject, we have some
exceptional testimony from the *Journal*; albeit limited in the time span it covers, it provides infor-
mation about all the allocations and various uses of tapestries in the apartments of the royal family,
particularly between 1666 and 1669. As far as we can tell, the identity of the user often determined the
choice of themes. For example, the graceful *Psyche* series was most likely to be found in the queen's

apartments, while the *Children's Games* set was most often seen in the room of the young dauphin,
Louis (1661–1711).[40] Louis XIV held *The Hunts of Maximilian* in high esteem: he had them placed in
the Grand Apartment at Versailles as early as 1673, complemented by matching silk wall hangings that
were painted and embroidered with gold thread.[41] In the second part of the reign, the creation of the
marble-clad Trianon Palace on the grounds of Versailles in 1687 prompted tapestry hangs that more
than ever reflected the king's particular taste for antique-themed weavings.[42] For example, a report
dated November 30, 1693, states that "the Small Scipio after Giulio Romano in 8 pieces [woven at the
Gobelins] was hung at Trianon" and "the Raphael grotesques in 12 pieces, representing the 12 months
of year, were also hung at Trianon; this is said to be a copy of the one belonging to M. de Guise." The
"Little Scipio" replica mentioned here was woven at the Gobelins manufactory before 1691 (see fig. 52).
It was a copy of the famous sixteenth-century *Story of Scipio* tapestry set that had once belonged to
the marshal d'Albon de Saint-André.[43] As for the copy of the *Grotesques*, more generally known as
The Grotesque Months, it too had been woven at the Gobelins before 1689, after the sixteenth-century
Brussels set of the same name, which had belonged to the ducs de Guise (fig. 18). Displayed in the
king's cabinet at the Trianon, it was joined by new hangings that were round at the top in order to fit
a niche where the king could lie down. These new hangings had been produced by 1696, also at the
Gobelins, after designs by Noël Coypel (1628–1707).[44] In December 1695, Édouard Colbert, marquis de

Villacerf (1628–1699, superintendent of the Office of Royal Buildings, Gardens, Arts and Manufactories from 1691), reported on this subject that "although the manufactory at the Gobelins ceased to operate because of the war…, the king recently ordered three tapestry pieces for Trianon, which will be made shortly."[45] Pierre Mesmyn, senior clerk at the Office of Royal Buildings (1680s–90s), annotated the report with: "In the month of February 1688, I sent to Versailles pieces from the *Fructus Belli*, the de Guise *Hunts of Maximilian*, and the de Guise *Grotesques*, which had been completed….The king found these works much to his liking, but mainly the de Guise *Hunts*, whose designs are assuredly more pleasing."[46] These replica tapestries were made on the Gobelins looms after the old sixteenth-century tapestries.[47]

The situation was similar at the newly constructed Château of Marly, where, in November 1700, Louis XIV had placed in his apartments two Gobelins weavings from *The Triumphs of the Gods* (see fig. 48), whose cartoons had been magnificently redone by Coypel—a long and costly process—after the original sixteenth-century set acquired by the king just a few years earlier (see plate 2a).[48] The sovereign's intervention in this decorative decision was crucial, as demonstrated by the instructions given Jules Hardouin-Mansart (1646–1708, architect and superintendent of the Office of Royal Buildings from 1699) the previous September 14, "The King has ordered that new designs for grotesques and arabesques be made shortly for tapestry sets for the four large apartments at the Château of Marly, and to make many small pieces that can be used in several locations."[49]

An Exceptional Inventory

Louis XIV's immediate predecessors did not attach great importance to keeping inventories, and there is now no known inventory of the royal tapestry collections from the reigns of Henri II to Louis XIII. Early in the reign of Louis XIV, an inventory of tapestries did exist, though it has since disappeared. The numbers assigned in that inventory also appeared in the separate *Journal* until 1669, though not always consistently thereafter. As of October 7, 1667, the *Journal* further mentions the existence of an "abridged inventory" of the collection of the Furniture Warehouse, which may have been one and the same.[50] The first real inventory of tapestries from the period of Louis XIV was prepared around January or February 1666. However, the very detailed (albeit unnumbered) document lists only the pieces stored in Paris at the Petit Bourbon warehouse (located opposite the Louvre colonnade). At the time, there were 44 sets there, constituting 372 individual hangings, as well as 6 embroidered sets.[51]

The next inventory was on a completely different scale and reflected a growing administrative efficiency. It was begun in 1672 and ended on February 20 of the following year.[52] This inventory, officially titled *General Inventory of the Crown's Furniture*, covered all the collections in the Furniture Warehouse. It originally comprised six volumes. In it, the tapestries were divided into four sections, according to their materials (whether or not there was gold or gilt metal–wrapped thread in the weave) and status (whether or not the pieces formed part of a set).[53] The order of the tapestry sets presents the accessions and acquisitions chronologically since the 1660s. The inventory utilizes a consistent numbering, necessitated by the constantly growing collection, but such numbering would not correspond to that in the *Journal* until 1671. The inventory numbers were meticulously copied onto the tapestry linings, which unfortunately were not always preserved.[54] This major inventory also represented an unprecedented centralization of the collection: all movable assets scattered throughout the various royal residences outside Paris were added to it. This is how the tapestry collection at the Château of Blois was reincorporated into the capital assets.[55] In fact, an inventory prepared by Gédéon Berbier du Metz in 1668 of the furniture at the Châteaux of Blois and Chambord, mentions "the order that the king gave us on the first of this month of October to transport those furnishings from said inventory, that we may deem useful in the service of His Majesty, to the Crown's Furniture Warehouse in Paris."[56] This explains the arrival of the fifteenth-century collections formed by Charles VIII and Louis XII. The recent discovery of the existence of a second, perhaps more secure furniture warehouse,

at the Château of Vincennes is especially noteworthy.[57] The old collection of the Château of Versailles was likewise entered in the *General Inventory*.[58]

In the *General Inventory* of 1673, the attributions of models to artists are those given by Félibien in the second edition of his *Entretiens sur les vies et sur les ouvrages des plus excellens peintres anciens et modernes* (Discussions, concerning the lives and works of the most excellent painters, ancient and modern; 1685–88). Even though the attributions are often erroneous or approximate—but always flattering—one wonders whether Félibien had not been consulted about this, and everything points toward his having been shown the tapestries (unless he saw them at the displays during the Feast of Corpus Christi). The descriptions, too, despite care and diligence, are sometimes incorrect and inconsistent, while, for the oldest tapestries, the workshop attributions are unreliable. With the growing accumulation of new records throughout the reign of Louis XIV, from 1673 until the king's death in 1715, the *General Inventory* contained many changes, deletions, and "discharged" items, that is to say, items crossed out as a result of number changes or disposal. Moïse-Augustin Fontanieu (1662–1725, steward of the Furniture Warehouse from 1711) therefore decided to make an updated version to reflect the changes. The new version, sometimes called the "Inventory of 1729" (because of its end date), was written chiefly in 1716 and consisted of eight volumes. The descriptions from 1673 were usually copied verbatim but sometimes helpfully supplemented, particularly in the last tapestry section on "odd" wool and silk pieces that came from incomplete sets.[59]

Patronage and the Royal Manufactories

Purchases of "old," that is, antique, sets, as remarkable as they were, could not however satisfy the king's ambition, which was to make France a major center of tapestry design and production. Thus, every effort was made to overhaul existing manufactories, as well as to create new ones.

The Manufactory at the Gobelins

Before discussing production at the Gobelins, we should recall that this most famous of the French tapestry manufactories of Louis XIV's reign came under the superintendence of the Office of Royal Buildings, Gardens, Arts, and Manufactories, an agency directed successively by Antoine Ratabon, 1656–64; Jean-Baptiste Colbert, 1664–83; François-Michel Le Tellier, marquis de Louvois, 1683–91; Édouard Colbert, marquis de Villacerf, 1691–99; Jules Hardouin-Mansart, 1699–1708; and finally Louis-Antoine de Pardaillan de Gondrin, marquis (and later duc) d'Antin, 1708–36. The director of the manufactory reported to the superintendent, because, according to Jules-Robert de Cotte (director from 1709 to 1747) in 1745, "It is well known that the superintendents and directors general of the Office of Royal Buildings, from M. Colbert to M. Orry, have always reserved the Gobelins and Savonnerie manufactories for themselves, giving no information thereof to the senior architect of the king, nor to the inspector general when there was one. They always reserved for themselves the direct work with the comptroller of Paris, who is the director of those manufactories under the orders of the director general."[60] The first directors of the Gobelins under Louis XIV were, first and foremost, painters: Charles Le Brun (1619–1690) from 1663 to 1690, then Pierre Mignard (1612–1695) from 1690 to 1695; and then architects: Antoine Desgodetz (1653–1728) from 1695 to 1708, followed by Jules-Robert de Cotte, son of the king's chief architect, beginning in 1709.

THE GOBELINS IN THE TIME OF LE BRUN

History generally holds that the Royal Tapestry Manufactory at the Gobelins was founded in 1662 and that Le Brun was its first director.[61] However, in light of the evidence in written documents, it is necessary to qualify these certainties. For example, Georges Guillet de Saint-George (ca. 1624–

1705), a biographer of Le Brun, believed that the creation of the Gobelins dated back to 1660: "That same year of 1660, M. Colbert, who, with the support of Mgr Cardinal Mazarin, began to enter into competition with M. Fouquet for the Superintendence of Office of Royal Buildings, received an order from the king to establish royal manufactories for the Crown's furnishings at the Hôtel of the Gobelins in the Faubourg Saint-Marceau. M. Colbert did so with great care and chose M. Le Brun as director of that establishment."[62] In addition, at that same time, the artistic as well as administrative supervision of the manufactory fell to Jean Valdor (d. 1675) of Liège, as suggested by the payment of 4,100 livres he received from the Royal Treasury in 1662 "on account of the tapestries that he had made at the Gobelins for the service of the king."[63] Furthermore, Nicolas Guérin (ca. 1645–1714), secretary of the Royal Academy of Painting and Sculpture, stated in his "Account of What Occurred at the Establishment of the Academy" that Gédéon Berbier du Metz, steward general of the Crown's Furniture, also took part in founding the manufactory in 1662: "M. Colbert…, having resolved to reestablish and promote the tapestry manufactory at the royal residence known as the Hôtel of the Gobelins, charges M. du Metz with doing so."[64] The presence of Valdor, working with Le Brun and Berbier du Metz at the Gobelins in September 1662, has been confirmed.[65]

Thus, in the early days, Le Brun's role probably was limited to supplying the models necessary for the workshops. Indeed, the artist did not obtain letters patent from the king appointing him full director of the Royal Tapestry Manufactory at the Gobelins until March 8, 1663. These new responsibilities did not go smoothly, and Le Brun soon complained of them, as Olivier Lefèvre d'Ormesson (1616–1686) noted in his diary: "Sunday, November 15, [1665]…I dined at M. Le Roux's with M. Le Brun, who…expressed dismay at the hardness of the times, and, although he got on very well with M. Colbert and was in charge of the work at the Gobelins, he did not seem happy about it, saying that the more he did, the more work was required of him, without evidence of satisfaction, and that there was even jealousy of him, because the king was pleased with him."[66]

The founding of the manufactory was accompanied by the acquisition, in 1662, of several houses to supplement the buildings on the same site that had been dedicated to the production of tapestries since the time of Henri IV.[67] But the development of the manufactory could not continue without a clear regulatory framework. An *Édit du roy pour l'établissement d'une manufacture des meubles de la Couronne aux Gobelins* (Edict of the king establishing a manufactory of crown furniture at the Gobelins), dated November 1667, provided clarification in that regard.[68] It specified that the manufactory would be called "Manufacture Royale des Meubles de la Couronne" (Royal Furniture Manufactory of the Crown) and confirmed that it was placed under the authority of Colbert with Le Brun as its director. It also provided for an apprenticeship of sixty children at the school, or "seminary," of the manufactory, after which the workers could become craftsmen. Among various privileges, naturalization was granted to foreigners after working for ten years at the manufactory. The last article of the edict banned the importation of foreign tapestries.

In 1673, the court circular *Le Mercure Galant* published, in the emphatic style of the period, a picturesque description of the manufactory in its early years, which is helpful for understanding the community environment that prevailed there.

Although…the Gobelins has long been in operation, it has flourished only for the past ten or twelve years, in other words, since the great monarch of the universe himself has been at the helm of his State. The illustrious M. Le Brun, whose knowledge is extensive, who can rightly be regarded as one of the greatest painters of our era, and who is no less famous for the thousands and thousands of works that have come from his hand than for the million more for which he provided the drawings, is the chancellor and rector of the Royal Academy of Painting and Sculpture and director general of all the works that are produced at the Gobelins. The building, which could serve as a princely abode, or rather, which could pass for a small town, contains four or five grand courtyards. In this house, there is a doorman

and a concierge, and not only are the workers lodged but also their wives and children and all those who do work for them, which goes to infinity, as the craftsmen sometimes each have forty or fifty people working under them…; that is one of the reasons they are all lodged together. There is nevertheless a stronger one, and it is said that it is so that M. Le Brun may see their work at all times, so that he may correct them, and so he may see if they are progressing and not wasting their time. We can add to all these reasons that it is more glorious for this great prince, who puts so many heads and hands to work, to see all those who are working for him in the same place than if they were each scattered in their homes. They also gain great advantage from this because, in addition to the fact that their lodgings cost them nothing and that the king pays them for all their work, they all have a pension from His Majesty, which is given to them in consideration of their merit alone.[69]

THE GOBELINS STAFF

The workshop foremen were the other most important people at the Gobelins.[70] Simply put, in Le Brun's day, there were four main workshops, two high-warp (vertical loom) and two low-warp (horizontal loom). Jean Jans the Elder (ca. 1618–1691) and, from 1668, his son ran the most important high-warp workshop from 1662 to 1723. Jean Lefebvre the Elder (active until 1700) and, from 1699, his son were in charge of the second high-warp workshop from 1662 to 1736. Paul Fréart Chantelou (1609–1693) observed in his diary, when recalling the 1665 visit of the sculptor Gian Lorenzo Bernini (1598–1680) in France, that Colbert had "restored the high-warp manufactory, where [once] only two workers remained in Paris."[71] Under Louis XIV, there were two other high-warp workshops, that of Henri Laurent from 1662 to 1669 and that of Louis Ovis de La Tour from 1703 to 1734. The two largest low-warp workshops were those of Jean de La Croix from 1662 to 1712 and Jean-Baptiste Mozin from 1671 to 1693. In 1693, Dominique de La Croix succeeded Mozin and in 1712 he combined the two low-warp workshops. From the end of the century, two additional low-warp workshops were directed by the Souet and de La Fraye families. A third and last one was active under the supervision of the low-warp foreman Étienne Le Blond from 1701 to 1727.

Another important position, that of manufactory inspector, was held by a painter who was also the keeper of the models. Beaudrin Yvart (1611–1690), followed by his son Joseph (1649–1728), fulfilled the role without having the title. In 1699, the painter Pierre Mathieu (ca. 1657–1719), of the Royal Academy of Painting and Sculpture, succeeded them. The concierge, Jacques Rochon, followed by Antoine Cozette from 1691, was in charge of the materials-supply warehouse (wool and silk) and the tapestry warehouse. The Gobelins dye shop was run by Josse van den Kerchove (1656–1695), who was succeeded by his son, Jacques. Finally, there were a chaplain and a doorman.

It is difficult to know the exact number of weavers. According to Lorenzo Magalotti (1637–1712), secretary to the grand duke of Tuscany who was traveling in France in 1668, there were four hundred people employed at the Gobelins.[72] The most accurate documents on the subject did not appear until 1693–94, when the manufactory was about to close its doors because of the ongoing war against the League of Augsburg (1688–97); these detailed lists were published by Jules Guiffrey (1840–1918).[73] One, titled "List of the workers [in the workshop] of Jans, weaver to the king at the Gobelins, explaining their capacity, their age, and the time they have been in His Majesty's service," contains sixty-seven names. By extrapolation, that is, by counting fifty workers for each of the other three workshops, Guiffrey estimated that, for the period from 1663 to 1693, the average number of weavers working at the Gobelins ranged between two hundred and three hundred. A transcription of two descriptions of weavers excerpted from the list can shed light on their skills: "John Vavoq.—Age fifty-five years or so, has worked here since the establishment of the manufactory, thirty-one to thirty-two years ago, and is one of the best workers, who has always been employed at doing heads and flesh" and "Jean-Baptiste Gaucher.—Age about forty years, has been working here for ten years,

fit for all sorts of works except heads and flesh; I [Jans] use him for the things I do every week for the payment of my workers and for the care of my shops, as he is very smart with all these things; he has four children." A second list, "Statement of tapestry workers dismissed from the Gobelins manufactory, requesting separate passports to return each to his home in Flanders in the following cities," includes twenty-two workers requesting to return to Brussels, Antwerp, and Bruges, thus reminding us that many of them were Flemish. A final document—this one unpublished—which is somewhat older, as it was written in 1689, helpfully points out that Jans's workshop has twenty-one looms, Lefebvre's nine, Mozin's ten, and La Croix's seven.[74]

MANUFACTORY EXPENSES AND PRODUCTION COSTS

The Accounts of the Office of Royal Buildings inform us that, for the period from 1664 to 1694, the Janses received 779,759 livres 2 sols 10 deniers; Lefebvre, 389,026 livres; La Croix, 301,831 livres; and Mozin (from 1671), 298,613 livres in payment for their work. Thus, the Gobelins budget averaged approximately 65,000 livres per year (the Jans workshop receiving about 25,000 livres), totaling a significant overall expenditure of two million livres over the entire period in question.[75] A document from 1688 further tells us that, before 1680, tapestries were sold by the square ell (or *aune*), but did not take into account the difficulty of the task. In 1680, Colbert therefore introduced payment by the "*bâton*," with each *bâton* equivalent to a sixteenth of a square ell, thus refining the labor cost of each tapestry.[76] The workers were then paid according to the complexity of their work, human heads being the most expensive. Pay rates for low-warp work were less than those for high-warp work. The document states that the price was calculated based on the design model or cartoon, not on the weaving. "Before placing a piece on the loom, the drawing or painting was placed on the floor; all parts of the painting were measured separately based on the various features of the design; each price was accurately calculated for the *bâtons* of the different parts constituting said piece." However, that pricing did not apply to the high-warp weaving of the so-called *Subjects of the Fable* after Raphael and Giulio Romano (discussed below), for which a fixed rate was used, that is, 380 livres per square French ell in the Jans workshop, which was considered superior, and 330 livres in the Lefebvre workshop. This anomaly was due to the fact that these tapestries were "infinitely more labor intensive, the execution much more difficult, and the weave incomparably finer, so that said set will go for more than those [of *The Story of the King* set] depicting the heroic actions of the king, which were paid 450 livres per square [French] ell." Finally, from a "Report on tapestry pieces that are on the looms in the workshops of Royal Manufactory at the Gobelins," written in May 1694, we learn that thirty-two pieces were being woven, nineteen of them on high-warp looms and thirteen on low-warp. This gives a good idea of the manufactory's normal pace of activity. The document also specifies the time needed to complete the pieces, which makes it possible to determine that it took three and one-half years to four years to weave a large piece, for example, one measuring more than six by four French ells.[77] Between 1664 and 1691, 232 high-warp and 378 low-warp tapestries were produced in this way—a considerable output of more than six hundred pieces in nearly thirty years.[78]

TAPESTRIES AFTER THE DESIGNS OF LE BRUN

Charles Le Brun, in whose hands the artistic fate of the Gobelins manufactory had been placed, was responsible for an exceptional group of tapestry series that are among the most famous creations of French art.[79] Steeped in classicism but also manifesting spectacular pictorial effects, his contributions to the art of tapestry range from allegory to ancient history, with occasional forays into mythology and even, more rarely, into contemporary history. His most famous series, all created in the early years of the manufactory, are *The Story of Alexander*, a monumental epic cycle for which the artist was universally admired; *The Muses*; *The Elements*; *The Seasons*; and, proceeding from these, *The Child Gardeners*, an essentially poetic and intellectual series that, collectively, sang the praises of the happy

years of the reign of Louis XIV. Then there were *The Story of the King*, a series of political propaganda whose scenes are still highly effective, and *The Royal Residences / The Months of the Year*, in which each residence was meant to evoke the individual reigns of the sovereign's predecessors. Such prolific productivity was possible only because of the numerous collaborators with whom Le Brun surrounded himself.[80] The most brilliant of these was Adam Frans van der Meulen (1632–1690), but others must have played a vital role, such as Yvart, much of whose work has yet to be discovered.[81] Most of these series were woven in multiple editions, which allowed them to be distributed in France as well as abroad, as diplomatic gifts.

The Story of Meleager

Mistakenly attributed by the art historian Maurice Fenaille (1855–1937) to the tapestry workshop at Maincy, established by the former superintendent of finance Nicolas Fouquet, *The Story of Meleager* is in fact one of Le Brun's earliest productions for the Gobelins. The narrative derives from Ovid's *Metamorphoses*. The entrepreneur Jean Valdor initiated the commission by entering into a contract with the weaver Jean Jans the Elder in 1659, and he retained ownership of the original cartoons, composed by Le Brun, who hired François Bellin (d. 1661) to paint the landscape backgrounds. Claude Nivelon (1648–1720), Le Brun's biographer, alluding to the commission, specifies that Valdor was "much in honor and esteemed at court," as if the initiative had received the endorsement of the royal government, which, however, could not have invested in the project for want of funds.[82] The idea of a royal initiative for this series is not far-fetched, since the first edition went into the royal collection in 1670, Jans having received more than half of the price for the weaving from the Royal Treasury in 1668.[83]

The Story of Constantine

Although the series was originally designed for Fouquet, we should touch on *The Story of Constantine.* The series was inspired by the four monumental wall frescoes painted (as fictive tapestries) by Raphael's pupils in the Hall of Constantine at the Vatican. Le Brun's sequence of new scenes was meant to extend and complete the renowned Renaissance cycle about the ancient Roman emperor Constantine, who was baptized as a Christian in 324. Weaving began at Maincy, following Le Brun's designs, and then continued, with some modification, at the Gobelins for Louis XIV. The set, however, was not completed as envisioned.[84] According to the *Journal* and the *General Inventory*, both of which were contemporaneous with the events, only *The Baptism of Constantine* and *The Apparition of the Cross* (also called *The Vision*) were woven at Maincy for Fouquet. The two tapestries were apparently complete in 1661 except for their borders, which were added later. Of the two works, only *The Baptism* was an interpretation by Le Brun of the original Vatican composition by Romano. For the others, the *Mercure Galant* of November 1686 reported that Mazarin had gone to Fouquet's Château of Vaux-le-Vicomte to encourage Le Brun, who was working there, to outdo the Renaissance masters by inventing a new battle scene, different from the one in the Vatican fresco cycle. "This drawing [of *The Triumph of Constantine*] had been done for tapestries that Monsieur Fouquet was having made. Cardinal Mazarin saw it one day when he went to Vaux and was so pleased with the drawing of that Triumph that he told Monsieur Le Brun that he would like to see him do a Battle to accompany it, and that is what gave him the occasion to make the other drawing of the Battle of Constantine against Maxentius, which Raphael had already treated, but which he wanted to further personalize."[85]

Fouquet's arrest in 1661 put an end to the project, which was then pursued at the Gobelins somewhat differently. Although Yvart painted the cartoon for the *Triumph* after Le Brun's drawing, the cartoon for the *Battle* was not based upon an original invention by Le Brun. Instead, the Gobelins version faithfully repeated the Vatican composition (fig. 19). Le Brun himself provided the hand-drawn

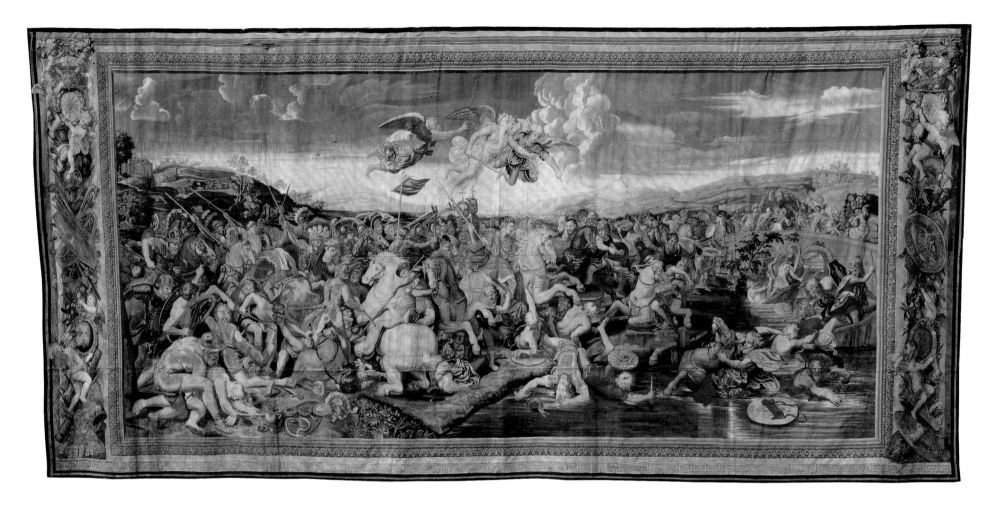

FIG. 19

Paris, Gobelins manufactory, in the
low-warp workshop of Jean de La Croix
(French, d. 1714) and Guillaume Lenfant
(French, d. 1714?), after the design by
Giulio Romano (Italian, ca. 1499–1546).
*The Battle against Maxentius at the
Milvian Bridge*, from *The Story of
Constantine*, before 1667. Tapestry: wool,
silk, and gilt metal–wrapped thread,
423 × 913 cm (166⁹⁄₁₆ × 359⁷⁄₁₆ in.).
Paris, Mobilier National, GMTT 44/4

copy of the sixteenth-century fresco that was then used as the visual guide for the tapestry cartoon for
the Gobelins. He had made this firsthand copy while living and studying in Rome from 1642 through
1645. Le Brun also conceived a design for the *Marriage*, likewise enlarged by Yvart, but it is not known
if this design was made for Fouquet. The weavings of these three latter compositions were done at
the Gobelins. *The Story of Constantine*, with its heroic size, clearly prefigures Le Brun's *Alexander* cycle
(discussed below).

Armorial Portieres

In the early days of the manufactory at the Gobelins, around 1662, the creation of armorial portieres
bearing the device of the king was one of the priorities of the new reign. Only two new portieres were
designed by Le Brun for the king, *The Portiere of Mars* and *The Portiere of the Chariot of Triumph*
(see plate 8a). An initial set of twelve pieces—perhaps from two versions of the same models, one
for hangings with gold thread and one for those without—was apparently completed in early 1666,
since several of the resulting tapestries were then used on various occasions, including visits and
events held that year at the Château of Fontainebleau.[86] Le Brun had already created a portiere for
Fouquet, *The Portiere of Renown*, which was then adapted for Louis XIV. According to the *Journal*,
a contemporary document of events and the only reliable one in this case, a single portiere was made
at Maincy for the superintendent before his arrest in 1661. Eleven others were subsequently woven
at the Gobelins, ten of which were completed before November 1666; together they formed a set.[87]
Interestingly, the 1691 inventory of the Gobelins models states that the original cartoons for
the *Mars* and *Chariot* portieres, ascribed to Yvart, had been placed in the Tuileries Palace in 1669.[88]

The Story of Alexander

In 1659, according to Hippolyte Jules Pilet de La Mesnardière (1610–1663), Louis XIV decided to identify himself with Alexander the Great, whose achievements he had discovered when reading the account of him written by the ancient historian Quintus Curtius Rufus.[89] The king's interest in the Macedonian conqueror emerged the year before he ordered Le Brun to produce *The Queens of Persia at the Feet of Alexander* (see fig. 59), the first painting in the cycle to which the artist would devote many years. The choice of the cycle's subject was thus made by the king himself, rather than the painter, as Nivelon, his main biographer, suggested. In all, Le Brun spent more than ten years, from 1661 to 1672, designing the five monumental paintings for tapestries that were soon placed on the Gobelins looms. The first painting was joined by four others, here listed in the order painted: *The Battle of Granicus*, *The Entry of Alexander into Babylon*, *The Battle of Arbela* (see fig. 60), and *The Wounded Porus before Alexander*. These four pictures are now in the Musée du Louvre, Paris. This famous series was woven eight times on the Gobelins looms during the reign of Louis XIV, four times in high warp and four times in low warp, vividly reflecting the importance attributed to Le Brun's most famous work.[90]

The Muses

The creation of this series, for which Le Brun undoubtedly provided the models in 1662, is poorly documented (fig. 20). The figures reprise the Muses painted by the artist in 1658–60 for Fouquet on the vaulted ceiling of a salon in the Château of Vaux-le-Vicomte.[91] For the tapestry cartoons, Le Brun's figures were situated in a landscape executed by an as yet unidentified painter. A proposal drawn— perhaps by this unidentified landscape painter—for the tapestry showing the muse Urania appeared on the Paris art market in 2013.[92] Her seated figure derives from a pose in another painting by Le Brun, *Saint John on Patmos*, in the Château of Versailles. According to the inventory of Gobelins models drawn up by Yvart in 1691, only the figures of the Muses existed, as if there was a plan to lay them down on the landscape cartoons at the time of weaving.[93] This same landscape painter may have also designed the Gobelins *Verdures* tapestries that were in the royal collection.[94]

The Elements

The series titled *The Elements*, like *The Seasons*, which it completes, was created by Le Brun for the Gobelins in 1664 (fig. 21). These two series can be counted among the manufactory's greatest successes under Louis XIV. Their iconographic and literary programs, combining allegory, devices, and emblems, was conceived with the help of the official writers who formed the Petite Academy, the institution founded in 1663 to formulate mottoes, symbols, and emblems for the reign. In his memoirs, one of the writers, Charles Perrault (1628–1703), recalled the circumstances of their creation as well as his personal contribution: "M. Colbert asked us for designs for tapestries that were to be made at the Gobelins manufactory. He was given several, from among which the one of the Four Elements, where we found a way to include several things to the glory of the king, was chosen....I will comment only that all the devices were mine."[95] The royal historiographer, Félibien, wrote the explanatory inscriptions that adorn the borders of the high-warp weavings, while the medallions in the corners of the borders applied to *The Elements* evoke the royal virtues of Piety, Magnanimity, Goodness, and Valor. In fact, these two series were a veritable panegyric of the king, as Félibien clarified in an illustrated book on the king's tapestries. Published in two editions, the first, of 1665, was confined to the *The Elements*. The second dated from 1670:

> In the description of the Four Elements, I tried to show how the great things that His Majesty has done since He took the leadership of his State have been depicted in mysterious paintings.

Paris, Gobelins manufactory, attributed to the high-warp workshop of Jean Lefebvre (French, act. the Gobelins until 1700), after the design by Charles Le Brun (French, 1619–1690) and others. *Clio*, from *The Muses*, ca. 1670. Tapestry: wool, silk, and gilt metal–wrapped thread, 330 × 405 cm (129¹⁵⁄₁₆ × 159⁷⁄₁₆ in.). Paris, Mobilier National, GMTT 114/2

Paris, Gobelins manufactory, in the low-warp workshop of Jean de La Croix (French, d. 1714), after the design by Charles Le Brun (French, 1619–1690) and others. *Earth*, from *The Elements*, ca. 1667. Tapestry: wool, silk, and gilt metal–wrapped thread, 350 × 630 cm (137¹³⁄₁₆ × 248 in.). Paris, Mobilier National, GMTT 62/2

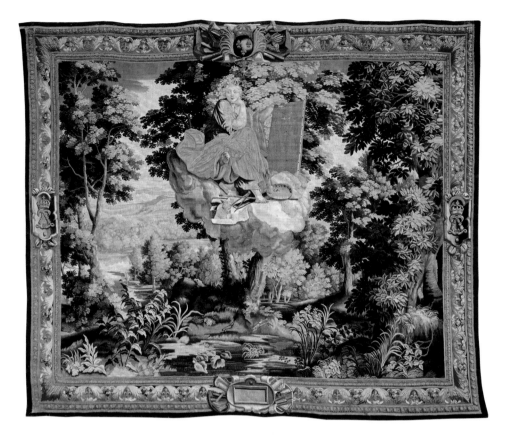

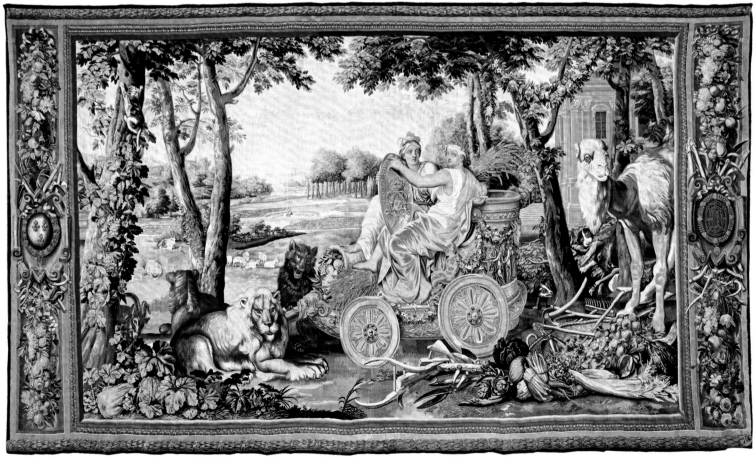

…To show that His Majesty, having all but placed the Elements in a new order and also made the Seasons more beautiful and more fruitful, or should I say filled our days with happiness and lavished our years with all manner of good, four paintings were made where the Four Seasons are represented; and these paintings are no less mysterious for having been guided with skill and judgment.[96]

This is a unique case in history where a contemporary printed book provides a complete exegesis of tapestries.

The Seasons

As with *The Elements*, Perrault recalled his personal contribution to the series *The Seasons* in his memoirs: "The design of the series of the Four Seasons of the Year was then made after the model of the Four Elements.…Of the sixteen devices adorning that series, there are nine that are mine." For the series, which associates a royal residence with each season, van der Meulen also contributed to the cartoons for *Spring* and *Autumn* (see plate 9a).[97]

The Child Gardeners

The *Seasons* series had been complemented by woven *entrefenêtres* — tapestries intended to hang on the narrow walls between window bays — on which winged putti busied themselves with gardening (see fig. 58). The new series of *The Child Gardeners* was created after this earlier one, with some modifications. Here, the gardens and gardening work performed by the children refer to the four seasons. The first two sets had been commissioned by Colbert, perhaps for a commercial purpose, before being purchased by the Crown for presentation to ambassadors. The novel theme of childhood illustrated in this series proved enduringly popular, as weaving continued until 1720. The subjects were also copied by weavers in Brussels.

The Story of the King

The production of the *Story of the King* series is emblematic of the Gobelins in the time of Le Brun. Although its origin is poorly documented, the beginnings of its creation can be dated to 1664 (figs. 22, 23). Initially, the project aroused lively debate about the mode of representation, particularly about whether to employ allegory. Disagreement on this point on Le Brun's part may explain why most of the initial sketches for the series were drawn not by him but by van der Meulen. Because he hailed from Brussels, he was particularly qualified for treating contemporary subjects, so much so that he eventually played a preeminent role in the creation of the series. In its original composition, the series included fourteen subjects devoted to the major political and military events of the early reign of Louis XIV, from his coronation (June 7, 1654) (see fig. 33) to the capture of Dôle (February 14, 1668). Van der Meulen not only worked on all the military scenes but also contributed to four or five of the seven nonmartial scenes in the series.[98]

According to the dates in the borders of the tapestries, weaving began in 1665 and lasted until 1679. Because of the many portraits to be executed, for which assuredly the very best weavers were marshaled, the pay rate applied to the production of this series was the highest ever charged at the time, that is, 400 to 450 livres per square French ell. Louis XIV had the *Story of the King* series expanded at the end of his reign, probably on the advice of the marquis d'Antin, director general of the Office of Royal Buildings since 1708. Accordingly, in 1710, new commissions were distributed among the best painters of the day. The king's taste for battle had waned in favor of commemorating family events and official ceremonies, but the weaving of these new subjects did not commence until after the sovereign's death.[99]

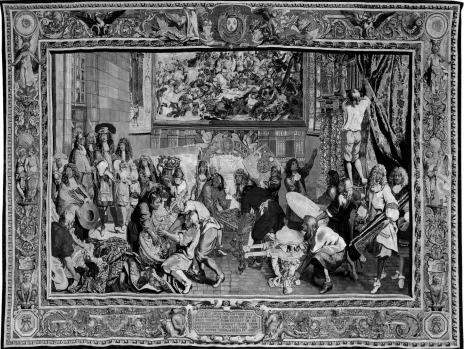

FIG. 22

Charles Le Brun (French, 1619–1690).
The King Visits the Gobelins, study for *The King's Visit to the Gobelins Manufactory, October 15, 1667*, ca. 1672. Drawing: black chalk on paper, 58.1 × 92.7 cm (22⅞ × 36½ in.). Paris, Musée du Louvre, Département des Arts Graphiques, 27655

FIG. 23

Paris, Gobelins manufactory, in the high-warp workshop of Jean Jans the Younger (Flemish, ca. 1644–1723, act. France before 1668), after the design by Charles Le Brun (French, 1619–1690) and others. *The King's Visit to the Gobelins Manufactory, October 15, 1667*, from *The Story of the King*, 1673–80. Tapestry: wool, silk, and gilt metal-wrapped thread, 510 × 700 cm (200¹³⁄₁₆ × 275⁹⁄₁₆ in.). Paris, Mobilier National, GMTT 95/10

The Royal Residences / The Months of the Year

The theme of this series played upon the ancient tradition of representing the months of the year in association with the signs of the zodiac and with hunting. Le Brun introduced the motif of the French royal residences, evoking the festivities typically enjoyed during seasonal and holiday visits to specific domains. He also portrayed the rich furnishings of these residences, including silver items, and even the rare and exotic animals in the menagerie at Versailles.[100] This illustration of French court life should not distract us from the fact that, by thus showcasing the dwellings of his forebears, Louis XIV—in a much more political spirit than might appear at first glance—wished to represent himself as the worthy successor of the great builders and patrons who were his predecessors. Thus, visibly, in the series, the Château of Vincennes is meant to evoke Saint Louis (1214–1270); the Louvre Palace, Charles V (1338–1380); the Château of Blois, Louis XII; the Châteaux of Chambord, Fontainebleau, Madrid, and Saint-Germain, both François I and Henri IV; the Château of Monceaux, Henri IV (see plate 11b); the old Château of Versailles, Louis XIII; the Palais Royal in Paris, Richelieu and Anne of Austria; the Tuileries Palace, Catherine de' Medici (1550–1574) and Henri II; and the Château of Mariemont, a recent Flemish conquest of 1668, Louis XIV. This last domain constituted the king's personal contribution to the expansion of the Crown properties.

Models were prepared for *The Royal Residences* beginning in 1665. Although no preparatory drawing for this series by Le Brun himself seems to have survived, the idea for the theatrical presentation of residences through columned porticoes and figured scenes was his, as confirmed by the "sketch painted by M. Lebrun representing the month of April, four *pieds* wide by three [from which the large one was made]," which appears in the 1691 inventory of the Gobelins models.[101] The full-size cartoons were made by Le Brun's associates, particularly van der Meulen and Pieter Boel (1622–1674), whose representations of animals were essential to the series's success (see plate 11a and fig. 62). The first high-warp tapestries produced were hung at Versailles in the Grand Apartments in 1673.[102]

BERNINI'S CRITIQUES

Among the important accounts that have come down to us regarding the Gobelins in the time of Le Brun, the sculptor Bernini's ranks high on the list. Having come to Paris in 1665 to work on expansion plans for the Louvre, the great Italian master went to the Gobelins to view its latest creations. He made interesting critical observations, which were transcribed by his guide, the art collector Chantelou. Bernini went to the manufactory for the first time on September 6, 1665. "He found the tapestries made there to be quite well executed, including the high-warp ones. He highly praised the drawings and paintings of M. Le Brun and his rich creativity," but "there were various things that were worthless." Two days later, the Italian opened up to Chantelou more explicitly about the Gobelins productions, lamenting the weakness of the models: "While we were dining, the cavalière told me that in just one of my [Poussin] paintings of the Sacraments he found much more to satisfy him than in all those large paintings he had seen at the Gobelins, in that, 'in the works of Signor Poussin, there is (he said) content, age, Raphael, and everything that can be desired in painting.'" On October 10, Bernini returned to the Gobelins, where this time he was received by Le Brun. "He first gazed intently at a tapestry design of Endymion in the Arms of Sleep, which he said was in good taste and praised it highly. Then he saw two large paintings of the Battle of the Granicus and the Triumph of Alexander. After he had gazed at them for some time, M. Le Brun had the painting of the Battle of the Granicus pulled into the courtyard, as he had done when the king was at the Gobelins. The cavaliere looked at it again for quite some time, backing away from it as far as he could. Afterward, he said several times, *è bella, è bella*." Thus, during his second visit, Bernini expressed a clear admiration for Le Brun's art, while denouncing "an error that is committed in the borders of tapestries made at the Gobelins, in which they place flowers and children using the same colors as within the story that composes the piece, which is a great failing."[103]

TAPESTRIES AFTER THE DESIGNS OF OTHER ARTISTS

Festoons and Rinceaux

This large set, which belonged to the royal collection, has hitherto gone unnoticed due to its destruction in 1797.[104] It depicted scenes with the king surrounded by foliage scrolls. A new analysis of the documents and the existence of several reweavings that are preserved but unfortunately inaccessible make it possible to determine that it was the work of Adam Frans van der Meulen, probably in association with other painters (fig. 24). In the memoir of his work for the king starting in 1664, van der Meulen stated, "I also painted a *grotesque*, the view of Fontainebleau, with the king in front and several figures, stags, and dogs in said grotesque."[105] The 1691 Gobelins inventory also mentions "a small *grotesque* painting where there is a small hunt in the middle, by M. Vandermeulen, 70."[106] All indications suggest that these two quotations relate directly to the original set. The weaving of the two high-warp pieces included in the set was begun by Jean Jans the Elder and completed by his son. Its execution can be dated to around 1668, the year of the father's death. As the models for the series belonged to Valdor, one wonders if, by turning to van der Meulen, he had sought to support a fellow Fleming.

Metamorphoses

Despite the large role played by the creations of Le Brun, the Gobelins also put a series of *Metamorphoses* on the loom after various fashionable painters, the principal one being Charles de La Fosse (1636–1716).[107] The series went through many editions, but the first weaving, delivered by Jean Jans in 1680, was reserved for the king. Four pieces, still with their splendid border, are preserved at the Rijksmuseum, Amsterdam.[108] Until now, it had been believed that their creation briefly preceded their delivery. In fact, Le Brun supplied the first subject, *Diana and Endymion*, as early as about 1658.[109] Furthermore, the estate inventory of Anne Lebé (d. 1674, wife of the weaver Jean Jans) shows that,

as of that date, the subject of Apollo pursuing Daphne had already been composed by René-Antoine Houasse (ca. 1645–1710), one of the contributors to the series. The inventory also mentions the models for the borders, which it attributes to Jean-Baptiste Monnoyer (1636–1699).[110]

The Story of Moses

In the early 1680s, Le Brun wished to pay tribute to Nicolas Poussin (1594–1665)—Poussin, considered a "French Raphael," had been Le Brun's master—by having a *Story of Moses* woven from a set of paintings that the late artist had painted at different moments. Of the ten paintings assembled at the time for this series, four belonged to the king (now in the Musée du Louvre, Paris) and four others to private individuals. To these, Le Brun added two of his own compositions dating back several years. Until recently, the commission of this series had been wrongly attributed by Fenaille to Louvois, when, in fact, it was begun earlier, under Colbert (fig. 25).[111]

The King's Galleys

In 1667, Colbert had a plan to execute a tapestry set portraying the king's galleys, as described in this incredible, hitherto completely forgotten letter, addressed to Nicolas Arnold (1608–1674), who was quartermaster general of the galleys in Marseille from 1665. We know that this project was not pursued.

In camp in front of the Isle [modern-day Lille], August 20, 1667. You know that I am having beautiful tapestries made for the king at the Gobelins and, in the various drawings that I am making, I thought that there could scarcely be ones more beautiful than those that would represent all His Majesty's galleys at sea. This is what compels me to write this letter to you in my own hand to ask you to seek out the best painter you can find in Provence; likewise if there be none good enough for this, it would not be amiss to bring in one from Italy, which I

FIG. 25

Paris, Gobelins manufactory, in the high-warp workshop of Jean Lefebvre (French, act. the Gobelins until 1700), after the design by Nicolas Poussin (French, 1594–1665). *Moses Exposed on the Water*, from *The Story of Moses*, before 1685. Tapestry: wool, silk, and gilt metal–wrapped thread, 360 × 511 cm (141¾ × 201³⁄₁₆ in.). Paris, Mobilier National, GMTT 32/1

leave to your choice; have him make the drawing of His Majesty's galleys, twenty in number, ready to fight alongside the great Royalle [the flagship *La Royale*] that you will have built. To that end, it shall be necessary to make a handsome view and see to it, if possible, that the city, port, and citadel of Marseille are in the painting to serve as an ornament. Then he must needs do a portrait from life of the finest of the king's galleys and, most notably, of all the parts, weapons, artillery, and generally everything that serves the galleys, true to life, such that it may be used as the opportunities arise; in addition, he must needs do a particular view of the arsenal that you are building, as beautiful as can be, with all the galleys, as perfect as those in the workshops. Pray have all these things worked upon promptly and make sure that the painter is skilled and acceptable in perspective; once you have had these works done for the galleys, it will be necessary to do the same for the vessels. With my best regards, Colbert.[112]

THE GOBELINS UNDER LOUVOIS

The arrival in 1683 of François-Michel Le Tellier, marquis de Louvois—a figure known for taking a hard line—as the head of the Office of Royal Buildings was accompanied by an authoritarian takeover of the manufactory, as evidenced by a letter from Father Bourdelot (1610–1685) to the prince de Condé (called "the Grand Condé"; 1621–1686) dated November 18 of that year:

> M. de Louvoy dreadfully pressures the painters and other workers at the Gobelins to work and, once they have started a piece for the king, he makes them quit all others; when it is finished, he makes them resume with the same haste and without pause, regarding which the painters went to M. de Louvoy to complain, saying that the brush was noble and would suffer neither coercion nor violence. He scolded them with harsh words and there is starting to be talk of eliminating all such work and expenditures at the Gobelins. M. Le Brun was treated no better.[113]

Meanwhile, Nicolas Guérin reported Le Brun's concerns to the maréchal de Créquy (1625–1687) after the change of superintendent: "I had offered to continue the same functions with more diligence and more zeal than ever…and [Louvois] had at first shown me so much kindness and goodwill that I dared flatter myself that he was honoring me with special protection. But I have reason to fear that some person seeking to ingratiate himself to my detriment has done me a disservice with him and has altered the good feelings he had for me."[114]

In October 1683, wishing to give the manufactory a new artistic direction, Louvois declared bluntly, "I would be pleased to have tapestries made at the Gobelins with better designs than those currently in the works. Please see if there are no pieces in Rome that we might have copied to serve as designs at the tapestry manufactory, making sure, however, to start nothing without orders, but only send me what you believe could be copied, regardless of the dimensions of the paintings, the subjects, and the painters who made them."[115] It was clearly this letter that led to the creation of *Subjects of the Fable* after the designs of Raphael and Romano. Aside from this Italian inspiration, two other major series were created in the time of Louvois, that is, the luminous *Gallery of Apollo at the Château of Saint-Cloud*, after the vaulted ceiling that Pierre Mignard had painted for the king's brother, and the amazing *[Old] Indies*, whose humanity still moves us. Meanwhile, the manufacturing processes were overhauled to improve the quality of the materials—silks were brought in from Lyon and wools from England—while the brilliance of the dyes reached its peak.[116] Louvois's successor, Édouard Colbert, marquis de Villacerf, confined himself to managing the manufactory and was obliged to close it between 1694 and 1699, during the war against the League of Augsburg. At that time, Martin Lister (1639–1712) noted in his *Journey to Paris in the Year 1698*, "The manufactory of the Gobelins, once so famous, has miserably fallen into decay."[117]

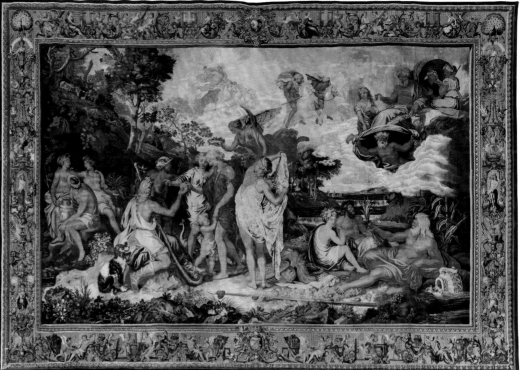

FIG. 26

Paris, Gobelins manufactory, in the
high-warp workshop of Jean Lefebvre
(French, act. the Gobelins until 1700), after
the design attributed to Giulio Romano
(Italian, ca. 1499–1546) and others. *The
Coronation of Psyche*, from *Subjects of the
Fable*, 1686–91. Tapestry: wool, silk, and
gilt metal–wrapped thread, 490 × 562 cm
(192¹⁵⁄₁₆ × 221¼ in.). Paris, Mobilier
National, GMTT 154/1

FIG. 27

Paris, Gobelins manufactory, in the
high-warp workshop of Jean Jans the
Younger (Flemish, ca. 1644–1723,
act. France before 1668), after the design
by Raphael (Italian, 1483–1520) and
others. *The Judgment of Paris*, from
Subjects ofthe Fable, 1687–91. Tapestry:
wool, silk, and gilt metal–wrapped thread,
445 × 640 cm (175³⁄₁₆ × 252 in.). Musée
des Arts Décoratifs, Strasbourg, XXXV.85

Subjects of the Fable

While derivative of Renaissance models and frescoes, this somewhat strange series of various ancient myths can be considered a creation in its own right, due to the significant contributions of the cartoon painters at the Gobelins. The commission was initiated by Louvois and his associates. According to Nicolas Guérin, who was well informed about the origin of the series, "early in the year 1684, shortly after the death of Mgr Colbert, there was apparently an intention to do some new things…and it was proposed to search the drawings in the king's cabinet to provide tapestry designs. M. de La Chapelle [Henri de Bessé, sieur de La Chapelle (ca. 1625–1694), the first officer of the Office of Royal Buildings in charge of the Gobelins] chose several of them, which he had M. de Louvois approve. Colorful sketches were made of them and they were distributed to several painters."[118] In 1686, full-size cartoons were exhibited in the chapel of the Tuileries Palace and then approved by Louvois before sending them to the Gobelins. The official sources of this series were original drawings and engravings, after Raphael and Giulio Romano, but also the frescoes by Romano at the Palazzo del Te in Mantua, including those of the Psyche room (figs. 26, 27).[119]

Despite the impressive scale of the work accomplished, the reaction was mixed when the woven panels were shown to the king and court. Fearing further damaging criticism of the Gobelins, Bessé promptly denounced the weaknesses in the design of several cartoons in a report dated December 15, 1693. He pointed out, for example, that the painting of Venus and Adonis contained "some parts that are not so successful in the first arrangement of Giulio Romano's drawing," shortcomings worsened by the fact that the cartoon artist, Pierre de Sève (1623–1695), "was beginning to decline" when he painted it. As for the *Venus in Her Chariot* cartoon prepared by François Bonnemer (1637–1689), Bessé also found in it a "failed correction of Cupid sitting on his mother's lap."[120] Despite that, the set was hung in the apartments at the Château of Marly in 1700, after woven inserts of modesty draperies had been added, at the king's behest, to cover the nude figures.[121]

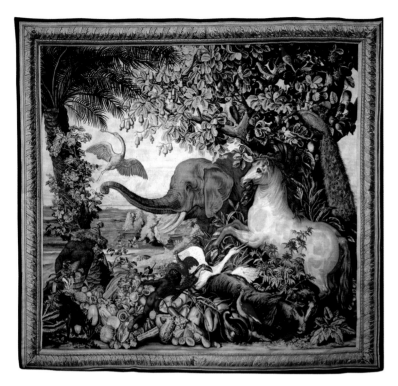

FIG. 28

Paris, Gobelins manufactory, in the low-warp workshop of Jean-Baptiste Mozin (French, d. 1693), after the design by Albert Eckhout (Dutch, ca. 1610–1666) and Frans Post (Dutch, 1612–1680). *The Elephant*, from *The [Old] Indies*, 1689–90. Tapestry: wool and silk, 470 × 485 cm (185 1/16 × 190 15/16 in.). Paris, Mobilier National, GMTT 192/1

The Chambers of the Vatican

The admiration for Raphael, considered a model of perfection in painting, induced Louvois to have the frescoes in the famed Vatican Stanze transposed into tapestries. The tapestry cartoons were based on studies done on site by members of the French Academy in Rome. In fact, Louvois was taking advantage of a project to copy the frescoes originally begun by Colbert. We should recall that the tapestry series *The Story of Constantine* after Raphael and Le Brun already included two compositions borrowed from the Vatican, *The Battle of Constantine* and *The Apparition of the Cross.* These subjects were repeated in the new series *The Chambers of the Vatican*, inaccurately described in the royal inventories as *The Vatican Loggia* (see figs. 45, 64).[122]

The Gallery of Apollo at the Château of Saint-Cloud

For the perfection of the weaving and the brilliancy of the color scheme, the series *The Gallery of Apollo at the Château of Saint-Cloud* after Pierre Mignard now emerges as one of the most brilliant successes of the Gobelins under Louis XIV (see plate 12a). Fenaille had mistakenly assumed that Louvois, who supported Mignard's art, had ordered the gallery's painted ceiling (executed by the artist for the king's brother in 1678) transcribed into tapestries on his own behalf.[123] Instead, this should be seen as a decision by Louis XIV himself. Remember that the king knew the gallery, having admired it on a visit in 1680, during which he uttered the famous words, "I wish very much that the paintings in my gallery at Versailles achieve the beauty of these."[124] In addition, the first set (woven in the high-warp workshop of Jean Jans the Younger) had been presented to the king at Versailles in 1692. Finally, the *Journal* informs us that this set and a piece from the second set were used in the apartments of the Château of Marly in 1700, after modesty draperies had been added at the king's request by the Gobelins weavers.[125] These additions can still be easily detected today.

The [Old] Indies

In 1679, Prince Johan Maurits of Nassau-Siegen (1604–1679), former governor general of the Dutch West Indies in Brazil, presented Louis XIV with eight spectacular paintings by Albert Eckhout (ca. 1610–1666) portraying the wildlife of that region, so that they might be executed as tapestries. These enthused the king, who came to see them twice. According to the painter Paul Milly, "after seeing them," Louis XIV expressed "extraordinary satisfaction and spoke cheerfully, indicating that he wanted to see them again, as the king said, 'at his leisure.'" We know that Henri Bessé revived the project eight years later, as he himself recounted in an invaluable memoir, "June 19, 1687....The low-warp workers having no further work, I proposed making the first of the *Indians* series. I had the paintings brought from the furniture warehouse and shown to Monseigneur de Louvois, who spoke of them to the king, and His Majesty approved this proposal."[126] At that time, things had clearly changed, and the burgeoning taste for the exotic must have helped the long-delayed idea for the weaving to gain acceptance. A first set was executed in just two years (1688–89) in the low-warp workshops of Jean de La Croix and Jean-Baptiste Mozin. A second was undertaken between 1689 and 1690 in the same workshops. This is the only one still preserved in the collection of the Mobilier National, Paris (figs. 2, 28).[127]

REVIVAL OF THE GOBELINS

The year 1699 was the beginning of a new era at the Gobelins. Following a five-year closure, work resumed at the manufactory, and talented cartoon painters were in demand once again. The best of them was the ornamentalist Claude III Audran (1658–1734). In terms of subjects, religious themes made an unexpected return under the influence of the increasingly devout king.

Portieres of the Gods, Representing the Elements and the Seasons

In 1699, Jules Hardouin-Mansart, the newly appointed superintendent of the Office of Royal Buildings, commissioned Claude III Audran, the greatest decorative artist of the day, to refresh and update the designs of the portieres hanging in the royal residences. Accordingly, Audran created models for the eight-piece *Portieres of the Gods*, divided into two separate sets, in which pagan deities personified the Four Seasons and the Four Elements. Louis Boullogne the Younger (1654–1733) and Michel II Corneille (1642–1708) painted the figures in the cartoons, while Alexandre-François Desportes (1661–1743) did the animals, but Audran himself executed the decorative elements and grotesques. The deity of each portiere sits under a canopy, accompanied by his or her various attributes and emblems and the corresponding sign of the zodiac. The first set, woven with gold thread and begun in 1700 in the low-warp workshops, represented only the Four Seasons. Then, in 1701, a spectacular set was produced in the high-warp workshop of Jean Jans the Younger, with the background fields executed entirely in gold and silver thread. The set survives in the Mobilier National, Paris. According to the Accounts of the Office of Royal Buildings, these portieres had been ordered "for the king's apartments." Thanks to a drawing preserved in the Nationalmuseum, Stockholm, there is a record of their display in the bedroom of Louis XIV at Versailles. Apparently a sketch made by a visitor, it confirms an important historical presentation of Audran's *Portieres of the Gods*.[128] It is also known that, in 1701/2, the high-warp weaver Jean Lefebvre started "six portieres [of the gods] with gold backgrounds for the king's *cabinet*," that is to say, his council room, at Versailles.[129]

The Grotesque Months in Bands

Although the series was woven not for Louis XIV but for his son, the Grand Dauphin, we should mention *The Grotesque Months in Bands*, a refined tapestry set with a lasting artistic legacy. Starting in 1706, the Grand Dauphin had a new château built, in Meudon, under the direction of the architect Jules Hardouin-Mansart. In 1708, as the interior decoration was being completed, Claude III Audran was commissioned to design hangings for the bedroom alcove. In their finished state, the hangings comprised twelve vertical bands representing the twelve months of the year, each associated with a pagan deity and a sign of the zodiac. These associations had been used earlier, in antiquity, during the first-century reign of Augustus, by the Roman poet Marcus Manilius, in his *Astronomica*. Weaving of the low-warp tapestries took place in the workshops of Dominique de La Croix and Etienne Le Blond between 1709 and 1710. The hangings, "made specifically for the bedroom of Monseigneur [the Grand Dauphin] in his apartments at the new Château in Meudon," were delivered directly there in the spring of 1710. The set survives in the Mobilier National, Paris.[130]

The Old Testament

Existing easel paintings by Antoine Coypel (ca. 1661–1722) were the visual source for the *Old Testament* tapestry series. In the late seventeenth century, the artist had created several paintings depicting episodes from the Old Testament for various private collectors, including Philippe d'Orléans, duc de Chartres (1674–1723, duc d'Orléans from 1701, regent of France from 1715). These paintings were displayed to the public during the 1699 and 1704 Salons at the Louvre, where they were particularly well liked. Given this success, in 1710 the Office of Royal Buildings commissioned Coypel to make enlargements as cartoons for an *Old Testament* series. The seven compositions selected were *Susanna and the Elders* (1695, now in the Museo del Prado, Madrid); *Athalia Driven from the Temple* (1696, Musée du Louvre, Paris); *Jacob and Laban* (1696, present location unknown); *The Sacrifice of the Daughter of Jephthah* (before 1697, Musée des Beaux-Arts, Dijon); *Esther before Ahasuerus* (1697, Musée du Louvre, Paris); *Tobit Recovering His Sight* (ca. 1695, present location unknown); and *The Judgment of Solomon* (before 1699, present location unknown).[131] The first weaving of the *Old Testa-*

ment series (1711–29) was sent to the French Embassy in Rome in 1731. Five of the original pieces are currently in the collection of the Musei Vaticani, Rome.[132]

The New Testament

It is to Louis XIV himself that we owe the *New Testament* series. The project was initiated in 1697, when the monks of the Benedictine priory of Saint-Martin-des-Champs in Paris commissioned Jean Jouvenet (1644–1717) to make four huge paintings to decorate the nave of their church, on the occasion of a major campaign to beautify their buildings. The subjects depicted episodes from the life of Christ: *Christ in the House of Simon the Pharisee*, *Christ Driving the Money-changers from the Temple*, *The Raising of Lazarus*, and *The Miraculous Draft of Fishes*. These pictures are now in the Musée du Louvre, Paris, and the Musée des Beaux-Arts, Lyon. These paintings, except *The Miraculous Draft of Fishes*, were exhibited at the 1704 Salon, where they were much admired. In August of the following year, "Louis XIV, who had had them brought to Trianon, commissioned M. Jouvenet to repeat them for execution as tapestries at the Gobelins," in order to create a *New Testament* series. The first set, woven in the Lefebvre high-warp workshop, was offered by the young Louis XV (1710–1774, r. from 1715) to Czar Peter I (1672–1725, r. from 1682), when he visited France in May 1717. This remarkable set is still conserved in the State Hermitage Museum, Saint Petersburg.[133]

The Manufactory at Beauvais

Colbert created the Royal Manufactory of Tapestries at Beauvais from the ground up, to promote tapestry sales among wealthy collectors.[134] A royal edict of August 5, 1664, is its founding document. Its first director was Louis Hinart (fl. 1639–78, d. 1697), a tapestry merchant from Beauvais.[135] Since there were fewer private customers than expected, the Crown's Furniture Warehouse acquired

FIG. 29

Beauvais manufactory, under the direction of Louis Hinart (French, d. 1697), after the design by Florentin Damoiselet (French, b. 1644). *The Little Queen*, from *Children's Games*, by 1669. Tapestry: wool, silk, and gilt metal–wrapped thread, 339 × 512 cm (133⁷⁄₁₆ × 201⁹⁄₁₆ in.). Paris, Musée du Louvre, Département des Objets d'Art, OAR 71

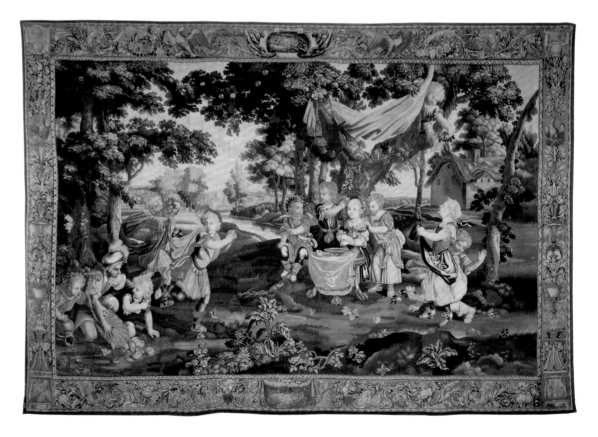

FIG. 30

Beauvais manufactory, under the direction
of Philippe Béhagle (French, 1641–1705).
A Ride through the Forest of Vincennes,
from *Verdures*, by 1698. Tapestry: wool
and silk, 400 × 380 cm (157½ × 149⅝ in.).
Location unknown

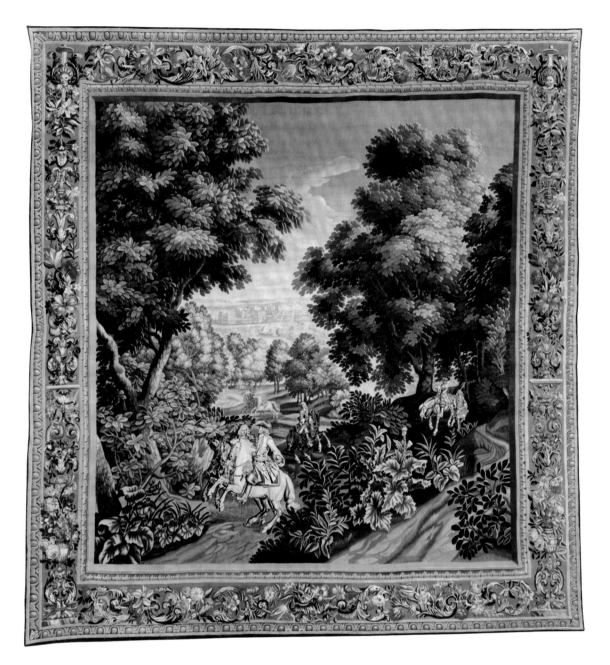

forty-five hangings to support the manufactory. These pieces were mostly verdures, some after com-
positions by the landscape painter Jacques Fouquières (ca. 1580–1659), and others depicting views
of Saint-Cloud.[136] The only gold-thread Beauvais tapestry ever delivered to the Crown was remini-
scent of *Children's Games* after Florentin Damoiselet (b. 1644) (fig. 29).[137] It was also under Hinart that
the interesting tapestry set known as *Poliphilus's Dream* after Eustache Le Sueur (1616–1655) was
presented by Louis XIV to the king of Ardres (present-day Benin) in 1671.[138] Starting in 1684, Hinart's
successor, Philippe Béhagle (1641–1705), made fewer deliveries to the Crown, but these included
some of the best series ever created by Beauvais under Louis XIV: *The Grotesques* after Jean-Baptiste
Monnoyer,[139] *The Seaports*,[140] *Birds of the Aviary* (whose production was begun in the Hinart era),
and other series with rural or rustic subjects, such as *Verdures*, showing royal residences (fig. 30), and
Country Pleasures.[141] In the last years of the seventeenth century, they were allocated to the Château
of Marly, specifically to the apartments of the duc (1670–1736) and duchesse du Maine (1676–1753),
and "His Majesty found [one in particular] beautiful and well made."[142]

The Manufactory of the Savonnerie

French royal sponsorship and patronage extended to the parallel luxury-textile art of carpet making. This industry also benefited from superlative designs supplied by the greatest and most talented court artists of the day, for, just as with tapestry, carpets were essential to an interior decoration that, in its totality, expressed the grandeur of the monarchy.

Like the Gobelins, the carpet manufactory of the Savonnerie was created by Henri IV and revived by Louis XIV. Introduced into France by the carpet-maker Pierre Dupont (ca. 1577–1640), the technique of making knotted-pile carpets "in the manner of Turkey and the Levant," in his words, began to gain ground under Louis XIII, when Simon Lourdet (ca. 1595–1667?), an apprentice of Dupont, established a workshop in a former soap factory located in Chaillot, west of Paris. The building's original purpose—*savon* is the French word for soap—gave its name to the manufactory then situated on the site. While still quite young, Louis XIV commissioned several carpets from Lourdet, including one for his bedroom alcove at the Louvre Palace in 1658.[143] Three others were acquired from the same carpet-maker in 1663, two of them for the Château of Versailles and the third for the Louvre.[144] This last piece is now conserved at the J. Paul Getty Museum, Los Angeles (fig. 31).[145] In 1668, a new carpet was delivered for the alcove in the king's bedroom at the Tuileries Palace (now in the Musée du Louvre, Paris), along with one for the throne room. These two cost the considerable sum of 12,150 livres.[146]

In 1664–66, thirteen carpets for the Gallery of Apollo at the Louvre preceded the next, even more ambitious project for the palace—the weaving of ninety-three carpets for the Grand Gallery, the long corridor running along the Right Bank of the Seine and connecting the Louvre with the Tuileries Palace. The rhythmical decoration of the vault, walls and *trumeaux*, and window bays of the gallery determined the two models for the carpets, which would alternate along its entire length. In the first, landscapes decorated the ends of each carpet; these were replaced with monochromatic faux bas-reliefs in the second type. The carpets with landscapes were to be placed in front of the *trumeaux*; those with bas-reliefs, in front of the windows. Charles Le Brun designed the carpets, with the full-size cartoons painted by associates in his workshop. Several drawings by the painter for the bas-reliefs prove his direct involvement.[147] The carpets were woven at Chaillot between 1670 and 1685 in the two workshops of the Dupont and Lourdet families; more than forty still exist in French collections (fig. 32).[148] Except for carpets ordered in 1709 for the chapel at Versailles, the manufactory received few commissions during the rest of the reign.[149]

Only the production of tapestries and carpets are considered here on the occasion of this exhibition. But we cannot forget the sumptuous works, most of them destined for Versailles, executed by goldsmiths, gem cutters, cabinet-makers, carvers, embroiderers, sculptors, and engravers who were also working at the Gobelins. They, too, contributed to the dazzling artistic influence of the manufactory under the reign of Louis XIV.[150]

FIG. 31

Paris, Savonnerie manufactory,
in the Chaillot workshop of Simon Lourdet
(French, ca. 1595?–1667) and Philippe
Lourdet (French, act. bef. 1664–1671).
Carpet, ca. 1665–67. Wool and linen,
670.6 × 440 cm (264 × 173¼ in.).
Los Angeles, J. Paul Getty Museum,
70.DC.63

FIG. 32

Paris, Savonnerie manufactory, in the
Chaillot workshop of Louis Dupont (French,
1640–1687?). Carpet, 1678. Wool and
linen, 670 × 357 cm (263¾ × 140½ in.).
Paris, Mobilier National, GMT 2037

Part of the present essay draws upon a previously published text. The new information, analysis, interpretation, and citations added here build upon this foundation and update our understanding of the subject. See Vittet and Brejon de Lavergnée with de Savignac 2010, 12–21.

1. Jules Guiffrey, allowing for the "discharged" tapestries, arrived at the number of 2,740 pieces. Guiffrey 1885–86, vol. 1, xi. That number does not include some of the Gobelins tapestries, delivered and entered in the inventory after the death of Louis XIV, nor certain miscellaneous pieces classified among the paintings. Fenaille 1903, 423–24.

2. Campbell 2007, 317. Campbell estimated that the collection of Henry VIII contained about 2,450 hangings.

3. Delmarcel 2000, 101.

4. Archives Nationales (hereafter AN), Minutier Central, XCVI, 66, September 15, 1645.

5. Paris 2003, 166–68, no. 19, with reproductions of drawings made in 1621, when the series still existed.

6. Archives Nationales and Rambaud 1964, 719, 737.

7. Vittet and Brejon de Lavergnée with de Savignac 2010, 349–50 (inv. nos. 71, 72), 352 (inv. no. 74), 353 (inv. no. 76), 355–56 (inv. nos. 79–81), 435 (inv. no. 31), 435–36 (possibly inv. no. 32), 436–37 (inv. nos. 35, 36), 437 (possibly inv. no. 38). The inventory numbers are those assigned to tapestry sets by the *General Inventory of the Crown's Furniture* under Louis XIV.

8. Vittet and Brejon de Lavergnée with de Savignac 2010, 318 (possibly inv. no. 37), 354 (possibly inv. nos. 77, 78), 356–57 (inv. nos. 83, 84).

9. Vittet and Brejon de Lavergnée with de Savignac 2010, 286 (inv. no. 14), 352 (inv. no. 73), 356 (inv. no. 82), 435–37 (inv. nos. 30, 34, 37, 39).

10. Vittet and Brejon de Lavergnée with de Savignac 2010, 136–37 (inv. no. 55), 286 (inv. no. 12), 356–57 (inv. nos. 83–84).

11. Vittet and Brejon de Lavergnée with de Savignac 2010, 354 (inv. no. 78), 429 (inv. 12).

12. Vittet and Brejon de Lavergnée with de Savignac 2010, 31–33 (inv. nos. 1–3), 34 (possibly inv. no. 4), 34–38 (inv. nos. 5, 6, 8–9 bis), 64–65 (possibly inv. no. 24), 65–67 (inv. nos. 25, 26), 230–31 (inv. no. 106), 290 (inv. no. 30), 332 (possibly inv. no. 48), 337 (possibly inv. no. 57), 353 (possibly inv no 75), 430 (possibly inv. no. 16). See also Vandenbroeck 2009 for a thorough study on one of these series, *The Temptation of Saint Anthony*.

13. Campbell 2002b; and New York 2002, 371–77 (cat. no. 44). Another famous tapestry series, known as *The Gallery of François I* and woven on looms at Fontainebleau, had left the royal collection well before the reign of Louis XIV, probably as early as the sixteenth century. It is now in the Kunsthistorisches Museum, Vienna. New York 2002, 470–76 (cat. no. 55).

14. The so-called *Valois Tapestries* left France for Italy in 1589 and are now in the Galleria degli Uffizi, Florence; see Bertrand 2009b. The set titled *The Genealogy of the Gods*, made for Henri II, left the royal collection before the reign of Louis XIV. It is now divided between the Mobilier National, Paris, and the Musée des Arts Décoratifs, Lyon. Bélime-Droguet 2005, 11; and Bertrand 2009a, 188, no. 15.

15. Vittet and Brejon de Lavergnée with de Savignac 2010, 34 (inv. no. 4); and Vittet 2012d, 8.

16. Vittet and Brejon de Lavergnée with de Savignac 2010, 34 (possibly inv. no. 4), 39–57 (inv. nos. 12, 14–18), 296

(inv. no. 3), 299–306 (inv. nos. 6–9), 439–40 (inv. nos. 46, 47).

17. Denis 2010.

18. Vittet 2012b, Patrizi 2014, and entry 5, this catalogue.

19. Vittet and Brejon de Lavergnée with de Savignac 2010, 39–41 (inv. nos. 11, 13), 58–59 (inv. no. 21), 295–98 (inv. nos. 2, 4, 5), 307 (possibly inv. no. 11), 307–9 (inv. nos. 12, 13, 15), 316 (inv. no. 31), 317 (possibly inv. no. 32), 431–32 (inv. nos. 20, 21). See also entry 6, this catalogue.

20. Regarding Vouet's *Story of Rinaldo and Armida* tapestries, see Brejon de Lavergnée et al. 2011; and Bremer-David 2011.

21. Vittet and Brejon de Lavergnée with de Savignac 2010, 343–47 (inv. no. 68); and Coquery 2013, 124, 257–58, cat. no. 1.1a–h.

22. Vittet and Brejon de Lavergnée with de Savignac 2010, 59–64 (inv. nos. 22, 23); 295 (possibly inv. no. 1), 309–12 (inv. nos. 16–20).

23. Vittet 2012a. An additional piece showing "the battle between a snake and a leopard devouring a monkey" sold at auction, Hôtel Drouot-Richelieu, Paris, April 5, 2013, no. 198.

24. Vittet and Brejon de Lavergnée with de Savignac 2010, 64–65 (inv. no. 24), 312–13 (inv. no. 22).

25. Castelluccio 2004, 275–76.

26. Vittet and Brejon de Lavergnée with de Savignac 2010, 65–67 (inv. nos. 25, 26), 149–53 (inv. no. 63); 365 (inv. no. 111). We believe the valuable d'Épernon set known as *The Triumphs of the Gods* was perhaps ordered by Henri III. Apparently, the set was split up and dispersed while in the possession of the ducs d'Épernon. Some pieces passed to King John II Casimir Vasa of Poland (1609–1672, r. 1648–68), having come into his possession upon his marriage to Marie-Louise Gonzaga (1611–1667). Subsequently, Louis XIV was able to reassemble most of the hangings. (See entry 2 and plate 2a, this catalogue.) Regarding the set called *The Story of Henri III*, see Bélime-Droguet 2012. A previously unknown fragment, depicting the duc d'Anjou on horseback, was sold in Bourg-en-Bresse, France, on February 16, 1992, no. 13. I thank Nicole de Pazzis-Chevalier for this information.

27. Colbert and Clément 1861–82, 1:162. Without gold threads but splendidly executed and apparently superior in design to the original, four panels of the *Scipio* set survive, somewhat faded but complete, in San Simeon, California. They belonged to the famous American newspaper magnate William Randolph Hearst (1863–1951). See entry 4, this catalogue.

28. Vittet and Brejon de Lavergnée with de Savignac 2010, 82–92 (inv. nos. 32, 33), 230–31 (inv. no. 106), 331 (inv. no. 46).

29. The drawings are now in the Musée du Louvre, Paris.

30. Vittet and Brejon de Lavergnée with de Savignac 2010, 99–109 (inv. nos. 37–40, 43, 45), 206–11 (inv. no. 94), 283–85 (inv. nos. 1, 2, 4–8), 331–37 (inv. nos. 47–58); 433 (inv. nos. 22–24).

31. Vittet and Brejon de Lavergnée with de Savignac 2010, 99–101 (inv. no. 38). See also entry 3, this catalogue.

32. An attribution, however, has been proposed. See Paris 2012–13a, 164.

33. Vittet and Brejon de Lavergnée with de Savignac 2010, 433 (inv. no. 24); and Mulherron 2012.

34. Vittet and Brejon de Lavergnée with de Savignac 2010, 422 (inv. nos. 188–90), 423 (possibly inv. nos. 191, 192).

35. Vittet and Brejon de Lavergnée with de Savignac 2010, 67–75 (inv. nos. 28, 29), 82 (inv. no. 31); 289 (inv. no. 26), 313 (inv. no. 23), 315 (inv. no. 29), 317 (inv. no. 34), 318–19 (inv. nos. 38, 40), 361 (inv. no. 97), 365 (inv. no. 110), 366 (inv. no. 112), 368–69 (inv. nos. 119–23), 371–75 (inv. nos. 132–47), 377 (inv. nos. 152–54). Purchases through the intermediary of

Duru, a tapestry merchant from Vincennes, had begun in 1661, as evidenced by this letter from him on October 20: "I offered 5,000 livres for the tapestry of Alexander [inv. no. 38, of the tapestries with wool and silk], which I had the honor to speak to you about, and 4,500 livres for the Gombau and Massée. I think they will not give the Alexander for less than about 6,000 livres and 5,200 livres for the other one. I will await your orders to conclude the deal." Bibliothèque Nationale de France (hereafter BNF), Mélanges Colbert 103, fol. 703.

36. Vittet and Brejon de Lavergnée with de Savignac 2010, 363–64 (inv. no. 107).

37. Préaud 1993, nos. 735–37.

38. Vittet and Brejon de Lavergnée with de Savignac 2010, 32–35 (inv. nos. 3–5), 37 (inv. no. 9), 56 (inv. no. 17), 64–65 (inv. no. 24), 98–99 (inv. no. 36); and Ducéré 1903, 41, 71, 190–91.

39. Knothe 2010, 342–52; and Vittet 2011c, 187–91.

40. Vittet 2011c, 177–84.

41. Vittet 2011c, 184–87. For an overview of the *Hunts of Maximilan*, see Musée du Louvre (Paris) and Balis 1993; and New York 2002, 329–37 (cat. nos. 37–40).

42. Vittet 2011c, 193–96.

43. Vittet and Brejon de Lavergnée with de Savignac 2010, 320–29 (inv. no. 43), 395 (inv. no. 159); the *Journal* states that the Gobelins version was "made and copied by order of the king from the original, which is in the furniture warehouse." This later set is now divided between the Mobilier National and the Musée du Louvre, Paris. See entry 4, this catalogue; and Bertrand forthcoming b [2015].

44. Vittet and Brejon de Lavergnée with de Savignac 2010, 386–93 (inv. no. 156), 415 (inv. no. 173). The late seventeenth-century set is now divided between the Mobilier National, Paris, and the Musée National du Château de Pau.

45. AN, O¹ 2040 B, dossier 1.

46. AN, O¹ 2040A, dossier 2. Fenaille 1903, 323.

47. Vittet and Brejon de Lavergnée with de Savignac 2010, 378–85 (inv. no. 155), 421 (inv. no. 186). The *Lucas Months* series was copied at the same time, but its fate is unknown. Vittet and Brejon de Lavergnée with de Savignac 2010, 395–401 (inv. no. 160).

48. Salmon 2011, 17–36.

49. AN, O¹ 1474, fol. 117-vo. As Gobelins copies of *The Triumphs of the Gods* were already available, two existing modern sets may have been used in order to save time.

50. This conclusion is based on the note written in the document's margin, "Here ends what is entered in the abridged inventory." AN, O¹ 3304, fol. 69-vo.

51. AN, O¹ 3282B; and Favreau 2005.

52. The handwriting in the document is entirely consistent from beginning to end, with no updates or additions. It seems, then, to have been written continuously from 1672 to 1673, rather than having been started in 1663 or 1666. On the one hand, it contains no mention of the six *Muses* tapestries, woven after the design of Charles Le Brun (1619–1690), that were sent to Moscow in 1668 (nor is there any mention of their replacement in May 1670). On the other hand, new entries in the *Journal* stopped on August 11, 1672, probably because agents at the Furniture Warehouse were occupied with preparing the *General Inventory*. Jules Guiffrey dated the commencement of the written document to 1663, and Stéphane Castelluccio to 1666. Guiffrey 1885–86; and Castelluccio 2004.

53. This is the inventory published in Guiffrey 1885–86. The

tapestries are listed in vol. 1, 293–374.

54. For an example of an extant mark, see fig. 61.

55. Vittet and Brejon de Lavergnée with de Savignac 2010, 136–37 (inv. no. 55), 286 (inv. nos. 12–14), 349–57 (inv. nos. 71–84), 435–37 (inv. nos. 30–39).

56. AN, O¹ 3282B; BNF, Mélanges Colbert 280, fol. 36-vo.

57. Vittet and Brejon de Lavergnée with de Savignac 2010, 67–82 (inv. nos. 28–31), 316–20 (inv. nos. 31–42), 428–31 (inv. nos. 5–19).

58. Vittet and Brejon de Lavergnée with de Savignac 2010, 313–15 (inv. nos. 23–29). These very important provenance notes in the *General Inventory* of 1673 were omitted in Guiffrey 1885–86.

59. The four-part organization of this inventory has been retained in Vittet and Brejon de Lavergnée with de Savignac 2010.

60. BNF, Fr 7801, fol. 319; see also AN, O¹ 2036, fols. 12–13. In fact, the positions of comptroller of Paris and director of the Gobelins were not joined until the appointment of Antoine Desgodetz in 1695.

61. Havard and Vachon 1889, 37–148, left us a useful overview of the Gobelins production under Louis XIV.

62. Dussieux et al. 1854, 1:23; and Lichtenstein and Michel 2008, 2:532.

63. Gady 2010, 399. In the first half of the year, Valdor had already received the large sum of 14,000 livres for "tapestries he had had made at M[a]incy [a workshop established by Fouquet] for His Majesty," an assignment we may see as a preparatory phase for the overhaul of the Gobelins, which occurred immediately afterward.

64. Lichtenstein et al. 2009, 243.

65. Gady 2010, 399.

66. Ormesson 1860–61, 2:405–6.

67. Guiffrey 1881–1901, vol. 1, cols. 175, 177, 223–24; and Fenaille 1923, 84–88.

68. Jouin 1889, 694–97.

69. *Le Mercure Galant* 1673, 3:246–50. Le Brun himself was consulted for the report. Jouin 1889, 406–7.

70. Regarding the Gobelins staff, see Guiffrey 1881–1901; and Guiffrey 1892a, 171–81, 267–79.

71. Chantelou 2001, 175–76.

72. Magalotti 1991, 119.

73. Guiffrey 1892a, 267–74; and Knothe forthcoming [2015].

74. AN, O¹ 2040 A, dossier 2.

75. Guiffrey 1892a, 171–79.

76. AN, O¹ 2040 A, dossier 2. According to Jans the Younger, however, the initiative for this rate change came from Berbier du Metz. Guiffrey 1892a, 213, 218, 220, 222–24, 226–27.

77. Guiffrey 1892a, 262–66.

78. Guiffrey 1892a, 209–11.

79. Brassat 1992, 142–49, 181–83 (no. 22), 199–200 (no. 39), 204–6 (no. 44), 213–14 (no. 51).

80. See Guiffrey, 1892a, 180–81, for a list of painters employed.

81. Gady 2010, 383–84 and notes.

82. Nivelon and Pericolo 2004, 232.

83. Brosens 2003–4; Gady 2010, 315–19, 371; Vittet and Brejon de Lavergnée with de Savignac 2010, 148 (inv. no. 61); and Gady 2013, 140.

84. Vittet and Brejon de Lavergnée with de Savignac 2010, 107–8 (inv. no. 43).

85. *Le Mercure Galant…*, November 1686, 119–20. See also Dussieux, et al. 1854, 1:20; and Nivelon and Pericolo 2004, 267–72.

86. Vittet and Brejon de Lavergnée with de Savignac 2010, 106–7 (inv. no. 42), 149 (inv. no. 62), 338 (inv. no. 60), 340 (inv. no. 61).

87. Vittet and Brejon de Lavergnée with de Savignac 2010, 109 (inv. no. 45).

88. Guiffrey 1892a, 194–95.

89. Cojannot-Le Blanc 2011. See comments, dating from 1668, in Magalotti 1991, 118–19, 122.

90. Kirchner 2008, 223–65; Gady 2010, 218–20; and Vittet and Brejon de Lavergnée with de Savignac 2010, 160–67 (inv. no. 74). See also entry 10, this catalogue.

91. Vittet and Brejon de Lavergnée with de Savignac 2010, 108 (inv. no. 44), 157–59 (inv. nos. 72– 73).

92. Motte Masselink, Masselink, and Drelon 2013, no. 5.

93. Guiffrey 1892a, 195.

94. Vittet and Brejon de Lavergnée with de Savignac 2010, 338 (inv. no. 59). The drawing had been attributed to Le Brun in the inventory.

95. Vittet and Brejon de Lavergnée with de Savignac 2010, 128 (inv. no. 51), 129–36 (inv. nos. 53, 54), 142–47 (inv. no. 58); Milovanovic 2009b, 37; and entry 9, this catalogue.

96. Félibien 1670, 71–72; and Knothe 2010, 352–54.

97. See entry 9, this catalogue.

98. Vittet forthcoming [2015].

99. Vittet 2014, 54–59.

100. Vittet and Brejon de Lavergnée with de Savignac 2010, 170–83 (inv. no. 83).

101. Guiffrey 1892a, 198.

102. Vittet 2011c, 184–87.

103. Chantelou 2001, 161, 163, 167, 243, 247.

104. Vittet and Brejon de Lavergnée with de Savignac 2010, 157 (inv. no. 71).

105. Richefort 2004, 281.

106. Guiffrey 1892a, 204.

107. Vittet and Brejon de Lavergnée with de Savignac 2010, 201–5 (inv. no. 92).

108. Hartkamp-Jonxis and Smit 2004, 338–45, cat. no. 103a–d.

109. Gady 2010, 319, fig. 151.

110. "Drawings and paintings for use at said manufactory… a large painting of landscapes and figures depicting Apollo pursuing Daphne painted by said M. Houasse," 300 livres; "five large grotesque pieces painted on canvas for use as tapestry borders done by M. Baptiste," 450 livres. AN, Minutier Central, XVI, 547, November 19, 1674.

111. Vittet 2011b. The exile in 1681 of Henri Testelin, who enlarged one of the paintings added to the cycle by Le Brun, confirms the theory of its creation prior to the death of Colbert. Bertrand 2011, 60.

112. Costa de Beauregard 1909.

113. Szanto 2008, 19.

114. Dussieux et al. 1854, 1:67; and Jouin 1889, 423.

115. Louvois 2007, 67.

116. For the procurement of wool and the improvement of dyes at the Gobelins under Louvois, see Vittet 2011a, 131.

117. Lister 1873, 132.

118. Dussieux et al. 1854, 1:53–57.

119. Mailho-Daboussi 2012.

120. Vittet and Brejon de Lavergnée with de Savignac 2014, 146–48.

121. Vittet and Brejon de Lavergnée with de Savignac 2010, 239–44 (inv. nos. 116, 117). The series had been delivered to the Furniture Warehouse in June 1696. AN, O¹ 2040 B, dossier 1, letter from Cozette to Mesmyn dated June 18, 1696.

122. Vittet and Brejon de Lavergnée with de Savignac 2010, 251–56 (inv. nos. 124, 125). See entry 12, this catalogue.

123. Vittet 2011a, 127–31.

124. Mazière de Monville, p. 102. Translation from Berger 1993, 2, 47n11.

125. Vittet and Brejon de Lavergnée with de Savignac 2010, 244–49 (inv. nos. 118, 119).

126. Fenaille 1903, 282–83, 371.

127. Vittet and Brejon de Lavergnée with de Savignac 2010, 394 (inv. no. 158), 402–7 (inv. no. 161).

128. Nationalmuseum, Stockholm, Cronstedt Collection, CC 513. Paris 1985, 80, cat. no. C 25.

129. Vittet 2014, 26–35.

130. Vittet 2014, 36–41.

131. *The Judgment of Solomon* was sold at auction, Doyle, New York, January 26, 2011, lot 79.

132. Vittet 2014, 42–53.

133. Vittet 2014, 60–73.

134. Badin 1909; Coural and Gastinel-Coural 1992; and Bremer-David 2007.

135. Between 1664 and 1666, Hinart partnered with Jean Valdor, who was also active at the Gobelins at the same time. Nivelon and Pericolo 2004, 211, n. b; and Gady 2010, 503, n. 1467.

136. Vittet and Brejon de Lavergnée with de Savignac 2010, 340–42 (inv. nos. 62–66), 357–60 (inv. nos. 85–96), 361–63 (inv. nos. 98–106), 366–68 (inv. nos. 113–18), 369–71 (inv. nos. 124–31), 375–76 (inv. nos. 148–51).

137. Vittet and Brejon de Lavergnée with de Savignac 2010, 137–41 (inv. no. 56); and Reyniès 2014. Reyniès found the source of inspiration in the engravings of Jacques Stella (1596–1657).

138. Vittet 2007c, 198 and n. 59.

139. Reyniès 2010a; and Bremer-David 2015.

140. Forti Grazzini 2003, 116–25 (cat. no. 18).

141. Vittet and Brejon de Lavergnée with de Savignac 2010, 413–14 (inv. nos. 169–71), 416–18 (inv. nos. 176–79); and Reyniès 2010b.

142. Badin 1909, 12. In the last years of the reign of Louis XIV, the Beauvais manufactory crafted the series *The Story of Telemachus*, whose creator has been identified as the Lille painter Arnould de Vuez (1644–1720).

143. AN, 259 AP 52, fol. 152-vo. This was probably carpet no. 17 in the *General Inventory*.

144. BNF, Mélanges Colbert 267, fol. 9-vo. These were carpets nos. 18, 20, and 41 in the *General Inventory*. They were billed at 6,648 livres 15 sols.

145. Bremer-David 1997, 130–37 (cat. no. 13).

146. BNF, Mélanges Colbert 280, fol. 178-vo.

147. These drawings are now in the Rijksmuseum, Amsterdam, and in the École Nationale Supérieure des Beaux-Arts, Paris.

148. Verlet 1982, section II and appendix A; Magalotti 1991; Bremer-David 1997, 138–45 (cat. no. 14); and Burchard 2012.

149. Versailles 2006.

150. González-Palacios 1993, 1:19–60; Castelluccio 2007; Versailles 2007; Knothe 2008; and Knothe forthcoming [2015].

Louis XIV and Louis XV

Their Coronations and Their Tapestries, 1654 and 1722

Pascal-François Bertrand

You have seen those marvelous Works that are in H[is] M[ajesty]'s Furniture Warehouse and that are often displayed during major celebrations.

—ANDRÉ FÉLIBIEN, 1666

I T IS THE FUNCTION OF RITUAL TO CELEBRATE individuals and institutions. Rituals and their ceremonies are adorned with ephemeral decorations whose purpose is both to express the magnificence and splendor of the occasion and the individuals honored and to impress the guests and the audience attending the event. The consecration and coronation of a king represent a special moment in the life of a monarch because these ceremonies raise him above the station of mere mortals, transforming him into a divine being and worker of miracles.

In France, the coronation city is Reims, where Clovis (ca. 466–511) was baptized by Saint Remigius, bishop of the city, in 498. The sacrament made the converted ruler the first Christian king of his realm, which was henceforth titled "eldest daughter of the Church," and Clovis's successors were made, according to tradition, "Most Christian Kings."[1] The origin of the chrism used for his anointment during the baptism was miraculous: it had been brought in an ampulla by a dove, a symbol of the Holy Spirit. The miracle substantiated the divine nature of kingship and conferred upon the city of Reims the privilege of consecrating kings. The relic, the Holy Ampulla, was kept at the Basilica of Saint Remigius in Reims until the French Revolution. All the kings of France, from Henri I (1027) to Charles X (1825), were crowned in Reims, save two—Louis VI the Fat (1108) and Henri IV (1594)—who were crowned in Orléans and Chartres, respectively.

The coronation celebrations and ceremonies took place at the cathedral, the archbishop's palace, and the Basilica of Saint Remigius. They were carried out in an established series of rituals that has been reported in many accounts, so that we know in detail the sequence of the ceremonies and their meaning. Specific descriptions were published of certain ceremonies, such as the coronations of François I (1515) and Henri IV.[2] Accounts were also collected in compilations such as the *Recueil des roys de France, leurs couronne et maison* (The kings of France, their crown and house), 1580; Godefroy's *Cérémonial françois* (French ceremonies),1649; and Pons Augustin Alletz's *Cérémonial du sacre des rois de France* (Coronation ceremony of the kings of France), 1775.[3] The coronations of Louis XIV (June 7, 1654) and Louis XV (October 25, 1722) were the subject of several documents that provide precise information about the various phases of the ceremonies and celebrations that constituted the events.[4] These documents always mention the decorations, but only summarily. They are generally described as rich and splendid, as if that were self-evident and required no explanation. But we know that in matters of royal representation, everything was painstakingly fine-tuned to express meaning, down to the smallest details.

To visualize such decoration and understand its significance, we must turn to the graphic records, relatively few of which remain, despite the symbolic importance of the events. Most such records were commissioned by the king or the court of France, whence their highly favorable tenor. The coronation of Henri III (1574), featured in a tapestry series (now lost) depicting his deeds, was

FIG. 33

Paris, Gobelins manufactory, in the
high-warp workshop of Jean Jans the
Elder (Flemish, ca. 1618–1691, act. France
before 1662), after the design by Charles
Le Brun (French, 1619–1690). *The
Coronation of the King*, from *The Story of
the King*, 1665–71. Tapestry: wool, silk, and
gilt metal–wrapped thread, 492 × 676 cm
(193¹¹/₁₆ × 266⅛ in.). Paris, Mobilier
National, GMTT 95/2

woven for the first duc d'Épernon (1554–1642), one of the most powerful courtiers during the reigns of Henri III (1551–1589, r. from 1574) and Henri IV (1553–1610, king of Navarre from 1572 and king of France from 1589).[5] Another tapestry, like the former, from the Royal Tapestry Manufactory at the Gobelins, shows the coronation ceremony of Louis XIV (fig. 33). An album of drawings by the chevalier Henri d'Avice (act. 1642–70), only recently published, was intended to accompany a description of Louis XIV's coronation; it constitutes a true commemorative. However, for reasons that we understand but partially, just three large engravings after these drawings were published, in a pamphlet with the title *La Pompeuse et magnifique cérémonie du sacre du Roy Louis XIV fait à Rheims le 7 juin 1654* (The solemn and magnificent coronation ceremony of King Louis XIV at Reims on June 7, 1754).[6] This concept was adopted and developed under Louis XV. A painter from the Royal Academy of Painting and Sculpture, Pierre Dulin (1669–1748), was sent to Reims to make drawings of the celebrations and ceremonies with the ultimate purpose of creating models for a set of tapestries commemorating the event. The tapestry project was abandoned, but we do not know why. However, the drawings were engraved and compiled in a collection called *Album du sacre de Louis XV* (*Album of the Coronation of Louis XV*).[7]

I | a

The Miraculous Draft of Fishes
from *The Acts of the Apostles*

Design by Raphael (Italian, 1483–1520), 1516
Border design by Francis Cleyn (also spelled Clein),
(German, 1582–1658, active in England from 1623), ca. 1625–36
Surrey, Mortlake Tapestry Works, a royal enterprise from 1637
under the management of Sir James Palmer (English, 1584–1657), 1636–37
Tapestry: wool, silk, and gilt metal– and silver-wrapped thread
530 × 580 cm (208¹¹⁄₁₆ × 228³⁄₈ in.)
Paris, Mobilier National, inv. GMTT 16/4

DESCRIPTION

The figurative field of this tapestry portrays an episode from the
Gospel according to Luke (5:1–10) known as the Call of the First
Disciples (plate 1a). The scene is set at the Sea of Galilee, where
Jesus had been preaching from a boat to a crowd on the shore. After
speaking to the crowd, Jesus instructed Simon, called Peter, to put
out into deep water and lower the nets. Despite Simon's failed fishing
attempts of the previous night, he agreed to follow Jesus's instructions.
The resulting haul of fish was so great that Simon and his companion
signaled for help from their partners, Zebedee and his sons, James
and John, who were in a second boat. Believing Jesus to be respon-
sible for the miraculous draft of fishes, Simon fell to his knees, saying,
"Depart from me, for I am a sinful man, oh Lord." Jesus replied,
"Do not be afraid, henceforth thou shalt be fishers of men." A related
account in the Gospel according to Matthew (4:18–22) identifies
Simon's unnamed companion as Simon's brother Andrew.

The upper border of this tapestry displays the armorial shield
of Charles I of England, who commissioned the weaving. The
lower border contains a moralizing inscription that appears embroi-
dered on a cloth suspended within a hexagonal frame. Each corner
of the border features a monochromatic reserve portraying one of
Jesus's miracles (clockwise from upper left): Raising Lazarus (John
11:1–44), Raising the Widow's Only Son (Luke 7:11–15), Dispelling
an Impure Spirit (Matthew 17:14–21), and Forgiving the Sins of
the Woman Who Wipes His Feet with Her Hair (Luke 7:36–50).[22]
Putti are interspersed between these elements; some carry reli-
gious devices and others wrestle with the fresh catch of struggling
marine life.[23]

COMMENTARY

The present *Miraculous Draft of Fishes* tapestry is prized especially
for the strength of color it still preserves. Indeed, in some details,
the tapestry more faithfully represents today the original chromatic
scheme of the painted cartoon than the cartoon itself, which has
suffered fading of certain fugitive pigments. The color of Jesus's
vermilion-pigmented red cloak, for example, still appears vibrant
in its reflection in the water while the corresponding cloak on
his seated figure has faded to white (see fig. 46).[24] In the words of

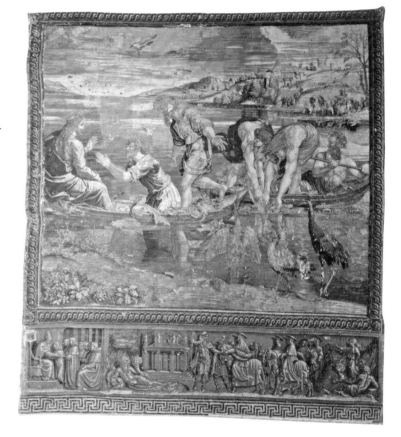

FIG. 47
Brussels, workshop of Pieter van Edingen,
called van Aelst (Flemish, ca. 1450–1533),
after the design of Raphael (Italian,
1483–1520) and assistants. *The Miraculous
Draft of Fishes* (verso), from *The Acts of
the Apostles*, 1517–19. Tapestry: wool, silk,
and gilt metal–wrapped thread, 493 ×
440 cm (194¹⁄₁₆ × 173¹⁄₄ in.). Vatican City,
Vatican Museum, 43867

Thomas P. Campbell, "Perhaps the best record of the original color-
ation and subtlety of Raphael's palette is to be found in the very
fine *Acts of the Apostles* woven for Charles I at the Mortlake works
between 1626 and 1636 and now in the Mobilier National, Paris."[25]
Age and deterioration, however, have undeniably affected cartoons
and tapestries alike. This is most apparent in comparing both to a
view of the unlined, unfaded reverse of *The Miraculous Draft of Fishes*
tapestry from the editio princeps preserved in the Musei Vaticani
(fig. 47). This back view offers unparalleled insight into the Brussels
weavers' palette from around 1517 to 1519 and a startling, fresh
perception of the contemporary color aesthetics of the Sistine Chapel.

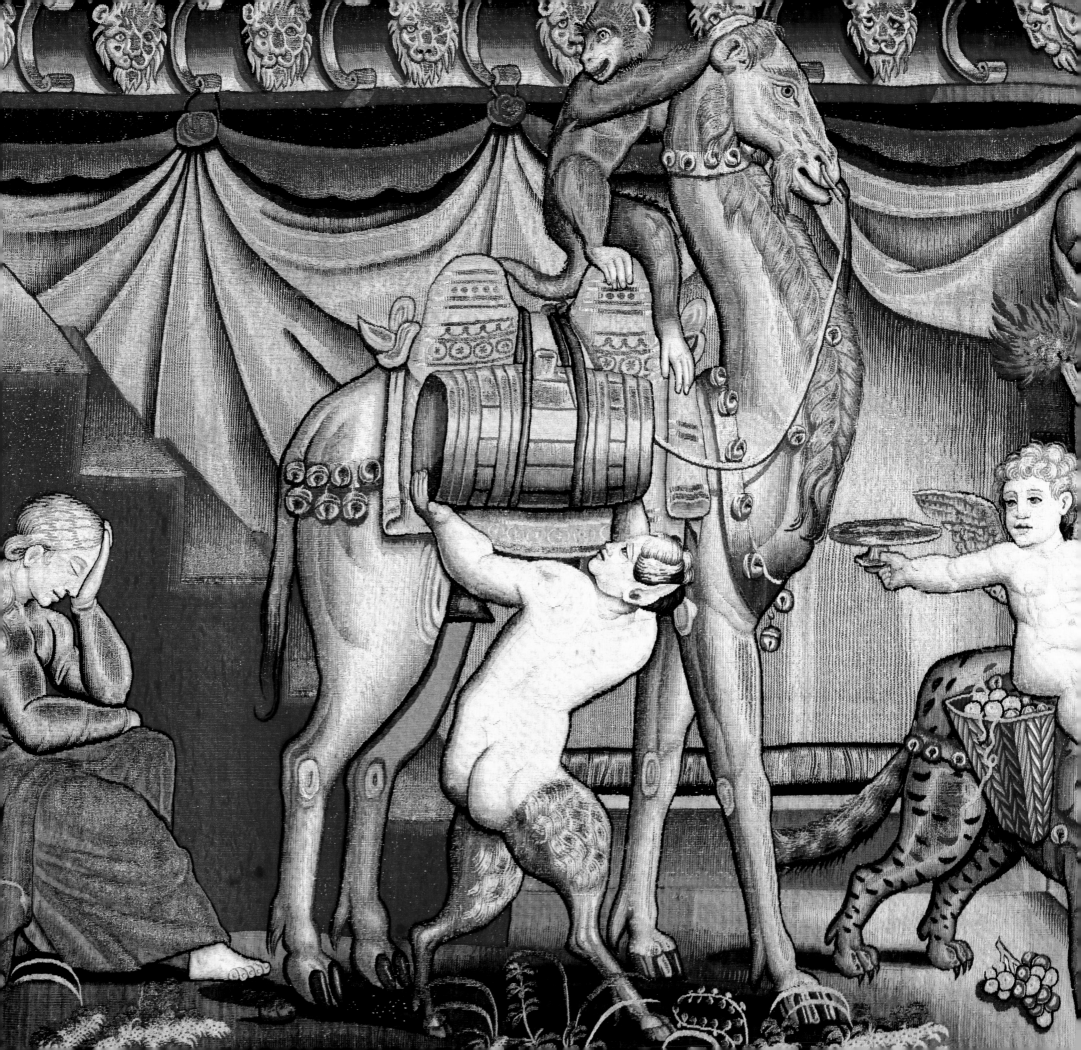

2

The Triumphs of the Gods

Agents of Louis XIV actively sought tapestries from the acclaimed sixteenth-century *Triumphs of the Gods* cycle, the design of which was then ascribed variously to Raphael (1483–1520) or to his equally admired pupil Giulio Romano (ca. 1499–1546).[1] The eventual assemblage—or reunion—of a partial set, acquired in two stages over a nine-year period from 1664 to 1673, and its entry into the monarch's holdings were both a consequence and a manifestation of the prevailing and persistent esteem for works conceived during the master's Roman period (1508–20).

The broad revival of the antique genre known as the grotesque was the most inventive, adaptable, and pervasive decorative style exploited by Italian Renaissance artists since its rediscovery, by excavation, on the interior walls of the so-called Domus Aurea (Golden House), the first-century house of Emperor Nero (37–68, r. from 54), in Rome in the late 1480s. Classical pagan deities appeared in the frescoes there as statues, standing within niches or attenuated pavilions surrounded by a whimsical array of symmetrically arranged hybrid mythical creatures, acanthus scrolls, and jeweled swags. Artists in Renaissance Rome, particularly Raphael and his circle, employed the style to great and varied effect in a string of commissions ornamenting private and public interiors at the Vatican, including the Stufetta and Loggia of Cardinal Bibbiena (1517), the Loggia (1517–19), and the vault of the Sala dei Pontefici (1518–20; Hall of the Popes).

About 1517 to 1520, Pope Leo X (b. Giovanni di Lorenzo de' Medici 1475–1521, r. from 1513) commissioned from Raphael a cycle of eight tapestries in this style, which, upon its delivery (probably after Leo X's death as they do not appear in his postmortem inventory of 1521), was likely appreciated not only for its splendid design in the antique manner but also for its adroit embodiment of contemporary spiritual, intellectual, and political themes within the classical vocabulary.[2] Titled *Grotesques of Leo X*, two subsequent editions of the tapestry series were acquired by secular princes who found the compositions and their embedded meanings equally appropriate to their own identities and interests; the earlier of these editions belonged to Henry VIII, king of England (1491–1547, r. from 1509), and the later edition belonged to Władysław IV, king of Poland (1595–1648, r. from 1632), and then, eventually, to Louis XIV. In the case of Louis XIV, the acquisition was also valued aesthetically as one of the most important artistic creations of the Roman school of Raphael and his esteemed pupil Giulio Romano.

Genesis of the Editio Princeps

The papal hangings disappeared from the Vatican after 1767 and only brief written records survive to document the appearance of the editio princeps of the grotesque tapestries.[3] Thanks to a papal inventory of 1544, the subjects of the original "eight panels of gold and silk, grotesques of various colors" were named (here listed by their modern titles): *Triumph of Venus*, *Triumph of Hercules*, *Triumph of Minerva*, *Triumph of Apollo*, *Faith among the Virtues*, *Triumph of Mars*, *Triumph of Bacchus*, and *Grammar among the Liberal Arts*. Their association with Leo X was revealed in a papal inventory of 1608, which recorded them as "eight tapestries called *Grotesques of Leo X*."[4] Circumstantial evidence implies that although the original commission was received by Raphael, his workshop executed the designs and cartoons under his supervision. According to Giorgio Vasari (1511–1574) in 1568, it was a stucco sculptor and fresco painter in the workshop of Raphael, Giovanni da Udine (1487–1564), who created "cartoons for some tapestries full of grotesques, which are in the first

rooms of the Consistory" at the Vatican.[5] Vasari made this report after having met Giovanni da Udine in person. The consensus of current scholarship holds to this authorship but also recognizes the involvement of other colleagues, including Giovanni Francesco Penni (ca. 1496–1528), Perino del Vaga (1501–1547), and, to varying extent, Giulio Romano. Thomas P. Campbell proposes that the tapestries were woven from about 1520 to 1521 in Brussels, perhaps under the direction of Pieter van Edingen, called van Aelst (ca. 1450–1533), who also delivered the first edition of *The Acts of the Apostles* to the same patron.

Lorraine Karafel has analyzed the iconography of several subjects from surviving later editions of the *Triumphs of the Gods* series in order to decipher the original metaphorical and doctrinal relevance of the editio princeps that was delivered to the papal palace, perhaps for the Hall of the Popes.[6] In the erudite, humanist ambience of early sixteenth-century Rome, it was possible to construe a harmony between Neoplatonic philosophy and Christian theology. Themes and images from classical mythology, literature, and art were appropriated and assimilated into new intellectual and visual programs to express or inspire Christian morality and virtue. The "poetic theology" of Giovanni Boccaccio (1313–1375) had already posited that works of some ancient authors prefigured Christianity, and this concept was carried forward by Pico della Mirandola (1463–1494) when he gained influence at the court of Lorenzo de' Medici (the father of Pope Leo X).[7] Thus, Hercules, through his labors, was interpreted to anticipate the struggle of the Christian soul for salvation. Minerva, through her protection of Perseus during his combats against Medusa and the monster guardian of Andromeda, came to symbolize divine protection of the Christian soul against temptations of the flesh as well as the dangers of life. And Venus in her boat represented the ship of the Roman Catholic Church, which transported the Christian soul toward redemption and salvation.[8] These concepts were cleverly portrayed in the *Triumphs of the Gods* tapestry series, whose design was inspired by antique wall decoration. Although the *Triumph of Bacchus* has not been fully decoded yet, the scene's crushed grapes and flowing wine might foreshadow the Christian Eucharist and the blood of Christ sacrificially spilled at the Crucifixion for the redemption of souls. Fifteenth-century papal treatises on the sanctity of Christ's holy blood and discourses on the "blood of the grape" had already inspired artistic representations on the theme, notably tapestries showing Christ squeezing the juice of grapes into a chalice or crushing grapes in a wine press.[9]

Politically and topically, however, the iconography of the series was also an allegorical celebration of the pontificate as a new pagan-Christian Golden Age. The individual subjects of the tapestries have been interpreted within the context of the birth horoscope of Pope Leo X visualized in the decorated vault of the Hall of the Popes. The ceiling of that audience hall was painted about 1518 to 1519 by Giovanni da Udine and Perino del Vaga according to Raphael's scheme, which shows the celestial sky with the planets, signs of the zodiac, and constellations aligned in correspondence with Giovanni de' Medici's birth and astrological destiny. Assuming *The Triumphs of the Gods* was intended for this space, the Bacchus of the series can be identified with his ancient Roman personification Liber, the deity associated with the zodiac sign Libra and the period when grapes are harvested and pressed into wine, as portrayed in the lower register of the hanging.[10]

Production of Later Editions

The appearance of the lost editio princeps is known indirectly by the existence of three later, sixteenth-century editions of the series produced in Brussels after the original cartoons or copies of them. These later sets are only partially extant now. Two pieces survive from a set of seven tapestries woven with gilt metal–wrapped thread from about 1540 to 1542, possibly in the Dermoyen workshop, which was purchased by Henry VIII of England.[11] Three other pieces survive from a set of seven tapestries also woven with gilt metal–wrapped thread from about 1560 to 1570 under the direction of Frans Geubels (Flemish, fl. ca. 1545–85). These three hangings were purchased by Louis XIV from different sources:

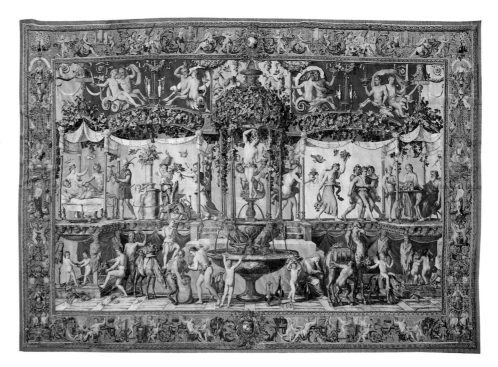

one from the estate of Bernard de Nogaret de La Valette, second duc d'Épernon (1592–1661), and the other two from the estate of the former king of Poland, John II Casimir Vasa (1609–1672, r. 1648–68).[12] Three unrelated pieces from the late sixteenth century after modified designs survive in a French provincial collection.[13]

Entry and Reception in the French Royal Collection

Louis's initial purchase in 1664 from the heiress of the second duc d'Épernon secured three of the eight possible subjects: *Triumph of Apollo* and *Triumph of Venus* together with *Faith among the Virtues*. Nine years later, in 1673, four more subjects, woven with the same border designs, appeared on the art market from an entirely different source, that of the estate of the former king of Poland, who had brought them to Paris from Warsaw in 1669.[14] Thus with the addition of *Triumph of Bacchus*, *Triumph of Hercules*, *Triumph of Mars*, and *Triumph of Minerva*, the French Crown succeeded in assembling—or reuniting—a set of seven pieces.[15] The missing subject, *Grammar among the Liberal Arts*, was never found. The seven hangings joined the magnificent display of tapestries in the courtyards of Versailles for the Feast of Corpus Christi on June 17, 1677.[16]

The profound and persistent admiration for the series found another expression in an initiative of the 1680s to weave a fresh, slightly modernized version of the papal editio princeps. Noël Coypel (1628–1707) created new cartoons, called *Arabesques after Raphael,* for the Royal Furniture Manufactory of the Crown at the Gobelins.[17] According to Pascal-François Bertrand, these cartoons were based on the tapestries executed for Pope Leo X and not on the mid-sixteenth-century edition that had arrived recently in the French royal collection.[18] Even a cartoon for *Grammar among the Liberal Arts*, the subject missing from the Crown's set, was prepared by French students living in Rome who studied the papal tapestry still accessible in the Vatican. Seven complete eight-piece sets were woven at the Gobelins between 1686 and 1713 (fig. 48).[19] This production of Coypel's updated *Triumphs of the Gods* complemented a tandem initiative to create tapestries faithfully replicating Raphael frescoes from the Vatican Stanze. As Bertrand explains, "The Gobelins thus spread some of the most significant examples of perfect painting, for Raphael was then considered the uncontested master of modern painting…such tapestries brought the Vatican to Paris and Versailles, the heart of the realm."[20]

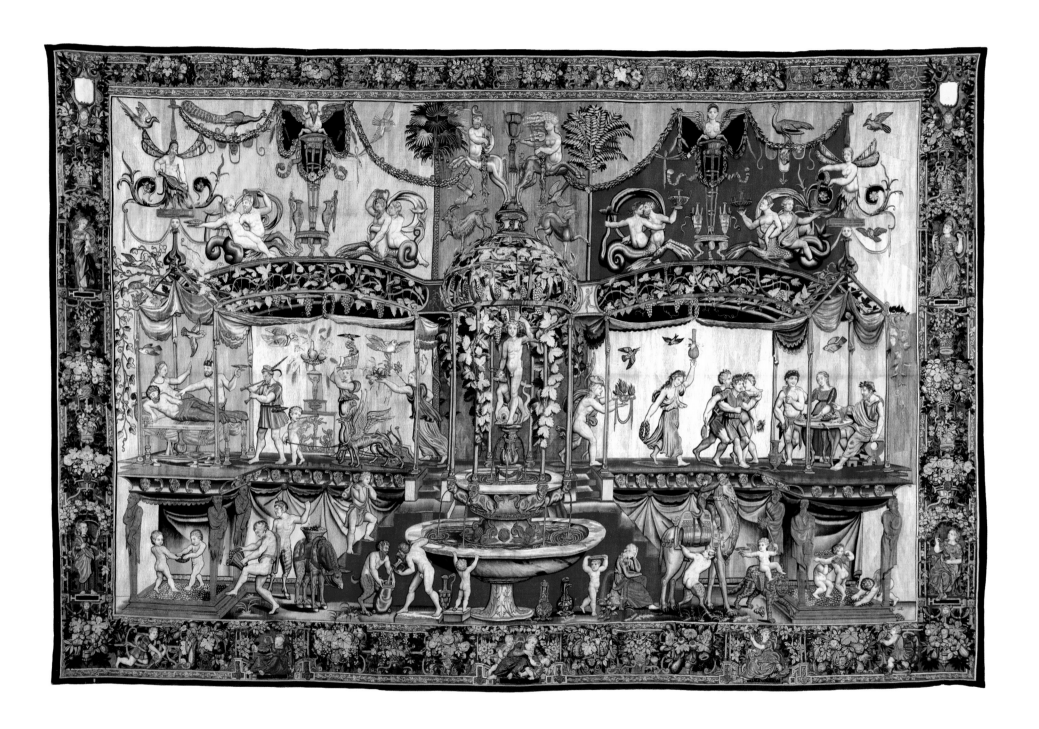

2 | a

Triumph of Bacchus
from *The Triumphs of the Gods*

Design overseen by Raphael (Italian, 1483–1520), ca. 1518–19
Design and cartoon by Giovanni da Udine (Italian, 1487–1564),
in collaboration with other artists from the workshop of Raphael, ca. 1518–20
Brussels, workshop of Frans Geubels (Flemish, fl. ca. 1545–85), ca. 1560
Tapestry: wool, silk, and gilt metal–wrapped thread
495 × 764 cm (194⅞ × 300¹³⁄₁₆ in.)
Paris, Mobilier National, inv. GMTT 1/3

DESCRIPTION

Triumph of Bacchus celebrates the ancient Roman god of wine, wine-making, and revelry, Bacchus, whose statue stands atop a massive, tiered fountain flowing with red wine (plate 2a). An arbor of grapevines shields the figure, who reaches for some grapes dangling from the overhanging branch. Bacchants, carrying refreshments and playing instruments, amble toward lateral pavilions, where, at left, a nymph lies in bed with the sleeping Silenus and, at right, gods feast at table. The lower register of the tapestry shows the production of wine and its transportation in casks. Above, amorous Nereids ride astride airborne tritons, in company with pairs of centaurs, goats, and fantastical winged creatures. The lush border is composed of baskets of flowers and fruit interspersed with seven female figures (three seated below and two standing at each side). They represent the cardinal and theological virtues: in the lower border, Justice [IVSTITIA], Charity [CHARITAS], and Prudence [PRVDENCIA]; in the left border, Faith [FIDES] and Hope [SPES]; and in the right border, Fortitude [FORTITVDO] and Temperance [TEMPPERANTIA].[21] Twin blank shields appear in the upper corners of the border.

COMMENTARY

It is apparent that many of the figural poses and ornamental forms in the original compositions derived from antique models and contemporary visual sources known to the circle of Raphael. It has been noted, for instance, that the central statue of Bacchus in *Triumph of Bacchus* generally followed a marble sculpted only a few years previously, in 1511–12, by Jacopo Sansovino (1486–1570) for the Florentine residence of Giovanni Bartolini (d. 1544).[22] That marble figure holds up a wine bowl in his left hand (fig. 49). The pose of Bacchus in the tapestry, however, varies somewhat from this model. The woven version of the god reaches up to pluck a cluster of grapes, in the manner of an antique precedent.[23] The woven version is, therefore, a conflation of the new and the old. This sophisticated blending visually expressed the overarching theme of the pontificate of Leo X as the harbinger of the new pagan-Christian Golden Age.

Duplicate versions of *Triumph of Bacchus* survive from the two earlier sixteenth-century editions, and while the figurative fields closely follow the same composition, their border types differ markedly. That of the earlier example, dating from about 1540 to 1542, is narrower and simpler than the present one. Its design consists of

four hexagons, each containing a boy's head, set at the cardinal points, with interval stretches of fine, thin scrolls and delicate, winged figures.

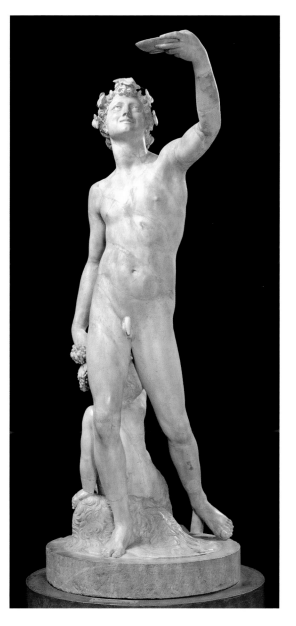

FIG. 49

Jacopo Sansovino (Italian, 1486–1570). *Bacchus*, 1511–12. Sculpture: marble, H: 146 cm (57½ in). Florence, Museo Nazionale del Bargello, inv. no. 120

3

The Story of Vulcan

Louis XIV, king of France, vastly enriched the tapestry holdings of the royal collection in the mid-1660s when he purchased for 48,969 livres nearly twenty sets, comprising around 130 hangings, from the confiscated possessions of the disgraced Nicolas Fouquet (1615–1680, superintendent of finance 1653–61).[1] Like his mentor, Cardinal Jules Mazarin (1602–1661, first minister of France from 1642), Fouquet was a keen art collector. He also had developed a strong taste for garden design, architecture, and interior decoration. The grandeur of his vision and style culminated in the mid-1650s with the creation of the glorious Château of Vaux-le-Vicomte, complete with decorated interiors and furnishings and set within an encompassing landscape garden, all executed under the combined direction of the architect Louis Le Vau (1612–1670), the artist Charles Le Brun (1619–1690), and the garden designer André Le Nôtre (1613–1700). Most of the tapestries acquired through the confiscation were immediately employed in the king's residences, adorning formal parade apartments or displayed in the annual observances of the religious holy day, the Fête-Dieu (Feast of Corpus Christi). Some ten pieces, created in the tapestry workshops established by Fouquet in the village of Maincy, however, were sent to the Royal Tapestry Manufactory at the Gobelins in Paris, either to be used as new models there or to be altered and incorporated into sets of tapestries for the crown.

When the Fouquet *Story of Vulcan* tapestry set entered the royal collection in 1665–66, it was inventoried as following the designs of the esteemed master Raphael (1483–1520). At that time, *The Story of Vulcan* was regarded as one of the greatest mythological tapestry sets available. Its merits had been impressed upon the young Louis XIV a few years earlier, in 1657, when Cardinal Mazarin gave a duplicate Mortlake set to Charles X Gustav, king of Sweden (1622–1660, r. from 1654), as an extraordinary diplomatic gesture.[2] The Crown's acquisition of the Fouquet set redressed a lacuna in Louis XIV's holdings. More significantly, the Fouquet set was famous for inspiring the celebrated poet Jean de La Fontaine (1621–1695) in the summer of 1659, when he was a guest at Vaux-le-Vicomte, to write a poem titled "Les amours de Mars et Vénus" (The loves of Mars and Venus). He included the poem in his *Songe de Vaux* (Dream of Vaux).[3]

Genesis of the Editio Princeps

The Story of Vulcan was the first tapestry series to be woven at the nascent Mortlake Tapestry Works in Surrey. The compositions replicated those of an older, sixteenth-century tapestry series, seemingly produced on speculation about 1544–45 by an Antwerp tapestry merchant.[4] Little is known of its original conception, not even the identity of its designer. Modern scholars propose that it was a Northern artist influenced by the Roman school of Raphael. Some see a stylistic link to Perino del Vaga (1501–1547), a painter in the workshop of Raphael who later moved to Genoa, where he created designs for the *Story of Aeneas* tapestry series. Similar in manner, the *Aeneas* hangings were produced in Brussels about 1540.[5]

Archival documents indicate that Henry VIII, king of England (1491–1547, r. from 1509), purchased a set of *The Story of Vulcan*, perhaps the editio princeps of seven pieces, on the market in Antwerp. He displayed it at Whitehall Palace, London, where it was inventoried as "new" in 1547. Interregnum authorities then dispersed the set during the Commonwealth sale of the 1650s, and its survival is a matter of conjecture. Today, the sixteenth-century *Story of Vulcan* is known thanks to five extant pieces preserved at Biltmore, the Vanderbilt estate in Asheville, North Carolina (fig. 50).[6]

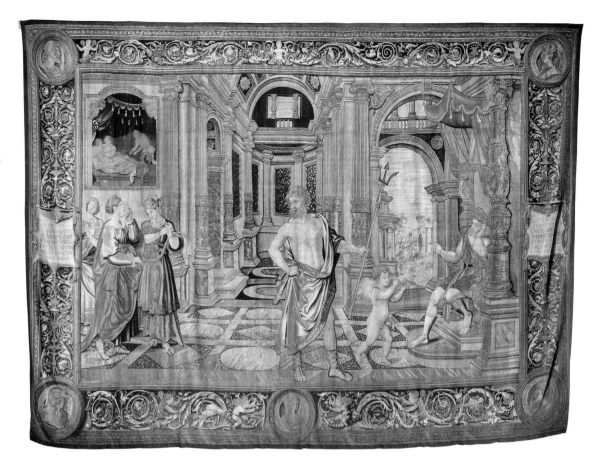

It is apparent from the Biltmore tapestries that each sixteenth-century hanging had Latin inscriptions woven in its lateral borders; at left, the inscriptions help to identify the scene, and at right, they provide a suitable moralizing comment. For example, Ella Siple translated those for *Neptune and Cupid Plead with Vulcan for the Release of Venus and Mars* as, on the left, "The Graces plead through the lips of Neptune, and Cupid asks that he loose the bond; by their entreaties the wicked husband is warned, he frees them both" and, on the right, "All respect the pact of peace, the Graces again are favorable to the lovers and the dark rumors of suspicion quit the established bed."[7]

Production at Mortlake

How exactly the sixteenth-century designs for *The Story of Vulcan*, or tapestries woven after them, reached Mortlake is not certain. Possibly the founder and owner of the Mortlake looms, Sir Francis Crane (ca. 1579–1636), was granted access to the sixteenth-century set then in the English royal collection through the intercession of his patron, the Prince of Wales, the future King Charles I (1600–1649, r. from 1625). Updated border designs were devised for the Mortlake editions, but they did not include the old inscriptions. From descriptive contemporary records, it is possible to deduce the range of subjects that composed the initial sets woven there in the 1620s.[8] In each instance, nine subjects from a wider selection portrayed the narrative, as in the following sequence: *Vulcan at the Forge*, *The Dance with Pan Piping [while Mars and Venus Embrace]*, *Apollo Watches Mars and Venus*, *Apollo Reveals the Intrigue to Vulcan*, *Vulcan Surprises Mars and Venus*, *Vulcan Forges and Spreads the Net*, *Vulcan Complains to Jupiter*, *The Gods Assemble to See the Intrigue*, and *Neptune and Cupid Plead with Vulcan for the Release of Venus and Mars*. Additional subjects were sometimes substituted for, or combined with, these principal ones.

None of the three initial Mortlake sets of nine pieces survives intact. Two sets can be partially traced by the armorials they retain. One was originally purchased in 1623 by George Villiers, first duke of Buckingham (1592–1628). In 1653, it passed into the possession of Cardinal Mazarin. Either through his agency or that of Louis XIV, it was given in 1657 to Charles X Gustav of Sweden. The second set was purchased from Mortlake about 1625 by the Prince of Wales. Its remaining pieces are dispersed.[9]

Entry and Reception in the French Royal Collection

Inventoried in 1666 in the French royal collection as one of a set of eight pieces, after the design of Raphael, *The Story of Vulcan* was formally purchased in 1668 for 11,819 livres.[10] It was highly regarded at that time for its mention in Jean de La Fontaine's poem "Les amours de Mars et Vénus" and for its perceived Italianate design. There was a proposal in 1690 (unrealized) to weave a new edition of the set on French looms.[11] Five of the original eight subjects remain in the Mobilier National: *Cupid Takes Aim at Mars, Who Is Attended by Alectryon*; *Vulcan Surprises Mars and Venus*; *Vulcan Forges and Spreads the Net*; *Vulcan Complains to Jupiter*; and *Neptune and Cupid Plead with Vulcan for the Release of Venus and Mars*.[12] The individual subject titles of the three lost hangings are not recorded.

3 | a

Neptune and Cupid Plead with Vulcan for the Release of Venus and Mars from *The Story of Vulcan*

Design by an unidentified Northern artist,
formerly attributed to Perino del Vaga (Italian, 1501–1547), ca. 1530–40
Border design by Francis Cleyn (also spelled Clein)
(German, 1582–1658, act. England from 1623), ca. 1625–28
Surrey, Mortlake Tapestry Works, then under the ownership of Sir Francis Crane
(English, ca. 1579–1636), ca. 1625–36
Tapestry: wool, silk, and gilt metal–wrapped thread
440 × 585 cm (173¼ × 230⁵⁄₁₆ in.)
Paris, Mobilier National, inv. GMTT 36/2

DESCRIPTION

The figurative field of this tapestry depicts a scene from a story first told in Book 8 of the Greek epic *The Odyssey*, by Homer (and partially recounted subsequently in Latin by Ovid [43 BC–AD 17/18] in Book 4 of his *Metamorphoses*). It illustrates a particular episode from the Loves of the Gods, in which Neptune and Cupid plead with Vulcan to release the illicit lovers Mars and Venus, who have been caught in bed, snared under a net (plate 3a). Neptune stands in a palatial hall, gesturing with his trident toward the lame Vulcan, who sits under a baldachin. Cupid strides between the two gods, his hands uplifted in expressive entreaty. The tearful Graces stand a short distance away, wringing their hands. Above their heads, a window opens onto an interior space where the resolution of the affair is visualized: Vulcan unbinds the net that ensnared Mars and Venus, his unfaithful wife.

The brown-ground borders of this tapestry are filled symmetrically with subtly polychromatic acanthus leaf scrolls and foliates. Twin putti support a blank blue cabochon in the central cartouche above and a blank folded vellum sheet in the central cartouche below. Monochromatic gilt cartouches set diagonally in the border's four corners each contain an uptilted head while the two lateral cartouches depict Vulcan spreading the net with the assistance of a female servant who personifies Jealousy, on the left, and Venus requesting Vulcan to make armor for her son Aeneas, on the right.

COMMENTARY

As neither the border of this *Neptune and Cupid* nor those of the other tapestries in *The Story of Vulcan* set bear a coat of arms, the identity of their first owner remains unknown, as does the date by which they left England. This tapestry and two other pieces from the original set of eight carry the woven monogram for Sir Francis Crane, indicating a production date before 1636, the year of his death, for at least three of the hangings.[13] The border design does share some characteristics with another created about 1625–28 for a different Mortlake series, *Hero and Leander*.[14] The similarities, particularly regarding the shape and placement of the cartouches, help to estimate the date of the former, even though certain border details otherwise differ.

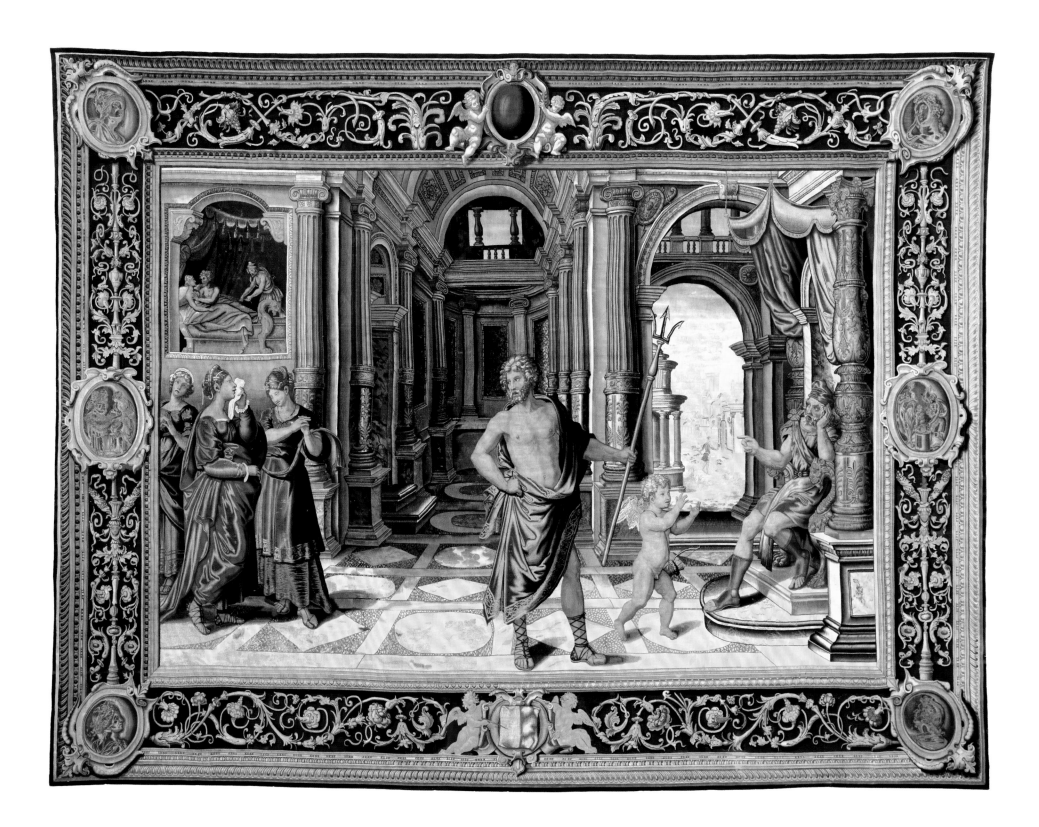

4

The Story of Scipio or The Story of Scipio Africanus

When Louis XIV assumed independent rule in 1661, the tapestry holdings of the French Crown were literally and metaphorically rich and visually spectacular. Thanks particularly to the informed taste of the sophisticated Italophile François I, king of France (1494–1547, r. from 1515), the royal collection already contained several extremely valuable sets, woven with profuse quantities of precious metal–wrapped thread in the 1530s after the designs of Raphael (1483–1520) and his followers. These included, most notably, *The Acts of the Apostles*, after Raphael; *The Story of Scipio*, after Giulio Romano (ca. 1499–1546) and Giovanni Francesco Penni (ca. 1496–ca. 1528); and *The Story of Saint Paul* and *The Story of Joshua*, both formerly attributed to Raphael but actually after Pieter Coecke van Aelst (1502–1550).[1] French royal registers of 1542–52 record the arrival of these sets, and their early presence was maintained in successive inventories, such as those of 1666 and 1716, with the notational numbers of 1, 2, 3, and 25 (of the tapestries enhanced with gold).[2]

Notwithstanding this legacy, Louis's own taste and aspirations for the monarchy prompted him to acquire additional antique editions of many of the very same series. These duplicative sets carried their own intrinsic value in terms of high quality; prestigious provenances; unique borders, sometimes blazoned with famous coats of arms; well-preserved colors; and excellent condition. Louis XIV's purchases brought a depth to the collection that was to have profound meaning for succeeding generations, too, since the duplicate sets more often escaped the destructive vicissitudes of time than did those of François I. To wit, all four of François I's sets named above were burned in the summer of 1797 by the nearly bankrupt Directoire government (1795–99) in order to retrieve their precious-metallic content. The melting down of François I's glittering *Story of Scipio* twenty-two piece editio princeps yielded some 36 marcs of gold and 90 marcs of silver.[3] This dreadful loss was mitigated only by the partial survival of another antique *Story of Scipio* set (the subject of this entry), which Louis XIV purchased in 1665, and by the campaign of the 1680s to replicate this second set in its entirety at the Royal Furniture Manufactory of the Crown at the Gobelins.[4]

Genesis of the Editio Princeps

A relative wealth of documentation and preliminary designs survives for the editio princeps of *The Story of Scipio*, though the original tapestries do not. The scope of the editio princeps was large, commingling events from the Roman general Scipio's deeds with his triumphs, and subsequent woven editions either omitted certain scenes or incorporated new ones, so the survey of the collective production is complex. The present summary is indebted to the exhaustive analysis and reconstruction undertaken by Emmanuel Raoul d'Astier de la Vigerie, Bertrand Jestaz and Roseline Bacou, Thomas P. Campbell, and Elfriede R. Knauer.[5]

The editio princeps, titled *The Story of Scipio Africanus* in French period records, comprised twenty-two tapestries portraying twelve scenes from the Second Punic War (218–201 BC) as described by Livy (59 BC–AD 17) and, in later editions of the *Histories*, by Polybius (ca. 200–118 BC), together with ten scenes of Scipio's triumphal return to Rome as inspired by the *Roman History* of Appian (ca. AD 95–165).[6] The commission was approved by François I in July 1532 after an agent of the Brussels-based Venetian tapestry merchant Marc Crétif exhibited three tapestries woven on speculation. Less than three years later, in April 1535, nineteen more tapestries, woven of wool, silk, and gilt

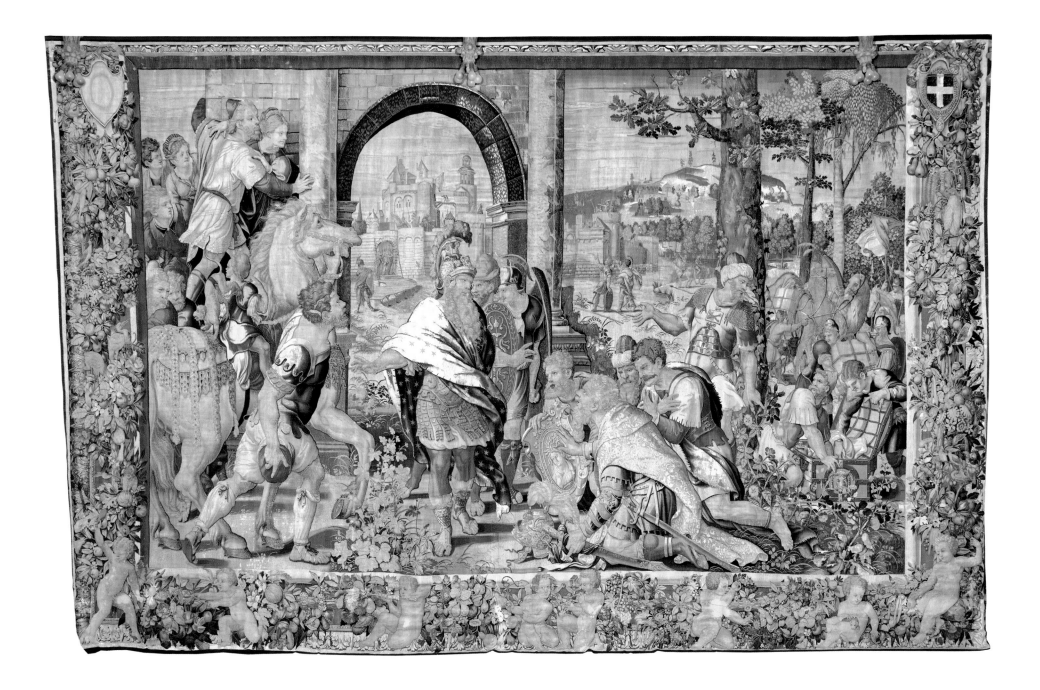

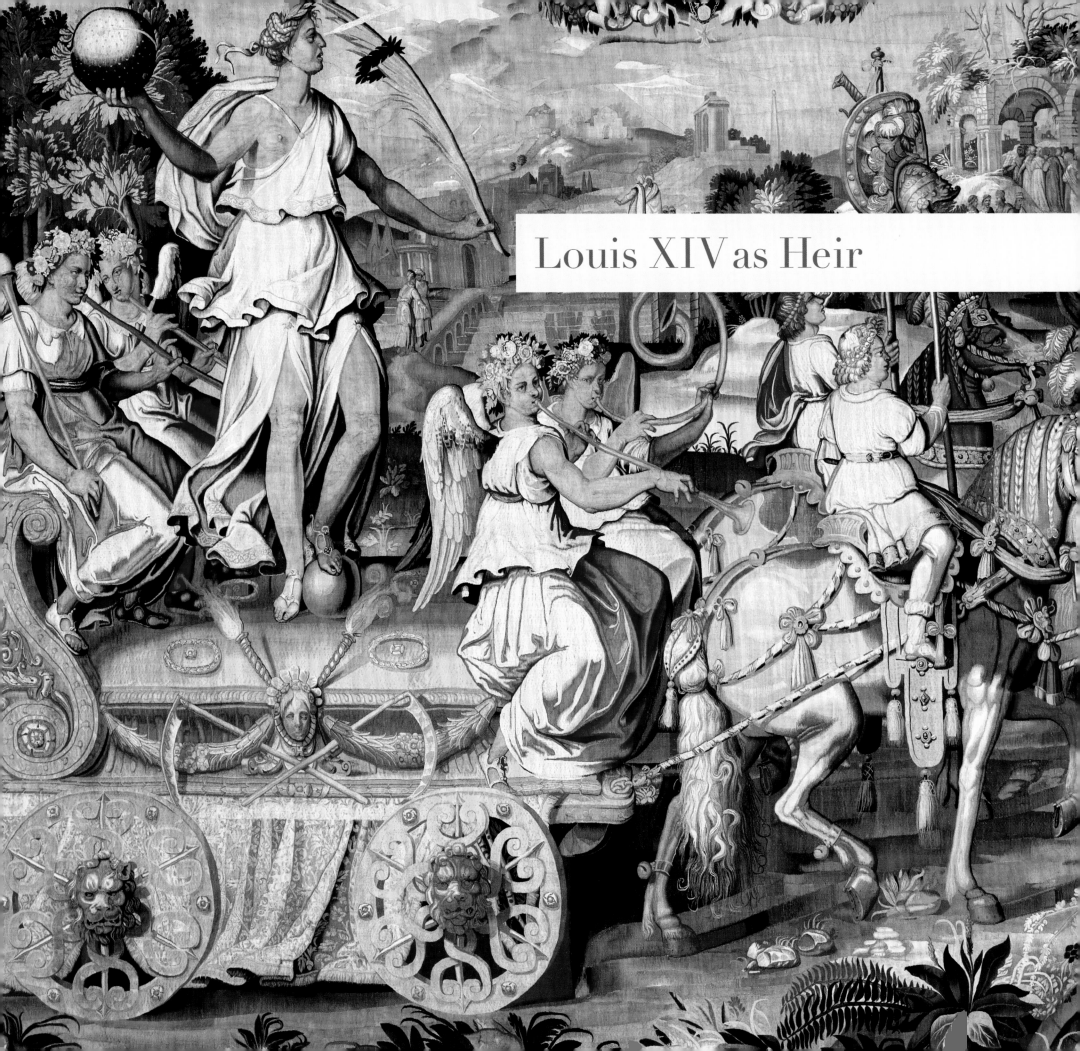

Louis XIV as Heir

5

The Story of Queen Artemisia

Until about 1600, the French Crown's most prestigious tapestry sets had been made abroad, especially the more costly hangings portraying human figures and those woven with precious metal–wrapped thread that had been supplied, chiefly, by the powerful network of well-financed, international entrepreneurial operations in Brussels and Antwerp. Although a fragmented French tapestry industry existed, it was, collectively, undeniably weaker than the efficiently organized northern competition. Moreover, French production varied in quality. More research is required to better understand the extent of domestic weaving activities during the sixteenth century and the role of the Parisian Guild of Master Weavers and Tapestry Merchants, to document tapestry workshops, and to identify surviving hangings.[1] This last objective is complicated by the fact that French weavers were not yet required to mark their works. While some sets of French origin, masterfully executed after sophisticated designs, did enter the royal collection, they were outnumbered by imports from the Southern Netherlands (present-day Belgium).

The situation evolved, however, at the turn of the seventeenth century, when Henri IV (1553–1610, king of Navarre from 1572 and king of France from 1589) pragmatically built up the domestic tapestry industry in a strategic attempt to turn the luxury textile market to the kingdom's economic advantage.[2] As a consequence of his revitalizing initiatives, high-quality, skillfully woven Parisian tapestries began to enter the French royal collection in far greater numbers. Fostered by Henri IV and his successors, artists and weavers in Paris were commissioned more and more often to design and execute tapestries suitable for decorating royal palaces and other state venues on formal occasions. One half-century later, Louis XIV, grandson of Henri IV, inherited this rich patrimony, and by then, there were no fewer than eight sets, encompassing some sixty-six individual hangings, of *The Story of Queen Artemisia* among the Crown's newly abundant holdings of Parisian weavings.[3] These were inspired by a manuscript written by the French humanist Nicolas Houel (1524–1587) and the related illustrations by a group of French Mannerist artists, including Antoine Caron (1521–1599).

Genesis and Production

The narrative text of *L'histoire de la royne Arthemise* (The story of Queen Artemisia) was written by the humanist, philanthropist, and apothecary Houel in the tradition of a *fable histoire* (historical story). Intended to present an ancient model for the legitimacy of the disputed rule of Catherine de' Medici (1519–1589, queen consort of France 1547–59, and queen regent of France 1551, 1553, 1560–66, 1574)[4] during the minority of Charles IX, king of France (1550–1574, r. from 1560), Houel's multivolume epic was later condensed by the author into seventy-four sonnets. These sonnets were eventually illustrated by Caron and other artists of the Fontainebleau school (plate 5b).[5] Both the prose and the verse versions were erudite inventions, a synthesis of some eighty-seven ancient and modern literary sources that reflected Houel's broad knowledge of antiquity and his own times.[6] His writings were full of thinly veiled allusions to contemporary life and perceived relevancies of antique precedents to current events. All in all, *The Story of Queen Artemisia* was an attempt to rationalize and justify the circumscribed role of a female regent at a fractious and unstable time when, under prevailing Salic law, women were excluded from the French throne and executive power.[7] The complexities of the subject and its appeal to subsequent rulers, male and female, have been extensively studied and debated over the last century.[8]

OPPOSITE:
The Chariot of Triumph Drawn by Four Piebald Horses
(detail, plate 5a)

The Story of Queen Artemisia described, in two subtle yet distinct divisions, episodes from the life of a fictionalized ancient ruler, Queen Artemisia, who was a conflation of two historical figures: Artemisia I, mother of Lygdamis, who sided with the Persians against the Greeks at the Battle of Salamis in 480 BC, and Artemisia II, widow of Mausolus, king of Caria (d. 353 BC). The first division of the narrative related how the loving wife orchestrated the funeral cortege of Mausolus and constructed his mausoleum at Halicarnassus (present-day Bodrum, Turkey), one of the Seven Wonders of the Ancient World, to preserve and exalt his memory. The second part of the narrative depicted her just deeds as virtuous regent during the minority of her son, the young king Lygdamis, and her selfless maternal devotion in educating him. Houel, however, envisioned a much grander presentation of the story, and he advised Catherine de' Medici that the illustrations could be enlarged into tapestries.[9] Forty years passed before this scheme was realized.

About 1601, Henri IV took up this idea and commissioned the first of several *Story of Queen Artemisia* tapestry sets from Parisian weavers Maurice I Dubout (d. 1611) and Girard II Laurent (d. between 1613 and 1616).[10] The pair eventually, about 1606, settled in a workshop located in the lodgings of the Louvre Palace, where they continued to produce *Artemisia* and other subjects. Before 1610, orders spilled over to another, new workshop established in the Hôtel of the Gobelins in the Faubourg Saint-Marcel, which was operated by two immigrant weavers, Marc de Comans (1563–1644) from Antwerp and François de La Planche (1573–1627) from Oudenaarde.[11]

Full-scale cartoons for both workshops were created by a string of artists, beginning with Toussaint Dubreuil (1561–1602). He was followed by a succession of the king's painters of tapestry cartoons: first, Henri Lerambert (ca. 1540/50–1608), then Laurent Guyot (ca. 1575–after 1644) with Guillaume Dumée (1570–1646). The resulting cartoons, some thirty-one faithful adaptations of the original illustrations and approximately fifteen others more loosely imagined, provided the newly established Parisian workshops with nearly four dozen scenes. Thanks to its fluctuating currency with contemporary patrons, the series proved extremely versatile and popular not just with Henri IV but also with his widowed queen, Marie de' Medici (1573–1642, queen consort of France 1600–1610 and queen regent of France 1610–14), who ruled as regent during the minority of their son Louis XIII (1601–1643, r. from 1610) and with other secular and ecclesiastical princes across Europe and the papal states. The series' ancillary theme on the education of the ideal prince explains this broader appeal.[12] Produced from 1601 through the 1620s, the two Parisian workshops wove an estimated thirty sets, totaling some 210 individual hangings.[13]

Entry and Reception in the French Royal Collection

The enduring attraction of *The Story of Queen Artemisia* was anchored in the heroine's perceived position as the ultimate role model for a virtuous and benevolent ruler, a just and fair judge, a righteous but conciliatory military authority, a patron of art and literature, a preserver and exalter of dynastic renown, and a selfless parental force in the education of a young prince. Tapestries portraying events and deeds from her life were supremely suitable to hang in French royal palaces as they visualized a compelling personification of the ideal ruler. Moreover, the story had personal meaning for Louis XIV, since he was but four years of age when his own father died. His mother, Anne of Austria (1601–1666, queen consort of France 1615–43), ruled as regent from 1643 to 1651, during the turbulent series of civil wars known as the Fronde, until Louis XIV came of age. His own acquisition in the 1660s of yet another antique set for the royal collection demonstrated his appreciation for the series, and throughout that decade, *Story of Queen Artemisia* tapestries—regardless of whether they did or did not include precious metal–wrapped thread—were displayed in his residences.[14]

5 | a

*The Chariot of Triumph Drawn
by Four Piebald Horses*
(also known as *The Golden Chariot*)
from *The Story of Queen Artemisia*

Design by Antoine Caron (French, 1521–1599), ca. 1563–70
Border design attributed to Henri Lerambert (French, ca. 1540/50–1608),
ca. 1606–7
Cartoon by Henri Lerambert, ca. 1606–7
Paris, workshop at the Louvre of Maurice I Dubout (French, d. 1611), ca. 1606–7
Tapestry: wool and silk
483 × 614 cm (190³⁄₁₆ × 241¾ in.)
Paris, Mobilier National, inv. GMTT 11/4

DESCRIPTION

The funeral cortege of King Mausolus, spouse of Queen Artemisia II, winds its way through a receding landscape over a bridge in the foreground at right and under an architectural ruin in the middle distance (plate 5a). A golden chariot, which transports the body of the deceased king, rolls immediately before the viewer.[15] It is drawn by two pairs of piebald horses with braided manes and plumed head-dresses. Their four riders hold upright staffs that support the king's parade armor, consisting of red hauberk, gilt gauntlets, shield, sword, and helmet. At each corner of the chariot sits a winged female, who, as an allegory of Renown, blows a long straight trumpet or a horn. A monumental figure of Immortality stands in the center of the chariot. Balancing with one foot on a small ball, she holds a palm branch threaded through a myrtle wreath in one hand and a celestial sphere in the other.[16] The side of the chariot facing the viewer is fitted with symbols of death and mourning, including a pair of crossed scythes and smoking torches.

The blue-ground borders are ornamented with cream-and-yellow rinceaux. Simulated cut-leather strapwork cartouches mark the cardinal points. The twin lateral cartouches contain miniature standing figures of Mars, at left, and Venus, at right, while the central cartouche of the bottom border contains the reclining figure of Juno with her attribute of a peacock. Circular medallions punctuate the horizontal borders. These contain the crowned cipher HMM, for Henri IV of France, who commissioned the tapestry set, and his queen, Marie de' Medici.[17] Hybrid grotesque female creatures flank each medallion; their torsos metamorphose into elaborate scrolls. The center of the top border bears, between pairs of grisaille putti, the armorial shield of Henri IV, surrounded by the collars of the French Orders of Saint Michael and of the Holy Spirit.[18] Grisaille captives, with rope-bound wrists, occupy the four corners.

COMMENTARY

According to the Houel manuscript, book 1, chapter 6 (for which no sonnet was composed), the vehicle in this episode of the narrative was called *The Golden Chariot*. The royal inventory of 1666, however, inaccurately identified the vehicle in the corresponding tapestry as *The Chariot of Triumph Drawn by Four Piebald Horses*. The hanging is from a complete set of eight wool-and-silk pieces that remains intact today in the Mobilier National, Paris.[19] The other subjects are: *Four Trumpeters on Foot*; *Four Caparisoned Horses*; *Foot Soldiers Carrying Vases*; *The Chariot Pulled by Two Lions*; *The Chariot Pulled by Two Rhinoceroses*; *The Chariot Pulled by Two Unicorns*; and *The Chariot, with the Queen and Prince, Pulled by Two Elephants*. All but the last subject derive from book 1, chapter 6, of the manuscript, and they depict details from the somber funeral cortege of King Mausolus. Contrarily, *The Chariot, with the Queen and Prince, Pulled by Two Elephants* derives from book 2, chapter 12, and portrays a triumphal entry of Lygdamis.

Five of the compositions from the set closely follow surviving designs by Caron and, coincidentally, their corresponding weavings, including the present tapestry, are each unique among the entire extant group of *Artemisia* hangings.[20] Indeed, the monumental standing figure in *The Chariot of Triumph Drawn by Four Piebald Horses* shares an affinity with her counterpart in an unrelated drawing by Caron, *The Crowning of Esther*.[21] The three other compositions of this set, however, draw upon later, supplemental designs, dating to around 1606 and attributed to Lerambert.[22] The border of this tapestry set relates stylistically to a well-documented set of *Story of Queen Artemisia* tapestries woven from 1606 to 1608 in the Louvre workshops for the Cardinal Alessandro Damasceni-Peretti Montalto (1571–1623).[23]

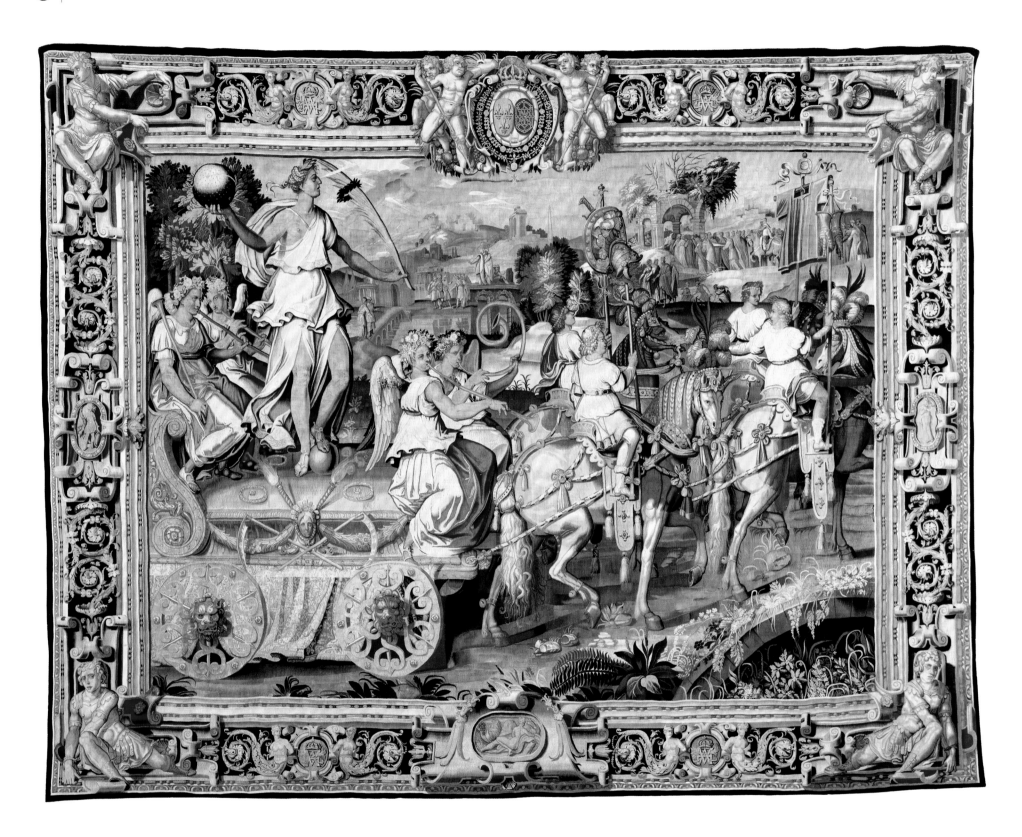

5 | b

The Golden Chariot for
The Story of Queen Artemisia

Antoine Caron (French, 1521–1599), ca. 1563–70
Preparatory drawing: black chalk, pen and brown ink, brown wash,
heightened with white on beige paper
41.5 × 55.5 cm (16¼ × 21⅞ in.)
Paris, Bibliothèque Nationale de France, Département des Estampes
et de la Photographie, inv. RÉSERVE AD-105-FT 4, folio 12 recto

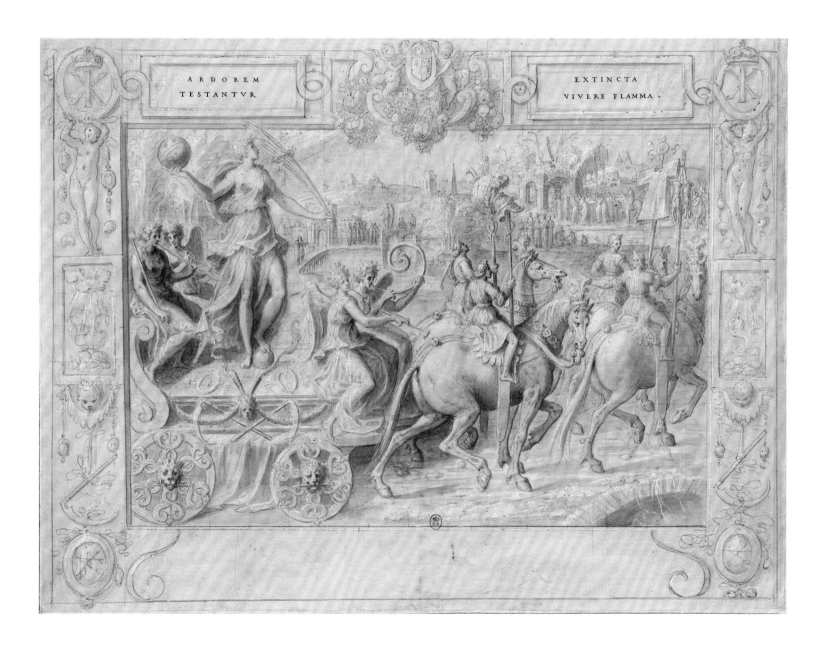

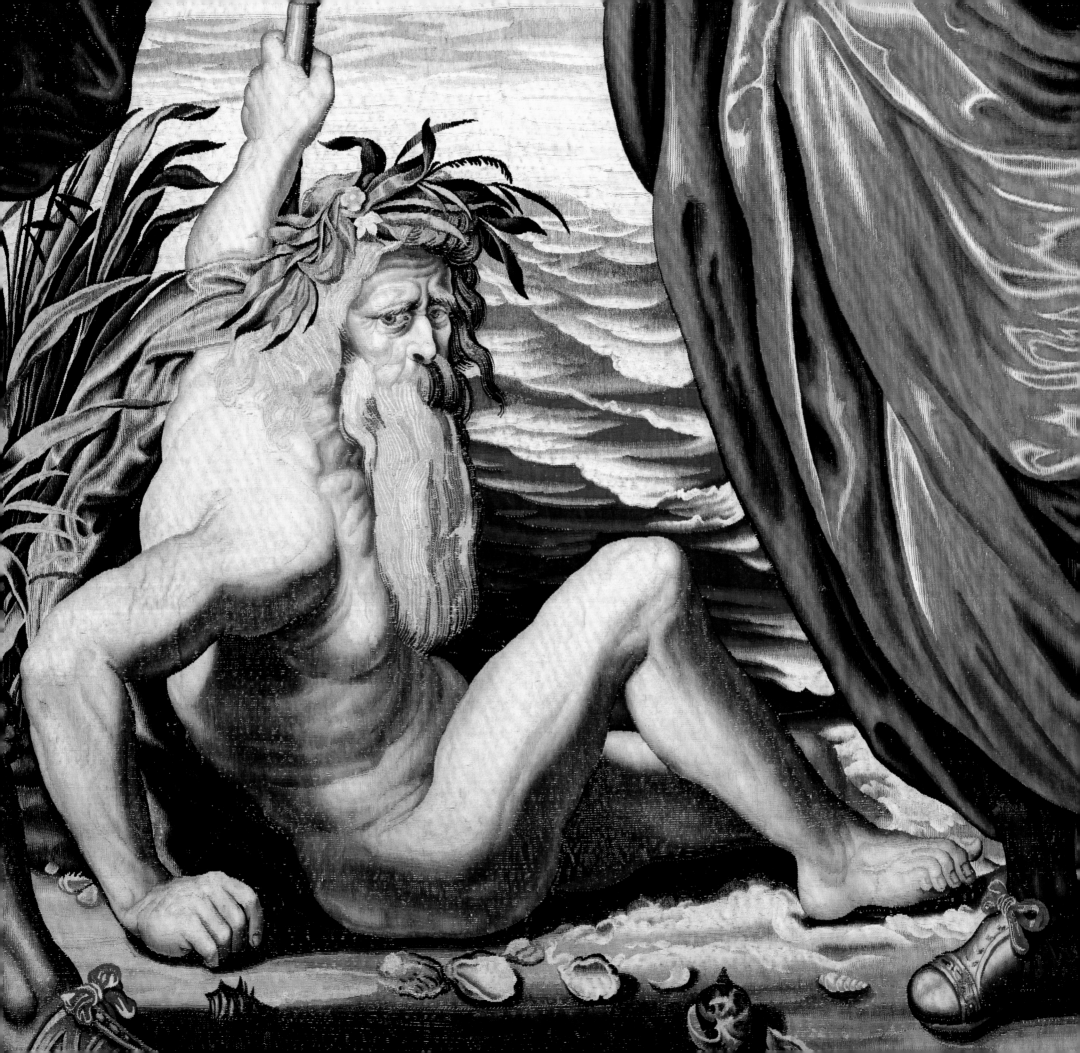

6

The Story of Constantine

The grandeur of the emerging Baroque style was introduced to the Parisian tapestry workshops through the models and cartoons for the *Story of Constantine* series, commissioned from the Antwerp-based artist Peter Paul Rubens (1577–1640). A grandson and nephew of tapestry merchants, the well-traveled, educated, and urbane humanist Rubens had close personal and business ties to the commercial community of the Antwerp–Brussels tapestry trade. Indeed, he had executed models and full-scale cartoons for an earlier Brussels tapestry cycle that celebrated the career of the ancient Roman consul and military hero Decius Mus (d. 340).[1] Given this background, it is not surprising that the Paris-based tapestry entrepreneurs Marc de Comans (1563–1644), originally from Antwerp, and François de La Planche (1573–1627), from Oudenaarde, approached this artist for fresh, sophisticated tapestry designs to be woven on the looms in the workshop they operated in the Faubourg Saint-Marcel (then a suburb southeast of the city wall of Paris).[2]

The venture had the promise of success since Rubens already had patrons within the French court. The timing of the commission, 1622, coincided with the start of his ambitious pictorial cycle of twenty-four larger-than-life paintings celebrating Marie de' Medici (1573–1642, queen consort of France 1600–1610 and queen regent of France 1610–14). These were destined for her Parisian residence, the Luxembourg Palace.[3] And, as it turned out, the historical subject of the new complex, monumental twelve-piece *Story of Constantine* tapestry series found a favorable reception with her son, Louis XIII (1601–1643, king of France, r. from 1610), whose victory over a noble-led Huguenot revolt in the spring of 1622 caused him to be likened to Constantius II (317–361), a son of Constantine the Great (272–337).[4] The topical subject of *The Story of Constantine* was so well received that the French Crown acquired the first two sets, woven in the 1620s. Later, Louis XIV, the son of Louis XIII, acquired a partial—and by then—antique set produced in the 1620s (which included the present tapestry, *Constantius [II] Appoints Constantine as His Successor*) and three more additional sets, woven in the 1650s and 1660s.[5]

Genesis and Production

At face value, the speculative venture of *The Story of Constantine* tapestry series was deliberately targeted to strike a resonant note with the young Louis XIII, for the ancient Roman emperor was esteemed at the turn of the seventeenth century as the first model of a Christian ruler. Moreover, Constantine's conversion to Christianity was perceived as a historic parallel to the conversion of the king's father, Henri IV (1553–1610, king of Navarre from 1572 and king of France from 1589), from Calvinism to Roman Catholicism in 1593.[6] Even more topically, Louis XIII was celebrated as the new champion of Catholicism in battles against ambitious Huguenot nobles in the area of La Rochelle during April 1622. The devoutly Catholic Rubens seems to have been keenly interested in the military campaign, for the artist received reports nearly every week on the king's progress.[7] Following later hostilities in the south and the Truce of Montpellier, the victorious king was welcomed as Constantius II, son and successor to Constantine, in the town of Arles, on October 29, 1622.[8] Did Rubens also hear of these triumphal entries into towns along the king's return route to Paris? With hindsight, the perceived historical allusions in the tapestry series were so compelling that, together with contemporary (but ambiguous) correspondence concerning its genesis, most modern scholars reasoned that

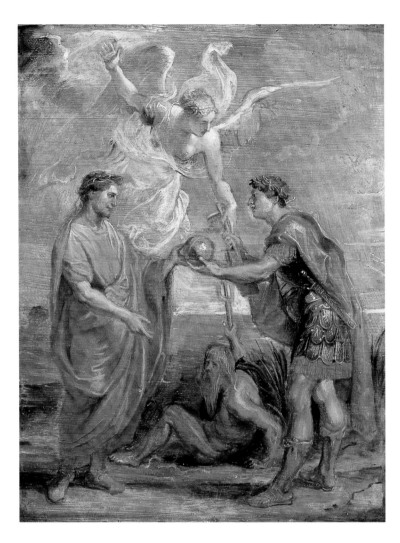

FIG. 54
Peter Paul Rubens (Flemish, 1577–1640).
*Constantius [I] Appoints Constantine
as His Successor*, 1622. Model: oil on
panel, 37.6 × 30.2 cm (14¹³⁄₁₆ × 11⅞ in.).
Sydney, Art Gallery of New South
Wales, Gift of James Fairfax AO 1993,
inv. 483.1993

Louis XIII actually commissioned *The Story of Constantine*. Fresh analysis by Koenraad Brosens argues otherwise.[9]

The French antiquarian Nicolas-Claude Fabri de Peiresc (1580–1637), an adviser to the French court and an acquaintance of Rubens, had been informed of the venture, for he received, in advance, insights concerning its iconographic program directly from the artist.[10] Peiresc was certainly present in the Faubourg Saint-Marcel tapestry workshop in November 1622, when at least four distemper-on-paper cartoons, painted by Rubens's assistants after his oil-on-panel models, were unveiled to French royal administrative officials and others. Whether by chance or by design, Peiresc found himself strategically positioned to discuss the compositions and the subjects with the visitors.

Each scene demonstrated Rubens's personal familiarity with historical literature and theological tracts that recorded the life of Constantine and that interpreted the legacy of his deeds, especially the multivolume *Annales ecclesiastici* (Ecclesiastical annals), printed 1588–1607 by Cardinal Cesare Baronius (1538–1607), as well as ancient Roman and Italian Renaissance art, which he had seen and studied while abroad, from 1600 to 1608.[11] Particularly influential was the Vatican's fresco cycle, painted 1520–24 by assistants of Raphael (1483–1520), including Giulio Romano (ca. 1499–1546) and Giovanni Francesco Penni (ca. 1496–ca. 1528), in the Hall of Constantine. Rubens selectively borrowed models from this cycle, such as the equestrian figure of the emperor in *The Battle against Maxentius at the Milvian Bridge*.[12] Ultimately, the twelve individual subjects composing the complete set were (in chronological and narrative order): *Constantius [I] Appoints Constantine as His Successor* [306]; *The Marriage of Constantine* [307] conflated with the later *Marriage of Licinius* [313]; *The Vision (of the Emblem of Christ Appearing to Constantine)* [312]; *The Labarum* [312]; *The Battle against Maxentius at the Milvian Bridge* [312]; *The Collapse of the Milvian Bridge* [312]; *The Trophy* [312]; *The Entry into Rome* [312]; *The Baptism of Constantine* [324, per Baronius's *Annales ecclesiastici*]; *The Founding of Constantinople* [324]; *Constantine and Helena Worshipping the True Cross* [326]; and *The Death of Constantine* [337].[13]

A postmortem inventory of the estate of La Planche, compiled during the month of August 1627, listed the original twelve models by Rubens (valued together at 1,200 livres) and all twelve working cartoons prepared by Rubens's assistants (valued together at 500 livres) among the property owned jointly with his Faubourg Saint-Marcel business partner Comans. Of these, only the original models survive (fig. 54).[14] By 1627, three partial *Story of Constantine* tapestry sets and one full twelve-piece tapestry set had been produced, all of them with gilt metal–wrapped, wool, and silk thread.

Identification of the editio princeps is a matter of debate. Two different sets are possible candidates as both were purchased by the French Crown. The scholarship, however, has traditionally deemed one case more likely than the other. Seven pieces of the presumed editio princeps bear the armorial shields of the king of France (on the left) and the king of Navarre (on the right). These pieces were given by Louis XIII as a diplomatic gift to the visiting papal legate, Cardinal Francesco Barberini (1597–1679), on the eve of Barberini's departure from Paris on September 24, 1625. Despite being unfinished (the remaining five of the twelve hangings apparently were not ready yet), the incomplete set was considered nonetheless suitable for the occasion because, aside from its great aesthetic and material merit, its religiously—and secularly—laden subject would not have been lost upon the papacy of Urban VIII (b. Maffeo Barberini, 1568–1644, r. from 1623, and uncle of Francesco Barberini).[15] Later, Francesco complemented the gift of the seven weavings with five more pieces after designs he specially commissioned from Pietro da Cortona (1596–1669) and had woven in Rome. All twelve panels of the combined set are now in the Philadelphia Museum of Art.[16] Alternatively, another of the initial four Faubourg Saint-Marcel sets produced before 1627 might have been the editio princeps. Originally comprising eight pieces, also bearing the arms of France and Navarre, it entered the royal collection presumably in the 1620s but was sold subsequently by order of the Directoire government (1795–99) and remains untraced.[17]

The models supplied by Rubens did not include any concept for a border but the surrounds of all four initial tapestry sets replicated the same design more or less, varying only in the presence or absence of royal arms in the lateral cartouches.[18] Isabelle Denis attributed the common design, on stylistic grounds, to Laurent Guyot (ca. 1575–after 1644), the king's painter of tapestry cartoons from about 1608.[19]

Entry and Reception in the French Royal Collection

Although the present *Constantius [I] Appoints Constantine as His Successor* was not actually inherited by Louis XIV, it is nonetheless presented here as representative of the initial two sets of *The Story of Constantine* that were acquired by the Crown as they came off the looms of the Faubourg Saint-Marcel workshop from 1625 to 1627. The purchase in late 1662 by Louis XIV of the partial antique set of *The Story of Constantine*, which included the present tapestry, followed in the wake of the latest renewal of tensions between the French Crown and the papacy. These tensions had been triggered by a bloody confrontation, in which papal soldiers, known as the Corsican Guard, attacked the French ambassador's escort and pages in Rome on August 20, 1662. Was the royal purchase of antique *Constantine* hangings merely coincidental, or did their embedded theological and political meanings have fresh relevance for the king in 1662? While the answer may remain in doubt, the subsequent purchase in 1667 by Louis XIV of an additional *Story of Constantine* set, woven under the direction of Raphael de La Planche (act. 1625–66), director from about 1633 until at least 1666 of a spin-off Parisian workshop located in the Faubourg Saint-Germain, surely echoed the diplomatic coup achieved with the Treaty of Pisa of 1664, when the papal nuncio traveled to Versailles to offer apology for the incident.[20] Two more sets, also woven at the Faubourg Saint-Germain workshop in the 1660s, entered the royal collection in the late 1690s.[21]

Notwithstanding all these monumental portrayals of the deeds of the emperor Constantine after Rubens, the Royal Tapestry Manufactory at the Gobelins continued a project initiated in the early 1660s at the short-lived Maincy workshop to create tapestry versions of the Vatican's Hall of Constantine fresco decorations by the pupils of Raphael. This project included scenes from Romano's *Battle against Maxentius at the Milvian Bridge*. The artist Charles Le Brun (1619–1690) supplied new designs for additional subjects, and several tapestry sets of this alternate series joined the growing royal collection (see fig. 19 and the essay by Vittet, this catalogue).[22]

Constantius [I] Appoints Constantine as His Successor
from *The Story of Constantine*

Design by Peter Paul Rubens (Flemish, 1577–1640), 1622
Border design attributed Laurent Guyot (French, ca. 1575–after 1644), ca. 1622–23
Paris, Faubourg Saint-Marcel workshop under the direction of entrepreneurs Marc de Comans
(Flemish, 1563–1644, act. in France from 1601) and
François de La Planche (Flemish, 1573–1627, act. in France from 1601), ca. 1625–by 1627
Tapestry: wool, silk, and gilt metal–wrapped thread
458 × 407 cm (180⁵⁄₁₆ × 160¼ in.)
Paris, Mobilier National, inv. GMTT 43/3

DESCRIPTION

This scene portrays an event that, according to ancient and medieval historians, took place in England when an angel directed the Roman co-emperor Constantius to designate his son Constantine as his successor just before his own death on July 25, 306 (plate 6a).[23] Two figures in ancient Roman garb stand on a shell-strewn shore, with blue waters rippling to the distant horizon. The constricted, narrow, and deep pictorial field is accentuated by the steep recession of clouds, heavy and gray above but luminously white out to sea. Constantine, at left, is crowned with laurel and wears armor under his cloak. He leans forward to receive an orb from his father, opposite. Simultaneously, he receives a ship's rudder, signifying temporal power, with a stave in the form of a Latin cross from an angel hovering above. Suspended in air, with her drapery swirling in the wind, she is the allegorical figure of Divine Providence.[24] The older man at right, Constantius I, is also crowned with laurel, but he wears a toga of wine-red hue. Expressively gesturing with his left hand to his chest, he conveys authority to his son through the act of passing the *orbis terrarum* (terrestrial orb). An elderly Neptune, with a long gray bread and a wreath of marine reeds, sits on the ground between them; his trident at the center of the composition is nearly obscured by the transfer of the orb.

The dark-ground border is punctuated with auricular cartouches at each side's center point and at each corner. Colorful garlands of flowers and fruit as well as tied bundles of green palm branches are between the cartouches. A different grotesque mask fills each corner while the Christogram, the Chi-Rho symbol ☧, fills the upper medallion, encircled by a floral wreath. An eagle, with a snake in its beak, projects through the open cartouche below. The lateral escutcheons, blue on the left and red on the right, are blank.

COMMENTARY

Originally, the present hanging was from a complete set of twelve pieces, also woven by 1627, of which only ten are now extant.[25] The set was divided already by January 1635, when four of the hangings, including this one, were listed in the posthumous inventory of Charles de Comans (d. 1634), who in 1628 had succeeded his father, Marc de Comans, in the business.[26] The four were purchased by Louis XIV late in 1662 from a tapestry dealer known as la dame Petit (dates unknown, act. 1660s), and they have remained in the French royal/national collection since then. Six other pieces from the set were acquired in the seventeenth century by Charles de La Porte, duc de La Meilleraye (1602–1664); these passed in the nineteenth century into the Imperial Austrian collection and are now in the Kunstkammer of the Kunsthistorisches Museum, Vienna.[27] The survival of the last two pieces of the set is uncertain.

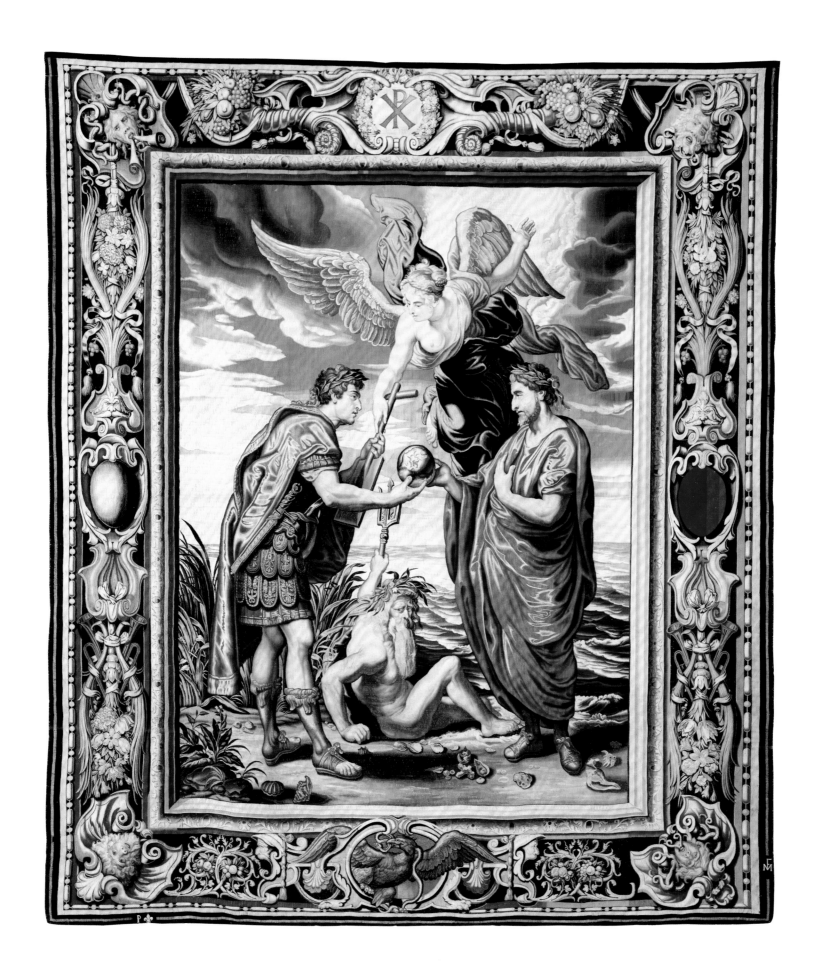

7

Stories from the Old Testament

On December 23, 1626, Louis XIII, king of France (1601–1643, r. from 1610), signed a royal warrant commanding that the artist Simon Vouet (1590–1649) return from Italy to serve the agency of the Office of Royal Buildings, Gardens, Arts and Manufactories, in France.[1] Upon Vouet's arrival in Paris in November 1627, he was named first painter to the king and, as the chronicler and art theorist André Félibien (1619–1695) recounts, "He began to make for his Majesty, some designs for tapestries that he had executed in oil and distemper."[2] Vouet eventually conceived at least five series that were made into tapestries (listed here in chronological order per the current scholarship): *The Story of Rinaldo and Armida*, *Loves of the Gods*, *Stories from the Old Testament*, *The Deeds of Ulysses*, and *The Story of Theagenes and Chariclea*.[3]

Félibien went on to explain that Vouet achieved this prolificacy with the aid of a large workshop of specialized assistants who worked his designs and painted models into full-scale cartoons. Among his assistants were the landscape painters Pierre Patel (1605–1676) and François Bellin (d. 1661), the animal painter Pierre Van Boucle (ca. 1610–1673), and the ornamentalists Jean Cotelle (1607–1676) and Michel Dorigny (1616–1665).[4] Félibien reiterated that Vouet was charged with "the supervision of tapestry cartoons" and that he carefully instructed the weavers, as evinced by the surviving contract of April 20, 1637, between the artist and the tapestry entrepreneur Maurice II Dubout (d. ca. 1656). That agreement dictated that there were to be no simplifications or modifications of the design, "especially in regards to the faces and flesh."[5] Although cartoons for *Stories from the Old Testament* do not survive, the artist's extant drawings, together with the derivative tapestries, provide a reliable reflection of the grandeur of his vision for the medium, which was imbued with the emerging Baroque lyricism that he had recently experienced in Italy.[6]

Genesis and Production

Certain critical information concerning the editio princeps, such as the precise date and execution of the royal command, is unknown, but Vouet's preparatory drawings suggest, stylistically, an origin in the mid- to late 1630s.[7] At least one cartoon for a Samson subject existed by 1639.[8] It is debatable how far weaving had progressed before the death of the king in May 1643, for, apparently, no delivery was made to the Crown until 1663. Engravings executed after the cartoons in 1665 by Vouet's son-in-law, François Tortebat (1616–1690), document that the overall concept originally comprised six subjects (listed here according to their order of appearance in the Old Testament): *The Sacrifice of Abraham* (Genesis 22:9–12), *Moses Rescued from the Nile* (Exodus 2:5), *The Daughter of Jephthah* (Judges 11:30–36), *Samson at the Banquet of the Philistines* (Judges 16:23–30), *The Judgment of Solomon* (1 Kings 3:16–28), and *Elisha Receiving the Mantle from Elijah* (1 Kings 19:19).[9] The engravings did not reproduce the tapestry border design (fig. 55). The inscribed legend on the Samson engraving indicated that the group represented the "Plan for royal tapestries conceived and painted by Simon Vouet by order of the most Christian king Louis XIII to decorate the Louvre." Exactly which room of the Louvre Palace was the intended location remains a matter of conjecture, because the commission never materialized as per the inscription, but Pascal-François Bertrand has interpreted the group of scriptural stories, so highly dramatic and emphatic, as a metaphor for divine action guiding royal power, namely, Divine Providence, Divine Justice, Divine Force, Divine Wrath, and Divine Will.[10]

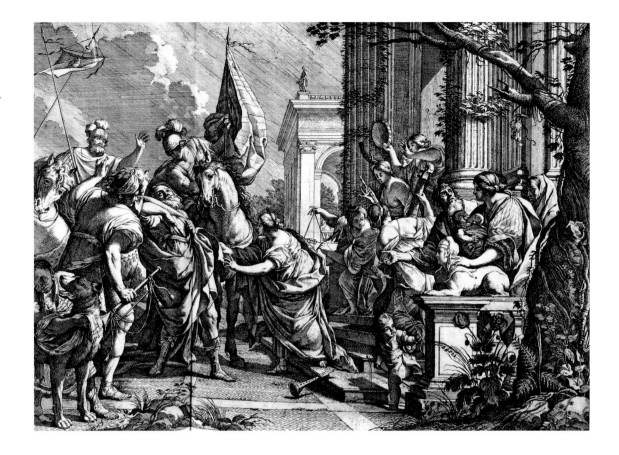

Vouet's luminous compositions, grandly palatial and lush verdant settings, and broadly gesturing figures dressed in rich drapery disguised the underlying violence of the scenes with their threatened infanticide and impending child sacrifice. Rather, he rendered these Old Testament tales into visually poetic, highly desirable, monumental textiles suitable for the décor of elite residences. The compositions of *Stories from the Old Testament* were woven in three Parisian tapestry workshops: the Louvre, the Faubourg Saint-Germain, and the Faubourg Saint-Marcel, as well as its satellite in Amiens, for private commissions delivered from about 1643 to about 1650.[11] For these, some of the wider compositions were woven in narrower widths, as *entrefenêtres* intended for the narrow walls between window bays, and new additional subjects were created, including compositions for the story of Lot and for the story of Rachel.[12] It is notable how quickly private commissions followed upon the death of the king, suggesting the lapse of the royal prerogative—if it existed—over the cartoons and, moreover, how favorably the compositions were received at the time.

Entry and Reception in the French Royal Collection

Unlike Vouet's extremely popular *Story of Rinaldo and Armida* tapestry series, represented by three sets in the French royal collection, no contemporary records reveal how the *Old Testament* hangings after his designs were received by Louis XIV. One possible explanation for why the stalled royal commission was not taken up again might be the fact that the production of an entirely different biblical series, including six scenes from *The Story of Abraham*, was under way for the Crown, with deliveries pending between 1661 and 1668.[13] But some measure of renewed appreciation for the Vouet edition can be deduced by the extraordinary program, in 1665, to have Tortebat engrave all six of the subjects that were originally planned to decorate the Louvre Palace in the 1640s as tapestries.

7 | a

The Daughter of Jephthah
from Stories from the Old Testament

Design by Simon Vouet (French, 1590–1649), mid- to late 1630s
Border design attributed, in part, to Jean Cotelle (French, 1607–1676), before 1643
Paris, workshop at the Louvre of Maurice II Dubout (French, d. ca. 1656),
begun in the 1640s–completed by 1659
Tapestry: wool and silk
480 × 595 cm (189 × 234¼ in.)
Paris, Mobilier National, inv. GMTT 23/2

DESCRIPTION

This scene's sun-drenched setting and festive, music-making maidens belie the heartrending drama of the biblical story about the ancient Hebrew military leader, Jephthah, and his daughter (plate 7a). In this portrayal, based on the account from the Old Testament book of Judges (11:30–36), Jephthah returns home victorious from battle against the Ammonites, who were an enemy of the wandering tribes of Israel. Mounted captains and male servants encircle him as he approaches his household. His only child, a daughter, is the first to come out, joyfully dancing forward to greet him. At the sight of her, Jephthah tears his garments in anguish as he recalls his promise to God. Her steps falter as he explains his vow to sacrifice the first person to exit the house as an offering of thanksgiving for the victory. The daughter, at the center of the composition, reaches out toward the distraught father to demonstrate that she accepts this fate so that he may honor his promise to God. The older woman at the far left, whose covered head projects just forward of the tree, seems to be the first of the domestic attendants to grasp the true horror of the situation.[14]

The broad border simulates carved stucco ornament of golden-yellow rinceaux and grotesques against a blue ground. Grisaille oak wreath–encircled medallions, each containing a classical head in profile, occupy the four corners while four cartouches, also in grisaille, are at the center of each vertical and horizontal border. Pairs of garland-draped putti flank each cartouche. The one at top, festooned with oak leaves, presents the crowned coats of arms of France and Navarre surrounded by the collars of the French Orders of Saint Michael and the Holy Spirit.[15] Those at each side, with ivy festoons, bear the initial L for Louis XIII. The one below, with berried laurel leaves, displays the club of Hercules entwined with a ribbon bearing the king's motto.

COMMENTARY

Only two pieces of the royal commission for *Stories from the Old Testament* are known to have been delivered, approximately twenty years after the death of Louis XIII: *The Daughter of Jephthah*, considered here, and the companion piece, *Moses Rescued from the Nile* (fig. 56). Why the full commission wasn't completed remains a mystery, but, presumably, weaving was interrupted by the monarch's death. Both hangings bear the device and motto of Louis XIII in the lower cartouche. Records state the pieces were woven on vertical, or so-called high-warp, looms in the Louvre workshop. Maurice II Dubout and his wife, Anne Jolain (d. after 1663), worked on *Jephthah* while their partner Girard III Laurent (ca. 1588–1670) produced *Moses*. The *Jephthah* hanging appeared in Dubout's postmortem inventory, begun September 23, 1659, some two-and-one-half years after his death, as "pictures in tapestry…a large piece of high-warp tapestry of silk…representing and making part of *Jephetté* which the widow said was made for the king…" and for which his widow, Jolain, received payment in two installments, dated 1658 and 1663.[16] The two tapestries are not listed in a royal inventory until the early 1666 document drawn up by Gédéon Berbier du Metz (1626–1709, intendant and controller general of the Crown's Furniture Warehouse from December 31, 1663).[17] Laurent, incidentally, relocated his operation to join other weavers at the Hôtel of the Gobelins in the Faubourg Saint-Marcel shortly after finishing *Moses*.

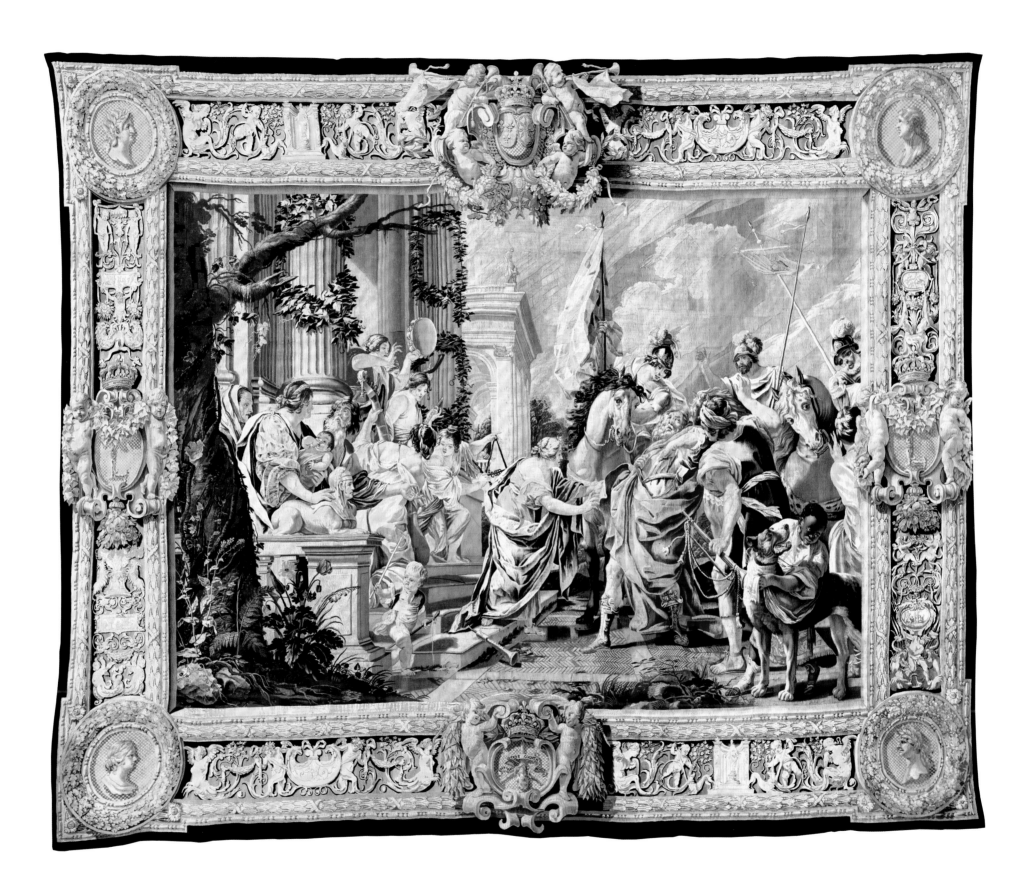

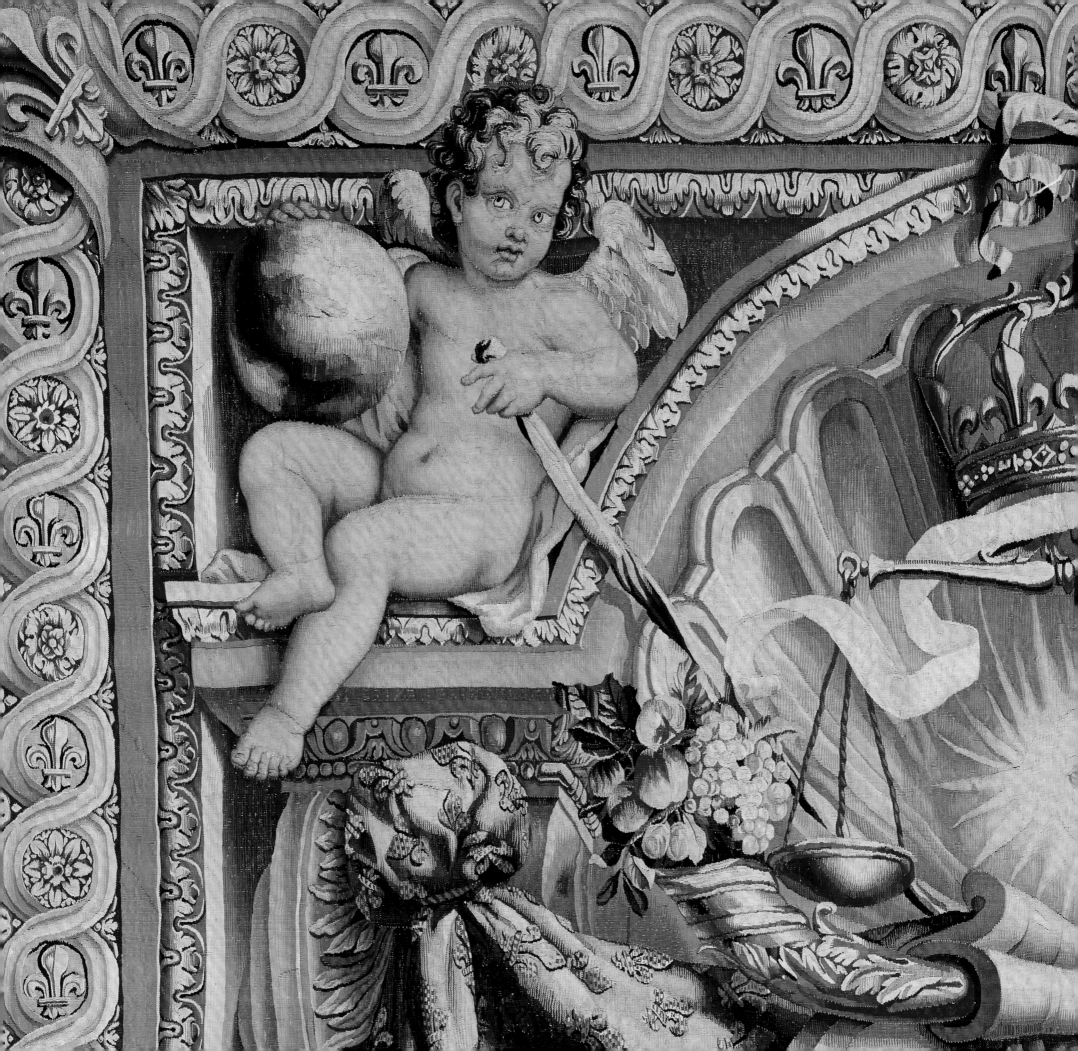

Louis XIV as Patron

8

The Portiere of the Chariot of Triumph

In 1661, with all "the ambition of a youthful king," the twenty-two-year-old Louis XIV assumed independent rule without a first minister and began consciously and systematically to develop highly sophisticated literary, visual, and performance imagery for the monarchy and for his personal *gloire*.[1] In the realm of the arts, he assumed the role of ultimate patron and protector, establishing new academies and manufactories to serve his objectives and promote his reputation domestically and abroad as the arbiter of informed, refined taste.[2] Concerning the medium of tapestry, that costly and prestigious symbol of princely power and aesthetic discernment, Louis XIV supported the centralization of the sundry Parisian weaving workshops into one large unified complex at the Hôtel of the Gobelins in the Faubourg Saint-Marcel per the advice of the able administrator Jean-Baptiste Colbert (1619–1683), who had joined his royal council of finance that year. Thus, the following year, in 1662, the Royal Tapestry Manufactory at the Gobelins was established with the mandate to produce extremely high quality tapestries after accomplished designs for the adornment of royal residences.

Both king and administrator agreed upon the choice of its first artistic director, Charles Le Brun (1619–1690). Le Brun had already demonstrated his knowledge, understanding, and extraordinary talent for conceiving and executing complicated programs of historical, mythological, and allegorical subjects as decoration for interior schemes. His most spectacular project to date was the Château of Vaux-le-Vicomte, which belonged to Nicolas Fouquet (1615–1680, superintendent of finance 1653–61), with its associated tapestry-weaving workshop at nearby Maincy.[3]

Genesis and Production

From the late 1650s to the early 1660s, Le Brun designed a group of armorial portieres and over-door panels to be woven as tapestry. The earliest designs—predating the *Chariot of Triumph*—were originally conceived for his patron Fouquet, who established the tapestry workshop at Maincy in 1658. The workshop was subsequently authorized by a royal patent in May 1660. Its purpose was to produce hangings for the magnificent interiors of Fouquet's country residence, the Château of Vaux-le-Vicomte, newly erected in the district of Melun.[4] A design for an initial portiere and another for an over-door panel were worked into cartoons there by Beaudrin Yvart (1611–1690). A few tapestries were made at Maincy from these cartoons and recorded in the September 1661 inventory of the possessions of the (by that time) disgraced Fouquet.[5] These hangings do not survive, but two drawings by Le Brun for the portiere and a written description for the woven over-door panels suggest their original appearance.[6] Both carried Fouquet's heraldic device and emblematic ornament; the former included allegorical figures that have since been interpreted as Fidelity and Fortitude.[7]

In June 1662, the Maincy workshop looms, models, and staff were moved to Paris and incorporated into the Royal Tapestry Manufactory at the Gobelins (renamed the Royal Furniture Manufactory of the Crown in 1667). The Maincy cartoons and Fouquet armorial tapestries were altered with new inserts to align their imagery with the king, Louis XIV. The adapted cartoons and hangings then became models for subsequent production. The adjusted armorial portiere (and subsequent versions with allegorical figures modified to represent Victory, or Fame, and Flora) was named *Renown* in the royal records. By this date, the talented, educated, and well-traveled Le Brun had been noticed by the king, taken into his employ, ennobled, and recruited to Paris, where, in March 1663, he became

director of the Gobelins. The manufactory produced additional armorial portieres for the king based on two further compositions supplied by Le Brun: *The Portiere of Mars* (with its first delivery of six tapestries woven with gilt metal–wrapped thread in November 1666) and *The Portiere of the Chariot of Triumph* (its first delivery of six tapestries also woven with gilt metal in November 1670).[8] A red chalk and gray wash preliminary design survives for the *Mars* tapestry, which, based on its media and style, is dated about 1658–61, though its blank, dual armorial shields suggest that Fouquet and Le Brun may have envisioned the project of Maincy weavings initially as a gift for the king.[9]

No compositional drawing has been identified for the *Chariot of Triumph* portiere, but the motifs of the royal crown, balance scales, radiant Apollo's head, winged putti, and much of its detailed military ornament can all be traced back to a border designed by Le Brun during the same period, 1658–61, for a tapestry series titled *The Story of Constantine* first produced at Maincy and later at the Gobelins (fig. 57 and see fig. 19).[10] In terms of his choice of subject and form, Le Brun seems to have been inspired by the ancient Roman marble relief depicting military trophies flanked by young winged Victory figures that had adorned the Piazza del Campidoglio since being moved there in 1590. The monument was one of two that had been reproduced graphically from the sixteenth century as the *Trophies of Marius*. Le Brun may have been personally familiar with the monument from his period in Rome from 1642 to 1645 or with an engraving of the relief.[11] In any case, the overall composition for the *Chariot of Triumph* cannot date before June 1662, when Louis XIV accepted the motto "Nec pluribus impar" (Not unequal to many [tasks]) and its corresponding imagery, which likened the glory of his governance across the French global domains to the sunlight that illuminates many planets.[12]

Weavers in multiple workshops at the Gobelins continued to produce tapestries after the three portiere designs of *Renown*, *Mars*, and the *Chariot of Triumph* through the reign of Louis XIV, the Regency (1715–23), and into the early years of independent rule (1723–24) by Louis XV (1710–1774, r. from 1715). In total, eight sets, comprising some sixty-six to seventy-one *Chariot of Triumph* portieres, were woven until 1724.[13] Only twelve of these contained gilt metal–wrapped thread, and they do not survive.[14] Simultaneous weaving was facilitated by copies of the cartoon prepared by Adam Frans van der Meulen (1632–1690) and in 1714–15 by Joseph Yvart (1649–1728) and Pierre Mathieu (ca. 1657–1719).[15]

Entry and Reception in the French Royal Collection

As implied by the etymology, portiere tapestries were intended to hang over doors (*portes*). In keeping with their function, they were frequently pulled or permanently draped aside a door to allow for passage. Thus, the visual vocabulary of these tapestries had to be immediately recognizable, even when they were hanging in folds. They were ideally suited for the emblazoned display of the owner's coat of arms, and their recurring presence throughout a dwelling reinforced the hereditary rank and social status of the household. From the earliest delivery of the royal armorial portieres designed by Le Brun to the Crown's Furniture Warehouse, they were displayed routinely over doorways in guard rooms, parade apartments, and bedchambers of the king and his family throughout the royal residences and especially on the solemn feast day of Fête-Dieu (Feast of Corpus Christi).

The lofty allegorical virtues and qualities of strength, abundance and prosperity, justice, and good government visually proclaimed by *The Portiere of the Chariot of Triumph* were especially poignant during the long years of chronic war pursued by Louis XIV; through military conquest, he attempted to defend and extend French rule into other parts of Europe and around the globe. The potent symbolism proved enduring even after his death, and the portieres continued to be displayed in royal palaces throughout the Bourbon reign until the Revolution in 1789, when twenty-four portieres of the *Chariot of Triumph* still decorated Versailles.[16]

8 | a

The Portiere of the Chariot of Triumph

Design by Charles Le Brun (French, 1619–1690), ca. 1662–63
Cartoon attributed to Beaudrin Yvart (French, 1611–1690), ca. 1662–63
Paris, Royal Furniture Manufactory of the Crown at the Gobelins, in the low-warp workshop of Jean de
La Croix (French, d. 1714, foreman of the first low-warp workshop 1662–1712), 1699–1703,
or possibly in the low-warp workshop of Jean de La Fraye (French, ca. 1655–1730,
foreman of the fourth low-warp Gobelins workshop from 1699), 1715–17
Tapestry: wool and silk
357.5 × 277.8 cm (140¾ × 109⅜ in.)
Los Angeles, J. Paul Getty Museum, acc. no. 83.DD.20

DESCRIPTION

The tight pictorial field of this tapestry presents a monumental portal, or niche, containing a massive parade chariot with piles of military trophies, including two cuirasses and their helmets, shields, spears, quivers and bundles of arrows, swords, bunched banners, and trumpets (plate 8a). The vehicle is stationed directly before the viewer, bursting forth from the perceived picture plane. Its front wheels have inexorably rolled forward, trapping and severing the body of a large snake, symbolic of vice or rebellion.[17] The face of the chariot is carved with an allegorical mask of a winged Victory, who sounds two curved horns. A large armorial cartouche, resting upright on the chariot, bears the arms of France, on the left, and of Navarre, on the right, surrounded by the collars of the Orders of Saint Michael and the Holy Spirit.[18] Just below the dual shields, a miniature, crowned, and palm-crossed L, a reference to Louis XIV, adorns the cartouche. Larger fronds of green, freshly cut palm branches encircle and protrude through the collars. Two winged putti, each with a terrestrial sphere, sit on the architrave above and hold a twisted blue ribbon that is tied to the armorial cartouche and crisscrosses its upper scrolls, from which spring two horns of plenty filled with fruit. The bare feet of the putti dangle in air. The radiant face of Apollo, the sun god, shines from the concave gadroons of the architrave. The closed crown of the French monarchy hangs by another blue ribbon from a fictive nail struck into the upper border of the tapestry. A set of balance scales is suspended from this crown, through which a white band flutters. The band bears the (now faded and barely discernible) motto of the king. An expanse of dark blue cloth, embroidered in an allover pattern of gilt fleurs-de-lis, is tied to two volutes, just below the central arch. The border of the tapestry takes the form of a guilloche band that encircles, alternately, gilt fleurs-de-lis and rosettes. A single, larger fleur-de-lis rests diagonally in each of the scale-meshed corners.

COMMENTARY

Records concerning the production of the portieres, and the *Chariot of Triumph* in particular, are difficult to follow from the 1690s through the early years of the 1700s because the Gobelins workshops were closed in April 1694 in a cost-saving step to help finance the long-running war against the League of Augsburg (1688–97). Weaving was interrupted, with some tapestries left on the looms, and employees scrambled to find work elsewhere.[19] But on January 1, 1699, the Royal Furniture Manufactory of the Crown reopened and production of *The Portiere of the Chariot of Triumph* recommenced in the low-warp workshop under the supervision of Jean de La Croix (d. 1714, foreman of the first low-warp Gobelins workshop 1662–1712). Five pieces were completed by 1703, when the commission was interrupted again for unspecified reasons. These five pieces were the only ones of this seventh edition to be finished within the king's lifetime, but they were not delivered before his death on September 1, 1715. Weaving resumed in October 1715 and continued through July 1720 in three other low-warp workshops: six pieces were made under the supervision of Jean de La Fraye (ca. 1655–1730, foreman of the fourth low-warp Gobelins workshop from 1699), six more were completed under Jean Souet (ca. 1653–1724 or later, foreman of the third low-warp Gobelins workshop 1699–1724), and one last piece was done under Étienne Le Blond (ca. 1652–1727, foreman of the fifth low-warp Gobelins workshop from 1701).[20]

The present piece is identified as one of six hangings delivered to the Crown's Furniture Warehouse on October 27, 1717, thanks to the preservation of a remnant of an early lining of the tapestry, which bears the inked inventory number 194 and a brief inscription. The *Journal of the Crown's Furniture Warehouse* recorded their arrival:

> October 27, 1717, Gobelins Portieres of Char No 194 tapestries of wool and silk: Delivered by M. Cozette, concierge of the royal manufactory of the Gobelins. Six portieres of low-warp tapestry of wool and silk, manufacture of the Gobelins, design by Le Brun, representing in the middle the arms and the device of Louis XIIII in a cartouche carried on a chariot of triumph, accompanied by trophies of armor; The border is a guillouche that encloses bronze-colored fleurs de lis and roses; each portiere has two and one half aunes in width, over three aunes in height, and the sixth one over 2 5/6 aunes [in height].[21]

One partial delivery of three pieces was noted in the *Journal* on December 7, 1718; the rest presumably figured among the twelve pieces delivered on February 1, 1743.[22]

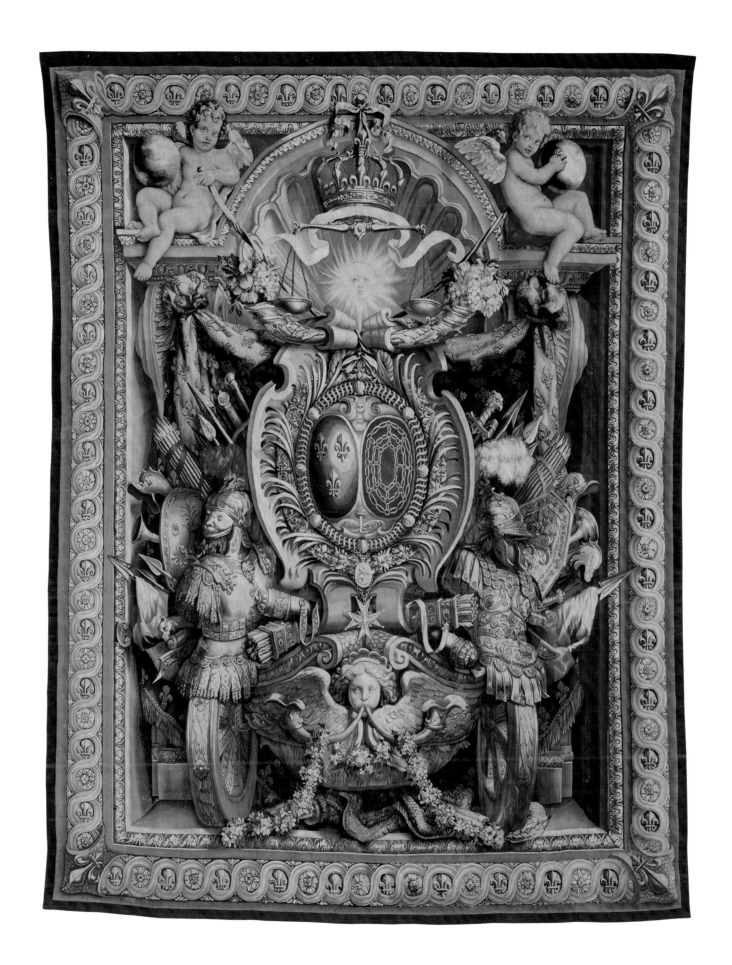

9

The Seasons

In the first half of the 1660s, Louis XIV, with his able administrator Jean-Baptiste Colbert (1619–1683, superintendent of the Office of Royal Buildings, Gardens, Arts and Manufactories from 1664), organized and harnessed an arts-and-letters propaganda machinery, composed of manufactories and academies, to visualize the king's magnificence and *gloire* for the benefit of the realm. Tapestries were to play a significant celebratory role in the new scheme, in addition to their traditional function as markers of princely status, splendor, taste, and wealth.[1] Henceforth, designs for tapestry at the newly established Royal Tapestry Manufactory at the Gobelins would conform to the overarching iconographic programs intended to aggrandize the public persona and embody the civilizing power of Louis XIV, as devised by the first painter to the king, Charles Le Brun (1619–1690), and the Petite Academy (the body of humanist scholars tasked from its foundation in 1663 with formulating fitting mottoes, symbols, and emblems for the reign, later renamed the Academy of Inscriptions and Belles-Lettres). Among the first tapestry designs to originate from this collaboration was an allegorical suite of *The Seasons*, which complemented a tandem series of *The Elements*. Both series visually expressed the king's virtues and the glories of his reign.[2] The program for *The Seasons* represented his moral magnificence and generosity in action while that of *The Elements* proclaimed his magnanimity, valor, piety, and goodness.[3]

Genesis and Production

The *Seasons* series was nothing less than an unabashed panegyric to the twenty-six-year-old king.[4] As an allegorical depiction of the four seasons, each hanging exhibited specific characteristics, yet the compositions for *Spring*, *Summer*, *Autumn*, and *Winter* conformed to an overall unifying program. Each pictorial field portrayed a royal château, or other landmark, within its topographical setting at the time of year when residency at that particular place would be most pleasant. Vegetation and implements or attributes appropriate to the locale and season filled the foreground. Pairs of pagan divinities hovered above, holding a roundel with a miniature scene featuring either the king partaking in a pastime typical of that venue or the building in which such an activity would have taken place. Thus, *Spring* portrayed the Orangery at Versailles, with Mars and Venus holding a miniature showing the king performing on horseback in the carousel staged there in 1664. *Summer* presented a garden view of the Château of Fontainebleau, with Apollo and Minerva holding a roundel with an elevation of the central pavilion of the Tuileries Palace (which was enlarged and covered with a dome in 1664). *Autumn* showed the terrace of the New Château of Saint-Germain-en-Laye, with Bacchus and Diana holding a miniature of the king at hunt. *Winter* depicted an old Parisian city gate, the so-called Conference Gate (demolished in 1730), with Saturn and Juventas, who served nectar to the Olympian gods, holding a miniature of a theatrical performance.[5]

Prints after the designs for both series were made and circulated even before the editio princeps of tapestries was completed in 1669. First, prints of *The Elements* were published in 1665 as *Les quatre élémens peints par M. Lebrun et mis en tapisseries pour Sa Majesté* (The four elements painted by M. Lebrun and made into tapestries for His Majesty) with iconographic explanations and commentary provided by the art theoretician André Félibien (1619–1695, historian of the Office of Royal Buildings from 1666). This was followed in 1667 by *Les quatre saisons peintes par M. Le Brun et mises en tapisserie pour Sa Majesté* (The four seasons painted by M. Le Brun and made into tapestries

for His Majesty) and then in 1670 by *Les tapisseries du roy, ou sont representez les quatre élémens et les quatre saisons de l'année, avec les devises qui les accompagnent et leur explication* (The king's tapestries, representing the four elements and the four seasons, with their accompanying emblems and their explanation). This edition included all the madrigals composed by Jean Chapelain (1595–1674), Charles Perrault (1628–1703), François Charpentier (1620–1702), and the abbé Jacques de Cassagnes (1636–1679) for the border emblems they invented in their capacity as director and members (respectively) of the Petite Academy.[6] Thanks to these explanations, the complex and erudite symbolism of the series and its emblematic medallions are better understood.

Borders of the *Elements* tapestries were rhythmically uniform overall, yet they were customized to harmonize with each of the individual subjects portrayed in the figurative field: *Fire*, *Air*, *Water*, and *Earth*. Thus each border featured different motifs. These four border designs were also applied to *The Seasons*; consequently, pairs from both cycles were visually connected when displayed in proximity. For example, the border design for *Earth* from *The Elements* also appeared on *Autumn* from *The Seasons* (see fig. 21).[7] This same border design was applied to the auxiliary *entrefenêtre* version of *Autumn*, which was intended to hang on the narrow walls between window casements. The *entrefenêtre* depicted putti harvesting seasonal fruits, including apples and grapes (fig. 58).

Weaving of *The Seasons* and the *entrefenêtre* gardening scenes commenced at the Gobelins in 1667 and ran roughly parallel with production of *The Elements* and its related *entrefenêtres* until about 1682. By then, five sets of *The Seasons* and six of *The Elements* had been completed, all of them containing some wefts of gilt metal–wrapped thread. Production then ceased until later in the king's reign, when two additional sets (without *entrefenêtres*) of *The Seasons* were begun in 1708 and 1712, and two more of *The Elements* in 1703 and 1707.[8]

Entry and Reception in the French Royal Collection

Embodying the most overt allegories in praise of Louis XIV, the ideal prince, and bearing sophisticated, learned emblems, sets of *The Seasons* and *The Elements* celebrated not only the youthful king and all his virtues but also his vision and determination to recruit, organize, and employ the greatest artists and master craftsmen to create beautiful and virtuoso artworks, such as these tapestries, to adorn his palaces. It is not surprising that sets of these tapestries were strategically presented as diplomatic gifts: for example, the king gave a set of *The Elements* to Cosimo III de' Medici (1642–1723, grand duke of Tuscany from 1670 and the king's cousin by marriage) in 1669 and a set of *The Seasons* to the minister of Christian V, king of Denmark and Norway (1646–1699, r. from 1670) in 1682.[9] Within the kingdom, early editions of *The Elements* hung in the New Château of Saint-Germain-en-Laye in the apartment of the king's brother, Philippe I, duc d'Orléans (called Monsieur, 1640–1701), when the court was in residence. Le Brun's compositions for *The Seasons entrefenêtres* became, with minor adjustments, models for another tapestry series, the so-called *Child Gardeners*, which likewise featured among the diplomatic gifts presented by the king as early as 1685.[10]

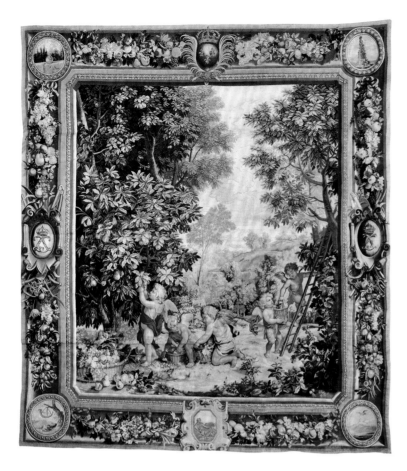

FIG. 58

Paris, Gobelins manufactory, in the high-warp workshop of Jean Jans the Younger (Flemish, ca. 1644–1723, act. France before 1668), after the design by Charles Le Brun (French, 1619–1690). *Autumn*, from a set of four *entrefenêtre* tapestries of *The Seasons*, before 1683. Tapestry: wool, silk, and gilt metal–wrapped thread, 480 × 427 cm (189 × 168⅛ in.). Paris, Mobilier National, GMTT 117/2

9 | a

Autumn from *The Seasons*

Design by Charles Le Brun (French, 1619–1690), with the collaboration
of Adam Frans van der Meulen (Flemish, 1632–1690, act. Paris from 1664)
on the hunt scene in the medallion, 1664
Border design by Issac Moillon (French, 1614–1673), 1664
Cartoon attributed to Beaudrin Yvart (French, 1611–1690), by 1667
Paris, Royal Furniture Manufactory of the Crown at the Gobelins, in the high-warp
workshop of Jean Jans the Elder (Flemish, ca. 1618–1691, act. France
and foreman of the first high-warp workshop from 1662), before 1669
Tapestry: wool, silk, and gilt metal–wrapped thread
480 × 580 cm (189 × 228⅜ in.)
Paris, Mobilier National, inv. GMTT 107/2

DESCRIPTION

Autumn is visualized by a landscape that shows a wooden cask and
a woven basket, which spill fruits of the season (figs, pomegranates,
pears, apples, grapes, melons, and squash), flanked by lush, leafy, and
fruit-bearing trees and vines (plate 9a). In the middle ground, boats
ply the river Seine, and in the background, across the riverbank,
there is a partial view of the terraced garden and a wing of the New
Château of Saint-Germain-en-Laye, the birthplace of Louis XIV. Two
ancient Roman deities sit on a cloud in the center of the composition.
Vine-crowned Bacchus, the god of wine, wears a leopard skin and
perches among golden vessels. Diana, goddess of the hunt, with
a crescent moon in her hair, sits above implements for the hunt and
nets for fishing. They both point to the equestrian figure of Louis XIV
in the miniature stag-hunt scene, encircled by a floral wreath held
between them.

The sumptuous border of the tapestry is wide, filled with color-
ful garlands of seasonal flowers in full bloom, ripe fruit, and plump
vegetables. The center of the top border contains a blue globe with
three golden fleurs-de-lis (the arms of France), topped by the royal
crown. The globe is encircled by the collars of the chivalric orders of
Saint Michael and the Holy Spirit, entwined with crossed palm fronds.
The globe is flanked by a crouching lion at left and a leopard at right.
A central cartouche within the lower border contains a long Latin
verse incorporating the rhetorical motto QVIS MELIORA DABIT? (Who
gives better?). Twin cartouches, backed by gardening tools and
containing the crowned monogram of interlaced Ls, for Louis XIV,
mark the midpoint of each lateral border. Each corner bears a circu-
lar reserve portraying a pictorial emblem and an accompanying
Latin phrase celebrating the king's virtues.

COMMENTARY

The lavish imagery of *Autumn* richly conveys an overflowing sense of
abundance, plenty, and prosperity, with the king at the center of all
of it, literally and figuratively. The château depicted was his birthplace
and his preferred country residence until the court's official move to
Versailles in May 1682. Louis XIV particularly enjoyed the extensive
hunting grounds of Saint-Germain-en-Laye, for hunting was a pastime
he pursued with relish and skill. But the Latin verse with the motto
"Who gives better?" layered additional meaning onto the scene, for
although the gods bestowed their bounty on the king, he generously
shared what he received with the people he protected. The fullness of
the border festoons further visualized the rich harvest.

According to Félibien, the king made the seasons more beautiful
and fertile, and thus *Autumn* was an allegory full of truth because
while the gods gave what was delicious, the king expanded upon this
liberality by rewarding people of extraordinary merit. Moreover, he
nourished in others a love of virtue.[11] Among the king's many virtues
were those "for which shrines were erected in antiquity," as revealed
in the border medallions of *Autumn* (clockwise from the upper left):
(1) like the fruit within a pomegranate, the inner qualities of the king,
far above those of other men, exceeded the external brilliant appear-
ance of rank and crown; (2) like the most swift and energetic falcon,
the king executed all his intentions with diligence and incredible
vigor; (3) like the creeping vine on a great pyramid, there was no limit
to the king's vast magnanimity and power; (4) like a hunting horn that
assembled, guided, and encouraged the pack, the king's sentiment
for his kingdom gave purpose and direction, especially to the army.[12]

The present hanging, *Autumn*, formed part of the only set
of *The Seasons* to have been woven at the Gobelins in the high-warp
loom workshops.[13] Very likely, this version of *Autumn* was among
the sets displayed at Versailles for the Feast of Corpus Christi on
June 17, 1677.[14]

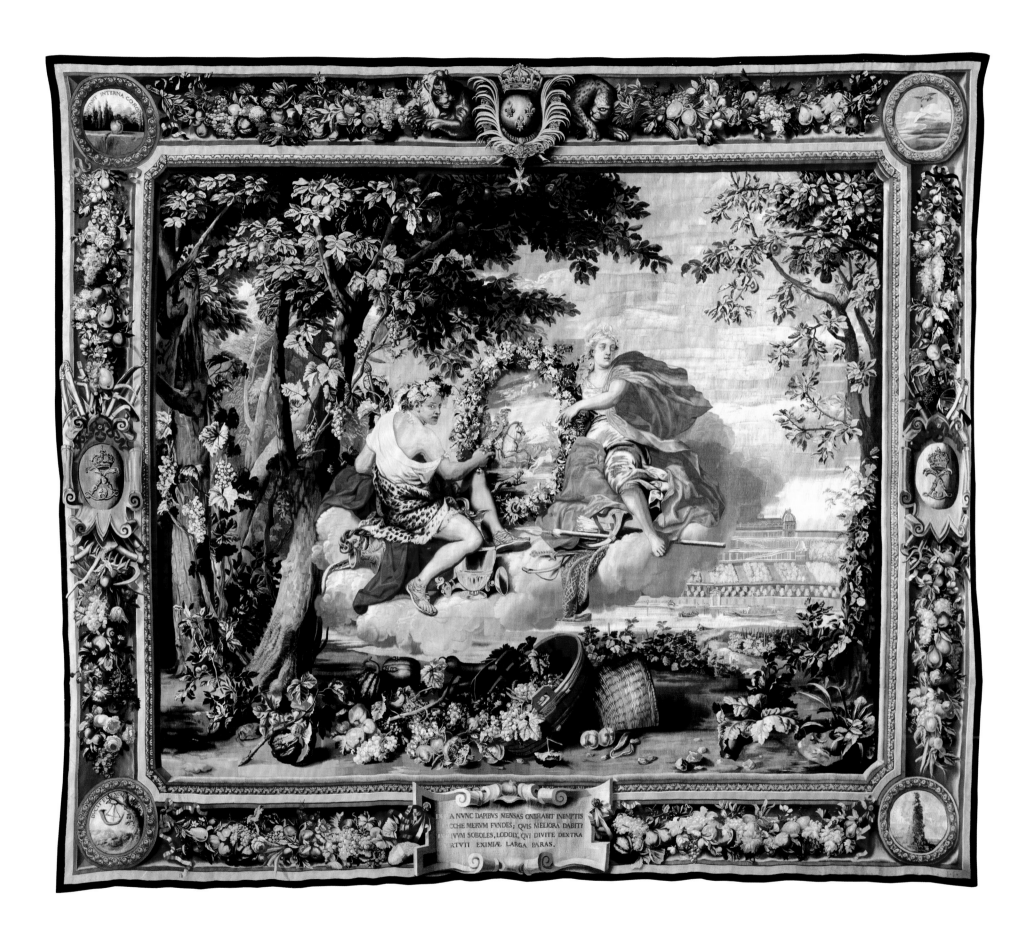

IO

The Story of Alexander

The greatest invention of the painter Charles Le Brun (1619–1690), and the one that gave him the most prolonged challenge during the years from 1661 to 1673, was *The Story of Alexander*. The series celebrated Le Brun's patron, the youthful and ambitious Louis XIV, by playing on the traditional trope of likening the king to an admired ancient role model. In this case, Le Brun masterfully elevated the trope's program to the plane of noble heroic virtue. The series was inspired by the life story of Alexander III, king of Macedonia (356–323 BC, r. from 336 BC). Known historically as Alexander the Great, he conquered a vast empire that stretched from Egypt into India (as far as modern-day Pakistan) in just twelve years. His short life and long legacy were distinguished by several remarkable aspects: his tutelage under the philosopher Aristotle (384–322 BC), his confident rule begun at the early age of twenty, his genius at military strategy and heroism on the battlefield, and his virtues of clemency and compassion.

Le Brun's version of the legendary figure was shaped by the courtly gallantry attributed to Alexander traditionally through folk epic, romance literature, and, more recently, seventeenth-century French tragedy, opera, and ballet. In this version, the ideal prince was characterized as decisive and courageous yet civil and pitying.[1] Le Brun's application of the Alexander analogy to Louis XIV was not the first instance; it had been applied already to the infant Louis in 1639. The artist's great project, however, likened his own role and status to that of Apelles, the renowned court painter to Alexander's father, Philip II, king of Macedonia (assassinated 336 BC).[2] The critical success of the Alexander paintings and the superlative tapestries woven after them in precious metal–wrapped threads at the Royal Tapestry Manufactory (from 1667 called the Royal Furniture Manufactory of the Crown) at the Gobelins were virtuoso embodiments of Baroque classicism's grand manner in subject, scale, and materiality.

Genesis and Production

The monumental treatment of *The Story of Alexander* exemplified the highest expression of Le Brun's particular grand manner style, which he developed during the course of about twelve years.[3] More than just another—albeit massive—rendering of a well-known heroic subject, Le Brun imbued each scene of the narrative with a moralizing lesson, in the tradition of *exemplum virtutis*, in which virtuous action was exemplified for the viewer and, in this case, for the patron, Louis XIV. The initial painting by Le Brun was not conceived as a model for tapestry. Instead, the commission began under exceptional circumstances: urged by the minister and art connoisseur Cardinal Jules Mazarin (1602–1661, first minister of France from 1642), Louis XIV invited the artist in 1661 to the Château of Fontainebleau to execute a painting in his presence. There is some debate as to which one, the patron or the painter, chose the subject, the Queens of Persia at the Feet of Alexander, but whatever the case, its portrayal of the ideal prince as clement conqueror provided ample opportunity to cite not only ancient literary sources but also revered Renaissance artistic precedents (fig. 59).[4]

The Queens of Persia at the Feet of Alexander was well received, and it launched the career of Le Brun as first painter to the king (an appointment announced in 1662 and confirmed by the brevet of 1664). The scope of the project then evolved from a single picture into a complex, multifaceted cycle that bolstered an effort to break the competing association of the heroic Alexander imagery with another contemporary figure, Louis de Bourbon, known for his military prowess and called the Grand

Condé (1621–1686), who was a relative of the king.[5] The initial painting was followed, over the next dozen years, by four more colossal canvases, which, altogether, served as models for a tapestry series.[6] Contemporaries reported that Le Brun himself painted the subsequent compositions — *The Battle of Granicus*, *The Battle of Arbela*, *The Entry of Alexander into Babylon*, and *The Wounded Porus before Alexander* [at the Battle of the Hydaspes River]—after having produced some 280 preparatory drawings and preliminary sketches (plates 10b, 10c, 10f, 10g) while in residence at the Gobelins, where he served as artistic director.[7] Art historians, however, see the hands of his assistants in the four enormous canvases; *The Battle of Arbela*, for instance, measures 12.65 meters (or 41½ feet) wide (fig. 60).

The entire series represented all the characteristics of the grand manner: a significant historical narrative, heroic action, and elevated meaning. While Le Brun quoted elements from renowned artistic precedents, specifically the fresco called *The Battle against Maxentius at the Milvian Bridge* by Giulio Romano (ca. 1499–1546) and Giovanni Francesco Penni (ca. 1496–ca. 1528) in the Hall of Constantine at the Vatican, he invented novel arrangements that ordered the chaos of multiple vanishing points and hundreds of figures through the effects of carefully controlled light, shadow, and color.[8] Finally, in 1673, the four additional pictures were exhibited in the Salon of the Royal Academy of Painting and Sculpture, and they were later hung in the Cabinet du Roi at the Louvre Palace.[9] These paintings were a frequent topic of instruction and discussion at the Royal Academy, where Le Brun had been appointed chancellor for life in 1663.

To a certain extent, the compositions also paid homage to the prized Renaissance set of *The Story of Scipio* tapestries. These had been woven after the designs of Romano and Penni for King François I (1494–1547, r. from 1515) from 1532 to 1535, when his court was based at the Château of Fontainebleau. Those tapestries and another set of the same subject (see entry 4, this catalogue) still survived in the 1660s and were admired as much for their design as for their skillful execution. Le Brun modeled several of his figures upon precedents in the sophisticated Scipio narrative.[10] For example, the terrified foot soldier in *The Battle of Arbela* echoed a fleeing warrior in *The Fire in the Camp* from the earlier series. Furthermore, the pose and open-armed gesture of Alexander in *The Queens of Persia at the Feet of Alexander* was directly inspired by that of Scipio in the hanging *The Reception of the Envoys from Carthage* (see plate 4a).[11] According to the art theoretician André Félibien (1619–1695), Le Brun's figure of Alexander, as revealed in the preliminary drawing (plate 10b), in the painting (see fig. 59), and in the tapestry (see fig. 53), embodied clemency, with one hand extending toward the women; friendship, with his other hand moving toward Hephaestion;

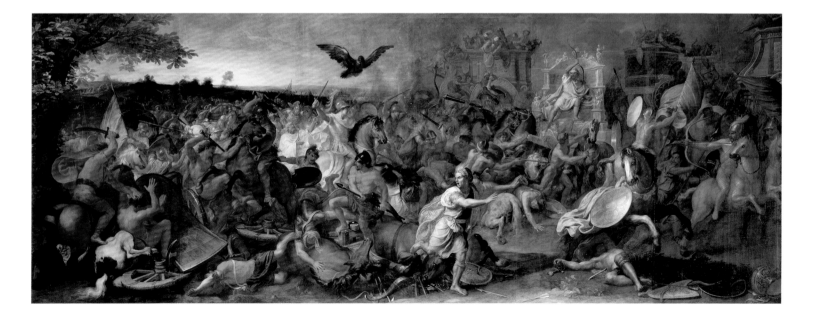

compassion, with his tranquil countenance; and civility, with his stately contrapposto stance. Furthermore, a full range of emotions—or passions, as Claude Nivelon (1648–1720) called them in his biography of Le Brun—was expressed through the other figures, such as the Egyptian attendant at the far right, who, with open mouth and wide eyes, raises her hands as she endeavors to comprehend the event, even if she cannot understand the words spoken in Greek (plate 10c).[12]

As work on the canvases progressed, specialized painters under the direction of Le Brun at the Gobelins prepared cartoons for the weavers' use in both the high-warp, vertical-loom and low-warp, horizontal-loom workshops (plate 10h).[13] For practical reasons dictated by the tapestry medium, the original canvases showing the vast battle scenes were reconceived as cartoons of three sections each, such that, for instance, the tripartite woven version of *The Battle of Arbela* consisted of one wide central tapestry and two narrower flanking tapestries.[14] Thus the portion of the battle considered here (plate 10d) corresponds to only the far-right side of Le Brun's composition (see fig. 60). A complete set of the *Story of Alexander* tapestries therefore comprised eleven pieces: *The Queens of Persia at the Feet of Alexander*, *The Battle of Granicus* (in three hangings), *The Battle of Arbela* (in three hangings), *The Entry of Alexander into Babylon*, and *The Wounded Porus before Alexander* [at the Battle of the Hydaspes River] (in three hangings). Three sets, however, contained an extra, twelfth piece: a narrow *entrefenêtre* designed for the small wall between window bays. That hanging replicated the vertical arrangement of ornamental elements in the lateral borders of the other tapestries en suite. In total, eight sets of the *Story of Alexander* tapestries were produced with precious metal–wrapped thread from about 1663 to 1689. The number of hangings, the design of the borders, and the dimensions of each set varied, as was customary at the time.[15]

Entry and Reception in the French Royal Collection

The *Story of Alexander* tapestries produced at the Gobelins after the designs of Le Brun rivaled the greatest antique tapestry series depicting the esteemed heroes of ancient history, such as François I's Renaissance *Story of Scipio* set after Romano. The critical success of the *Alexander* paintings and the superlative tapestries woven after them in precious metal–wrapped thread also established the painter and the manufactory as the indisputable successors to the most distinguished artists of the history genre and the famed master weavers of Brussels.

Moreover, the Alexander paintings and tapestries appropriated the traits and fortunes of the Macedonian hero-conqueror for the contemporary ruler Louis XIV, who, as the tapestries first came off the looms, was embarking on his own military campaigns in the so-called Dutch War of 1672–78. Understandably, editions of the tapestry sets were deemed suitable to be given to members of the French royal family and to heads of state, including, for example, the king's brother Philippe I, duc d'Orléans (1640–1701), in 1681; the king's cousin Anne-Marie-Louise d'Orléans, duchesse de Montpensier (1627–1693), sometime after March 1685; ministers of Christian V, king of Denmark and Norway (1646–1699, r. from 1670), in 1682; and Leopold Joseph, duc de Lorraine (1679–1729), in 1699.[16]

From 1672 to 1678, Gérard Audran (1640–1703) and Gérard Edelinck (1640–1707) produced the scenes from *The Story of Alexander* in print form on a grand scale. Le Brun personally supervised the creation and execution of the etched and engraved series to his exacting standards and, in doing so, not only strictly controlled the diffusion of the designs to a much wider audience but also elevated the artistic quality of the printed medium.[17] Critical acclaim for these prints contributed to the enduring prestige of Le Brun's great Alexander cycle, and their circulation generated new editions of the tapestry series in the weaving workshops of Aubusson and Brussels.[18]

Story of Alexander weavings were equally prized by the craftsmen at the Hôtel of the Gobelins, where examples were displayed on special occasions to show off the manufactory's most glorious works to eminent guests and royal administrators. The draftsman and engraver Sébastien Le Clerc (1637–1714) captured one such notable event, when Édouard Colbert, marquis de Villacerf (1628–1699,

superintendent of the Office of Royal Buildings, Gardens, Arts and Manufactories from July 1691), visited the Gobelins (plate 10i). Workmen are portrayed hoisting the last of the five main tapestries, *The Queens of Persia at the Feet of Alexander*.[19] The other subjects are just discernible, with *The Entry of Alexander into Babylon* already hanging on the short wall opposite the viewer. The drawing reveals how the subjects were arranged in the manufactory's gallery, with the three violent battle scenes flanked by the two peaceful episodes. The drawing was executed in preparation for a suite of six small-scale etchings, printed beginning in 1694. The full set of six images grouped individual prints of the five main *Story of Alexander* episodes together with this interior view of the gallery at the Gobelins hung with tapestry-woven versions of the same scenes.

IO | a

The Queens of Persia at the Feet of Alexander from *The Story of Alexander*

Design by Charles Le Brun (French, 1619–1690), 1661
Cartoon for the high-warp loom by Henri Testelin (French, 1616–1695), by 1664
Paris, Royal Tapestry Manufactory / Royal Furniture Manufactory of the
Crown at the Gobelins, in the high-warp workshop of Jean Jans the Elder
(Flemish, ca. 1618–1691, act. France and foreman of the first high-warp
workshop from 1662), ca. 1664, probably by 1670
Tapestry: wool, silk, gilt metal– and silver-wrapped thread
486 × 691 cm (191⁵⁄₁₆ × 272¹⁄₁₆ in.)
Paris, Mobilier National, inv. GMTT 84

DESCRIPTION

The tapestry *The Queens of Persia at the Feet of Alexander* celebrates the commander's restraint in victory and his clemency for the vanquished. Following the Battle of Issus (333 BC), the captive female family members of the routed Persian king, Darius III (ca. 380–330 BC, r. from 336 BC), kneel before two Macedonian warriors who approach their tent (plate 10a). The awning before the tent is tied to a palm and a fir, trees that indicate the geographical setting in Anatolia. As recounted by Quintus Curtius Rufus, the first-century Roman biographer of Alexander, the Persian queen mother, Sisygambis, throws herself at the feet of the Greek king in apology after having mistakenly addressed her appeal to the taller of the two men, Alexander's counselor and friend Hephaestion.[20] The lenient hero, with a graceful open-armed gesture, gently and respectfully corrects her error while sparing his friend embarrassment. Darius's other family members and servants react to the tension and its dissipation through pose and expression. The moralizing Latin verse in the cartouche below the narrative field extols the virtue of Alexander's self-mastery in this situation: "It is for a king to vanquish himself."[21]

The narrower tapestry presents a portion of a much larger composition depicting the subsequent encounter, on October 1, 331 BC, between the Macedonian troops led by Alexander and the Persian forces of Darius in *The Battle of Arbela* (plate 10d).[22] The event took place on a plain near Mosul (in present-day Iraq). Despite the greater numbers and superior arms of the Persians, they were overcome at dawn by the determined attack and ultimately defeated. The scene shows the chaos and confusion of the fierce melee, as a mounted Persian archer and his horse, each protected by fish-scale armor, are blindsided by a Greek cavalry officer charging from the right. A wide-eyed, terrified foot soldier attempts to flee the onslaught by retreating through the broken ranks of warhorses and elephants carrying troop towers.

After the Battle of Arbela, with King Darius on the run, the Persian warrior Mazaeus surrendered the city of Babylon to Alexander without a fight. In *The Entry of Alexander into Babylon*, the citizenry welcome the victorious Macedonian king with music, and the streets are strewn with flowers and lined with silver vessels burning frankincense (plate 10e).[23] Crowned with laurel, draped in a cloth of gold, one hand holding a staff surmounted by the winged Victory and the other grasping the hilt of his sword, Alexander stands in a chariot drawn by a pair of bejeweled and caparisoned elephants. The parade rolls through the thoroughfare of the beautiful city, spared the destruction of war, toward the golden statue of the Assyrian queen, Semiramis, its ancient founder. The cartouche below the pictorial field of this tapestry is blank, but the Latin verse usually associated with the subject encouraged the tireless pursuit of goodness with the words, "Thus by virtue heroes rise," meaning that persistent virtuous endeavor makes the hero.[24]

IO e

The Entry of Alexander into Babylon
from *The Story of Alexander*

Design by Charles Le Brun (French, 1619–1690), by 1665
Cartoon for the high-warp loom by Henri Testelin (French, 1616–1695), ca. 1665
Paris, Royal Tapestry Manufactory / Royal Furniture Manufactory of the Crown at the
Gobelins, in the high-warp workshop of Jean Jans the Elder (Flemish, ca. 1618–1691,
act. France and foreman of the first high-warp workshop from 1662)
or Jean Jans the Younger (Flemish, ca. 1644–1723, act. France and foreman of the
first high-warp workshop from 1668) or Jean Lefebvre (French, act. until 1700,
foreman of the second high-warp workshop 1662–99), ca. 1665, probably by 1676
Tapestry: wool, silk, and gilt metal– and silver-wrapped thread
495 × 810 cm (194⅞ × 318⅞ in.)
Paris, Mobilier National, inv. GMTT 82/3

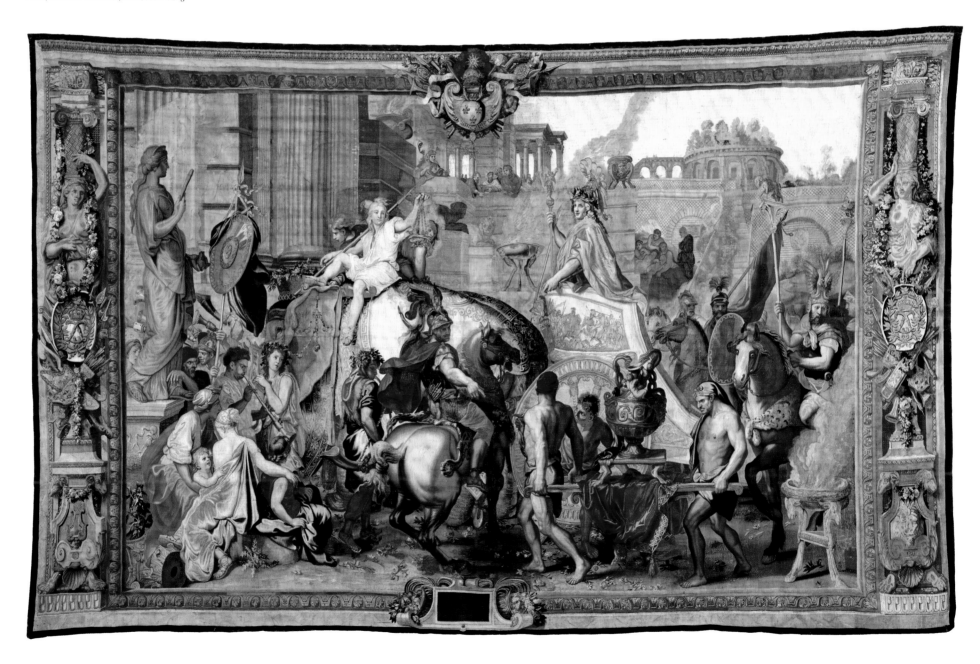

Youth, Seated, study for
The Entry of Alexander into Babylon

Charles Le Brun (French, 1619–1690), ca. 1664
Preparatory drawing: red chalk heightened with white chalk
on beige paper
35.6 × 41.9 cm (14 × 16½ in.)
Paris, Musée du Louvre, Département des Arts Graphiques,
inv. 29642

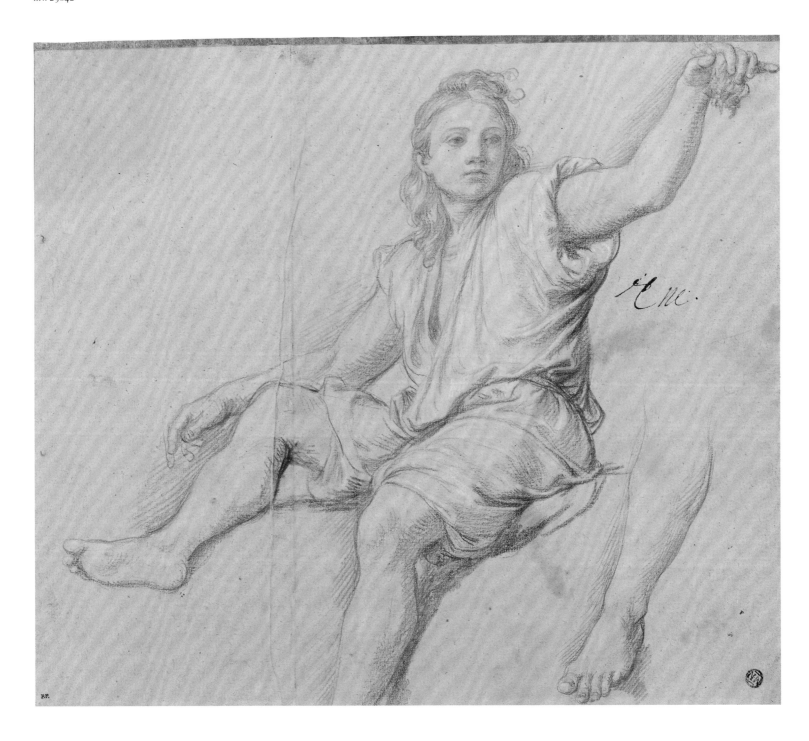

IO | g

Two Males, Nude, Standing,
study for *The Entry of Alexander into Babylon*

Charles Le Brun (French, 1619–1690), ca. 1664
Preparatory drawing: red chalk heightened with white chalk
on beige paper
55.5 × 40.1 cm (21⅞ × 15¹³⁄₁₆ in.)
Paris, Musée du Louvre, Département des Arts Graphiques,
inv. 29187

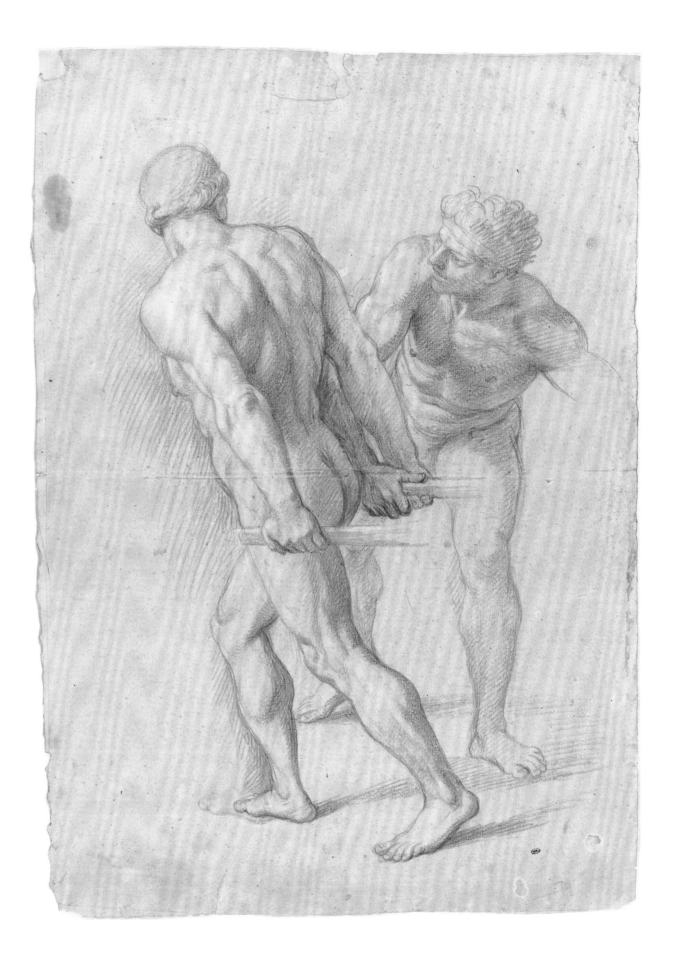

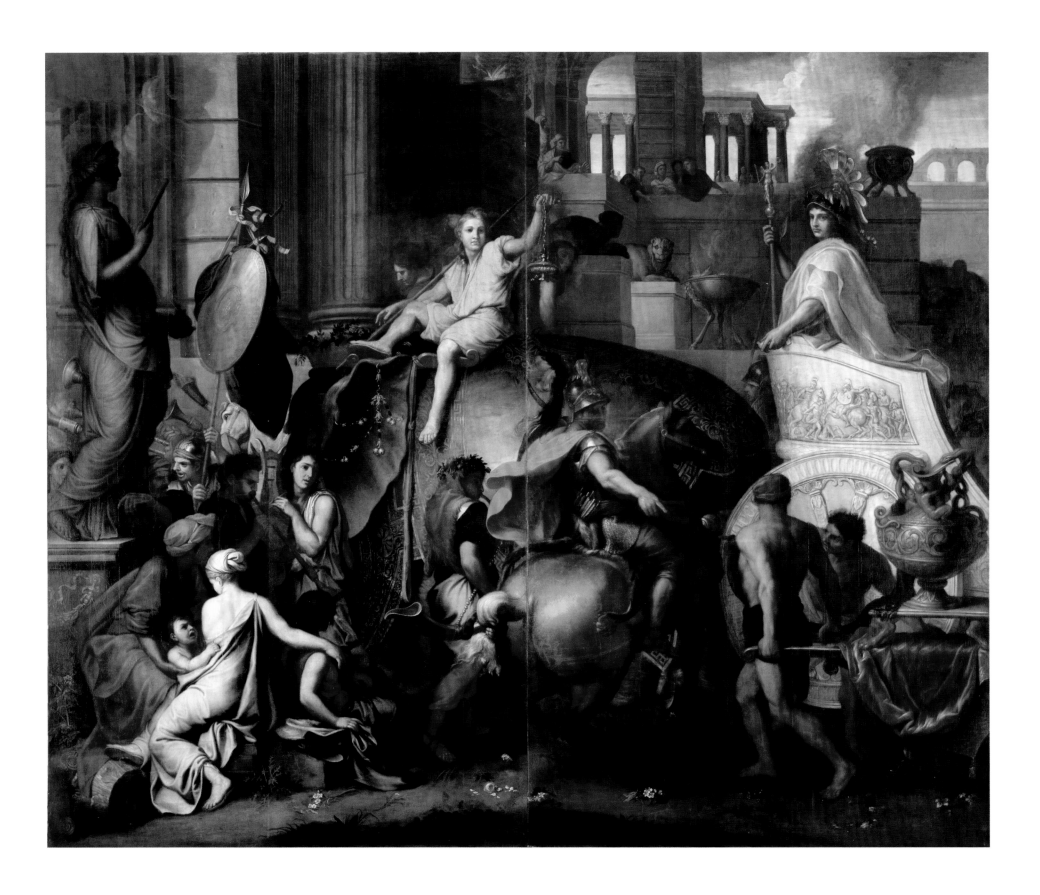

IO|h

The Entry of Alexander into Babylon

Design by Charles Le Brun (French, 1619–1690), by 1665
Cartoon for the horizontal-warp loom by François Bonnemer
(French, 1637–1689), Guy-Louis Vernansal (French, 1648–1729),
Gabriel Revel (French, 1643–1712), and/or Joseph Yvart
(French, 1649–1728), before 1690
Cartoon: oil on canvas
The four bands for this partial cartoon are now joined in pairs
and mounted on two stretchers, left: 317 × 192 cm
(124¹³⁄₁₆ × 75⁹⁄₁₆ in.) and right: 317 × 195 cm (124¹³⁄₁₆ × 76¾ in.)
Paris, Mobilier National, inv. Gob 704

IO|i

View of the Gallery in the Royal Hôtel at the Gobelins

Sébastien Le Clerc (French, 1637–1714), 1694
Preparatory drawing: pen and brown ink, gray wash,
and black and red chalk heightened with white on cream paper
11.9 × 23.3 cm (4⅝ × 9³⁄₁₆ in.)
Paris, Mobilier National, inv. GMTB 675

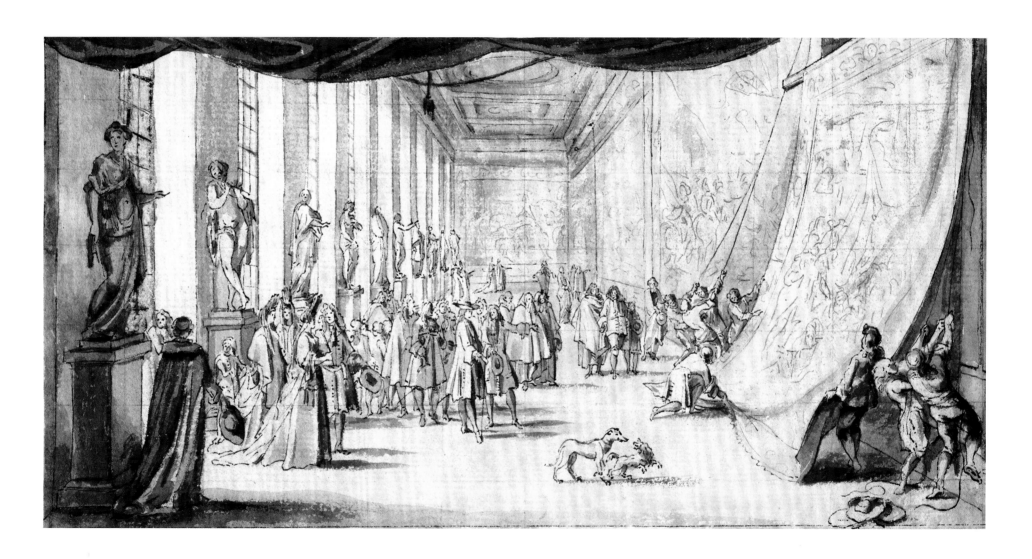

II

The Royal Residences / The Months of the Year

The series *The Royal Residences / The Months of the Year* was the invention of Charles Le Brun (1619–1690), and the date of its inception fits within the mid-1660s, when Le Brun was devising compelling iconographic programs to visualize and aggrandize the persona of his royal patron, Louis XIV. In this instance, Le Brun drew inspiration from the ancient, symbolically laden artistic tradition of calendrical cycles that portrayed the months of the year and their related occupations coupled with depictions of key castles and prized palaces associated with the king's dynastic seats of power.[1] In the medium of tapestry, there were several important and esteemed precedents, most notably the famed *Hunts of Maximilian*, after the designs of the Renaissance artist Bernard van Orley (ca. 1488–1541), which presented identifiable members of the Habsburg court hunting in the Sonian Forest within sight of recognizable buildings in the city of Brussels (see figs. 1, 14).[2] Formerly in the possession of the powerful de Guise family (and thus sometimes called the de Guise *Hunts*), this revered, antique twelve-piece set, woven with gold, entered the French royal collection about 1662 to 1665, when Louis XIV purchased several princely tapestry sets from the estate of his deceased minister, the consummate and voracious art connoisseur Cardinal Jules Mazarin (1602–1661, first minister of France from 1642).[3] At that time, the series was thought to have been designed by the great Nuremberg artist Albrecht Dürer (1471–1528). The influence of this acclaimed tapestry series at the French court cannot be overstated. Le Brun responded to its entry into the French royal collection by masterfully appropriating the theme and updating its formula with portraits, activities, and locations drawn from contemporary court life.

The creation of the designs for *The Royal Residences / The Months of the Year* and the production of the related tapestry sets at the Royal Furniture Manufactory of the Crown at the Gobelins coincided with, and complemented, an equally powerful cycle of biographical royal imagery, also devised by Le Brun for tapestry: *The Story of the King* (see figs. 22, 23, 33), which portrayed significant milestones of the reign of Louis XIV.[4] Together, the two tapestry series visualized the monarch, and the monarchy in general, in a grand, monumental, and costly medium.

Genesis and Production

The series *The Royal Residences / The Months of the Year* comprised twelve individual scenes, each representing a month of the calendar year, the corresponding sign of the zodiac and its symbol, a French royal residence, and a court activity typical of that time or place. Each scene showcased the wealth and reach of the monarch's power and influence, the rich patrimony of the Bourbon dynasty, the extraordinary quality and diversity of the royal exotic animal and art collections, and the king's own patronage, passions, and pursuits. For instance, the residences and their surrounding domains embodied Louis XIV's inheritance, his own ambitious building programs, and the military conquest that gained him the Château of Mariemont in Hainaut (present-day Belgium).[5] The scenes portrayed him as the ideal prince, gracefully, courteously, and competently fulfilling all the courtly duties and activities, including dance and horsemanship, demanded by his preeminent rank and the codes of civility.[6] Details presented in the shallow foregrounds revealed telling aspects of his personal interests and ostentatious taste. The wild and exotic animals and birds, for example, were drawn from live creatures brought from all over the globe to the royal menagerie at Versailles.[7] On the one hand, their presence in the tapestries demonstrated Louis XIV's fascination and support for natural science. The

Study of Purple Swamphens
(or *Study of Purple Rails*)

Pieter Boel (Flemish, 1622–1674, act. France from ca. 1668), ca. 1668
Black, white, and colored chalk, on light brown paper
28.8 × 43.5 cm (11⁵⁄₁₆ × 17⅛ in.)
Paris, Musée du Louvre, Département des Arts Graphiques, inv. 19389, recto

depictions of silver vessels, on the other hand, indicated not only the depth of the royal treasury but also, more significantly, the inventive designs, exceptional talent, and virtuoso skill of the silversmiths in the Crown's employ.[8] Above and beyond the aesthetic merits of the compositions, *The Royal Residences / The Months of the Year* presented awe-inspiring (but nonetheless fairly accurate) views of the splendid royal properties and possessions.

Period testimonials credit Le Brun, first painter to the king and artistic director of the Gobelins, with the invention of the overall compositional structure of *The Royal Residences / The Months of the Year*, yet the actual design of the component parts and the painted cartoons for both the high- and low-warp workshops were undertaken by teams of specialized artists employed by the Crown at the Gobelins.[9] The entire process, from design to finished tapestries, was collaborative. Some artists worked across the whole series while others focused on very specific aspects. Many preliminary sketches were made on site from live models. These were then worked into more finished studies that were lent to, or deposited at, the Gobelins for use as references by the painters preparing the cartoons. For instance, for *Château of Monceaux / Month of December*, Adam Frans van der Meulen (1632–1690) rendered the recognizable vista of the château (which was demolished at the end of the eighteenth century) as well as a royal boar hunt (transplanted from another locale as the king never actually visited the Château of Monceaux).[10] And the animal painter Pieter Boel (1622–1674) contributed all the portraits of birds, from the grand ostriches and elegant flamingos to the swamphens (plate 11a).[11]

In 1838, King of the French Louis-Philippe (1773–1850, r. 1830–48) retrieved some of the surviving sections of the cartoons from the Gobelins; he then had them restored and framed for a display in the Hall of Royal Residences, in the old museum of the Château of Versailles. These twelve are still preserved, though not all are presently displayed, at Versailles.[12] The cartoon for *Château of Monceaux / Month of December* from this group was prepared for the low-warp loom; note its shorter height and how the architectural elements have been treated so that, in the woven versions, the elevations would present the actual orientation of the buildings (fig. 62).

FIG. 62

Joseph Yvart (French, 1649–1728),
Abraham Genoels (Flemish, ca. 1640–1723,
act. Paris 1659–72), François Bonnemer
(French, 1637–1689), Jean-Baptiste Martin
(French, 1659–1735, called Martin des
Batailles), and others after the concept of
Charles Le Brun (French, 1619–1690).
Château of Monceaux / Month of December,
from *The Royal Residences / The Months
of the Year*, ca. 1668. Cartoon (for the
low-warp loom): oil on canvas, approx.
325 × 518 cm (127¹⁵⁄₁₆ × 203¹⁵⁄₁₆ in.).
Versailles, Musée National des Châteaux
de Versailles et de Trianon, MV 4691

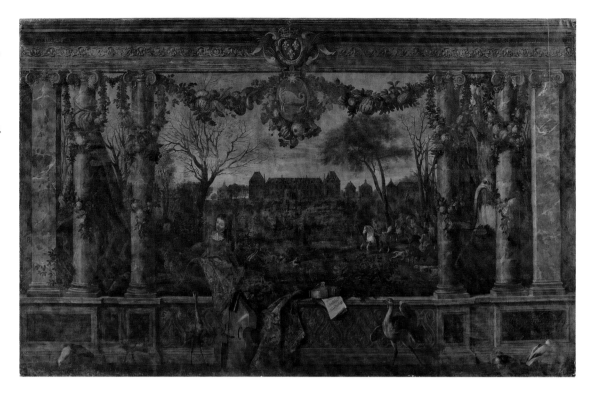

In total, seven complete sets of *The Royal Residences / The Months of the Year* were woven between 1668 and 1713: two sets on high-warp vertical looms and five on low-warp horizontal looms. An eighth set was begun but not finished. Of the narrower *entrefenêtre* designs en suite (those complementary tapestries destined to hang in the relatively slender wall spaces between windows), five sets of eight pieces each were produced.[13] Officially, 124 tapestries were woven, all with gilt metal–wrapped thread.

Entry and Reception in the French Royal Collection

The earliest deliveries of tapestries from *The Royal Residences / The Months of the Year*, including the larger version of the *Château of Monceaux / Month of December* considered here, arrived at the Château of Versailles in time for the celebration of the Feast of Corpus Christi on June 17, 1677. They were displayed in the courtyards, along with the famous *Hunts of Maximilian* hangings— then called the "*Months of the Year* formerly belonging to Monsieur de Guise"— and many other antique and modern sets.[14] Among the latter were several after the designs of Le Brun, including *The Story of the King, The Seasons* (see entry 9, this catalogue), and *The Story of Alexander* (see entry 10, this catalogue). Period records suggest the editio princeps of *The Royal Residences / The Months of the Year* then decorated the Grand Apartments at Versailles.[15] Later in the reign of Louis XIV, some tapestries from the set adorned the walls of a bedchamber in the royal pavilion at the Château of Marly.[16]

Hangings from *The Royal Residences / The Months of the Year* were superbly fitting as diplomatic gifts, and on several occasions they were given to formally acknowledge an alliance: for example, on September 16, 1682, together with a set of *The Seasons* and some *Story of Alexander* tapestries, to ministers of Christian V, king of Denmark and Norway (1646–1699, r. from 1670); in December 1682, to an English recipient, possibly Louise de Kérouaille, duchess of Portsmouth (1646–1734); and on October 27, 1683, to the Kurfürstin von Brandenburg, possibly Dorothea Sophia (1636–1689).[17]

II b

Château of Monceaux / Month of December
from *The Royal Residences / The Months of the Year*

Design conceived by Charles Le Brun (French, 1619–1690), ca. 1665–by 1668
Cartoon for the high-warp loom painted collaboratively by Beaudrin Yvart
(French, 1611–1690), Jean-Baptiste Monnoyer (Flemish, 1636–1699, act. France
ca. 1650/55–90/92), Pieter Boel (Flemish, 1622–1674, act. France from ca. 1668),
Guillaume Anguier (French, 1628–1708), Adam Frans van der Meulen (Flemish,
1632–1690, act. Paris from 1664), Abraham Genoels (Flemish, ca. 1640–1723,
act. Paris 1659–72), Adriaen-Frans Boudewyns (called Baudoin; Flemish, 1644–1711),
and Garnier (possibly Jean; French, 1632–1705), by 1668
Paris, Royal Furniture Manufactory of the Crown at the Gobelins, in the high-warp
workshop of Jean Jans the Younger (Flemish, ca. 1644–1723, act. France and foreman of
the first high-warp workshop from 1668) or in the high-warp workshop of Jean Lefebvre
(French, act. until 1700, foreman of the second high-warp workshop 1662–99),
ca. 1668–76
Tapestry: wool, silk, and gilt metal–wrapped thread
400 × 660 cm (157½ × 259¹³⁄₁₆ in.)
Paris, Mobilier National, inv. GMTT 108/12

DESCRIPTION

The pictorial field of the larger of the two tapestries considered here presents a landscape as viewed through an ornamental portico. Functioning like a proscenium, the portico has a low parapet, which is adorned with scrolls and French royal emblems in low relief. It is enclosed by pairs of male and female polychrome term figures, each flanked by an Ionic pilaster of veined red marble. Above, a polychrome marble entablature, with a frieze of scallop shells and fleurs-de-lis, stretches across. It is centered by a winged, blue oval cabochon bearing the arms of France encircled by the collars of the chivalric Orders of Saint Michael and the Holy Spirit and surmounted by the royal crown (plate 11b).[18] Hanging from the armorial shield is another oval, seemingly cast of bronze, bearing the zodiacal sign of Capricorn in relief. Leafy garlands, entwined with winter fruit, gourds, and squash drape from this medallion over to and around the terms. Two large, mature ostriches strut in front of and behind the parapet with other birds, including a silver gull, a purple swamphen (or rail), a bittern, a great bustard, a flamingo, a teal, and a shelduck.[19] An enormous Persian carpet cascades from the red ribbon that ties it to the neck of the term on the far left. Two valets lift a portion of the carpet and drape it over the front of the parapet so that it spills into the shallow foreground. A bass viol leans upright against the carpeted parapet while, to the right, a smaller treble viol and bow weigh down sheets of music on the parapet. Barren trees and shrubs and an overcast sky remind the viewer that it is winter. In the middle ground, the king on horseback leads mounted huntsmen and a pack of hounds in pursuit of boars. The south facade of the Château of Monceaux, with its detached pavilions and gatehouse, is visible in the far distance. The lateral borders of this tapestry each contain a vertical arrangement of scrolls and grotesque elements, culminating at top with a stag sitting on its haunches, its head turned toward the royal coat of arms. A blue oval cartouche, with the crossed Ls of Louis XIV beneath the royal crown, marks each border's midpoint. The entire tapestry is framed by a narrow band of egg-and-dart molding.

The smaller tapestry presents the same subject, but its format differs in several significant ways (plate 11c). First, it was deliberately woven to a shorter height and a narrower width. The weaving is intact and has not been cut down. The truncated pictorial field shows only the central part of the larger composition, and it is confined by Ionic columns to the left and right. The zodiacal medallion is topped by an unadorned winged blue cabochon. Of the birds, only the great bustard, bittern, and purple swamphen appear. Second, the entire composition is oriented in reverse of the larger version's scheme, with the exception of the architectural elevation of the château and its outer structures. The rendering of these buildings reflects their actual facades. Third, the tapestry has a border design that continues around the entire perimeter. It consists of a double band of golden acanthus leaves wrapped around a floral garland, each corner set with an agrafe. Blue ribbons secure a stylized cut-leather cartouche bearing the inscription CHASTE[AU] DE MONCEAVX in the middle of the lower border.

COMMENTARY

These two examples of *Château of Monceaux / Month of December* represent the range of production at the Royal Furniture Manufactory of the Crown at the Gobelins during the reign of Louis XIV. The larger hanging comes from the editio princeps of *The Royal Residences / The Months of the Year* begun on the high-warp looms in 1668. By 1676, four pieces were finished, including this *Château of Monceaux / Month of December*.[20] These were delivered to the Crown's Furniture Warehouse in time for display at the celebration of the Feast of Corpus Christi at Versailles in June 1677.[21] Other pieces followed in due course, and by August 19, 1683, the Furniture Warehouse was in receipt of a full set of twelve hangings as well as additional *entre-fenêtres* en suite. Since this version of the *Château of Monceaux / Month of December* followed the freshly painted cartoon for the high-

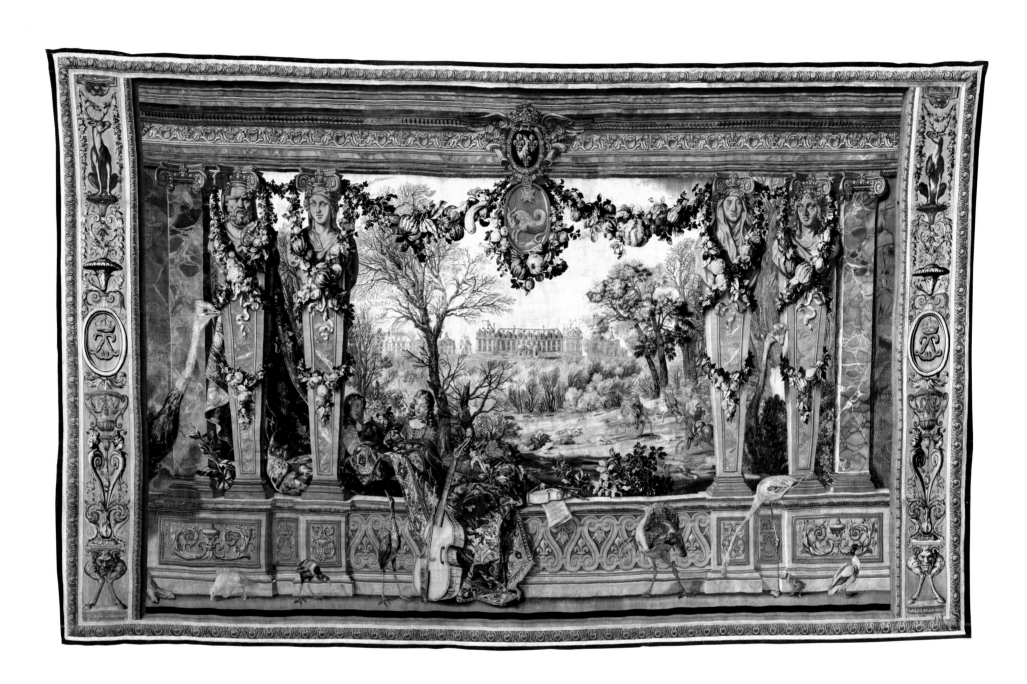

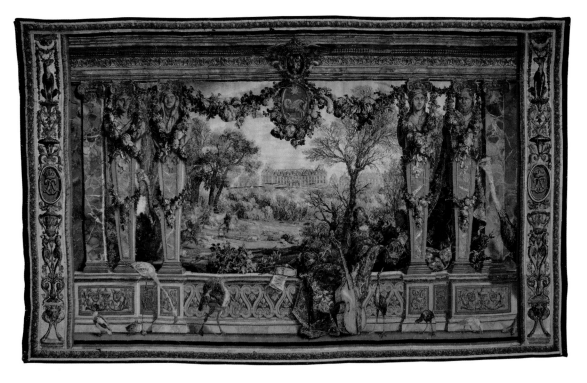

Château of Monceaux / Month of December
from *The Royal Residences / The Months of the Year*

Design conceived by Charles Le Brun (French, 1619–1690), ca. 1665–by 1668
Cartoon for the low-warp loom painted collaboratively by Joseph Yvart (French, 1649–1728), Abraham Genoels (Flemish, ca. 1640–1723, act. Paris 1659–72), Adriaen-Frans Boudewyns (called Baudoin; Flemish, 1644–1711), François Bonnemer (French, 1637–1689), Jean-Baptiste Martin (called Martin des Batailles or Martin des Gobelins; French, 1659–1735), Le Mire (dates unknown), Manory (dates unknown), François Arvier (dates unknown), and Arnis (dates unknown), ca. 1668
Paris, Royal Furniture Manufactory of the Crown at the Gobelins, in the low-warp workshop of Jean de La Croix (French, d. 1714, foreman of the first low-warp workshop 1662–1712), before 1712
Tapestry: wool and silk
317.5 × 330.8 cm (125 × 130¼ in.)
Los Angeles, J. Paul Getty Museum, 85.DD.309

FIG. 63

Paris, Gobelins manufactory, in the high-warp workshop of Jean Jans the Younger (Flemish, ca. 1644–1723, act. France before 1668) or possibly in the high-warp workshop of Jean Lefebvre (French, act. until 1700), after the cartoon by Beaudrin Yvart (French, 1611–1690), Jean-Baptiste Monnoyer (Flemish, 1636–1699, act. France ca. 1650/55–90/92), Pieter Boel (Flemish, 1622–1674, act. France from ca. 1668), Adam Frans van der Meulen (Flemish, 1632–1690, act. Paris from 1664), and others after the concept of Charles Le Brun (French, 1619–1690). *Château of Monceaux / Month of December* (verso, during conservation), from *The Royal Residences / The Months of the Year*, ca. 1668–76. Tapestry: wool, silk, and gilt metal–wrapped thread, 400 × 660 cm (157½ × 259¹³⁄₁₆ in.). Paris, Mobilier National, GMTT 108/12

warp workshops that had not yet been worn from repeated use, it can be appreciated now as a faithful rendering, down to the smallest detail, of the original design. The configuration of the high-warp vertical loom and the corresponding technical skill the apparatus required were deemed superior and more prestigious at the time because, unlike the low-warp horizontal-loom weavers, high-warp weavers could readily check the face and the reverse sides of the weaving and consequently correct any deficiencies immediately and more easily (fig. 63).

Conversely, the shorter height and reversed composition of the smaller tapestry represents the productivity of the low-warp horizontal-loom workshops. Weavings of *The Royal Residences / The Months of the Year* from these looms were uniformly shorter, by some thirty-two to thirty-five inches.[22] Moreover, because the low-warp tapestry technique created a woven image in reverse of the original design, the cartoons for the low-warp workshops were prepared with this factor in mind. In the case of the present series, some compositional features were allowed to be executed in mirror orientation (consider, for example, the zodiacal sign of Capricorn) as this effect did not diminish the overall concept, but certain important elements, such as the architectural elevation of the Château of Monceaux (not to mention the inscription in the cartouche), were conscientiously configured in the cartoon so that the woven portrayal accurately corresponded to the physical reality.

The smaller version of *Château of Monceaux / Month of December* represented yet another facet of production at the Gobelins, that of unofficial work undertaken for private commissions.[23] Such activity did take place, especially during the closure of the Gobelins, from April 1694 to January 1699, when weaving on royal orders ceased in an effort to help mitigate the cruel costs of the prolonged

war against the League of Augsburg (1688–97). But this private work is difficult to track as it was not listed in the formal records.[24] It is not possible to determine if the present example originated from a private command or from a speculative venture. One's first thought is to assume that only a patron closely affiliated with the French court would have desired hangings from the series and would have had both the means and the connections to place the order. And yet, the armorial shield in this hanging, and in related pieces that have come to light, is blank.[25] None of these hangings contain costly gilt metal–wrapped thread, and, moreover, they all bear inscriptions that identify the residence or location (a detail omitted from the royal weaves as unnecessary).

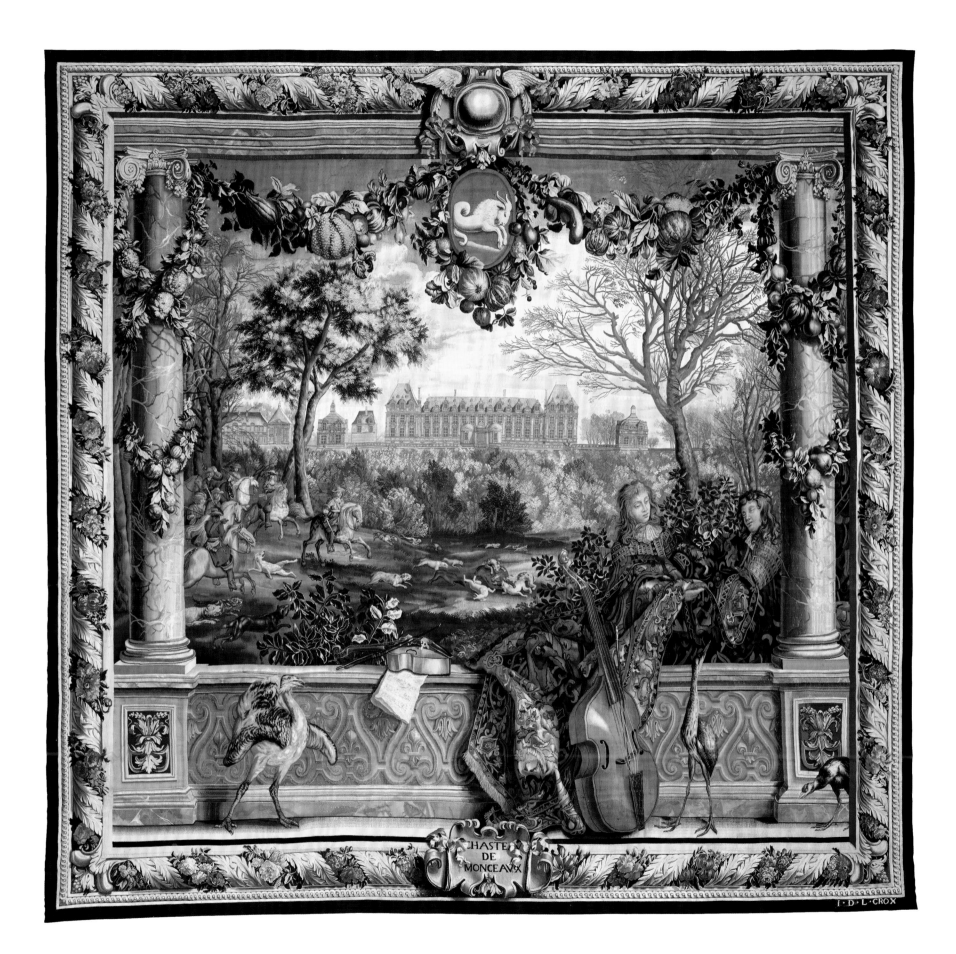

CHASTE
DE
MONCEAVX

I·D·L·CROX

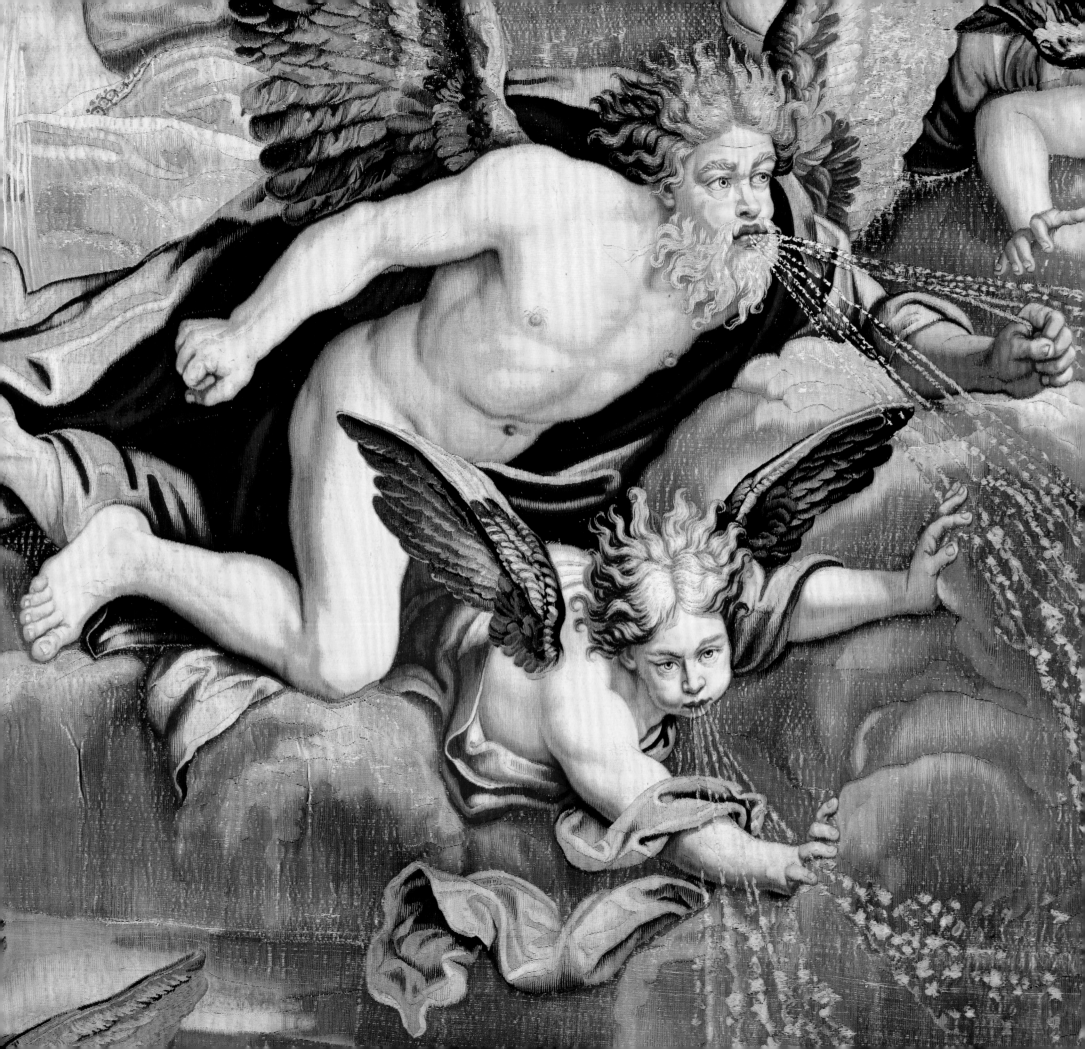

12

The Gallery of Apollo at the Château of Saint-Cloud

The seventeenth-century French art theoretician André Félibien (1619–1695) valued the medium of tapestry as "the most assured way to preserve long-term, and even disseminate paintings by the most talented men."[1] This maxim was not new, and a most compelling demonstration of the principle had already been carried out for François I, king of France (1494–1547, r. from 1515) in the woven replica of *The Last Supper*, the 1494–98 fresco by Leonardo da Vinci (1452–1519) in the convent of Santa Maria delle Grazie in Milan. The tapestry, produced in Brussels about 1514, effectively brought an immobile masterpiece from Milan to Fontainebleau, albeit for only a short term as François I presented the hanging to Pope Clement VII (1487–1534, r. from 1523) in 1533.[2] The weaving captured not only the original's design but also its scale and color.

The general premise of making and disseminating woven versions of the most perfect paintings persisted at the Royal Furniture Manufactory of the Crown at the Gobelins, especially from 1683 to about 1694, when the manufactory operated under the leadership of François-Michel Le Tellier, marquis de Louvois (1641–1691, superintendent of the Office of Royal Buildings, Gardens, Arts and Manufactories from 1683). And while such efforts did result in bringing from Italy to Versailles tapestry reproductions of renowned works, most notably the celebrated *Chambers of the Vatican* after the Stanze of Raphael (1483–1520) and his circle, the concept also worked in a parallel but opposite direction. Select works by French masters were also replicated in—and sometimes enlarged for—the woven medium. This guiding intention generated tapestry editions of paintings not originally conceived for the medium, such as *The Story of Moses* after pictures by Nicolas Poussin (1594–1665) (see fig. 25) and scenes by Pierre Mignard (1612–1695) from the painted ceiling at the Château of Saint-Cloud.[3] This latter instance was exceptional at the time because the artist Mignard was still living when weaving commenced. Under the aegis of Louis XIV, these tapestries were displayed in royal residences, courtyards, and public streets on special occasions and consequently reached a wide audience.

Genesis and Production

The tapestries representing the seasons after the designs of Pierre Mignard fall squarely within the artistic tradition of portraying the natural cycles of the year through allegories drawn from the stories and figures of classical mythology. Originally, the compositions were conceived not for tapestry but for the interior decorative scheme of a new gallery, called the Gallery of Apollo, at the Château of Saint-Cloud. The château, situated on a bluff to the west of Paris, overlooking the river Seine, was the residence from 1658 to 1701 of "Monsieur," Philippe I, duc d'Orléans (1640–1701), the younger brother of Louis XIV. Mignard's artistic program was a major aspect of the significant renovation and enlargement undertaken at Saint-Cloud in the 1670s under the direction of Monsieur's architect, Antoine Le Pautre (1621–1679).[4] But it was the artist, rather than the architect, who was responsible—with the patron's approval—for the gallery's iconographic subject and the novel arrangement of its compositions.

The decoration of the gallery was dedicated to the ancient pagan god Apollo. The central and largest ceiling canvas of the depressed barrel vault depicted the rising sun god leaving his palace in a chariot at the break of day. Four smaller ceiling canvases portrayed the seasons; their flanking placement alluded to the sun's governing role. *Spring* was personified by Zephyr and Flora; *Summer*,

by Ceres; *Autumn*, by Bacchus and Ariadne; and *Winter*, by Boreas and, rather unusually, Cybele. These five main pictures, as well as four smaller, rectangular canvases and eight roundels with related subjects were contained within elaborately sculpted stucco frames. The upper lunettes of the narrow west and east gallery walls portrayed, respectively, two more episodes from Apollonian mythology: *Latona and the Peasants of Lycia* and *Parnassus*.[5] Louis XIV made two visits to see the renovations at his brother's country residence, and the public debut of the long gallery at Saint-Cloud in October 1678 seems to have influenced the creation and decoration of the Hall of Mirrors at the Château of Versailles. Louis's first visit was on October 10, 1678, and the second occurred in 1680, when Louis reportedly said, "I wish very much that the paintings of my gallery at Versailles achieve the beauty of these."[6]

The decoration of the Château of Saint-Cloud's Gallery of Apollo, together with the adjoining Salon of Mars and Cabinet of Diana, brought great critical acclaim to the sexagenarian Mignard. But Mignard's artistic program was almost immediately rewritten intellectually by Laurent Morellet, who published under the pen name "Sieur Combes" (b. 1636, chaplain to Monsieur after 1668). The title of his first text, dated 1682, *La galerie de Saint-Cloud et ses peintures expliquées sur le sujet de l'éducation des princes* (The gallery of Saint-Cloud and its paintings explained for the education of princes), was self-explanatory. Subsequent editions of 1686 and 1695, however, were titled *Traité de morale pour l'éducation des princes, tiré des peintures de la Galerie de S. Cloud* (Moral treatise for the education of princes drawn from the paintings of the gallery of S. Cloud).[7] In these later editions, Morellet retroactively interpreted the subject of each painting as a moralizing lesson addressed especially to Monsieur's future grandchildren, who, through marriage alliances, would be called to reign all over Europe. Cybele in *Winter*, for instance, was seen as the personification of resistance to adversity.[8] In the broader context, Morellet's publications not only described and decoded the pictures, now imbued with lofty meaning, but also analyzed their artistic merits, so that visitors to the site and the wider, literate audience could fully appreciate Mignard's scheme within the long tradition of *speculum principum* (ideal princely behavior).

FIG. 64

Paris, Gobelins manufactory, in the high-warp workshop of Jean Lefebvre (French, act. Gobelins until 1700), after the design of Raphael (Italian, 1483–1520). *Parnassus*, from *The Chambers of the Vatican*, 1689. Tapestry: wool, silk, and gilt metal–wrapped thread, 485 × 778 cm (190¹⁵⁄₁₆ × 306⁵⁄₁₆ in.). Paris, Musée du Louvre, Département des Objets d'Art, OA 5397

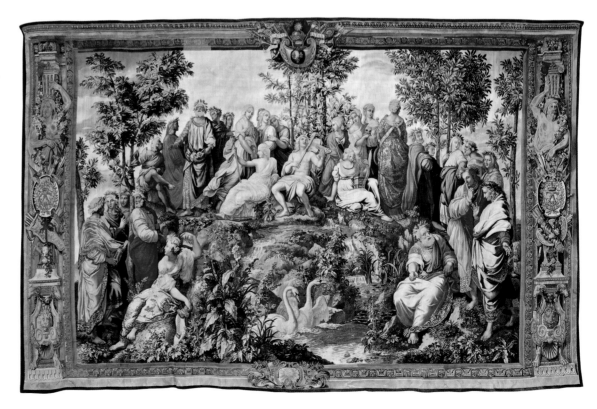

Artistically, Mignard's program was recognized by contemporaries as a significant creative invention, notwithstanding the esteemed, but in 1677 still unfinished, Gallery of Apollo in the Louvre Palace begun by Charles Le Brun (1619–1690) in 1663. In executing the commission at Saint-Cloud, Mignard paid homage to the French and Italian influences on his long career.[9] His deep familiarity with the Italian Renaissance and Baroque schools, acquired during a twenty-one-year sojourn in the Italian peninsula from 1636 to 1657, was demonstrated in the barefoot pose and form of Cybele, who echoed Raphael's muse of epic poetry, Calliope, in the 1511 fresco of *Parnassus* in the Stanze at the Vatican Palace (fig. 64).[10] The influence of this source is even more powerfully evident in Mignard's own interpretation of the subject of *Parnassus* for the Saint-Cloud cycle. And the shorebirds and dried crustaceans of Mignard's *Winter* recall those of Raphael's *Miraculous Draft of Fishes* from his famed *Acts of the Apostles* tapestry series (see entry 1, this catalogue).

The strength of the favorable reception of Mignard's artistic program was soon evinced in the decision by Le Tellier, the marquis de Louvois, to replicate six of the canvases, the four seasons and the two lunette subjects, in tapestry at the Gobelins. In this significant undertaking, which both echoed and countered the manufactory's earlier *Elements* and *Seasons* series by Le Brun (see entry 9, this catalogue), Louvois surely had the authorization of the artist and the patron, Mignard and Monsieur, and the tacit awareness of Louis XIV.[11] To this end, painters employed by the Gobelins prepared full-size cartoons, which Mignard himself retouched, before weaving commenced in late 1687 or early 1688.[12] The cartoon painters adjusted the perspective of the concave ceiling compositions for the vertical plane of the tapestries. In the case of the *Winter* hanging, they deepened the pictorial field with the addition of a foreground.[13] Rodolphe Parent (d. 1694), a collaborator of Mignard, designed borders for the tapestries with motifs appropriate to each individual subject.

The endeavor further benefited from Louvois's call to upgrade materials—specifically, the fineness of the wool—and to more rigorously control quality—especially concerning the dyestuffs and the dyeing process.[14] These improvements resulted in a sumptuous materiality that still strikes present-day viewers of surviving sets of the *Gallery of Apollo at the Château of Saint-Cloud* tapestries. Undoubtedly, the aesthetic merits of the weavings in progress were a deciding factor in Mignard's appointment as director of the Gobelins in 1690, not to mention his confirmation as first painter to the king (two positions made vacant by the death of Le Brun in February of that year). The extremely fine and vibrantly colored editio princeps was completed by 1691 and displayed for the king at Versailles in 1692.[15] Later, a woven insert covered the naked figure of Flora in *Spring*, and the tapestries were installed in the king's apartments at the Château of Marly in November 1700.[16]

Subsequently, the Château of Saint-Cloud, including the painted gallery, was severely damaged in October 1870, during the Siege of Paris, when Parisian forces opened fire on the Prussian artillery that occupied the site. The scorched ruins were razed in 1891. In terms of grandeur and color, the tapestries woven at the Gobelins from the late 1680s are the closest, surviving contemporary record of the original decoration. Written eyewitness descriptions of the decoration abound from across the centuries, but the hand of the artist is best preserved in corresponding, reduced-scale drawings of the seasons (fig. 65) that were later used to prepare a set of engravings executed around 1695 by Jean-Baptiste de Poilly (1669–1728).[17]

Entry and Reception in the French Royal Collection

Production on three sets of the *Gallery of Apollo at the Château of Saint-Cloud* tapestries began at the Royal Furniture Manufactory of the Crown at the Gobelins before its temporary closure in April 1694. Only one of these sets was completed and shown to Louis XIV, the Sun King, by that date, and its overarching Apollonian subject matter was deemed a worthy complement to other major Ludovican artistic programs. Indeed, Mignard's cycle was a very well received response, and challenge, to Le Brun's Gallery of Apollo at the Louvre Palace. The tapestries' ongoing production—in precious gilt

metal–wrapped threads no less—attested to the tacit approval of the Crown. The remaining two sets were delivered in the first decade of the 1700s, after the manufactory reopened in January 1699, and a fourth set—woven without gold—was begun in 1712 but not finished until 1719, after the king's death.[18] That last set decorated the king's bedchamber in the archbishop's palace at Reims on October 25, 1722, the occasion of the royal *levée*, the ceremony on the morning of the coronation of Louis XV (1710–1774, r. from 1715), which seemingly affirmed Morellet's grand pedagogical purpose (see the essay by Bertrand, this catalogue).[19] All four sets remained in the service of the Crown's Furniture Warehouse and were displayed routinely in the royal residences. Panels from the first and second sets, of which *Winter, Cybele Begs for the Sun's Return* is a part, were not dispersed at the time of the Revolution, and they remain today in the collection of Mobilier National, still in service adorning the formal parade galleries of the Château of Fontainebleau and the Château of Versailles.

12 | a

Winter, Cybele Begs for the Sun's Return
from *The Gallery of Apollo at the Château of Saint-Cloud*

Design by Pierre Mignard (French, 1612–1695), 1677–78
Border design by Rodolphe Parent (French, d. 1694), ca. 1686
Cartoon attributed to Pierre Bourguignon (French, ca. 1630–1698)
and retouched by Pierre Mignard, before 1686
Paris, Royal Furniture Manufactory of the Crown at the Gobelins,
in the high-warp workshop of Jean Jans the Younger (Flemish, ca. 1644–1723,
act. France and foreman of the first high-warp workshop from 1668), 1692–93
Tapestry: wool, silk, and gilt metal–wrapped thread
480 × 625 cm (189 × 246⅟₁₆ in.)
Paris, Mobilier National, inv. GMTT 69/4

DESCRIPTION

On a bleak, rocky seashore, the earth goddess Cybele raises her hand to implore the departing sun to return (plate 12a). Barely discernible in the upper-right corner of the cloudy sky, radiant Apollo has turned his back and drives his chariot away from the scene. Cybele wears a crown in the form of a citadel and reclines on the broken ground between her pair of companion lions. Riches lie neglected before her; they cannot alleviate her pitiful condition, indicated by her bare feet and chain-encircled wrists. The exposed earth is hard, with only scrappy vegetation and almost-bare trees. Even the waters spilling from the urn of the river god seem icy cold and nearly frozen. Vulcan alone offers aid in the form of a charcoal brazier to warm the air. A fox turns tail and flees while an assortment of shorebirds scavenge among the washed-up crustaceans. The choppy waves out at sea threaten ships seeking shelter. The sky directly above Cybele is occupied by the winged figures of Boreas, god of the north wind, and his sons, Zetes and Calais, who blow snow and hail down on Cybele.[20] Darkening clouds bring stars as the Pleiades pour down drenching rain.

The border of the tapestry simulates a stucco frame of blue-ground bands adorned with gilt rinceaux. Each corner is set with an illusionary, projecting diagonal clasp, console scrolls, and gadroons. The midpoint of each border contains a cartouche backed by winter fruits and theater masks, as attributes of the season, except for the top cartouche, which is flanked instead by opposing, stylized griffins and cornucopias. Three of the cartouches display signs of the Zodiac: Capricorn (December 22–January 19) at left, Aquarius (January 20–February 18) above, and Pisces (February 19–March 20) at right. The lower cartouche holds a smoking brazier.

COMMENTARY

The present hanging, *Winter, Cybele Begs for the Sun's Return*, formed part of the second high-warp, six-piece edition of the *Gallery of Apollo at the Château of Saint-Cloud* ordered by Édouard Colbert, marquis de Villacerf (1628–1699, superintendent of the Office of Royal Buildings from July 1691). The set was begun simultaneously in 1692 in two workshops, that of Jean Jans the Younger (ca. 1644–1723, foreman of the first high-warp workshop from 1668), which produced four of the hangings, and that of Jean Lefebvre (act. until 1700, foreman of the second high-warp workshop 1662–99), which made two, *Summer* and *Latona*. Three pieces, including *Winter*, were completed by the end of 1693, but, unfortunately, production on the three remaining weavings was interrupted in both workshops when the Gobelins closed from April 1694 to January 1699 on account of the cost of the long-running war against the League of Augsburg (1688–97). The set was not finished until 1702.

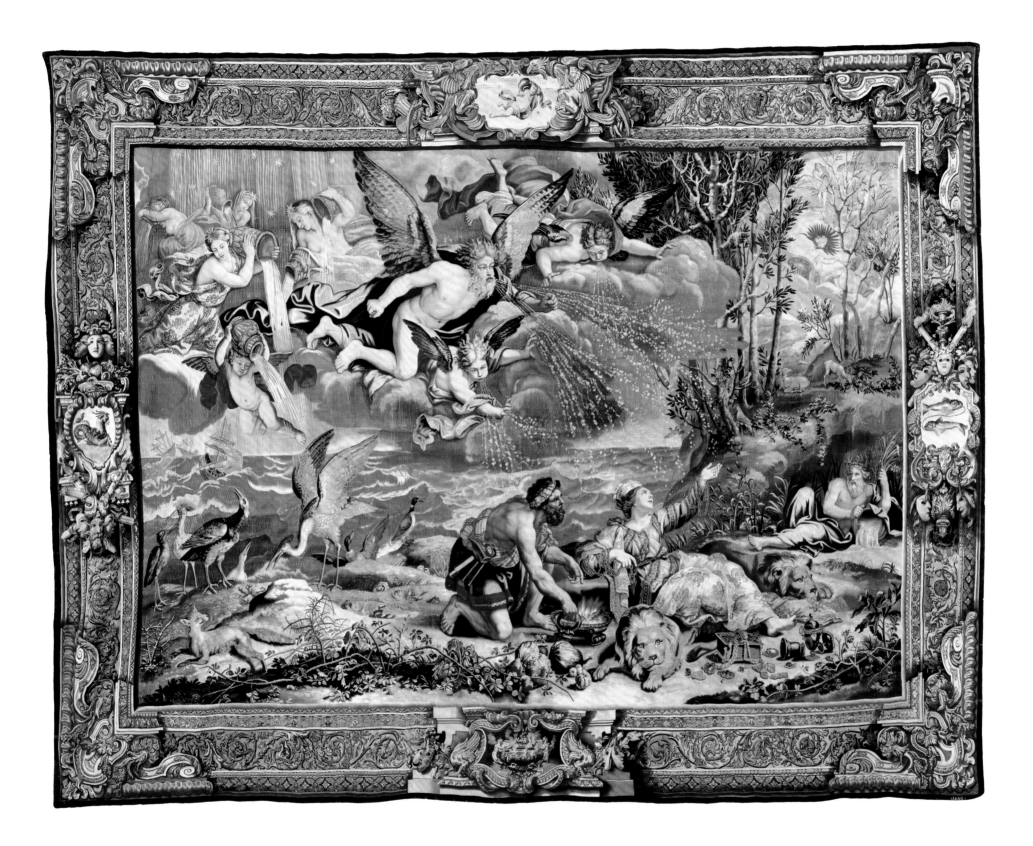

Checklist and Endnotes

I | The Acts of the Apostles

1a.

The Miraculous Draft of Fishes from *The Acts of the Apostles*
Design by Raphael (Italian, 1483–1520), 1516
Border design by Francis Cleyn (also spelled Clein), (German, 1582–1658, active in England from 1623), ca. 1625–36
Surrey, Mortlake Tapestry Works, a royal enterprise from 1637 under the management of Sir James Palmer (English, 1584–1657), 1636–37
Tapestry: wool, silk, and gilt metal– and silver-wrapped thread
530 × 580 cm (208 11/16 × 228 3/8 in.)
Inscriptions: On the top border, in the shield at center, the arms of Charles I surrounded by the buckled garter of the Order of the Garter, bearing the Middle French motto HONI SOIT QUI MAL Y PENSE (Shamed be he who thinks evil of it), all supported by the lion and the unicorn and with four putti who hold the royal regalia.[26] Left border: In the central cartouche, the monogram IHS, for the first three letters of the name *Jesus* in Greek and also a backronym for the Latin phrase IESUS HOMINUM SALVATOR (Jesus, savior of men). Right border: In the central cartouche, the Hebrew letters YHVH (*Yod-Heh-Vav-Hey*), representing the unutterable name for God in the Hebrew Bible, except with the addition of vowel signs.[27] Bottom border: In the central cartouche, the Latin text: QUID LABOR IN / PONTUM, SUDAT, / LABOR OMNIS INANIS, / SE NISI DIVINA DIRIGAT, / ARTE LABOR. / RETIA QUID FUGITIS PISCES, / EN CHRISTUS IN ALTU[M] / DESCENDENS. QUI VOS CONDIDIT, / IPSE CAPIT. (Who works at / sea, works hard. / [That] work [is] all futile, / unless [it is] divinely guided, / [then it becomes] skillful work. / Oh Fish who flee the nets: / Behold Christ descending / to the sea. He put you [in the deep], / [now] he catches [you].)[28]
Followed below by the Latin phrase *car. Re. Reg. / Mortl.*, which is an abbreviation of "Carolo rege regnante / Mortlake" (the reign of Charles / Mortlake). At the bottom of the central cartouche, a tiny cabochon bears the coat of arms of Sir James Palmer
Marks: On bottom blue selvage, at right, the shield of Saint George (a red cross on white shield indicating the tapestry was of English manufacture) and on the lateral blue selvage, lower right, the monogram SIP (for Sir James Palmer)
Paris, Mobilier National, inv. GMTT 16/4

PROVENANCE

1637, Charles I, king of England (1600–1649, r. from 1625), as one of a set of eight tapestries; presumably before January 1649, exported from England before the execution of the king;[29] March 19, 1659, inventoried at Meudon, France, after the death of Abel Servien (d. 1659, superintendent of finance from 1653), as one of a set of seven tapestries;[30] August 1659, purchased by Cardinal Jules Mazarin (1602–1661, first minister of France from 1642), through the intermediary agent Jean-Baptiste Colbert (1619–1683) and, in 1661, located in the Paris residence of the cardinal; 1665, sold by the heir of Cardinal Mazarin, his nephew by marriage, the duc de Mazarin (1632–1713), to Louis XIV; 1665, French royal collection, inv. no. 34 (of the tapestries enhanced with gold); by succession, Mobilier National, Paris

SELECTED BIBLIOGRAPHY

Müntz 1878–84, 2:22–24 and unnumbered plate; Guichard and Darcel 1881, vol. 1, unpaginated text and unnumbered plate; Guiffrey 1885–86, 1:300 (inv. no. 34); Müntz 1897, 26–27; Fenaille 1903, 43–44; Guiffrey 1913, 38; Thomson 1914, 72–75, 74 (fig. 17), 129; Thomson 1930, 281, 283–84; Birmingham 1951, 19 (cat. no. 18); Paris 1983–84a, 398–408; Coural and Gastinel-Coural 1983–84, 243; Beauvais 1993–94, 16 (fig. 1); Howarth 1994, 158; Puhlmann 1996/97, 55–68, 63 (fig. 12); Gastinel-Coural 1998a, 66; Michel 1999, 285, 315, 446, 465n69; New York 2002, 197; Favreau 2005, 59–60, 65n56; Hefford 2007b; Hefford 2007c, 175–79; Vittet 2007c, 185–86; Denis 2009; Brejon de Lavergnée 2009, viii–ix; Vittet and Brejon de Lavergnée with de Savignac 2010, 92–97 (inv. no. 34); Howarth 2011, 449, 469–71, 475n47, 478nn110–21; Paris 2012–13b, 157, 333 (cat. no. 108); De Strobel forthcoming

NOTES

1. Vittet and Brejon de Lavergnée with de Savignac 2010, 31 (inv. no. 1); and Guiffrey 1887, 282.
2. Paris 2012–13b, 28–31.
3. Vasari (1550, 1568) 1976, 4:202, as translated by Thomas P. Campbell in New York 2002, 197–98.
4. Regarding the temporary dispersal of the tapestries after the Sack of Rome in 1527 and their subsequent reassembly and return, see Shearman 1972, 140–41.
5. New York 2002, 193, 201; and De Strobel forthcoming. New insights into the fate of the original cartoons painted by Raphael will be revealed in the forthcoming publication edited by Anna Maria De Strobel.
6. Shearman 1972, 147.
7. Boccardo 2006, 182.
8. New York 2002, 202.
9. New York 2002, 193.
10. Howarth 2011, 469–72.
11. Hefford 2007c, 175–77; and Howarth 2011, 449–55. Hefford theorizes that working copies of the five other cartoons could have been provided by Cleyn, but payment records do not survive. Sapphira was the wife of Ananias; both were struck dead when they deceptively withheld portions of their wealth from the apostles (Acts 5:1–10).
12. One tapestry from the set, *Paul Preaching at Athens*, belonging to the Mobilier National, Paris (GMTT 34/2), was destroyed while on loan to the French Embassy in Warsaw during World War II; see Göbel 1933–34, vol. 3, part 2, unpaginated (fig. 131a); and Gastinel-Coural 1998a, 66.
13. Vittet and Brejon de Lavergnée with de Savignac 2010, 31 (inv. no. 1), 76–81 (inv. no. 30), 92–98 (inv. nos. 34, 35), 99 (inv. no. 37), 206–11 (inv. no. 94), 129 (inv. no. 52); and Coural and Gastinel-Coural 1983–84.
14. Shearman 1972, 141–43n35.
15. Félibien (1666) 1972, 1:283. Translation by Sharon Grevet.
16. Vittet and Brejon de Lavergnée with de Savignac 2010, 31 (inv. no. 1); and Meyer 1980, 13–19.
17. Vittet and Brejon de Lavergnée with de Savignac 2010, 96, 98 (inv. no. 35). Only one of these four weavings, *The Sacrifice at Lystra*, survives; it is on long-term loan to the Musée du Louvre, inv. no. 0A 5399.
18. Vittet and Brejon de Lavergnée with de Savignac 2010, 76–81 (inv. no. 30).
19. Fenaille 1923, 279–82; Fenaille 1903, 46; and Vittet and Brejon de Lavergnée with de Savignac 2010, 206–11 (inv. no. 94). *The Stoning of Stephen* is on loan to the Church of Saint-Étienne-du-Mont, Paris; see Coural and Gastinel-Coural 1983–84.
20. Vittet and Brejon de Lavergnée with de Savignac 2010, 129 (inv. no. 52). It remained in the successor French state collection of the Mobilier National until the end of the nineteenth century; see Fenaille 1903, 45–46; and Coural and Gastinel-Coural 1983–84, 243.
21. Coural and Gastinel-Coural 1992, 26, 27 (fig. 14), 29n26.
22. Hefford 2007b, 186–87.
23. Denis 2009. A study of fish by Francis Cleyn is included in an album of drawings preserved in the Special Collections of Southampton University (Hartley MS. 292); see Howarth 2011, 470–72. Citation courtesy of Jean Vittet.
24. Fermor 1996, 86.
25. New York 2002, 197.
26. Quarterly I and IV, grandquarterly: "Azure three fleurs-de-lis Or" (for France) and "Gules three lions passant guardant in pale Or" (for England); II: "Or a lion rampant within a double tressure flory-counter-flory Gules" (for Scotland); III: "Azure a harp Or stringed Argent" (for Ireland).
27. Explanation of the Hebrew inscription courtesy of Dinah Berland.
28. Translation of the Latin inscription by Michael Osmann.
29. Neither the tapestry nor the larger set was listed in the parliamentary 1649–51 inventory of the executed king's goods; see Hefford 2007b, 184, 189n3.
30. The missing, eighth tapestry was *The Death of Sapphira*, woven after the design of Francis Cleyn; see n. 11, above.

2 | The Triumphs of the Gods

2a.

Triumph of Bacchus from *The Triumphs of the Gods*
Design overseen by Raphael (Italian, 1483–1520), ca. 1518–19
Design and cartoon by Giovanni da Udine (Italian, 1487–1564), in collaboration with other artists from the workshop of Raphael, ca. 1518–20
Brussels, workshop of Frans Geubels (Flemish, fl. ca. 1545–85), ca. 1560
Tapestry: wool, silk, and gilt metal–wrapped thread
495 × 764 cm (194 7/8 × 300 13/16 in.)
Inscriptions: Left border, under each standing figure, the corresponding Latin words FIDES and SPES. Bottom border, under each seated figure, the corresponding Latin words IVSTITIA, CHARITAS, and PRVDENCIA. Right border: under each standing figure, the corresponding Latin words FORTITVDO and TEMPPERANTIA
Marks: On the bottom blue selvage at left, the mark of a plain white shield flanked by opposing Bs for the region of Brabant and city of Brussels and on the lateral blue selvage, lower right, the monogram FG (for Frans Geubels, the Brussels tapestry weaver and entrepreneur)[24]
Paris, Mobilier National, inv. GMTT 1/3

PROVENANCE

Charles I Gonzaga, duc de Nevers and duca di Mantova (1580–1637, duca di Mantova from 1627), as one of four tapestries;[25] 1637, by descent to Charles I's daughter Marie Louise Gonzaga, queen consort of Poland (1611–1667, r. 1645–48 and 1649–67), who in 1645 married Władysław IV Vasa, king of Poland (1595–1648, r. from 1632), and then, in 1649, married his brother, John II Casimir Vasa, king of Poland (1609–1672, r. 1648–1668); 1669, John II Casimir Vasa, who, after abdicating the Polish throne in 1668, moved to Paris and imported some seventy-six tapestries from the Polish royal palace, Warsaw; 1673, purchased by Louis XIV, king of France as one of four pieces (valued at 16,100 livres) and joined to a group of three tapestries, presumed to be of the same set, already in the French royal collection;[26] French royal collection, inv. no. 63 for the combined set (of the tapestries enhanced with gold); by succession, Mobilier National, Paris

SELECTED BIBLIOGRAPHY

Félibien (1672) 1972, 2:201; Tessin 1717, 227; Guichard and Darcel 1881, vol. 1, unpaginated text and plate; Guiffrey 1885–86, 1:307 (inv. no. 63); Fenaille 1903, 221–23; Guiffrey 1913, 24; Erkelens 1962, 137n15; Paris 1965, 38–39 (cat. no. 30); Szmydki 1987, 128–30; Forti Grazzini 1994, 2:378–79 (cat. nos. 140–42); Szmydki 1995, 10, 27–28, 296 (no. 729); Campbell 2002a, 225–28; Dacos 2004, 178n30; Forti Grazzini 2007, 400–402, 405nn16–18; Vittet 2007c, 184; Karafel 2009, 35n31; Vittet and Brejon de Lavergnée with de Savignac 2010, 149–53 (inv. no. 17); Brejon de Lavergné and Vittet 2011a, 18, 20, 24–25; Salmon 2011, 20 (fig. 2); Vittet 2011c, 187; Karafel 2013, 50, 53–54; Bertrand forthcoming b [2015]; Karafel forthcoming [2015]

NOTES

1. The chronicler and art commentator André Félibien (1619–1695) credited Giulio Romano with its design; see Félibien (1672) 1972, 2:201.

2. Information concerning the postmortem inventory of Leo X courtesy of Lorraine Karafel, whose forthcoming publication will offer a detailed study of these papal tapestries and their iconography; see Karafel forthcoming [2015].

3. Campbell 2002a, 225, 243n5.

4. Campbell 2002a, 225, 243n3.

5. "Fece similmente i cartoni di certi arazzi pieni di grottesche, che stanno nelle prime stanze del Consistorio." See Vasari (1550, 1568) 1984, 5:451. Nicole Dacos, however, argues that the cartoons were actually prepared in Brussels, perhaps by Tommaso Vincidor (d. 1534–1536); see Dacos 2004, 178n30.

6. Karafel 2009, 28–39.

7. Karafel 2013, 53–54.

8. Campbell 2002e; and Forti Grazzini 2007.

9. Cavallo 1993, 334–41 (cat. no. 22); and Cleland 2008.

10. Karafel 2013, 50–57.

11. Two subjects, *Triumph of Bacchus* and *Triumph of Hercules*, from this set, known historically as the *Antiques*, survive at Hampton Court Palace, England; see Campbell 2007, 267–75; and Campbell 2002a.

12. Three of the seven hangings, *Triumph of Bacchus*, *Triumph of Minerva*, and *Triumph of Venus*, survive in the Mobilier National, Paris. The other four disappeared from the Crown's Furniture Warehouse after 1789; see Fenaille 1903, 222–23; and Vittet and Brejon de Lavergnée with de Savignac 2010, 149–53 (inv. no. 63).

13. Now in the Château de la Cour d'Aron, Département de la Vendée; see Bertrand 2005, 151–52n56; and Saint-Sulpice-le-Verdon 2000, 102–11. In a communication with the author, Bertrand suggests that a greater number of subsequent editions of *The Triumphs of the Gods* were created than previously realized. He notes specifically a set of "grotesques de Raphaël," measuring twenty ells in overall length and four ells in height, listed in the 1727 inventory of Charles Henry, comte de Hoym (1694–1736), as having been purchased on October 23, 1725, from the Portuguese

ambassador to France (Azevedo Coutinho, envoy extraordinary to the king of Portugal from 1724). Coincidentally, these dimensions corresponded precisely with the overall dimensions of the four *Triumph* tapestries formerly in the collection of John II Casimir Vasa; see Szmydki 1987, 128–30; and Pichon 1880, 7 (no. 11). Citation courtesy of Pascal-François Bertrand.

14. Szmydki 1987, 128–30; and Szmydki 1995, 10, 27–28, 296n729.

15. Components of this assembled—or reunited—set were recorded under several variant titles during the seventeenth century: *Crotesques, Design by Raphael* (1648), *Triumphs of Venus* (1661), *Triumphs of Love* (1673), *Divertissements of the Gods in Crotesques* (1673), *Triumphs of the Gods* (1673), and *Crotesques by Raphael* (1677).

16. *Le Nouveau Mercure Galant* (1677), 50–54; and Vittet 2011c, 187.

17. Portions of Coypel's cartoons survive, including five sections from his rendering of *Triumph of Bacchus* (Musée du Louvre, Département des Peintures, inv. no. 3485); see Salmon 2011, 31–32.

18. Bertrand forthcoming b [2015]. Noël Coypel would have seen the papal set while director of the French Academy in Rome from 1672 to 1674.

19. Fenaille 1903, 221–45; Forti Grazzini 1994, 2:378–91 (cat. nos. 140–42); and Vittet and Brejon de Lavergnée with de Savignac 2010, 238 (inv. nos. 114–15), 260–70 (inv. no. 129), 272 (inv. no. 131).

20. Bertrand 2007, 353.

21. The border figures were identified as the cardinal and theological virtues in the 1672–73 French royal inventory published by Jules Guiffrey; see Guiffrey 1885–86, 1:298 (inv. no. 27).

22. Pope-Hennessy 2000, 123, 457.

23. The precise antique model has not been identified with certainty but likely variants may have been known to the workshop of Raphael. One candidate was the second-century Hellenistic marble of Dionysus plucking a bunch of grapes. Until 1584, the life-size statue was in the collection of the della Valle family in Rome (very likely as early as the era of Cardinal Andrea della Valle, 1463–1543). The statue was then acquired by Cardinal Ferdinando de' Medici (1549–1609, grand duke of Tuscany from 1587) and later entered the Galleria degli Uffizi, Florence, inv. no. 108. Guido Mansuelli actually noted a total of three similarly described statues in the della Valle inventory; see Mansuelli 1958, 133–34 (cat. no. 98) and unpaginated fig. 100. The second candidate was the figure of Bacchus plucking a bunch of grapes. Formerly considered antique, it was attributed to Antonio Federighi (ca. 1423–1490) in 1889 and dated to about 1465–70. It belonged to the Pannocchieschi d'Elci family, Siena (and now conserved in the headquarters of Banca Monte dei Paschi, Siena); see Florence 1986, 6–7, 32–37, 42n3; and Detroit–Fort Worth–Florence 1986, 222–23 (cat. no. 87).

24. Per a civic ordinance of May 16, 1528, confirmed by a Spanish imperial edict of May 1554, the city mark for Brussels was woven into every tapestry over the size of three ells (approximately 205.7 cm, based on the linear unit of one Flemish ell equal to 68.58 cm) along with the mark of the weaver or tapestry entrepreneur. See Delmarcel 2000, 362, 365.

25. The sixteenth-century provenance of this tapestry and others from the same set is a matter of conjecture as no documentation has yet come to light. Erkelens published the set as having belonged to Pope Gregory XIII (1502–1585, r. from 1572); see Erkelens 1962, 126. Vittet hypothesized the set may have been commissioned by a French king, perhaps Henri II (1519–1559, r. from 1547). Forti Grazzini repeated this possibility in Forti Grazzini 1994, 2:378 (cat. nos. 140–42), but he dropped it from his entry in Forti Grazzini 2007, 397–405 (cat. no. 49). On this point, see also Bertrand 2005, 38–39; Vittet and Brejon de Lavergnée with de Savignac 2010, 150 (inv. no. 63); and the essay by Vittet, this catalogue, 36n26.

26. Acquired in 1664 from the collection of the deceased Bernard de Nogaret de La Valette, second duc d'Épernon (1592–1661), those three pieces were identified historically by the title *Triumph of*

Venus, and alternatively *Triumph of Love*; see Vittet 2007c, 183–84; and Vittet and Brejon de Lavergnée with de Savignac 2010, 67 (inv. no. 27).

3 | The Story of Vulcan

3a.

Neptune and Cupid Plead with Vulcan for the Release of Venus and Mars from *The Story of Vulcan*
Design by an unidentified Northern artist, formerly attributed to Perino del Vaga (Italian, 1501–1547), ca. 1530–40
Border design by Francis Cleyn (also spelled Clein) (German, 1582–1658, act. England from 1623), ca. 1625–28
Surrey, Mortlake Tapestry Works, then under the ownership of Sir Francis Crane (English, ca. 1579–1636), ca. 1625–36
Tapestry: wool, silk, and gilt metal–wrapped thread
440 × 585 cm (173¼ × 230⁵⁄₁₆ in.)
Marks: On the lateral blue selvage, lower right, the monogram FC superimposed (for Sir Francis Crane, owner of Mortlake from its establishment in 1619 to his death in 1636)
Paris, Mobilier National, inv. GMTT 36/2

PROVENANCE

By June 1659–61, Nicolas Fouquet (1615–1680, superintendent of finance 1653–61), as one of eight tapestries displayed in the Room of the Muses, Château de Vaux-le-Vicomte, Maincy, France;[15] after the arrest of Fouquet on September 10, 1661, seized by the French Crown; 1665–66, entered the French royal collection as a set of eight hangings, inv. no. 38 (of the tapestries enhanced with gold) and subsequently purchased for the sum of 11,819 livres for the set in 1668;[16] by succession, Mobilier National, Paris

SELECTED BIBLIOGRAPHY

Müntz 1878–84, 2:22–24 (unnumbered plate); Bonnaffé 1882, 30, 47, 92, 98 (inv. no. 424); Guiffrey 1885–86, 1:301 (inv. no. 38); Fenaille 1903, 85; Guiffrey 1913, 37; Siple 1939, 275, 277; La Fontaine and Titcomb 1967, 18n6, 213–25 (plate 14); Schnapper 1994, 224 (fig. 78); Paris 1995, 43–44; Michel 1999, 449, 466n111; Vittet 2007c, 186, 198n19; Brejon de Lavergnée 2009, x–xi; Vittet and Brejon de Lavergnée with de Savignac 2010, 99–101 (inv. no. 38); Brejon de Lavergnée and Vittet 2011a, 40–42; Paris 2012–13a, 163–64, 167nn54–56; Bertrand forthcoming b [2015]

NOTES

1. Vittet and Brejon de Lavergnée with de Savignac 2010, 99.

2. Böttiger, 1898, 73.

3. La Fontaine and Titcomb 1967, 213–25. The poet actually reinterpreted the essence of the Neptune and Cupid episode, positing that it represented Vulcan's complaint rather than the gods' intercession on behalf of the lovers.

4. Campbell 2007, 307–9, 395n38.

5. Delmarcel 2000, 90–91. Wendy Hefford traced a pair of embracing figures in one scene of *The Story of Vulcan* to a composition of Neptune and Doris by Perino del Vaga; see Hefford 1999, 93. Dominique Cordellier, however, placed the unidentified designer in the same circle as Luca Penni (1500/1504–1577); see Paris 2012–13a, 164. Citation courtesy of Jean Vittet.

6. Siple 1938; and Siple 1939.

7. Siple 1938, 218.

8. Böttiger, 1898, 73–74; and Siple 1939.

9. Michel 1999, 166, 180nn146–47, 446n110, 449; and Stockholm 2002, 42–59, 132. One tapestry bearing a shield with the Prince of Wales's feathers is in the Victoria and Albert Museum, London, T.170–1978; see Hefford 2007c, 173–74 (fig. 85).

10. Vittet and Brejon de Lavergnée with de Savignac 2010, 99–101 (inv. no. 38).

11. Information courtesy of Pascal-François Bertrand. Bertrand discusses the significance of Fouquet's *Story of Vulcan* hangings in a chapter about the reweaving of older editions of tapestries from the French royal collection in Bertrand forthcoming b [2015].

12. Scholarship has traditionally called the subject here titled *Cupid Takes Aim at Mars, Who Is Attended by Alectryon* simply *Mars, Alectryon, and Cupid* or *Mars Re-armed*.

13. *Vulcan Forges and Spreads the Net* and *Vulcan Complains to Jupiter* bear the FC mark in the right lateral blue selvages.

14. Hefford 2007a.

15. La Fontaine and Titcomb 1967, 18. Citation courtesy of Pascal-François Bertrand.

16. A slightly different sum, 11,789 livres, was recorded in Bonnaffé 1882, 98 (inv. no. 424).

4 | The Story of Scipio

4a.

The Reception of the Envoys from Carthage from *The Story of Scipio* or *The Story of Scipio Africanus*
Design in the style of Giulio Romano (Italian, ca. 1499–1546), possibly as early as the 1530s, no later than 1548/55
Border design incorporating motifs by Tommaso Vincidor (Italian, d. 1534/36)
Brussels, attributed to the workshop of the Dermoyen family, possibly as early as 1544, no later than 1548/55
Tapestry: wool and silk
458.5 × 732.8 cm (180½ × 288½ in.)
Marks: On the bottom blue selvage, left, the mark of a plain red shield flanked by opposing Bs for the region of Brabant and city of Brussels
San Simeon, California, Hearst San Simeon State Historical Monument, inv. 529-9-93

PROVENANCE

Jean d'Albon de Saint-André (1472–1549, knight of the Order of Saint Michael from 1530) and/or Jacques d'Albon de Saint-André (ca. 1505/12–1562, knight of the Order of Saint Michael and marshal of France from 1547),[32] one of a set of ten pieces; Marie de' Médici (1575–1642, queen consort of France 1600–1610 and queen regent of France, 1610–14); by 1653, Cardinal Jules Mazarin (1602–1661, first minister of France from 1642) and, by 1661, located in his Paris residence; 1665, sold by the heir of Cardinal Mazarin, his nephew by marriage, the duc de Mazarin (1632–1713) to Louis XIV, king of France, valued at 60,000 livres; French royal collection, inv. no. 43 (of the tapestries woven with wool and silk); dispersed from the national collection after 1797;[33] 1905, possibly Michel van Gelder, Uccle-Brussels; 1906, possibly Léo Nardus, Suresnes (near Paris);[34] by 1920, Charles of London (Charles Duveen, an independent dealer and decorator and younger brother of Joseph Duveen);[35] March 11, 1920, French & Company together with Parish-Watson & Company, Inc., one of four tapestries (stock no. 7634-112-a), New York;[36] March 10, 1921, one of four tapestries sold to William Randolph Hearst (1863–1951); 1951, Hearst Monument Collection, San Simeon, California, 529-9-93

SELECTED BIBLIOGRAPHY

Félibien (1672) 1972, 2:201; Müntz 1878–84, 2:32–33; Guiffrey 1885–86, 1:339 (inv. no. 43); Fenaille 1903, 290–92; d'Astier de la Vigerie 1907, esp. 113–28; Romier 1909, 186–87; Brienne and Bonnefon 1916–19, 1:294, 3:88; Hunter 1916; Hunter 1925, 133–34; Paris 1978, 6–10, 15, 82–83; Lefébure 1993; Forti Grazzini 1994, 1:207–18 (cat. nos. 84–85); Schnapper 1994, 126, 308; Lefébure 1996; Michel 1999, 163, 179nn107–13, 315, 450–52, 466–67nn139–59; Kastner 2000, 69, 71; Delmarcel 2002, 199, 202, 207n8; Campbell 2002b, 349, 362nn42–43; Campbell 2002c, 400;

Bremer-David 2003–4, 49, 51, 66n64; Bertrand 2003–4, 114; Dacos 2004, 180–84; Favreau 2005, 48, 55, 64n17; Knauer 2005, 244–60; New York 2007, 333; Vittet 2007c, 186, 199n15; Vittet 2008, esp. 73; Hartkamp-Jonxis 2008; Vittet and Brejon de Lavergnée with de Savignac 2010, 320–29 (inv. no. 43); Vittet 2011c, 193, 197n74; Delmarcel 2014a, 72–75; Bertrand forthcoming b [2015]

NOTES

1. Regarding *The Story of Saint Paul*, see Delmarcel 2014b; and regarding *The Story of Joshua*, see Buchanan 2014.

2. Vittet and Brejon de Lavergnée with de Savignac 2010, 31–33 (inv. nos. 1–3), 65–67 (inv. no. 25).

3. Guiffrey 1887, 283–84, 291. An account of the melting-down operation, dated July 14, 1797, valued each recovered marc of gold at nearly 857 livres and each marc of silver at more than 52 livres.

4. The duplicative set, known as the d'Albon de Saint-André set, also suffered a change in 1797: the Directoire authorities expended 600 livres to "suppress the nudity" of some putti in its borders; see d'Astier de la Vigerie 1907, 64. Regarding the late seventeenth-century edition woven by the Royal Furniture Manufactory of the Crown at the Gobelins, see Lefébure 1996.

5. D'Astier de la Vigerie 1907; Paris 1978; Campbell 2002b, 341–49, 362nn3–43; Knauer 2005; and Knauer 2006–7.

6. For a summary of the subjects in the editio princeps, see Paris 1978, 6.

7. Campbell 2002b, 343. Regarding the Dermoyen family of weavers, see Buchanan 2014, 219–20, 360n22.

8. Cox-Rearick 1995, 377–83. On its meaning to François I, see Knauer 2005, 228–29; and Knauer 2006–7, 252–54.

9. Paris 2012–13b, 77; Forti Grazzini 1994, 1:207; and Paris 1978, 13.

10. Two full-scale cartoons for the *Triumphs* survive from the editio princeps. The titles are *The Bulls and Elephants* and *The Licteurs and the Musicians*. The former is in the State Hermitage Museum, Saint Petersburg, inv. no. 6343 (359 × 773 cm), and the latter is in the Musée du Louvre, Paris, inv. no. 3534 (364 × 660 cm); see Paris 1978, 118–19, 124–25. Regarding the latter, see Paris 2004, 77–79 (cat. nos. 5–6).

11. Paris 2004, 76–81 (cat. nos. 5–8); Campbell 2002a, 230; and Campbell 2002b, 343, 347, 362n8.

12. Dacos 2004. Citation courtesy of Jean Vittet.

13. For a French seventeenth-century inventory description of the editio princeps, see Reiset 1866, 243–45. Reiset did not identify his source, but he was quoting from the 1666 inventory drawn by Gédéon Berbier du Metz (1626–1709, intendant and controller of the Crown's Furniture Warehouse), a document that was later published in full in Favreau 2005.

14. Concerning the set now in Madrid, see Junquera de Vega and Herrero Carretero 1986, 1:176–84; and Campbell 2002d, 364–70. Another set was purchased in 1551 by Cardinal Ippolito II d'Este (1509–1572). Six tapestries from this set are now in the Academia Belgica, Rome; see Delmarcel 2002. One more tapestry, *The Meeting of Scipio and Hannibal*, in the Museo Stibbert, Florence, may be en suite; see Forti-Grazzini 1989, 469.

15. The dating of the commission continues to be a subject of debate in the scholarship. Given that the woven coats of the d'Albon de Saint-André arms applied equally to father and son, the discussion turns upon certain details in the tapestries' narrative fields, which appeared earlier in other weavings from different series. See n. 25 below and d'Astier de la Vigerie 1907, 115–16; Hefford 1986; and Cordellier 2000. Certainly Jacques d'Albon de Saint-André purchased tapestries from Brussels, as attested by the debt his estate owed to the Brussels tapestry entrepreneur Cornelis de Ronde (act. 1555–69) for a different set of hangings woven with gold thread. Guy Delmarcel and Claire Dumortier published the document (dated October 12, 1565) relating to the outstanding debt; see Delmarcel and Dumortier 1986. Citation courtesy of Jean Vittet. Later, at the moment when Queen Marie

de' Medici was making purchases from the estate of Jacques d'Albon de Saint-André, the deceased's tapestries were described as "Brussels fashion very exquisite, highlighted with gold, silver, and silk…"; see Romier 1909, 186–87.

16. Paris 2008, 72–73.

17. This set entered the Furniture Warehouse on December 24, 1690, as no. 159 in the inventory of tapestries with wool and silk; see Fenaille 1903, 290–96; Lefébure 1993, 81–87; Vittet and Brejon de Lavergnée with de Savignac 2010, 395 (inv. no. 159).

18. Vittet 2012c.

19. All ten of its pieces bear two d'Albon de Saint-André shields and collars each: one in the upper-left border and the other in the upper-right (Musée du Louvre, inv. nos. OA5388-OA5389, OA5393-OA5396, and OA6066-6067, and Mobilier National, GMTT 37/4-5).

20. The fate of three d'Albon de Saint-André hangings remains unknown: *The Meeting of Scipio and Hannibal, The Landing of Scipio in Africa*, and *The Fire in the Camp*. *The Meal with Syphax* was last seen publicly when it sold at the Galerie Georges Petit, Paris, April 22, 1929, no. 105. See n. 23 below.

21. Livy / Edmonds 1850, Book 30, chapters 37–44:1329–1331.

22. "De sable, à une crois d'or, chargé d'un lambel de gueules"; see d'Astier de la Vigerie 1907, 115.

23. Four tapestries from this set survive with the original borders intact, another survives with a replacement border of different design, and a last piece—presumably en suite—survives without borders. The four with original borders are at Hearst Castle (Hearst San Simeon State Historical Monument) in California: *The Battle of Ticinus, The Continence of Scipio, The Meeting of Scipio and Hasdrubal* or *The Battle on the Plain*, and *The Reception of the Envoys from Carthage* (inv. nos. 529-9-6294, 529-9-94, 529-9-92, and 529-9-93). The Cincinnati Art Museum preserves a portion of *The Capture of New Carthage* surrounded by a replacement floral border (inv. no. 1883.740). A narrative inner field from *The Battle of Zama*, without borders but seemingly en suite, sold at Piasa auction house, Hôtel Drouot-Richelieu, Paris, June 25, 2003, no. 152 (illustrated), formerly in the collection of Alphonse de Lamartine. Afterward, it was with the London-based dealer Franses; see Knauer 2006–7, 270; and Franses 2015. Information courtesy of Pascal-François Bertrand. This hanging may be linked with the folding screen, upholstered with salvaged mid-sixteenth-century tapestry remnants, from the Château of Coubert. It sold at Hôtel Drouot-Richelieu, Paris, November 29, 1935, no. 108 (illustrated). Border fragments on that screen have armorial shields (two blank and one with faint traces of illegible motifs), birds, and fruit of the same type as on extant d'Albon de Saint-André *Scipio* tapestries. Indeed, based on a comparison with the intact borders on the late seventeenth-century Gobelins edition of the set, Jean Vittet deduces that the border fragments on the folding screen once belonged to the d'Albon de Saint-André *Capture of New Carthage, Battle of Zama*, and *Landing of Scipio in Africa* panels. Information courtesy of Vittet. See also Vittet and Brejon de Lavergnée with de Savignac 2010, 320–29 (inv. no. 43).

24. Lefébure 1993, 86.

25. Nicole Dacos argued that the model—if not the cartoon—for *The Reception of the Envoys from Carthage* existed already in 1533, at the time of weaving the editio princeps for François I. She based her premise on two observations, the first more convincing than the second, which implied details from the model were known and repurposed by a network of artists by 1533–40. The first observation suggested that the posture of the footman leading the horses in the composition inspired a corresponding figure in *July* from *The Hunts of Maximilian* tapestry series, after the designs of Bernard van Orley (ca. 1488–1541), which was in production by that date (see fig. 14). The second observation noted a similarity of pose between the kneeling envoy, with hands crossed against his chest, and the kneeling figure of Arachne in a fresco painted just after 1540 by Herman Posthumus (act. ca. 1536–42) for the Italianate ducal residence in Landshut, Bavaria. See Dacos 2004, 183–84nn81–82; and Dacos 2001, 91–92 and unpaginated fig. 103.

Regarding the *Hunts of Maximilian*, see Musée du Louvre (Paris) and Balis et al. 1993.

26. On the significance of, and the literary inspiration for, the star-covered cloak, see Knauer 2005, 250–51n98.

27. The other two surviving cartoon are *The Meal with Syphax* and *The Battle of Ticinus*. All three are in the Musée du Louvre, Paris: *The Meal with Syphax*, 385 × 310 cm (inv. no. RF 44340), *The Battle of Ticinus*, 385 × 665 cm (RF 44339), and *The Landing of Scipio in Africa*, 360 × 426 cm (RF 51923). A fourth cartoon, for *The Battle of Zama*, was known to survive en suite until at least 1854, when the group of four was offered for sale from the collection of Madame Gentil de Chavagnac, at the Galerie Lebrun, Paris, June 20, 1854; see Cordellier 1998; and Cordellier 2000. A variant cartoon for *The Landing of Scipio in Africa*, 248 × 257 cm, dated ca. 1555, is in the collection of the Rijksmuseum, Amsterdam (inv. no. RP-T-2001-1); see Hartkamp-Jonxis 2008. (The article was translated into English by Diane Webb, with edits courtesy of Ebeltje Hartkamp-Jonxis, in June 2014. Translation on file with the Department of Sculpture and Decorative Arts, J. Paul Getty Museum, Los Angeles.) The cartoon was displayed in the 2013–14 exhibition *Michiel Coxcie: De Vlaamse Rafaël* at the M—Museum Leuven. See Leuven 2013, 188 (cat. no. 22); and Carpreau 2013, 36.

28. D'Astier de la Vigerie 1907, 128; Campbell 2002c, 400–401; and Favreau 2005, 64n6. For further discussion on the circle of possible Italian and Flemish cartoon painters active in Brussels and Antwerp during the 1540s and 1550s, see Hartkamp-Jonxis 2008, 91–93.

29. Halbturn 1981, 19–31; Buchanan 2014, 217; and Schmitz-von Ledebur 2014, 224. See Paris 1978 and Müntz 1897, 47–52, for the precise correspondences with the Vincidor precedents.

30. Delmarcel 2000, 108; and Campbell 2002c, 382, 404nn15–18.

31. Of the four surviving pieces with borders intact, the d'Albon de Saint-André shield and collar of the Order of Saint Michael appear only twice: in the upper-right border of *The Reception of the Envoys from Carthage* and in the upper-right border of *The Battle of Ticinus* (Hearst San Simeon State Historical Monument, inv. nos. 529-9-93 and 529-9-6294, respectively). Curiously, all ten pieces in the later copy of this set, woven 1688–90 at the Royal Furniture Manufactory of the Crown at the Gobelins, bear two d'Albon de Saint-André shields and collars each: one in the upper-left border and the other in the upper-right (Musée du Louvre, inv. nos. 0A5388-0A5389, 0A5393-0A5396, and 0A6066-6067, and Mobilier National, GMTT 37/4-5). Confirmation of the shields in the surviving d'Albon de Saint-André hangings courtesy of Hoyt Fields, Mary Levkoff, and Beverly Steventon, Hearst Castle, San Simeon, California.

32. Romier 1909, 11, 49.

33. D'Astier de la Vigerie 1907, 11, 121.

34. Probably en suite with the d'Albon de Saint-André *Battle of Ticinis* (Tessin in French) in the successive collections of Michel van Gelder, Uccle-Brussels, in 1905, and Léo Nardus, Suresnes (near Paris), as reported in Brussels 1906, 46–47, 88–89 (plate 30).

35. Charles of London had galleries located at 27–29 Brook Street, London, and at 2 West Fifty-Sixth Street, New York, as of March 1921; see *Arts & Decoration*, March 1921, 406.

36. French & Company showrooms were located then at 6 East Fifty-Sixth Street, New York. The galleries of Parish-Watson & Company, Inc., were accessed through Dreicer & Company, 560 Fifth Avenue, New York; *Arts & Decoration*, April 1921, 457.

5 | The Story of Queen Artemisia

5a.

The Chariot of Triumph Drawn by Four Piebald Horses (also known as *The Golden Chariot*) from *The Story of Queen Artemisia*
Design by Antoine Caron (French, 1521–1599), ca. 1563–70
Border design attributed to Henri Lerambert
(French, ca. 1540/50–1608), ca. 1606–7
Cartoon by Henri Lerambert, ca. 1606–7
Paris, workshop at the Louvre of Maurice I Dubout
(French, d. 1611), ca. 1606–7
Tapestry: wool and silk
483 × 614 cm (190³⁄₁₆ × 241¾ in.)
Marks: None
Paris, Mobilier National, inv. GMTT 11/4

PROVENANCE

Henri IV (1553–1610, king of Navarre from 1572 and king of France from 1589), as one of a set of eight; French royal collection, inv. no. 8 (of the tapestries with wool and silk); by succession, Mobilier National, Paris

SELECTED BIBLIOGRAPHY

Guiffrey 1885–86, 1:333 (inv. no. 8); Guiffrey 1898, 39 (no. 3); Guiffrey 1913, 29; Fenaille 1923, 149, 207; Versailles 1967, 26 (cat. no. 5), 32 (plate 5); Denis 1991, 25–26, 33n20; Adelson 1994, 183, 192n15, 197n102, 265, 268n11; Denis 1999, 35 (table nos. 26, 27), 46, 48nn21, 28; Favreau 2005, 62, 66n72; Denis 2007b, 124–28; Denis 2007c, 142–44, 146n13; Vittet and Brejon de Lavergnée with de Savignac 2010, 301–5 (inv. no. 8)

5b.

The Golden Chariot for *The Story of Queen Artemisia*
Antoine Caron (French, 1521–1599), ca. 1563–70
Preparatory drawing: black chalk, pen and brown ink, and brown wash, heightened with white on beige paper
41.5 × 55.5 cm (16¼ × 21⅞ in.)
Inscriptions: (Recto) Top border, flanking the coat of arms of Catherine de' Medici halved by those of the Valois king (for her deceased husband, Henri II, king of France, 1519–1559, r. from 1547),²⁴ the left cartouche contains the Latin text, ARDOREM TESTANTUR, and the right cartouche, EXTINCTA VIVERE FLAMMA, which reads, line by line, left to right, as the motto of the widowed queen: ARDOREM EXTINCTA TESTANTUR VIVERE FLAMMA (After the flame had died out, the tears testify to the ardor that lives on). (Verso) SONNET / *Apres cela marchoit d'une aleure plus lente / Les nobles signalez soit d'armes, ou de foy, / Que de deuil habillez honoroyent ce convoy, / Portant chacun en main la hache reluisante. / Un page bien monté en sa main peu puissante / Portait de dueil vestu l'espé d'armes du ROY, / Dont l'esclat flamboyant sembloit donner effroy / A la veue, et au coeur, de la troupe assitente. / Un aultre le suivoit qui portoit son harnois, / Dont vaillant il s'estoit efprouvé maintes fois; / Et dont il avoit faict tant d'armés en sa vie / Que le Ciel quelques fois s'en estoit estonné; / Permetant pour cela qu'a la mort asservie / Fut la bonté du coeur qu'il luy avoit donné.* (After which processed with a slow gait / The nobles announcing with arms or with faith, / Dressed all in mourning to honor this cortege, / Each with a gleaming axe in hand. / A mounted page in his weak hand / Held the KING's sword draped in mourning, / Its flamboyant radiance seeming to inspire awe / Before the eyes, and heart, of the assembled company. / Another [page] followed behind holding his equestrian tack / With which he [the king] had valiantly proven himself many times; / And with which he had raised many armies in his life / That the Heavens were often astonished; / For which even in being subjected to death / Was permitted the happiness of the heart that he had been given.)²⁵

Marks: None
Paris, Bibliothèque Nationale de France, Département des Estampes et de la Photographie, inv. RÉSERVE AD-105-FT 4, folio 12 recto

PROVENANCE

Circa 1582, Catherine de' Medici (1519–1589, queen consort of France 1547–59 and queen regent of France 1551, 1553, 1560–66, 1574); ca. 1599, Henri IV (1553–1610, king of Navarre from 1572 and king of France from 1589); Claude de Bullion (1569–1640, provost of Paris from 1616 and superintendent of finance from 1632); by inheritance to his grandson Gabriel Jérôme de Bullion, the comte d'Esclimont (d. 1752); given by the comte d'Esclimont to Jacques-Jérémie Roussel de Rocquencourt (1712–1776); 1765, given by Roussel de Rocquencourt to Louis XV, king of France (1710–1774, r. from 1715) and deposited in the Cabinet des Estampes under Hugues Adrien Joly (1718–1800);²⁶ by succession, Bibliothèque Nationale de France, Paris

SELECTED BIBLIOGRAPHY

Guiffrey 1898, 23 (no. 8); Fenaille 1923, 110 (drawing no. 26), 149; Versailles 1967, 26 (cat. no. 5), 32; Ehrmann 1986, 60–61 (drawing no. 26); Denis 1999, 46 (table nos. 26, 27)

NOTES

1. Recent publications, notably Grivel, Leproux, and Nassieu Maupas 2014; and Denis 2007b, 124, are shedding light on sixteenth-century French tapestry production. Concerning the role of the Parisian guild, see Brosens 2005; and Brosens 2011b.

2. Denis 2007b, 123–39.

3. Favreau 2011, 87–88. Later in the 1660s, Louis XIV acquired yet another antique set, of eight pieces, of *The Story of Queen Artemisia* for the royal collection. Vittet and Brejon de Lavergnée with de Savignac 2010, 39–40 (inv. no. 12), 50–55 (inv. nos. 15, 16), 70–75 (inv. no. 29), 299 (inv. nos. 6, 7), 301–5 (inv. no. 8), 316 (inv. no. 31), 331–32 (inv. no. 47).

4. Catherine de' Medici temporarily assumed the regency twice during the lifetime of her husband, Henri II (1519–1559, r. from 1547), in 1551 and 1553, when she participated in military campaigns. She also served as regent for her sons, François II (1544–1560, r. from 1559) and Charles IX (1550–1574, r. from 1560), and then for Henri III (1551–1589, r. from 1574). On her fragmented regencies, see Mamone 2008, 32.

5. Auclair 2007; Bertrand 2008, 238, 242n4; and Vittet 2012b. For the identification of other artists involved in the project, including Francesco Primaticcio (1504–1570), Nicolò dell'Abbate (ca. 1509–1571), his son Giulio Camillo Abbate (d. 1580 or 1582), Baptiste Pellerin (d. ca. 1595), and Toussaint Dubreuil (1561–1602), see Versailles 1967, 21; Béguin 1958; Barcelona-Paris 2003–4, 237–61; Paris 2007, 74–75 (cat. no. 9); Cordellier 2010, 7–8, 14; and Paris 2012–13a, 67–71.

6. The multiple-volume manuscript, begun around 1562/63, survives, as do the slightly later (now unbound) sonnets and fifty-three illustrations. The prose manuscript and thirty-nine illustrated sonnets are presently in the Bibliothèque Nationale de France, Paris, Département des Manuscrits, Ms. Fr. 306, and in the Département des Estampes et de la Photographie, inv. RÉSERVE AD-105-FT 4. Fourteen more illustrated sonnets are preserved in the Musée du Louvre, Paris, Département des Arts Graphiques, inv. 25138-39, RF 2972 bis1–4, RF 297521-7.

7. Gaehtgens 2008, 109.

8. For recent publications, see Ffolliott 1986; Florence 2008, 32; and Bertrand 2009b.

9. Auclair 2007, 20–21.

10. The date of death for Maurice I Dubout is given here as 1611, in agreement with Denis 2007b, 123, rather than "in or after 1606," as per Brosens 2007–8, 174. A determining factor in this matter is the document dated January 4, 1608, concerning Maurice I Dubout and Girard II Laurent cited by Jean Coural in Versailles 1967, 16.

11. Weavers operating under royal privilege in the Louvre workshop did not have to mark their hangings produced for the Crown, but, from 1607, the tapestries produced in the workshops operated by the immigrants Marc de Comans and François de La Planche did have to be identified with woven marks in order to distinguish them from hangings that were being illegally imported and sold in France. The absence or presence of a woven mark was no guarantee of origin, however, as the perimeter selvages incorporating such marks could be easily replaced without damage to the border or narrative field; see Denis 2007b, 124; and Brosens 2011b, 39.

12. Bertrand 2008.

13. This summary synthesizes the literature and draws principally from the research of Maurice Fenaille, Jean Ehrmann, Candace Adelson, and Isabelle Denis; see Fenaille 1923, 108–212; Ehrmann 1986; Adelson 1994, 160–288; Denis 1999. See also Paris 1972, 357–63 (cat. nos. 467–481).

14. See n. 3 above.

15. Houel 1563, book 1, chapter 6, 36–37. The present description of the chariot is based on a fresh reading of the manuscript by Anne-Lise Desmas.

16. According to the original text, this figure is Immortality and the wreath through which the palm frond passes is a crown of love (or Cupid); see Fenaille 1923, 149 (drawing no. 26). But in the royal inventory description written in 1666 by Gédéon Berbier du Metz (1626–1709, intendant and controller of the Crown's Furniture Warehouse from December 31, 1663), the standing figure was identified as Victory and the four seated females as figures of Renown; see Favreau 2005, 62, 66n72. Jules Guiffrey identified the same figure as Fortune; see Guiffrey 1898, 23 (no. 3), 39.

17. The letter M appears twice, superimposed upon itself, once upright and once upside down. The configuration of the three-letter cipher HMM has sometimes been confused for HM/AM, indicating Henri/Marie and Artemisia/Mausolus, but this latter interpretation is negated here by the presence of the French crown; see Adelson 1994, 183, 198n108.

18. "D'azur aux trois fleurs-de-lys or" for France and "de gueules à une chaine d'or en triple orle, en croix et en sautoir" for Navarre.

19. Favreau 2005, 62, 66n72; Ehrmann 1986, 60; and Vittet and Brejon de Lavergnée with de Savignac 2010, 301–5 (inv. no. 8). Vittet explains and corrects the erroneous mention of the Royal Tapestry Manufactory at the Gobelins in the original 1666 inventory entry.

20. According to the reckoning published in Denis 1999, 46–47. One Caron drawing, for the *Chariot Pulled by Two Unicorns*, however, has lately been reattributed to Nicolò del'Abbate; see Barcelona-Paris 2003–4, 240–41 (cat. no. 88).

21. The drawing is in the Biblioteca Reale, Turin; see Lévêque 1984, 77.

22. Barcelona-Paris 2003–4, 256–61 (cat. nos. 97, 100). Tapestries, woven with precious metal–wrapped thread, after two of these later designs were also produced in the workshop of the Faubourg Saint-Marcel.

23. Denis 1991; and Adelson 1994, 179, 183.

24. "D'azur aux trois fleurs de lys d'or et écartelé au I et IV d'or à six boules en orles, la supérieure de France, les autres de gueules, au II et III contre écartelé au 1 et 4 d'azur semé de fleurs de lys d'or et à la tour d'argent maçonnée et ouverte de sable, au 2 et 3 d'or au gonfanon de gueules frangé de sinople avec sur le tout d'or à trois tourteaux de gueules," in Russel 2005, 142.

25. This unnumbered sonnet describes a slightly different stage of the funeral procession of King Mausolus than the one portrayed in the drawing. Translation courtesy of Philippe Halbert.

26. Provenance for a group of *L'histoire de la reine Artémise* companion drawings as published in Barcelona-Paris 2003–4, 237.

6 | The Story of Constantine

6a.

Constantius [I] Appoints Constantine as His Successor
from *The Story of Constantine*
Design by Peter Paul Rubens (Flemish, 1577–1640), 1622
Border design attributed Laurent Guyot
(French, ca. 1575–after 1644), ca. 1622–23
Paris, Faubourg Saint-Marcel workshop under the direction of entrepreneurs Marc de Comans (Flemish, 1563–1644, act. in France from 1601) and François de La Planche (Flemish, 1573–1627, act. in France from 1601), ca. 1625–by 1627
Tapestry: wool, silk, and gilt metal–wrapped thread
458 × 407 cm (180 5/16 × 160 1/4 in.)
Marks: On bottom blue selvage, P and a fleur-de-lis (for the Faubourg Saint-Marcel workshop in Paris), and on the lateral blue selvage, lower right, the monogram FM, with the F placed above, and descending into, the M[28]
Paris, Mobilier National, inv. GMTT 43/3

PROVENANCE
Prior to 1627, Marc de Comans (1563–1644) and François de La Planche (1573–1627), Paris; 1627, posthumous inventory of François de La Planche, Paris, titled as "la Providence divine," one from a set of twelve tapestries;[29] 1627 by succession, Charles de Comans (d. 1634), Paris, and listed as one of four tapestries valued 8,000 livres in his posthumous inventory;[30] 1662, sold by "la dame Petit" (dates unknown, weaver and tapestry merchant active in the 1660s), as one of four tapestries at the price of 6,000 livres to Louis XIV and delivered to the Crown's Furniture Warehouse of the Château of Vincennes; 1662, French royal collection inv. no. 28 (of the tapestries enhanced with gold); by succession, Mobilier National, Paris

SELECTED BIBLIOGRAPHY
Guiffrey 1885–86, 1:298–99 (inv. no. 28); Guiffrey 1913, 44; Fenaille 1923, 250, 255; DuBon 1964, 23n78; Philadelphia 1964, 43, 89–91 (cat. no. 22b); Van Tichelen 1997, 66–67, 69n25; Merle du Bourg 2004, 17, 27nn30–32; Vittet and Merle du Bourg 2004, 155, 278–85; Bertrand 2005, 117, 180n193; Vittet 2007c, 188, 200nn25–26; Denis 2007a, 160, 163n17; Vittet and Brejon de Lavergnée with de Savignac 2010, 67–69 (inv. no. 28); Vittet 2010, 60–61, 63, 69n14, 79; Brosens 2011a; Brosens 2011c, 187–89, 349, 354–55, 366; Vittet 2011c, 177–78, 197nn5–7

NOTES
1. Peter Paul Rubens encountered cartoons for Raphael's *Acts of the Apostles* tapestry series while in Genoa (see entry 1, this catalogue). Rubens's *Decius Mus* series was created under the direction of the Brussels tapestry merchant Jan I Raes (1574–1651) and the Antwerp tapestry merchant Frans II Sweerts (fl. ca. 1616) for an unidentified Genoese patron. Seven full-size oil-on-canvas cartoons, dating 1616–17, survive in the Liechtenstein collection, Vienna, inv. nos. GE47-53; see Baumstark 1985; Tauss 2000; and Tauss 2012. For a summary of Rubens's contributions to tapestry design, see Antwerp 1997; Lille 2004, 268–302; and Herrero Carretero 2008.

2. DuBon 1964, 5, 9–10.

3. The cycle is now in the Musée du Louvre, Paris; see Saward 1982; and Thuillier and Foucart 1967.

4. Avrillas 2013, 135–38. Citation courtesy of Jean Vittet.

5. Vittet and Brejon de Lavergnée with de Savignac 2010, 29 (inv. no. 11), 67–69 (inv. no. 28), 109–15 (inv. no. 46), 232 (inv. no. 111), 412 (inv. no. 166).

6. The 1594 publication *De Cruce libri tres* by the Neostoicist Justus Lipsius (1532–1599) of Antwerp was doubly influential in developing the theme, for the author himself was a convert to

Roman Catholicism, and he was a teacher of Rubens's brother, the humanist and jurist Philip Rubens (1573–1611).

7. Patrick Avrillas noted especially the letters from Nicolas-Claude Fabri de Peiresc to Peter Paul Rubens dated April 14, 1622, and December 29, 1622; see Avrillas 2013, 142. For the April 28, 1622, letter, for example, see Rooses and Ruelens 1898, 396–98. Concerning the larger and longer theological and political context, see Fumaroli 1995; and Denis 2007a, 162 (cat. no. 14).

8. Saxy 1623, 21–28.

9. The present synopsis is indebted to Koenraad Brosens's masterful reexamination of the genesis and production of the *Story of Constantine* tapestry series as well as his critical summary of the contemporary correspondence and related art historical literature; see Brosens 2007–8, 166–82; and Brosens 2011c. For the scholarly reception of Brosens's analysis, see Bertrand 2013b; Vittet 2013; and Cleland 2012.

10. This relationship was disclosed in correspondence between Rubens and Peiresc. See especially the letter of December 1, 1622, as translated by DuBon 1964, 6–8. On Peiresc's subsequent acquaintance with Cardinal Francesco Barberini, recipient of the seven-piece *Story of Constantine* tapestry set from Louis XIII in 1625, see Fumaroli 1995, 96.

11. Denis 2007a, 155, 163n14.

12. Regarding the decoration of the Hall of Constantine, see Paris 2012–13b, 38–41, 75, 81–82, 326.

13. The identification of the individual subjects, and their chronological order, has been a matter of debate since the eighteenth century. The sequence quoted here derives from the study of Brosens 2011c, 187–240.

14. Brosens 2011c, 247–341, 365–66.

15. The mission of the papal legation was to settle a dispute arising from the 1620 massacre of Protestants in the strategic Alpine Valtelline region; see DuBon 1964, 11n38.

16. DuBon 1964; and Bertrand 2005, 49–52, 112–17.

17. Fenaille 1923, 249; Favreau 2005, 62, 64n8; Vittet and Brejon de Lavergnée with de Savignac 2010, 39 (inv. no. 11).

18. Some motifs previously appeared in borders woven for early editions of Rubens's first tapestry series, *The Story of Decius Mus*; see Herrero Carretero 2007, 97.

19. Denis 2007a, 158.

20. Vittet and Brejon de Lavergnée with de Savignac 2010, 109–15 (inv. no. 46). Isabelle Denis has noted that the cartoons used by the Faubourg Saint-Germain workshop had been modified by the artist Laurent Guyot. This would explain the rather curious statement made by the late seventeenth-century historian and art theorist André Félibien ascribing the designs of *The Story of Constantine* to Guyot; see Félibien (1685) 1792, 4:8; and Denis 2007a, 161. The occasion of the papal apology was commemorated as a tapestry subject, the *Audience of the Papal Legate Flavio Chigi of July 29, 1664*, which formed part of the famed *Story of the King* series; see Meyer 1980, 69–74. On the relationship between France and the Papal states during the reign of Louis XIV until 1690, see Fumaroli 1995.

The Story of Constantine continued to have an impact on eighteenth-century French tapestry production. In the 1750s, François Finet (1719–1767) prepared tapestry cartoons for the Royal Manufactory of Aubusson after engravings of Rubens's influential compositions. Painted in grisaille, two of Finet's cartoons survive, including one for *Constantius [I] Appoints Constantine as His Successor*. Faithful to the print, executed 1742–46 by Nicolas-Henri Tardieu (1674–1749), that cartoon incorporated an inscription with the variant title, *Entrevue de Constantine et de Crispe son Fils* (Interview between Constantine and his son Crispus); see Bertrand 2013a, 33–35.

21. Vittet and Brejon de Lavergnée with de Savignac 2010, 232 (inv. no. 111) and 412 (inv. no. 166).

22. See Bertrand 2007, 343–44, 354nn12–13; and Vittet and Brejon de Lavergnée with de Savignac 2010, *Constantine*, 107–8 (inv. no. 43), 122–27 (inv. no. 49), 154 (inv. no. 64), and renditions of a

variant series called *The Chambers of the Vatican* (which were inaccurately described in the royal inventories as *The Vatican Loggia*), 251–56 (inv. nos. 124–25).

23. Long discussed in the literature by the former title, *Constantine Investing His Son Crispus with Command of the Fleet*, the present identification of this tapestry subject is based on the reinterpretation of Koenraad Brosens, who traced Rubens's historical sources from Cesare Baronius's *Annales ecclesiastici*, 1588–1607, to Socrates Scholasticus's *Church History*, ca. 450, and to Ionnes Zonaras's *Epitome Historium*, twelfth century; see Brosens 2011a; and Brosens 2011c, 187–88. It should be noted, however, that Jules Guiffrey found this subject listed simply as *Constantin recevant le gouvernail* (Constantine receiving the rudder) in the *General Inventory of the Crown's Furniture Warehouse* of 1673; see Guiffrey 1913, 44n2.

24. As identified in the 1627 posthumous inventory of the estate of François de La Planche. Excerpts from the document were published in Brosens 2011c, 366.

25. Vittet and Brejon de Lavergnée with de Savignac 2010, 67–69 (inv. no. 28).

26. Vittet 2010, 60–61, 63, 69n14, 79.

27. They are preserved in the Kunsthistorisches Museum, Vienna, inv. nos. XVIII/1–6; see Denis 2007a; and Brosens 2011c, 349, 354–55.

28. The scholarship still debates the precise meaning of the FM mark, which appears on all ten surviving hangings from this set. The letters have been interpreted as the initials of Filip de Maeght (in French, Philippe de Maecht), who was one of the foremen of the *boutique d'or* (gold shop) at the Faubourg Saint-Marcel workshop prior to emigrating in 1625 to England, where he joined the Mortlake Tapestry Works, Surrey. If this reading of the initials is correct, then the weaving of the present tapestry, *Constantius [I] Appoints Constantine as His Successor*, and others of the set may have begun under his supervision before his departure. Seven of the other hangings bear, in addition to the FM mark, the initials HT for another foreman of the Faubourg Saint-Marcel's gold shop, Hans de Taye. For a summary of the discussion, see Brosens 2011c, 350, 352nn1–6, 354.

29. Fenaille 1923, 41.

30. See n. 26 above.

7 | Stories from the Old Testament

7a.
The Daughter of Jephthah from *Stories from the Old Testament*
Design by Simon Vouet (French, 1590–1649), mid- to late 1630s
Border design attributed, in part, to Jean Cotelle (French, 1607–1676), before 1643
Paris, workshop at the Louvre of Maurice II Dubout (French, d. ca. 1656), begun in the 1640s–completed by 1659
Tapestry: wool and silk
480 × 595 cm (189 × 234¼ in.)
Inscriptions: On the bottom border, in the central cartouche, on the ribbon interlaced with the device of the club of Hercules, the Latin text, ERIT HAEC QUOQUE COGNITA MONST[R]IS (They will be recognized, them also, with their brilliant deeds), which was the motto of Louis XIII
Marks: None[18]
Paris, Mobilier National, inv. GMTT 23/2

PROVENANCE

Before 1643, commissioned by Louis XIII, king of France (1601–1643, r. from 1610); 1663, delivered to the Crown's Furniture Warehouse, as one of an incomplete set of tapestries; 1666, French royal collection, inv. no. 21 (of the tapestries with wool and silk, incomplete sets); by succession, Mobilier National, Paris

SELECTED BIBLIOGRAPHY

Guiffrey 1885–86, 1:371 (inv. no. 21); Guiffrey 1913, 36; Fenaille 1923, 313, illus. opposite 318; Versailles 1967, 18 (cat. no. 26), 64, 67 (plate 67); Brejon de Lavergnée, Barbara 1987, 66–67 (cat. nos. 35–36); Lavalle 1990–91, 491–93, 504–6 (cat. no. 143), 508–9; Chambord 1996, 145–46; Reyniès 1999, 22–25; Paris 2002, 160–61 (cat. no. 90); Bertrand 2005, 51, 157n59; Favreau 2005, 47, 63, 66n75; Vittet 2007b, 164–65; Vittet 2007c, 190–91; Bertrand 2009c, 297–99; Vittet and Brejon de Lavergnée with de Savignac 2010, 432 (inv. no. 21); Bucharest 2011–12, 34–35 (cat. no. 2); Favreau 2011, 89nn52–54

NOTES

1. Since 1613, Vouet had been studying and practicing art in Italy, courtesy of a pension from the French Crown. Immersed and respected in the artistic milieu of Rome, he was appointed president of the artists' association there, the Academy of Saint Luke. See Paris 1990–91, 104.

2. Félibien (1685) 1972, 4:80, 82; Versailles 1967, 22; and Vittet 2007b, 168n1.

3. Denis 2007b, 129–30. On the general production after Vouet, see Lavalle 1990–91; San Francisco 1976–77, 202–11 (cat. nos. 61–64); Bennett 1992, 224–40 (cat. nos. 68–73); Chambord 1996, 143–89; Reyniès 1999; and Bremer-David 2011. Of these tapestry series, three sets of *The Story of Rinaldo and Armida* entered the French royal collection; see Vittet and Brejon de Lavergnée with de Savignac 2010, 40–41 (inv. no. 13), 58–59 (inv. no. 21), 295 (inv. no. 1).

4. Félibien (1685) 1972, 4:88; and Lavalle 1990–91, 489–525. Regarding François Bellin, see Gady 2013. Regarding Jean Cotelle, see Coquery 2002. Regarding Michel Dorigny, see Mérot 1992.

5. Paris 2001, 57n29.

6. Félibien (1685) 1972, 4:81.

7. Brejon de Lavergnée, Barbara 1987, 66–67 (cat. nos. 35, 36); and Paris 2001, 54–57 (cat. no. 13).

8. The painted canvas was listed in the 1639 postmortem inventory of Vouet's first wife, Virginia da Vezzo. The Samson cartoon and another for the Elijah subject then appeared in the subsequent 1649 postmortem inventory of the artist. Given that private commissions of *Stories from the Old Testament* tapestries were in progress from 1643, it can be surmised that the other cartoons were with the weavers when Vouet died. See Vittet 2007b, 164, 168nn4, 7.

9. Lavalle 1990–91, 504–6.

10. Vittet 2007b, 164; and Bertrand 2009c, 297–99.

11. Chambord 1996, 143–89; and Reyniès 1999. On the development of tapestry workshops located in the Faubourgs Saint-Marcel and Saint-Germain, as well as in Amiens, see the summary by Brosens 2007–8, 174–79.

12. Vittet 2004, 174, 178nn21–22.

13. Versailles 1967, 21, 64; and Vittet and Brejon de Lavergnée with de Savignac 2010, 348 (inv. no. 69).

14. A drawing for this profile head is in the Musée du Louvre, Département des Arts Graphiques, RF 28285. See Brejon de Lavergnée, Barbara 1987, 66–67 (cat. no. 36).

15. "D'azure aux trois fleurs-de-lys or" for France and "de gueules à une chaine d'or en triple orle, en croix et en sautoir" for Navarre. The armorial is actually woven in grisaille.

16. Contrary to Denis 2007b, 137, Coural gives the death date of Maurice II Dubout the Younger as 1656; see Versailles 1967, 18, 64; and Vittet and Brejon de Lavergnée with de Savignac 2010, 431–32 (inv. nos. 20, 21).

17. Favreau 2005, 63, 66n75. Even though the tapestries were not technically inherited by Louis XIV, he did inherit the commission.

18. Weavers operating under royal privilege in the Louvre workshop did not have to mark their hangings produced for the Crown, but from 1607, tapestries produced in the workshops operated by the immigrants Marc de Comans (1563–1644) and François de La Planche (1573–1627) did have to be identified with woven marks in order to distinguish them from hangings being illegally imported and sold in France. The absence or presence of a woven mark was no guarantee of origin, however, as the perimeter selvages that contained such marks could be easily replaced without damage to the border or narrative field; see Denis 2007b, 124; and Brosens 2011b, 39.

8 | The Portiere of the Chariot of Triumph

8a.
The Portiere of the Chariot of Triumph
Design by Charles Le Brun (French, 1619–1690), ca. 1662–63
Cartoon attributed to Beaudrin Yvart (French, 1611–1690), ca. 1662–63
Paris, Royal Furniture Manufactory of the Crown at the Gobelins, in the low-warp workshop of Jean de La Croix (French, d. 1714, foreman of the first low-warp workshop 1662–1712), 1699–1703, or possibly in the low-warp workshop of Jean de La Fraye (French, ca.1655–1730, foreman of the fourth low-warp Gobelins workshop from 1699), 1715–17
Tapestry: wool and silk
357.5 × 277.8 cm (140¾ × 109⅜ in.)
Inscriptions: Woven into the ribbon entwined with the balance scales in the pictorial field: NEC / PLVRIBVS / IMPAR (Not unequal to many [tasks])
Marks: Inscribed in ink on a portion of an early, perhaps the original, lining with the text, *Nᵒ 194. Portᵉ Du Char,/6: Sur 3: aus. [aunes] de haut -/2:au [aunes] de Cours* and, inverted, *10-6 six pieces/8 S[or 5?]20*
Los Angeles, J. Paul Getty Museum, acc. no. 83.DD.20

PROVENANCE

October 27, 1717, as one of a group of six delivered to the Crown's Furniture Warehouse; French royal collection inv. no. 194 (of the tapestries with wool and silk); Madame Fulco de Bourbon, New York; by descent to her son, Michael de Bourbon, Pikeville, Kentucky; 1983, J. Paul Getty Museum, Los Angeles

SELECTED BIBLIOGRAPHY

Guiffrey 1892b, 3, 10 (inv. no. 194); Fenaille 1903, 19–22; Bremer-David 1997, 2–9 (cat. no. 1); Wilson and Hess 2001, 150 (cat. no. 300); Marchesano 2010, 31–32, 37n77

NOTES

1. A quote from the king himself, printed in Nèraudau 1986, 30–31.

2. For a comprehensive survey of this vast topic, see Versailles 2009.

3. Bertrand 2007.

4. Maurice Fenaille summarized the production of the Maincy manufactory, including the sequence of armorial portieres, in his magisterial work, but other scholars have clarified, corrected, and contributed many essential and important facts; see Fenaille 1903, 1–24; Cordey 1922; Montagu 1962; Bertrand 2007, 341–44; Brosens 2011c, 102–5; the essay by Vittet, this catalogue; and Knothe forthcoming [2015].

5. Nicolas Fouquet was superintendent of finance from 1653 until his arrest on suspicion of embezzlement in August 1661; he was sentenced to life imprisonment. Vittet and Brejon de Lavergnée with de Savignac 2010, 109 (inv. no. 45); 337 (inv. no. 58).

6. One drawing is in the Musée des Beaux-Arts et d'Archéologie, Besançon, inv. no. D. 1786, and the other is in the State Hermitage Museum, Saint Petersburg, inv. no. 18959; see Montagu 1962; Bremer-David 1997, 2–9 (cat. no. 1); and Vittet and Brejon de Lavergnée with de Savignac 2010, 337 (inv. no. 58).

7. Montagu 1962, 531; and Standen 1999.

8. Vittet and Brejon de Lavergnée with de Savignac 2010, 106–7

(inv. no. 42); 149 (inv. no. 62). Designs for two other portieres, one with unicorn(s) and the other with lion(s), have been noted, but none of the extant tapestries corresponding to these descriptions bear the arms of the king. Rather, they are emblazoned with the heraldic serpent of Jean-Baptiste Colbert; see Fenaille 1903, 23; Bremer-David 1997, 2–9; *La Gazette de l'Hôtel Drouot* 11 (March 16, 2001): 120; and Standen 1999. More designs by Claude III Audran (1658–1734) for portieres with unicorns supporting the Colbert armorial shield are in the Nationalmuseum, Stockholm, NMH CC I 53, 54, 54B.

9. The drawing is in the École des Beaux-Arts, Paris, inv. Masson 2536; see Paris 2001, 309–12 (cat. no. 80); and, for the dating, Montagu 1962, 532.

10. Montagu 1962; Paris 2008, 42; and Dumonthier 1910?, 11 (plate 11, no. 2). See also Vittet and Brejon de Lavergnée with de Savignac 2010, 107–8 (inv. no. 43); 122–27 (inv. no. 49); 154 (inv. no. 64).

11. Such as the unnumbered plate included in Lafréry 1544?–1602.

12. Bremer-David 1997, 7, 9n9; and Standen 1999, 131, 134n30. The expanded motto was intended to be understood as "not unequal to the most numerous tasks" and, as the sun shines upon many planets, the king likewise governs many realms (or realms dispersed around the globe); see Milovanovic 2009b, 36, 41n14; and Milovanovic 2009a, 180, 184. See also Nèraudau 1986; and Ziegler 2010, 21–54. Final citation courtesy of Pascal-François Bertrand.

13. The last weavings of *Chariot of Triumph* portieres were not delivered to the Crown's Furniture Warehouse, however, until 1743; see Fenaille 1903, 16–24; and Vittet and Brejon de Lavergnée with de Savignac 2010, 149 (inv. no. 62), 232 (inv. no. 110), 340 (inv. no. 61), 416 (inv. no. 175), 420 (inv. nos. 181, 183).

14. Four examples containing gilt metal–wrapped thread were burned by a decree of the Directoire government dated June 10, 1797, yielding 152 *marcs*; see Guiffrey 1887.

15. Fenaille 1903, 16, 19. Joseph Yvart was paid 550 livres and Mathieu 690 livres from December 1714 to February 1715; see Guiffrey 1881–1901, vol. 5, columns 793–94.

16. Two of the twenty-four came from the group of six inventoried as no. 194. Meyer 1989.

17. The serpent as a symbol of vice and rebellion was a recurring convention in the visual and performing arts commissioned under Louis XIV; see Los Angeles 2010, 76.

18. "D'azur aux trois fleurs-de-lys or" for France and "de gueules à une chaine d'or en triple orle, en croix et en sautoir" for Navarre.

19. Regarding the possibility in May 1694 that foreign heads of state could obtain at a favorable price "charming" armorial portieres from among those brought to a standstill on the abandoned Gobelins looms and have the coats of arms adjusted accordingly, see Weigert and Hernmarck 1964, 66.

20. Fenaille 1903, 19.

21. *Journal du Garde-Meuble de la Couronne, beginning January 6, 1716. And continuing to December 31, 1723*, Archives Nationales (France), O¹ 3309, fol. 224r. Contrary to the transcription published in Guiffrey 1892b, 10 (inv. no. 194), and repeated in Fenaille 1903, 20, the Crown's Furniture Warehouse received six—not four— portieres of the *Chariot of Triumph* on October 27, 1717; it is not possible to ascertain with certainty which six of the eleven portieres woven between 1699 and 1717 as part of this edition were those actually delivered.

22. *Journal du Garde-Meuble de la Couronne, beginning January 6, 1716. And continuing to June 30, 1723*, Archives Nationales (France), O¹ 3338, fol. 246r:

> December 17, 1718, No 55. Three portieres of low-warp tapestry of wool and silk, manufacture of the Gobelins, design by Le Brun, representing in the middle the arms of France and of Navarre and the device of Louis XIIII in a cartouche carried on a chariot of triumph, accompanied by two trophies of armor; The border is a guilloche that encloses bronze-colored fleurs de lis and roses; Two of these portieres has each two and one-

half aunes in width, and the third one, two aunes 5/12 aunes in width by three aunes in height.

Concerning the delivery of February 1, 1743, see *Journal du Garde-Meuble de la Couronne*, among those added after January 29, 1732, Archives Nationales (France), O¹ 3338, fol. 216r:

> No 215 in silk. Twelve portieres of low-warp tapestry, wool and silk, design of Le Brun, Gobelins manufactory, representing in the middle the arms and the device of Louis XIV on a cartouche carried on a chariot of triumph accompanied by trophies of armor. The border is a guilloche that encloses fleurs-de-lys and bronze-colored roses, each having two aunes in width by three aunes in height.

See also Guiffrey 1892b, 14, 25–26. Citation courtesy of Pascal-François Bertrand.

9 | The Seasons

9a.
Autumn from *The Seasons*
Design by Charles Le Brun (French, 1619–1690), with the collaboration of Adam Frans van der Meulen (Flemish, 1632–1690, act. Paris from 1664) on the hunt scene in the medallion, 1664
Border design by Issac Moillon (French, 1614–1673), 1664¹⁵
Cartoon attributed to Beaudrin Yvart (French, 1611–1690), by 1667
Paris, Royal Furniture Manufactory of the Crown at the Gobelins, in the high-warp workshop of Jean Jans the Elder (Flemish, ca. 1618–1691, act. France and foreman of the first high-warp workshop from 1662), before 1669
Tapestry: wool, silk, and gilt metal–wrapped thread
480 × 580 cm (189 × 228⅜ in.)
Inscriptions: Bottom border, in the central cartouche, DELIA NVNC DAPIBVS MENSAS ONERABIT INEMPTIS / BACCHE MERVM FVNDES; QVIS MELIORA DABIT? / TV DIVVM SOBOLES, LODOIX, QVI DIVITE DEXTRA / VIRTVTI EXIMIÆ [MVNERA] LARGA PARAS. (Diane regales us with delicious treats, Bacchus his good wine; Who gives better? These are yours, Great King, whose liberal hand spreads your glorious benefits.)¹⁶ Woven into the emblematic roundels in the border (clockwise from upper left), PRÆSTANT INTERNA CORONÆ (Guaranteed the internal crown), ET FVLMINIS OCYOR ALIS (Quicker than the wings of thunder), CRESCIT IN IMMENSVM (Increases enormously), DVCIT ET EXCITAT AGMEN (Leads and excites the column)
Marks: On the outer white band, bottom right, the initials I • I • (for Jean Jans the Elder)
Paris, Mobilier National, inv. GMTT 107/2

PROVENANCE
April 24, 1669, as one of a group of four tapestries delivered to the Crown's Furniture Warehouse, initially inventoried as no. 76 (of the tapestries enhanced with gold) but, on October 27, 1683, joined with four *entrefenêtre* tapestries of *The Seasons* to create a set of eight hangings; French royal collection inv. no. 93, the newly combined set of eight hangings (of the tapestries enhanced with gold); by succession, Mobilier National, Paris

SELECTED BIBLIOGRAPHY
Guiffrey 1878–84, 1:124, unnumbered plate; Guiffrey 1885–86, 1:310 (inv. no. 76), 314–15 (inv. no. 93); Fenaille 1903, 72, 74, 78–80, 83; Guiffrey 1913, 58; Gastinel-Coural 1998a, 82; Gastinel-Coural 1998b, 112–13; Grivel and Fumaroli 1988, 108; Richefort 2004, 72–73; Brosens 2008b, 252n21; Vittet and Brejon with de Savignac 2010, 142–47 (inv. no. 58), 168 (inv. no. 76), 206 (inv. no. 93); Vittet 2011c, 188–89; Hans 2012

NOTES
1. Knothe 2010.
2. The potential of the allegorical subjects was recounted by Charles Perrault (1628–1703), a member of the Petite Academy involved in conceiving the emblematic program of *The Seasons* and *The Elements*; see Perrault 1909, 39; Gastinel-Coural 1998b, 113, 118n24; and Sabatier 2010, 86–98.
3. Bertrand 2007, 345; and Knothe 2007b.
4. In the words of Isabelle Denis, the program of *The Seasons* presented a veritable cosmology of glory to Louis XIV. As an educated, powerful prince, his taste for wealth and honors was tempered by respect for faith, justice, and the humanistic belief that man is superior to his fate; see Denis 1991, 25.
5. For the reidentification of the sites and events portrayed in these medallions, see Sauvel 1963, 61–68; Richefort 2004, 73; and Brosens 2008b.
6. These emblems were also excerpted and presented as miniatures in illuminated manuscripts prepared for the king by the painter Jacques Bailly (1629–1679). For summaries of the print, book, and illuminated manuscript editions, see Préaud 1980, 58–77 (nos. 1541–97); Grivel and Fumaroli 1988; Knothe 2007b, 362–64; Sabatier 2010, 89; and Marchesano 2015a.
7. The borders of *Earth* deviated slightly however, in that two miniature townscapes, featuring Dunkerque and the Parisian embankment known as the Conference, sometimes substituted for the customary royal ciphers of the lateral cartouches. See n. 15, below. See also Vittet and Brejon de Lavergnée with de Savignac 2010, 129 (inv. no. 53), 132 (fig. 105).
8. Fenaille 1903, 50–83; and Vittet and Brejon de Lavergnée with de Savignac 2010, 128 (inv. no. 51), 129–36 (inv. nos. 53, 54), 142–48 (inv. nos. 58–60), 154–55 (inv. nos. 65, 66), 168 (inv. nos. 75, 76), 170 (inv. no. 82) 206 (inv. no. 93).
9. Bremer-David 1986, 108n14.
10. Fenaille 1903, 84–97; and Vittet and Brejon de Lavergnée with de Savignac 2010, 212–17 (inv. no. 95), 260 (inv. no. 128).
11. Félibien 1690, 112.
12. The associated explanatory texts and verses were included in Félibien 1690, plates 25–28. See also Préaud 1980, 66–67 (nos. 1570–73).
13. The high-warp cartoon for *Autumn* survives in sections, including a piece that portrays the goddess Diana and part of the roundel she holds. The sections are divided between the Musée du Louvre and the Mobilier National. Information courtesy of Jean Vittet. See Compin and Roquebert 1986, 4:43 (inv. no. 3003).
14. Vittet 2011c, 188–89.
15. The border follows the one painted by Isaac Moillon and others for *Earth* in the companion series of *The Elements*.
16. The French version of the Latin text is, "De mets délicieux Diane nous régale, Bacchus de ses bons Vins; Quels presens valent mieux? Ce sont les tiens, Grand Roy dont la main liberale. Répand sur la vertu tes bienfaits glorieux"; see Félibien 1690, 111–12.

10 | The Story of Alexander

10a.
The Queens of Persia at the Feet of Alexander from *The Story of Alexander*
Design by Charles Le Brun (French, 1619–1690), 1661
Cartoon for the high-warp loom by Henri Testelin (French, 1616–1695),²⁹ by 1664
Paris, Royal Tapestry Manufactory / Royal Furniture Manufactory of the Crown at the Gobelins, in the high-warp workshop of Jean Jans the Elder (Flemish, ca. 1618–1691, act. France and foreman of the first high-warp workshop from 1662), ca. 1664, probably by 1670
Tapestry: wool, silk, and gilt metal– and silver-wrapped thread
486 × 691 cm (191⁵⁄₁₆ × 272¹⁄₁₆ in.)

Inscription: Woven on the ribbon entwined in the armorial and military trophy of the top border and in the ribbons of the border motif at left and right: NEC PLVRIBVS IMPAR (Not unequal to many [tasks]). Bottom border, in the central cartouche: SVI VICTORIA INDICAT REGEM (It is for a king to vanquish himself)
Marks: On the outer blue selvage, bottom right, the initials I • I • (for Jean Jans the Elder)
Paris, Mobilier National, inv. GMTT 84

PROVENANCE
Probably one of three pieces delivered on November 17, 1670, to the Crown's Furniture Warehouse;[30] October 27, 1683, one of the twelve pieces comprising inv. no. 74 (of the tapestries enhanced with gold); by succession, Mobilier National, Paris

SELECTED BIBLIOGRAPHY
Guiffrey 1885–86, 1:309 (inv. no. 74); Fenaille 1903, 172–73, 184; Guiffrey 1913, 62; Janneau 1933, 78, 89; Gastinel-Coural 1998a, 76; Knothe 2007a, 371; Paris 2008, 44, 57, 72–73, 108; Vittet 2008, 68, 71, 73; Kirchner 2008, 245–46, 440–41n481; Vittet and Brejon de Lavergnée with de Savignac 2010, 160–67 (inv. no. 74); Vittet 2011c, 188–91; Bertrand 2011; Bonfait 2011, 72, 75nn64–66; Kirchner 2013, 89–90, 134n181

10b.
Male Nude, Standing, study for *The Queens of Persia at the Feet of Alexander*
Charles Le Brun (French, 1619–1690), ca. 1661
Preparatory drawing: red chalk heightened with white chalk on beige paper
43.3 × 28.8 cm (17 1/16 × 11 5/16 in.)
Paris, Musée du Louvre, Département des Arts Graphiques, inv. 28010

PROVENANCE
Workshop of Charles Brun; 1690, Louis XIV, king of France, Cabinet des Dessins du Roi; by succession, Musée du Louvre, Paris

SELECTED BIBLIOGRAPHY
Paris 1984, 110 (cat. no. 145); Beauvais, Lydia 2000, 1:464–65 (cat. no. 1671); Paris 2008, 82; Kirchner 2013, 36–39

10c.
Draped Female, Arms at Waist Level, study for *The Queens of Persia at the Feet of Alexander*
Charles Le Brun (French, 1619–1690), ca. 1661
Preparatory drawing: red chalk heightened with white chalk on beige paper
44.6 × 29 cm (17 9/16 × 11 7/16 in.)
Paris, Musée du Louvre, Département des Arts Graphiques, inv. 29126

PROVENANCE
Workshop of Charles Brun; 1690, Louis XIV, king of France, Cabinet des Dessins du Roi; by succession, Musée du Louvre, Paris

SELECTED BIBLIOGRAPHY
Paris 1962, 66 (cat. no. 57); Beauvais, Lydia 2000, 1:466 (cat. no. 1681); Paris 2008, 84

10d.
The Battle of Arbela (right section of three parts) from *The Story of Alexander*
Design by Charles Le Brun (French, 1619–1690), 1669
Cartoon for the high-warp loom by Louis Licherie (French, 1629–1687), Gabriel Revel (French, 1643–1712), and/or Joseph Yvart (French, 1649–1728),[31] ca. 1669
Paris, Royal Furniture Manufactory of the Crown at the Gobelins, in the high-warp workshop of Jean Jans the Younger (Flemish,

ca. 1644–1723, act. France and foreman of the first high-warp workshop from 1668) or Jean Lefebvre (French, act. until 1700, foreman of the second high-warp workshop 1662–99), ca. 1670–76/77
Tapestry: wool, silk, and gilt metal– and silver-wrapped thread
480 × 367 cm (189 × 144½ in.)
Inscription: Written on the antique lining in ink is a succession of inventory numbers, the earliest of which states, *Nᵒ 74. ALEX / 11 P. 4 ["] 1/2 [de haut] • 3 1/6 [de cours]*
Marks: None
Paris, Mobilier National, inv. GMTT 92

PROVENANCE
One of two narrow panels of *The Battle of Arbela*, the first delivered by August 12, 1676, and the second on December 10, 1677, to the Crown's Furniture Warehouse;[32] October 27, 1683, one of the twelve pieces comprising inv. no. 74 (of the tapestries enhanced with gold); by succession, Mobilier National, Paris

SELECTED BIBLIOGRAPHY
Guiffrey 1885–86, 1:309 (inv. no. 74); Fenaille 1903, 172–73, 184; Janneau 1933, cover and 78; Gastinel-Coural 1998a, 76; Knothe 2007a, 371–72nn3, 7; Paris 2008, 44, 47, 60, 74–77, 108; Vittet 2008, 67, 71, 73; Kirchner 2008, 245–46, 440–41n481; Vittet and Brejon de Lavergnée with Savignac 2010, 160–67 (inv. no. 74); Vittet 2011c, 188–91; Bertrand 2011; Bonfait 2011, 65, 74nn1–3

10e.
The Entry of Alexander into Babylon from *The Story of Alexander*
Design by Charles Le Brun (French, 1619–1690), by 1665
Cartoon for the high-warp loom by Henri Testelin (French, 1616–1695),[33] ca. 1665
Paris, Royal Tapestry Manufactory / Royal Furniture Manufactory of the Crown at the Gobelins, in the high-warp workshop of Jean Jans the Elder (Flemish, ca. 1618–1691, act. France and foreman of the first high-warp workshop from 1662) or Jean Jans the Younger (Flemish, ca. 1644–1723, act. France and foreman of the first high-warp workshop from 1668) or Jean Lefebvre (French, act. until 1700, foreman of the second high-warp workshop 1662–99), ca. 1665, probably by 1676
Tapestry: wool, silk, and gilt metal– and silver-wrapped thread
495 × 810 cm (194⅞ × 318⅞ in.)
Inscription: Woven on the ribbon entwined in the armorial and military trophy of the top border, NEC PLVRIBVS IMPAR (Not unequal to many [tasks])
Marks: None
Paris, Mobilier National, inv. GMTT 82/3

PROVENANCE
Possibly one of three pieces delivered on November 17, 1670, or one of the four pieces delivered August 12, 1676, to the Crown's Furniture Warehouse;[34] October 27, 1683, one of the twelve pieces comprising inv. no. 74 (of the tapestries enhanced with gold); by succession, Mobilier National, Paris

SELECTED BIBLIOGRAPHY
Guiffrey 1885–86, 1:309 (inv. no. 74); Fenaille 1903, 172–73, 184; Guiffrey 1913, 62; Gastinel-Coural 1998a, 76; Knothe 2007a, 371; Paris 2008, 44, 61, 66–67, 76–77, 108; Vittet 2008, 69, 71, 73; Kirchner 2008, 245–46, 440–41n481; Vittet and Brejon de Lavergnée with Savignac 2010, 160–67 (inv. no. 74); Bucharest 2011, 40–43 (cat. no. 4); Bertrand 2011, 43–63; Vittet 2012e

10f.
Youth, Seated, study for *The Entry of Alexander into Babylon*
Charles Le Brun (French, 1619–1690), ca. 1664
Preparatory drawing: red chalk heightened with white chalk on beige paper
35.6 × 41.9 cm (14 × 16½ in.)

Paris, Musée du Louvre, Département des Arts Graphiques, inv. 29642

PROVENANCE
Workshop of Charles Brun; 1690, Louis XIV, king of France, Cabinet des Dessins du Roi; by succession, Musée du Louvre, Paris

SELECTED BIBLIOGRAPHY
Beauvais, Lydia 2000, 1:471 (cat. no. 1704)

10g.
Two Males, Nude, Standing, study for *The Entry of Alexander into Babylon*
Charles Le Brun (French, 1619–1690), ca. 1664
Preparatory drawing: red chalk heightened with white chalk on beige paper
55.5 × 40.1 cm (21⅞ × 15 13/16 in.)
Paris, Musée du Louvre, Département des Arts Graphiques, inv. 29187

PROVENANCE
Workshop of Charles Brun; 1690, Louis XIV, king of France, Cabinet des Dessins du Roi; by succession, Musée du Louvre, Paris

SELECTED BIBLIOGRAPHY
Paris 1962, 66 (cat. no. 53); Beauvais, Lydia 2000, 1:471 (cat. no. 1699)

10h.
The Entry of Alexander into Babylon
Design by Charles Le Brun (French, 1619–1690), by 1665
Cartoon for the horizontal loom by François Bonnemer (French, 1637–1689), Guy-Louis Vernansal (French, 1648–1729), Gabriel Revel (French, 1643–1712), and/or Joseph Yvart (French, 1649–1728),[35] before 1690
Cartoon: oil on canvas
The four bands of this partial cartoon are now joined in pairs and mounted on two stretchers, left: 317 × 192 cm (124 13/16 × 75 9/16 in.) and right: 317 × 195 cm (124 13/16 × 76¾ in.)
Paris, Mobilier National, inv. Gob 704

PROVENANCE
By 1690, Paris, Royal Furniture Manufactory of the Crown at the Gobelins; by succession, Mobilier National, Paris

SELECTED BIBLIOGRAPHY
Paris 2008, 48, 51n35; Brejon de Lavergnée with Caillon 2008, 38–39

10i.
View of the Gallery in the Royal Hôtel at the Gobelins
Sébastien Le Clerc (French, 1637–1714), 1694
Preparatory drawing: pen and brown ink, gray wash, and black and red chalk heightened with white on cream paper
11.9 × 23.3 cm (4⅝ × 9 3/16 in.)
Inscription: On the mount, in graphite: *très joli dessin original de Sebastien le Clerc, à la plume, lavè à l'encre de chine. Entièrement conforme / à la gravure et de même dimensions (Jombert 257-1) / (au revers un charmant croquis à la mine de plomb: la Danse de Marmot ?)* (very nice original drawing by Sebastien Le Clerc, pen, washed with ink. Conforms fully / to the engraving and of the same dimensions (Jombert 257-1) / (the reverse a charming pencil sketch: the Dance by Marmot ?)
Paris, Mobilier National, inv. GMTB 675

PROVENANCE
1896, Mobilier National, Paris

SELECTED BIBLIOGRAPHY

Jombert 1774, 2:110–12 (cat. no. 257-1); Vallery-Radot 1953, 126, 205; Knothe 2007a, 371, 372n21; Paris 2008, 102–3; Vittet 2008, 75; Bertrand 2011, 63

NOTES

1. Posner 1959; Beaussant 2008, 14–17; and Kirchner 2008, 236, 251–52, 439–40nn467–69.
2. Cojannot-Le Blanc 2011, 392; and Bertrand 2007, 347, 355n29.
3. On this subject, see Marchesano 2010.
4. Louis XIV had read a French translation of Quintus Curtius Rufus's biography of Alexander in the spring of 1658 during the siege of Dunkerque; see Cojannot-Le Blanc 2011, 371–95; Vittet 2008; and Bertrand 2011.
5. Marchesano 2015a.
6. On the evolution of the project from a single painting into a tapestry series, see Bertrand 2011, 50–53, especially n. 24; and Bonfait 2011.
7. Art historians list these subjects in three ways: in chronological order by historical date (*The Battle of Granicus* [334 BC], *The Battle of Arbela* [331 BC], *The Entry of Alexander into Babylon* [331 BC], and *The Wounded Porus before Alexander* [at the Battle of the Hydaspes River, 326 BC]), in order of execution (namely, *Granicus* and *Babylon* by September/October 1665, when they were viewed at the Gobelins by Gian Lorenzo Bernini, followed by *Arbela* in 1669, and *Porus* by 1673), or in ascending order following the rising crescendo of the moralizing lessons conveyed in the Latin verses. Those verses culminate with the phrase "thus by virtue heroes rise," corresponding with *Babylon*. A contemporary source, the *Mercure Galant* of November 1686, utilized this last arrangement when it presented a catalogue of Le Brun's prints, which included engraved versions of the five Alexander scenes. For an idea of how one battle subject may have been displayed for Bernini's visit to the Gobelins, see the tapestry portraying the king's visit to the Gobelins on October 15, 1667, fig. 23, this catalogue, and Meyer 1980, 109–14. For the surviving drawings, see Beauvais, Lydia 2000, 1:462–531 (cat. nos. 1669–1952); and Paris-Bergues 2012, 144–45 (cat. no. 36). Citation courtesy of Jean Vittet. Regarding Le Brun's compositional sketches for additional scenes from the life of Alexander, see Vittet 2008, 70–71.
8. Regarding the decoration of the Hall of Constantine at the Vatican, see Paris 2012–13b, 38–41, 75, 81–82, 326.
9. Kirchner 2008, 236, 251–52, 439–40nn467–69. Kirchner's comprehensive analysis of Le Brun's *Alexander* cycle surveys the possible locations for which the gigantic paintings may have been originally intended.
10. That impressive François I set of twenty-two pieces no longer survives, but it is documented in the French royal inventories. It is known indirectly now thanks to the late seventeenth-century copy of a smaller version of the series, which was woven at the Royal Furniture Manufactory of the Crown at the Gobelins (see entry 4, this catalogue). This later set is displayed today at the Musée du Louvre. See Vittet and Brejon de Lavergnee with de Savignac 2010, 32–33 (inv. no. 3), 320–29 (inv. no. 43), 395 (inv. no. 159).
11. Paris 2008, 72–73.
12. Félibien 1663, quoted in Parsons 1704, 26–27. Regarding Claude Nivelon's account in *Vie de Charles Le Brun*, see Cojannot-Le Blanc 2011, 388–95. Citation courtesy of Bénédicte Gady.
13. Brejon de Lavergnée with Caillon 2008. The cartoon for *The Queens of Persia at the Feet of Alexander*, painted by Henri Testelin for the high-warp loom, was subsequently mounted in 1861 into the ceiling of the antechamber of the great dining hall at the Château of Versailles; see Milovanovic 2010, 62, 85–98; and Kirchner 2013, 87–89.
14. Bonfait 2011, 65, 74nn1–3.
15. Fenaille 1903, 166–85; Paris 2008; and Vittet and Brejon de Lavergnée with de Savignac 2010, 155 (inv. no. 67), 155–56 (inv. no. 70), 160–67 (inv. no. 74), 169 (inv. nos. 80, 81), 218 (inv. nos. 96, 97), 230 (inv. no. 104), 287–88 (inv. nos. 18–22).

16. Knothe 2007a.
17. Michel, Christian 2010.
18. Vittet 2008, 75; and Bertrand 2013a, 28, 34–35, 58, 61, 69, 76nn41, 42, 45.
19. Bertrand 2011, 63. Another version of this drawing exists, executed in red and black chalk, with gray and brown wash over a red chalk counterproof, 12 × 23.9 cm (4¾ × 9⁷⁄₁₆ in.), in the Fogg Museum, Cambridge, Massachusetts, acc. no. 1979.58. See Cambridge-Tampa 1984, 35–36 (cat. no. 25), 102 (illus.).
20. Quintus Curtius Rufus, *Historiae Alexandri Magni* (first century AD), book 3, chapter 12, verses 15–16. Le Brun had access to new editions of the biography, such as *Histoire d'Alexandre le Grand, tirée de Quinte-Curce et autres auteurs* (Paris: J. Camusat, 1639), and *De la vie et des actions d'Alexandre Le Grand*, Claude Favre de Vaugelas, trans. (Paris: Augustin Courbè, 1653). Louis XIV himself was familiar with the 1653 French translation by de Vaugelas; see Milovanovic 2012; and Los Angeles 2010, 60n1.
21. See Marchesano 2010, 24.
22. Wide tapestries portraying the central portion of *The Battle of Arbela* bear a cartouche with the Latin verse DIGNA ORBIS IMPERIO VIRTUS (Virtue is worthy of the empire of the world); see Fenaille 1903, 170.
23. Quintus Curtius Rufus and several other ancient historians described the triumphal entry of Alexander into Babylon; see Los Angeles 2010, 74–76 (cat. no. 7).
24. The phrase in Latin is *sic virtus evehit ardens*. It not known why some *Story of Alexander* tapestries, even within the same set, have blank cartouches while others bear the French translations; see Fenaille 1903, 171; and Paris 2008, 47, 51.
25. Concerning NEC PLVRIBVS IMPAR (Not unequal to many [tasks]), this motto was intended to convey the king's ability to attend to the most numerous tasks and, as the sun shines on many planets, his ability to govern many realms (or realms dispersed around the globe); see Milovanovic 2009a, 180, 184; Milovanovic 2009b, 36, 41n14; and Nèraudau 1986. See also entry 8, n. 12, this catalogue.
26. This memorandum is discussed extensively in Knothe forthcoming [2015].
27. *Memoire de Jean Jan le Fils (1692) relatif aux tapisseries de haute lisse produites par la Manufacture des Gobelins entre 1662 et 1691*, Archives Nationales (France), o¹ 2040/A. An extract is printed in Paris 2008, 44, 106–7.
28. *Le Nouveau Mercure Galant*, July 1677, 50–54; and Vittet 2011c, 188–91.
29. Brejon de Lavergnée with Caillon 2008, 37.
30. Paris 2008, 44, 51n20, 108. See also Vittet and Brejon de Lavergnée with de Savignac 2010, 160 (inv. no. 74).
31. Brejon de Lavergnée with Caillon 2008, 35–36.
32. See n. 30, above.
33. Brejon de Lavergnée with Caillon 2008, 39.
34. See n. 30, above.
35. Brejon de Lavergnée with Caillon 2008, 38–39.

II | The Royal Residences / The Months of the Year

11a.
Study of Purple Swamphens (or *Study of Purple Rails*)
Pieter Boel (Flemish, 1622–1674, act. France from ca. 1668), ca. 1668
Black, white, and colored chalks on light brown paper
28.8 × 43.5 cm (11⁵⁄₁₆ × 17⅛ in.)
Paris, Musée du Louvre, Département des Arts Graphiques, inv. 19389, recto

PROVENANCE
Louis XIV, Cabinet des Dessins du Roi; by succession, Musée du Louvre, Paris

SELECTED BIBLIOGRAPHY

Lugt 1949, 1:6 (cat. no. 222), plate 11; Standen 1985, 2:394, 396, 401n14; Foucart-Walter 2001, 92 (cat. no. 15); Foucart-Walter and Pinault Sørensen 2001, 51–57

11b.
Château of Monceaux / Month of December from *The Royal Residences / The Months of the Year*
Design conceived by Charles Le Brun (French, 1619–1690), ca. 1665–by 1668
Cartoon for the high-warp loom painted collaboratively by Beaudrin Yvart (French, 1611–1690), Jean-Baptiste Monnoyer (Flemish, 1636–1699, act. France ca. 1650/55–90/92), Pieter Boel (Flemish, 1622–1674, act. France from ca. 1668), Guillaume Anguier (French, 1628–1708), Adam Frans van der Meulen (Flemish, 1632–1690, act. Paris from 1664), Abraham Genoels (Flemish, ca. 1640–1723, act. Paris 1659–72), Adriaen-Frans Boudewyns (called Baudoin; Flemish, 1644–1711), and Garnier (possibly Jean; French, 1632–1705), by 1668
Paris, Royal Furniture Manufactory of the Crown at the Gobelins, in the high-warp workshop of Jean Jans the Younger (Flemish, ca. 1644–1723, act. France and foreman of the first high-warp workshop from 1668) or in the high-warp workshop of Jean Lefebvre (French, act. until 1700, foreman of the second high-warp workshop 1662–99), ca. 1668–76
Tapestry: wool, silk, and gilt metal–wrapped thread
400 × 660 cm (157½ × 259¹³⁄₁₆ in.)
Marks: On the inner white band of the lower border, bottom right, the initials I • L • F • (for either Jean Jans the Younger or Jean Lefebvre).²⁶ Inscribed in ink on the antique lining is a succession of inventory numbers, the earliest of which is *Nᵒ 83. Mais' Roy / 12 P. 3 au 1/2 de haut. / 5 au (?) 7/12 de cours*
Paris, Mobilier National, inv. GMTT 108/12

PROVENANCE
June 20, 1677, as one of four tapestries delivered to the Crown's Furniture Warehouse, later joined by five tapestries delivered on December 20, 1677, and inventoried together as no. 69 (of the tapestries enhanced with gold);²⁷ then joined with four more tapestries delivered on August 19, 1683, as inv. no. 83; the newly combined set of twelve hangings, inv. no. 83 (of the tapestries enhanced with gold); by succession, Mobilier National, Paris

SELECTED BIBLIOGRAPHY

Guiffrey 1885–86, 1:308 (inv. no. 69), 311 (inv. no. 83); Fenaille 1903, 129–30, 141–44, 146, 163; Guiffrey 1913, 75; Versailles 1951, 61 (cat. no. 217); Meyer 1996, 51–53; Bremer-David 1997, 20–27; Bertrand 2007, 349; Vittet and Brejon de Lavergnée with de Savignac 2010, 156 (inv. no. 69), 170–83 (inv. no. 83); Vittet 2011c, 186–89, 197nn65, 64; Castelluccio 2014, 62, 194, 196–97, 252

11c.
Château of Monceaux / Month of December from *The Royal Residences / The Months of the Year*
Design conceived by Charles Le Brun (French, 1619–1690), ca. 1665–by 1668
Cartoon for the low-warp loom painted collaboratively by Joseph Yvart (French, 1649–1728), Abraham Genoels (Flemish, ca. 1640–1723, act. Paris 1659–72), Adriaen-Frans Boudewyns (called Baudoin; Flemish, 1644–1711), François Bonnemer (French, 1637–1689), Jean-Baptiste Martin (called Martin des Batailles or Martin des Gobelins; French, 1659–1735), Le Mire (dates unknown), Manory (dates unknown), François Arvier (dates unknown), and Arnis (dates unknown),²⁸ ca. 1668
Paris, Royal Furniture Manufactory of the Crown at the Gobelins, in the low-warp workshop of Jean de La Croix (French, d. 1714, foreman of the first low-warp workshop 1662–1712), before 1712
Tapestry: wool and silk
317.5 × 330.8 cm (125 × 130¼ in.)

Inscription: Bottom border, in the central cartouche, CHASTE[AU] / DE / MONCEAVX (Château of Monceaux)
Marks: On the blue selvage, bottom right, the initials I • D • L • CROX (for Jean de La Croix)
Los Angeles, J. Paul Getty Museum, 85.DD.309

PROVENANCE

Comte de Camondo (possibly Count Behor Abraham de Camondo, 1829–1889, or his son Count Isaac de Camondo, 1829–1911), Paris (sold Galerie Georges Petit, Paris, February 1–3, 1893, no. 291); by 1903, Gaston Menier, Paris (sold Galerie Charpentier, Paris, November 24, 1936, no. 111); Baron Gendebien-Salvay, Belgium; Vincent Laloux, Brussels; 1985, J. Paul Getty Museum, Los Angeles

SELECTED BIBLIOGRAPHY

Guiffrey (1886) 1978, 361;[29] Journal des arts 1893;[30] Fenaille 1903, 129–30, 160–62; Meiss with Smith and Beatson 1974, 1:206, vol. 2:(unpaginated), fig. 713; Bremer-David 1986; Boccara, Reyre, and Hayor 1988, 205–9; Standen 1990, 49, 51, 52nn10, 13; Standen 1992/93, 8; Bremer-David 1997, 20–27 (cat. no. 3); Wilson and Hess 2001, 149–50 (cat. no. 299); Jolly 2002, 24–25, 377; Malgouyres 2008

NOTES

1. Meiss with Smith and Beatson 1974, 1:206, and 2:(unpaginated) fig. 713.
2. Campbell 2002d, 297–99; and New York 2002, 329–39 (cat. nos. 37–40).
3. Vittet and Brejon de Lavergnée with de Savignac 2010, 82–92 (inv. no. 32).
4. Vittet 2007a; and Meyer 1980.
5. See the essay by Vittet, this catalogue; and Meyer 1996. Concerning the Château of Monceaux, which Louis XIV never visited in person, see Coope 1959.
6. Sauvel 1961.
7. Foucart-Walter and Pinault-Sørensen 2001, 56. On the menagerie at Versailles, see Mabille and Pieragnoli 2010.
8. These woven portrayals are all the more valuable because the precious-metal vessels no longer survive; see Buckland 1983; Mabille 2004; and Mabille 2007.
9. A notation of 1690 by Beaudrin Yvart mentioned "the sketch of Monsieur Le Brun of the Month of April, Versailles," as quoted in Gastinel-Coural 1998b, 122.
10. The memorandum of Adam Frans van der Meulen listed his contributions to the project, as quoted in Fenaille 1903, 131. See also Richefort 2004, 83–88, 228–30 (cat. nos. 74–87).
11. Foucart-Walter and Pinault-Sørensen 2001; and Foucart-Walter 2001, 84–86 (cat. nos. 8–9), 92–93 (cat. no. 15), 96 (cat. no. 19), 111–12 (cat. no. 41), 125–26 (cat. no. 57).
12. Constans 1995, 2:558–60 (cat. nos. 3152–65).
13. Regarding the entrefenêtres en suite, see Standen 1990; and Standen 1992/93.
14. Le Nouveau Mercure Galant, July 1677, 50–54; and Vittet 2011c.
15. Vittet 2011c, 187, 197n55.
16. Bremer-David 1997, 23; and Castelluccio 2014, 62, 64–65, 194, 196–97, 249, 252.
17. Fenaille 1903, 152–55, 163–65; and Bremer-David 1986, 108n14.
18. "D'azur aux trois fleurs-de-lys or" for France.
19. The identification of the purple swamphen, or rail (Porphyrio porphyrio), was kindly provided by Dr. Miguel Sagesse of Western University of Health Sciences, Pomona, California. Pieter Boel's preparatory drawing has traditionally carried the title in French, Études des poules sultanes; see Foucart-Walter 2001, 92–93 (cat. no. 15).
20. Since the documentation concerning the first two editions of The Royal Residences / The Months of the Year is fragmentary and because the sets were delivered piecemeal, it is difficult to outline the precise production chronology; see Fenaille 1903, 141–47, 163;

and Vittet and Brejon de Lavergnée with de Savignac 2010, 169 (inv. nos. 78, 79), 170–84 (inv. nos. 83–85). In July 2012, the inked inventory numbers preserved on the original lining of the present Château of Monceaux / Month of December (see entry 11b, Mobilier National GMTT 108/12) were noted during a viewing of the tapestry at the Mobilier National, Paris. The physical evidence contradicts Fenaille's statement that a second version of the Château of Monceaux / Month of December (GMTT 110) belonged to the set numbered 83 in the General Inventory of the Crown's Furniture. Indeed, Vittet places that Château of Monceaux / Month of December (GMTT 110) within the set numbered 84.
21. Vittet 2011c, 189, 197n64. For insight into the political meaning of such public display on a religious holy day, see Knothe 2010.
22. Fenaille remarked on this, noting how the low-warp Royal Residences / The Months of the Year tapestries measured 2¾ ells or aunes in height (equivalent to 324 cm) versus those from the high-warp looms, which measured 3½ ells (or 413 cm); see Fenaille 1903, 143.
23. On this topic, see Fenaille 1903, 160–62; and Bremer-David 1986.
24. Bremer-David 1986, 24, 27n18.
25. Two entrefenêtres depicting the Jardin des plantes (Botanical garden), each with a parapet like that of the smaller Château de Monceaux / Month of December, are known: one bearing the woven mark I • D • L • CRO[IX], in the Musée du Louvre, Paris, inv. OA 12 182, and the other, without marks, in the Virginia Museum of Fine Arts, Richmond, 66.25. Two other tapestries bearing the same border design and inscribed cartouches but with pierced balustrades instead of parapets could be related: Château of Vincennes / Month of July, with the foreman's woven initials L • D • L, in the Victoria and Albert Museum, London, T.371-1977, and Château of Chambord / Month of September, without a woven mark, in the National Museum of Western Art, Tokyo, OA 1977-1. See Bremer-David 1986, 105–12; Standen 1992/93; and Malgouyres 2008.
26. Generally, the initials woven in this tapestry, I • L • F •, are associated with Jean Jans the Younger (Flemish, ca. 1644–1723), act. France and foreman of the first high-warp workshop from 1668), though Fenaille noted they could have been valid for another foreman, Jean Lefebvre (act. until 1700, foreman of the second high-warp workshop 1662–69); see Fenaille 1903, 146, 178. See also Vittet 2008, 74; and Paris 2008, 42, 51n7.
27. One of the five tapestries delivered on December 20, 1677, Château of Fontainbleau / Month of June, duplicated another one delivered earlier, on June 20, 1677. Authorities at the Crown's Furniture Warehouse therefore set aside this duplicate tapestry as inv. no. 16 (of the tapestries enhanced with gold, "incomplete sets") and then combined it with a different set of The Royal Residences / The Months of the Year, inv. no. 84 (of the tapestries enhanced with gold); see Vittet and Brejon de Lavergnée with de Savignac 2010, 170–84 (inv. nos. 83, 84), 287 (inv. no. 16).
28. Some of the specialist artists working at the Gobelins cannot be identified. The artists were listed in two contemporary documents: a memorandum drawn up in 1692 by the workshop foreman, Jean Jans the Younger, and the other in 1736 by Charles Chastelain (1672–1755), inspector and painter at the Gobelins. In 1988, Chantal Gastinel-Coural clarified the identity of some of them; see Fenaille 1903, 129–30; and Gastinel-Coural 1998b, 110–25. Knothe forthcoming [2015].
29. The caption for a line-drawing illustration lists the Mobilier National as either the source of the image or the location of the tapestry at that time; see Guiffrey (1886) 1978, 361, 529.
30. "Chronique de l'Hôtel Drouot—Ventes artistiques en France et à l'étranger," Le Journal des arts, January 28, 1893, 2; and "Chronique de l'Hôtel Drouot—Ventes artistiques en France et à l'étranger," Le Journal des arts, February 4, 1893, 3–4.

12 | The Gallery of Apollo at the Château of Saint-Cloud

12a.
Winter, Cybele Begs for the Sun's Return from The Gallery of Apollo at the Château of Saint-Cloud
Design by Pierre Mignard (French, 1612–1695), 1677–78
Border design by Rodolphe Parent (French, d. 1694), ca. 1686
Cartoon attributed to Pierre Bourguignon (French, ca. 1630–1698) and retouched by Pierre Mignard, before 1686
Paris, Royal Furniture Manufactory of the Crown at the Gobelins, in the high-warp workshop of Jean Jans the Younger (Flemish, ca. 1644–1723, act. France and foreman of the first high-warp workshop from 1668), 1692–93
Tapestry: wool, silk, and gilt metal–wrapped thread
480 × 625 cm (189 × 246⅛ in.)
Marks: None
Paris, Mobilier National, inv. GMTT 69/4

PROVENANCE

One of five tapestries delivered to the Crown's Furniture Warehouse on May 31, 1704, and grouped with one tapestry, Spring, previously registered in October 1700, in order to compose a set of six pieces inventoried together as no. 119 (of the tapestries enhanced with gold); by succession, Mobilier National, Paris

SELECTED BIBLIOGRAPHY

Guiffrey 1885–86, 1:322 (inv. no. 119); Fenaille 1903, 410–11, 418; Guiffrey 1913, 92; Berger 1993, 20–21, 23, 42–43, 48n26; Paris 1989a, 20–21 (cat. no. 6); Vittet and Brejon de Lavergnée with de Savignac 2010, 245–48 (inv. no. 119); Vittet 2011c; Bertrand forthcoming a; Bertrand forthcoming b [2015]

NOTES

1. Félibien (1666) 1972, 1:282.
2. The tapestry remains in the collection of the Musei Vaticani; see De Strobel 2010, 40; and New York 2002, 143–44, 145n37.
3. For a general discussion of this phenomenon, see Bertrand 2007, 351–53, 355nn45–56; and Bertrand forthcoming b [2015]. Regarding The Story of Moses, see Schotter et al. 2012.
4. Martinez and Martinez 2005.
5. For a comprehensive reconstruction of the lost Mignard decorative scheme for the Château of Saint-Cloud, see Berger 1993. For an analysis and interpretation of its meaning, see Sabatier 1999, 207–15.
6. As reported by Mazière de Monville 1731, 102. Quotation and translation are taken from Berger 1993, 2, 47n11. See also Paris 1989b, 19 (cat. no. 4).
7. Bertrand forthcoming a.
8. As summarized in Berger 1993, 23.
9. Robert Berger argued that Mignard was influenced in his choice of Cybele by Noël Coypel's 1666–72 allegory Earth, painted for the small apartment of the king at the Tuileries Palace; see Berger 1993, 36, 42, 57n144.
10. The persistent esteem for Raphael and his school as the preeminent masters is evinced by an initiative undertaken at the Royal Furniture Manufactory of the Crown during the mid-1680s to weave tapestry versions of their famed frescoes in the Vatican Stanze, including the Parnassus, after cartoons prepared by students at the French Academy in Rome. This initiative coincided precisely with the simultaneous Gobelins production of tapestries after Mignard's Gallery of Apollo at the Château of Saint-Cloud. See Vittet and Brejon de Lavergnée with de Savignac 2010, 256 (inv. no. 125, where the series inspired by the Vatican Stanze was inaccurately called, at that time in the royal inventories, The Vatican Loggia); and Ribou 2014, 116–17.
11. Jean Vittet sheds new light on the origins of this tapestry series and presents a fresh perspective on the circumstances reported

by Maurice Fenaille; see Vittet 2011a; and Fenaille 1903, 399–420.

12. The artists responsible for each cartoon were named in a document written in 1692 by Jean Jans the Younger for Édouard Colbert, marquis de Villacerf (1628–1699), the newly appointed superintendent of the Office of Royal Buildings. This document is quoted by Jean Vittet, who re-outlines the early chronology of the tapestry production; see Guiffrey 1892a, 212, 236, and Vittet 2011a, 130. Remnants of the cartoons survive in the Musée du Louvre; see Compin and Roquebert 1986, 4:93 (inv. 6668), 5:304 (inv. nos. 6664, 6669–71).

13. The original composition of Mignard's lost concave ceiling painting *Winter* is clearly outlined in the engraved view of the Gallery of Apollo from 1810, *The Civil Marriage of Napoléon and of Marie-Louise of Austria,* by Jean Louis Charles Pauquet (1759–ca. 1824) and Charles Normand (1765–1840), after the design of Charles Percier (1764–1838) and Pierre-François-Léonard Fontaine (1762–1853); see Percier and Fontaine 1810, unnumbered plate.

14. See the revealing correspondence of 1692 from Henri de Bessé, sieur de La Chapelle (ca. 1625–1694), to the marquis de Louvois, reproduced in Vittet 2011a, 131.

15. Bucharest 2011, 48–49 (cat. no. 7).

16. Guiffrey 1881–1901, vol. 4, columns 623–24; and Vittet and Brejon de Lavergnée with de Savignac 2010, 244–49 (inv. no. 118).

17. Boyer 2008, 69–70 (cat. nos. 12, 13). Bertrand proposes that the drawings for the engravings were executed after the cartoons rather than the actual ceiling paintings. He notes, however, that the two putti behind Cybele in the drawing of *Winter* do not appear in all but one of the corresponding tapestries; see Bertrand forthcoming b [2015].

18. Vittet and Brejon de Lavergnée with de Savignac 2010, 244–49 (inv. nos. 118–19), 272 (inv. no. 130). Two more sets, without gold, were produced during the reign of Louis XV; see Fenaille 1903, 399–420.

19. Gastinel-Coural 1998a, 65; Bertrand forthcoming a; and Bertrand forthcoming b [2015].

20. The identification of these figures follows the description reported in the contemporary court circular *Le Mercure Galant* of 1680 rather than that of Maurice Fenaille, which named the central winged male figure Saturn; see *Le Mercure Galant,* June 1680, 151–53; and Fenaille 1903, 404. See also the transcription and translation of the 1680 text in Berger 1993, 8, 49n36.

References Cited

Adelson 1994
Adelson, Candace J. *European Tapestry in the Minneapolis Institute of Arts.* Minneapolis: Minneapolis Institute of Arts, 1994.

Alcouffe 2004
Département des Objets d'Art du Musée du Louvre, ed. *Objets d'art: Mélanges en l'honneur de Daniel Alcouffe.* Dijon: Faton, 2004.

Alletz 1775
Alletz, Pons Augustin. *Cérémonial du sacre des rois de France.* Paris: G. Despréz, 1775.

Antwerp 1997
Delmarcel, Guy, Nora De Poorter, Paul Huvenne, Elsje Janssen, Iris Kockelbergh, Justus Müller Hofstede, Denise Smets-Matthys, Ward Smets-Matthys, Fieds Sorber, and Isabelle Van Tichelen. *Rubenstextiel = Rubens's Textiles.* Exh. cat. Antwerp: City of Antwerp, 1997.

Archives Nationales and Rambaud 1964–71
Archives Nationales and Mireille Rambaud. *Documents du Minutier central concernant l'histoire de l'art (1700–1750).* 2 vols. Paris: S.E.V.P.E.N., 1964–71.

Arminjon and Reyniès 1999
Arminjon, Catherine, and Nicole de Reyniès, eds. *La tapisserie au XVIIe siècle et les collections européenes. Actes du colloque international de Chambord, October 18–19, 1996.* Cahiers du patrimoine 57. Paris: Éditions du Patrimoine, 1999.

d'Astier de la Vigerie 1907
d'Astier de la Vigerie, Emmanuel Raoul. *La belle tapisserye du roy (1532–1797) et les tentures de "Scipion l'Africain."* Paris: Librairie Honoré Champion, 1907.

Auclair 2007
Auclair, Valérie. "Changement de programme: De *l'Histoire d'Artémise* de Nicolas Houel à la tenture d'Henri IV." In Paris 2007, 19–26.

Avrillas 2013
Avrillas, Patrick. *Louis XIII et la bataille de l'isle de Rié, 1622: Les armes victorieuses de la monarchie absolue.* La Crèche: Geste Éditions, 2013.

Badin 1909
Badin, Jules. *La manufacture de tapisseries de Beauvais depuis ses origins jusqu'à nos jours.* Paris: Société de Propagation des Livres d'Art, 1909.

Barcelona-Paris 2003–4
Lambert, Gisèle. *Dessins de la Renaissance: Collection de la Bibliothèque nationale de France, Département des estampes et de la photographie.* Exh. cat. Barcelona: Fundacío Caixa Catalunya; Paris: Bibliothèque Nationale de France, 2003.

Baumstark 1985
Baumstark, Reinhold. *Peter Paul Rubens: The Decius Mus Cycle.* New York: Metropolitan Museum of Art, 1985.

Bayard 1984
Bayard, Jean-Pierre. *Sacres et couronnements royaux.* Paris: Guy Trédaniel, 1984.

Beaussant 2008
Beaussant, Philippe. "Alexandre: De la Macédoine à Versailles." In Paris 2008, 14–17.

Beauvais 1993–94
Piel, Caroline, and Isabelle Denis. *La tenture des "Actes des apôtres" de la cathédrale de Beauvais.* Exh. cat. Beauvais: Galerie Nationale de la Tapisserie, 1993–94.

Beauvais, Lydia 2000
Beauvais, Lydia, with Madeleine Pinault Sørensen, Véronique Goarin, and Catherine Scheck. *Musée du Louvre, Département des arts graphiques: Inventaire général des dessins école française; Charles Le Brun, 1619–1690.* 2 vols. Paris: Réunion des Musées Nationaux, 2000.

Béguin 1958
Béguin, Sylvie. "*La suite d'Arthémise.*" *L'œil* 38 (February 1958): 32–39.

Bélime-Droguet 2005
Bélime-Droguet, Magali. "La chambre des arts au château d'Ancy-le-Franc: Primatice et Ruggiero de Ruggieri?" *Les cahiers d'histoire de l'art* 3 (2005): 8–21.

Bélime-Droguet 2012
Bélime-Droguet, Magali. "La tenture de *l'Histoire d'Henri III.*" Special issue, "La tapisserie en France du moyen âge à nos jours," *L'archéothema: Revue d'archéologie et d'histoire* 20 (April 2012): 62–67.

Bennett 1992
Bennett, Anna Gray. *Five Centuries of Tapestry from the Fine Arts Museums of San Francisco.* Rev. ed. San Francisco: Fine Arts Museums of San Francisco; San Francisco: Chronicle Books, 1992.

Berger 1993
Berger, Robert W. "Pierre Mignard at Saint-Cloud." *Gazette des beaux-arts* 121 (January 1993): 1–58.

Bertrand 2003–4
Bertrand, Pascal-François. "Review of *Mazarin, prince des collectionneurs: Les collections et l'ameublement du Cardinal Mazarin (1602–1661); Histoire et analyse,* by Patrick Michel." *Studies in the Decorative Arts* 11, no. 1 (2003–4): 114–17.

Bertrand 2005
Bertrand, Pascal-François. *Les tapisseries des Barberini et la décoration d'intérieur dans la Rome baroque.* Studies in Western Tapestry 2. Turnhout, Belgium: Brepols, 2005.

Bertrand 2007
Bertrand, Pascal-François. "Tapestry Production at the Gobelins during the Reign of Louis XIV, 1661–1715." In New York 2007, 340–55.

Bertrand 2008
Bertrand, Pascal-François. "From *The Story of Artemisia.*" In Brosens 2008a, 236–44.

Bertrand 2009a
Bertrand, Pascal-François. "Écrire l'histoire de la tapisserie de la Renaissance en France." In Zerner and Bayard 2009, 173–93.

Bertrand 2009b
Bertrand, Pascal-François. "French Royal Tapestries." *Burlington Magazine* 151, no. 1272 (March 2009): 190–92.

Bertrand 2009c
Bertrand, Pascal-François. "Louis XIII: Richelieu et la tapisserie." In Boyer, Gaehtgens, and Gady 2009, 293–312.

Bertrand 2011
Bertrand, Pascal-François. "*Les reines de Perse aux pieds d'Alexandre*; ou, *la Famille de Darius:* Un sujet emblématique pour l'Académie royale de peinture et pour les Gobelins?" In Brejon de Lavergnée and Vittet 2011b, 43–63.

Bertrand 2013a
Bertrand, Pascal-François. *Aubusson, tapisseries des lumières: Splendeurs de la Manufacture royale, fournisseur de l'Europe au XVIIIe siècle.* Corpus albuciense 2. Ghent: Snoeck, 2013.

Bertrand 2013b
Bertrand, Pascal-François. "Rubens: Subjects from History 3; The Constantine Series. Corpus Rubenianum Ludwig Burchard." *Burlington Magazine* 155, no. 1323 (June 2013): 419.

Bertrand forthcoming a
Bertand, Pascal-François. "Une application de la théorie du décorum: Le décor textile de la chambre du roi au palais de l'archévêque de Reims; Le jour du sacre de Louis XV." In *Études sur le XVIIIe siècle* (forthcoming).

Bertrand forthcoming b [2015]
Bertand, Pascal-François. *La peinture tissée: Théorie de l'art et tapisseries des Gobelins sous Louis XIV.* Rennes: Presses Universitaire de Rennes, 2015 (forthcoming).

Bertrand and Delmarcel forthcoming [2015]
Bertrand, Pascal-François, and Guy Delmarcel, eds. *Portrait and Tapestry / Portrait et Tapisserie.* Studies in Western Tapestry 7. Turnhout, Belgium: Brepols, 2015.

Besançon 1994
Besançon, Alain. *L'image interdite: une histoire intellectuelle de l'iconoclasme.* Esprit de la cité. Paris: Fayard, 1994.

Birmingham 1951
Exhibition of English Tapestries. Exh. cat. Birmingham: City of Birmingham Museum and Art Gallery, 1951.

Blois 2012
Latrémolière, Élisabeth, and Florent Quellier with Pierre-Gilles Girault and Hélène Lebédel-Carbonnel. *Festins de la Renaissance: Cuisine et trésors de la table.* Exh. cat. Blois: Château Royal de Blois; Paris: Somogy éditions d'art, 2012.

Boccara, Reyre, and Hayot 1988
Boccara, Jacqueline, with Séverine Reyre and Monelle Hayot. *Âmes de laine et de soie.* Paris: Éditions d'Art Monelle Hayot, 1988.

Boccardo 2006
Boccardo, Piero. "Prima qualità 'di seconda mano': Vicende dei Mesi di Mortlake e di altri arazzi e cartoni fra l'Inghilterra e Genova." In *Genova e l'Europa atlantica—Inghilterra, Fiandre, Portogallo: Opere, artisti, committenti, collezionisti—Inghilterra, Fiandre, Portogallo,* edited by Piero Boccardo and Clario Di Fabio, 182–85. Cinisello Balsamo, Milan: Silvana, 2006.

Bonfait 2011
Bonfait, Olivier. "L'échec de Poussin." In Rome-Bordeaux-Paris 2011–12, 2:65–75.

Bonnaffé 1882
Bonnaffé, Edmond. *Les amateurs de l'ancienne France: Le surintendant Foucquet.* Paris: Librairie de l'Art, 1882.

Böttiger 1898
Böttiger, John. *La collection des tapisseries de l'état suédois.* Vol. 4 of *Résumé de l'édition suédoise.* Translated by Gaston Lévy-Ullmann. Stockholm: Fröléen, 1898.

Boyer 2008
Boyer, Jean-Claude. *Pierre Mignard.* Musée du Louvre, Cabinet des dessins 17. Paris: Musée du Louvre; Milan: 5 Continents, 2008.

Boyer, Gaehtgens, and Gady 2009
Boyer, Jean-Claude, Barbara Gaehtgens, and Bénédicte Gady. *Richelieu: Patron des arts.* Paris: Maison des Sciences de l'Homme, 2009.

Brassat 1992
Brassat, Wolfgang. *Tapisserien und Politik: Funktionen, Kontexte und Rezeption eines repräsentativen Mediums.* Berlin: Mann, 1992.

Brejon de Lavergnée 1987
Brejon de Lavergnée, Arnauld. *L'inventaire Le Brun de 1683: La collection des tableaux de Louis XIV.* Notes et documents des musées de France 17. Paris: Ministère de la Culture et de la Communication, Réunion des Musées Nationaux, 1987.

Brejon de Lavergnée 2009
Brejon de Lavergnée, Arnauld. *Fastes royaux: Les tapisseries de Louis XIV.* Hors-série de Connaissance des Arts 429. Paris: Société Française de Promotion Artistique, 2009.

Brejon de Lavergnée et al. 2011
Brejon de Lavergnée, Arnauld, Charissa Bremer-David, Tracee J. Glab, and John B. Henry III. *Magnificence and Awe: Renaissance and Baroque Art in the Viola E. Bray Gallery at the Flint Institute of Arts.* Flint, Michigan: Flint Institute of Arts, 2011.

Brejon de Lavergnée and Vittet 2011a
Brejon de Lavergnée, Arnauld, and Jean Vittet. *L'éclat de la Renaissance italienne: Tissages d'après Raphaël, Giovanni da Udine, Jules Romain.* Dossier de l'art thématique 1. Dijon: Faton, 2011.

Brejon de Lavergnée and Vittet 2011b
Brejon de Lavergnée, Arnauld, and Jean Vittet, eds. *La tapisserie hier et aujourd'hui: Actes du colloque École du Louvre et Mobilier national et Manufactures nationales des Gobelins, de Beauvais et de la Savonnerie, June 18–19, 2007.* Rencontres de l'École du Louvre 24. Paris: École du Louvre, 2011.

Brejon de Lavergnée with Caillon 2008
Brejon de Lavergnée, Arnauld, with Béatrice Caillon. "Les cartons peints de *l'Histoire d'Alexandre.*" In Paris 2008, 28–39.

Brejon de Lavergnée, Barbara 1987
Brejon de Lavergnée, Barbara. *Dessins de Simon Vouet, 1590–1649.* Musée du Louvre, Cabinet des dessins, Inventaire général des dessins, école française. Paris: Réunion des Musées Nationaux, 1987.

Bremer-David 1986
Bremer-David, Charissa. "Tapestry *Château de Monceaux* from the Series *Les Maisons Royales.*" *J. Paul Getty Museum Journal* 14 (1986): 105–12.

Bremer-David 1997
Bremer-David, Charissa. *French Tapestries and Textiles in the J. Paul Getty Museum.* Los Angeles: J. Paul Getty Museum, 1997.

Bremer-David 2003–4
Bremer-David, Charissa. "French & Company and American Collections of Tapestries, 1907–1959." *Studies in the Decorative Arts* 11, no. 1 (2003–4): 38–68.

Bremer-David 2007
Bremer-David, Charissa. "Manufacture Royale de Tapisseries de Beauvais, 1664–1715." In New York 2007, 406–19.

Bremer-David 2011
Bremer-David, Charissa. "Tapestries at the Flint Institute of Arts: *The Story of Rinaldo and Armida.*" In Brejon de Lavergnée et al. 2011, 30–43.

Bremer-David 2015
Bremer-David, Charissa. *Conundrum: Puzzles in the "Grotesques" Tapestry Series.* Los Angeles: J. Paul Getty Museum, 2015.

Brienne and Bonnefon, 1916–19
Brienne, Louis-Henri de Loménie, comte de, and Paul Bonnefon. *Mémoires de Louis-Henri de Loménie, comte de Brienne, dit le jeune Brienne.* 3 vols. Société de l'histoire de France Publications 373, 380, 385. Paris: Renouard, H. Laurens, successeur, 1916–19.

Brosens 2003–4
Brosens, Koenraad. "Charles Le Brun's *Meleager and Atalanta* and Brussels Tapestry c. 1675." *Studies in the Decorative Arts* 11, no. 1 (Fall–Winter 2003–4): 5–37.

Brosens 2005
Brosens, Koenraad. "The *Maîtres et Marchands Tapissiers* of the Rue de la Verrerie: Marketing Flemish and French Tapestry in Paris around 1725." *Studies in the Decorative Arts* 12, no. 2 (Spring–Summer 2005): 2–25.

Brosens 2007–8
Brosens, Koenraad. "Who Commissioned Rubens's *Constantine* Series? A New Perspective: The Entrepreneurial Strategy of Marc Comans and François de la Planche." *Simiolus: Netherlands Quarterly for the History of Art* 33, no. 3 (2007–8): 166–82.

Brosens 2008a
Brosens, Koenraad. *European Tapestries in the Art Institute of Chicago.* Christa C. Meyer Thurman, general editor. Chicago: Art Institute of Chicago; New Haven: Yale University Press, 2008.

Brosens 2008b
Brosens, Koenraad. "From *The Seasons.*" In Brosens 2008a, 245–52.

Brosens 2011a
Brosens, Koenraad. "A Case of Mistaken Identity: Rubens' So-Called *Constantine and Crispus* Oil-Sketch in Sydney." *Burlington Magazine* 153, no. 1295 (February 2011): 86–89.

Brosens 2011b
Brosens, Koenraad. "Les importations des tapisseries flamandes en France, 1600–1650: Un nouveau regard sur Marc de Comans et François de La Planche." In Brejon de Lavergnée and Vittet 2011b, 35–42.

Brosens 2011c
Brosens, Koenraad. *Rubens: Subjects from History 3; The Constantine Series.* Corpus Rubenianum Ludwig Burchard, Part 13. London: Harvey Miller, 2011.

Brussels 1906
Destrée, Joseph. *Tapisseries et sculptures bruxelloises: À l'Exposition d'art ancien bruxellois organisée à Bruxelles au Cercle artistique et littéraire de juillet à octobre 1905.* Exh. cat. Brussels: G. van Oest, 1906.

Buchanan 2014
Buchanan, Iain. "The Story of Joshua." In New York 2014, 214–21.

Bucharest 2011
Vittet, Jean. *Les Manufactures des Gobelins: Quatre siècles de création; Tapisseries royales (1600–1800).* Exh. cat. Bucharest: Muzeul Național de Artă al României, 2011.

Buckland 1983
Buckland, Frances. "Gobelins Tapestries and Paintings as a Source of Information about the Silver Furniture of Louis XIV." *Burlington Magazine* 125, no. 962 (May 1983): 271–79, 283.

Burchard 2012
Burchard, Wolf. "Savonnerie Reviewed: Charles Le Brun and the *Grand Tapis de Pied d'Ouvrage a la Turque,* Woven for the Grande Galerie at the Louvre." *Furniture History* 48 (2012): 1–43.

Cambridge-Tampa 1984
Oberhuber, Konrad, and William W. Robinson, eds. *Master Drawings and Watercolors: The Hofer Collection.* Exh. cat. Cambridge, MA: Fogg Art Museum, Harvard University Art Museums; Tampa, FL: Tampa Museum, 1984.

Campbell 2002a
Campbell, Thomas P. "Designs for the Papacy by the Raphael Workshop, 1517–30." In New York 2002, 225–45.

Campbell 2002b
Campbell, Thomas P. "Italian Designs in Brussels, 1530–35." In New York 2002, 341–63.

Campbell 2002c
Campbell, Thomas P. "Netherlandish Designers, 1530–60." In New York 2002, 379–405.

Campbell 2002d
Campbell, Thomas P. "Patronage and Production in Northern Europe, 1520–60." In New York 2002, 263–303.

Campbell 2002e
Campbell, Thomas P. "The Triumph of Hercules." In New York 2002, 246–52 (cat. no. 26).

Campbell 2007
Campbell, Thomas P. *Henry VIII and the Art of Majesty: Tapestries at the Tudor Court.* New Haven: Yale University Press, 2007.

Campbell and Cleland 2010
Campbell, Thomas P., and Elizabeth Cleland, eds. *Tapestry in the Baroque: New Aspects of Production and Patronage.* The Metropolitan Museum of Art Symposia. New York: Metropolitan Museum of Art; New Haven: Yale University Press, 2010.

Carpreau 2013
Carpreau, Peter. "De artistieke persoonlijkheid van Coxcie." Special issue, "Thema: Michiel Coxcie (1499–1592): De Vlaamse Rafaël," *Openbaar Kunstbezit Vlaanderen* 51, no. 4 (2013): 16–39.

Castelluccio 2004
Castelluccio, Stéphane. *Le garde-meuble de la couronne et ses intendants du XVIe au XVIIIe siècle.* CTHS [Le comité des travaux historiques et scientifiques] histoire 15. Paris: Éditions du CTHS, 2004.

Castelluccio 2007
Castelluccio, Stéphane. *Les meubles de pierres dures de Louis XIV et l'atelier des Gobelins.* Dijon: Faton, 2007.

Castelluccio 2014
Castelluccio, Stéphane. *Marly.* Montreuil: Gourcuff Gradenigo, 2014.

Cavallo 1993
Cavallo, Adolfo Salvatore. *Medieval Tapestries in the Metropolitan Museum of Art.* New York: Metropolitan Museum of Art; New York: Harry N. Abrams, 1993.

Chambord 1996
Saunier, Bruno. *Lisses et délices: Chefs-d'œuvre de la tapisserie de Henri IV à Louis XIV.* Exh. cat. Chambord, Loir-et-Cher: Caisse Nationale des Monuments Historiques et des Sites, 1996.

Chantelou 2001
Chantelou, Paul Fréart de. *Journal de voyage du Cavalier Bernin en France.* Edited by Milovan Stanic. Paris: Macula-Insulaire, 2001.

Cleland 2008
Cleland, Elizabeth. "*The Holy Family with the Infant Christ Pressing the Wine of the Eucharist.*" In Brosens 2008a, 48–55.

Cleland 2012
Cleland, Elizabeth. "Koenraad Brosens, *Rubens. Subjects from History 3: The Constantine Series* (*Corpus Rubenianum Ludwig Burchard*, XIII [3]). London: Harvey Miller Publishers; Turnhout: Brepols, 2011." *HNA [Historians of Netherlandish Art] Review of Books* (November 2012). http://www.hnanews.org/archive/2012/11/vl_brosens0912.html.

Cojannot-Le Blanc 2011
Cojannot-Le Blanc, Marianne. "'Il avoit fort dans le cœur son Alexandre…': L'imaginaire du jeune Louis XIV d'après La Mesnardière et la peinture des *Reines de Perse* par Le Brun." *XVIIe siècle* 251, no. 2 (April 2011): 371–95.

Colbert and Clément 1861–82
Colbert, Jean-Baptiste, and Pierre Clément. *Lettres, instructions et mémoires de Colbert.* 7 vols. Paris: Imprimerie Imperiale, 1861–82.

Compin and Roquebert 1986
Compin, Isabelle, and Anne Roquebert. *Catalogue sommaire illustré des peintures du Musée du Louvre et du Musée d'Orsay, école française*, vols. 4–5. Paris: Réunion des Musées Nationaux, 1986.

Constans 1995
Constans, Claire. *Musée national du château de Versailles: Catalogue des peintures.* 3 vols. Paris: Réunion des Musées Nationaux, 1995.

Coope 1959
Coope, Rosalys. "The Château of Montceaux-en-Brie." *Journal of the Warburg and Courtauld Institutes* 22 (1959): 71–87.

Coquery 2002
Coquery, Emmanuel. "La tapisserie et ses bordures." In Paris 2002, 149–53.

Coquery 2013
Coquery, Emmanuel. *Charles Errard, ca. 1601–1689: La noblesse du décor.* Paris: Arthena, 2013.

Cordellier 1998
Cordellier, Dominique. *Deux cartoons pour les tentures de "l'Histoire de Scipion."* Louvre Feuillets 7. Paris: Musée du Louvre, Département des Arts Graphiques, 1998.

Cordellier 2000
Cordellier, Dominique. "*L'arrivée en Afrique*: Un carton pour la tenture de *Scipion.*" *Revue du Louvre* 50, no. 5 (December 2000): 17–19.

Cordellier 2010
Cordellier, Dominique. *Toussaint Dubreuil.* Musée du Louvre, Cabinet des dessins 5. Paris: Musée du Louvre; Milan: 5 Continents, 2010.

Cordey 1922
Cordey, Jean. "La manufacture de tapisseries de Maincy." *Bulletin de la Société de l'histoire de l'art français* (1922): 38–52.

Costa de Beauregard 1909
Costa de Beauregard, Olivier. "Lettre de Colbert relative à une tapisserie." In *Bulletin de la Société nationale des antiquaires de France* (1909): 201–2.

Coural and Gastinel-Coural 1983–84
Coural, Jean, and Chantal Gastinel-Coural. "Les Actes des Apôtres." In Paris 1983–84b, 242–45.

Coural and Gastinel-Coural 1992
Coural, Jean, and Chantal Gastinel-Coural. *Beauvais: Manufacture nationale de tapisserie.* Paris: Centre National des Arts Plastiques; Paris: Mobilier National, 1992.

Cox-Rearick 1995
Cox-Rearick, Janet. *The Collection of Francis I: Royal Treasures.* Antwerp: Fonds Mercator; New York: Harry N. Abrams, 1995.

Dacos 2001
Dacos, Nicole. *Roma quanta fuit: Tre pittori fiamminghi nella Domus Aurea.* Translated by Maria Baiocchi. Rome: Donzelli, 2001.

Dacos 2004
Dacos, Nicole. "Un raphaélesque calabrais à Rome, à Bruxelles et à Barcelone: Pedro Seraphín." *Locvs amœnvs* 7 (2004): 171–96.

Da Vinha, Maral, and Milovanovic 2014
Da Vinha, Mathieu, Alexandre Maral, and Nicolas Milovanovic, eds. *Louis XIV: L'image et le mythe.* Histoire: Aulica—L'invers de la cour. Rennes: Presses Universitaires de Rennes; Versailles: Centre de Recherche du Château de Versailles, 2014.

Delmarcel 2000
Delmarcel, Guy. *Flemish Tapestry.* New York: Harry N. Abrams, 2000.

Delmarcel 2002
Delmarcel, Guy. "The *Scipio* Tapestries after Giulio Romano and Gian Francesco Penni in the Academia Belgica in Rome." In *"Aux Quatre Vents": A Festschrift for Bert W. Meijer*, edited by Anton W. A. Boschloo, Edward Grasman, and Gert Jan van der Sman with Oscar van Houten, 199–207. Florence: Centro di Firenze, 2002.

Delmarcel 2014a
Delmarcel, Guy. "Gli Arazzi del *Grand Scipion* nell'Academia Belgica." In Geerts, Caciorgna, and Bossu 2014, 67–78.

Delmarcel 2014b
Delmarcel, Guy. "The Life of Saint Paul." In New York 2014, 124–35.

Delmarcel and Dumortier 1986
Delmarcel, Guy, and Claire Dumortier. "Cornelis de Ronde: Wandtapijtwever te Brussel (gestorben 1569)." *Revue Belge d'archéologie et d'histoire de l'art* 55 (1986): 41–67.

Delmarcel, Reyniès, and Hefford 2010
Delmarcel, Guy, Nicole de Reyniès, and Wendy Hefford. *The Toms Collection: Tapestries of the Sixteenth to Nineteenth Centuries*. Giselle Eberhard Cotton, general editor. Lausanne: Fondation Toms Pauli; Zurich: Verlag Niggli AG, 2010.

Denis 1991
Denis, Isabelle. "*L'Histoire d'Artémise*, commanditaires et ateliers: Quelques précisions apportées par l'étude des bordures." *Bulletin de la Société de l'histoire de l'art français* (1991): 21–36.

Denis 1999
Denis, Isabelle. "Henri Lerambert et *l'Histoire d'Artémise*: Des dessins d'Antoine Caron aux tapisseries." In Arminjon and Reyniès 1999, 33–50.

Denis 2007a
Denis, Isabelle. "*The Battle of the Milvian Bridge*." In New York 2007, 155–63 (cat. no. 14).

Denis 2007b
Denis, Isabelle. "The Parisian Workshops, 1590–1650." In New York 2007, 123–39.

Denis 2007c
Denis, Isabelle. "*The Riding Lesson*." In New York 2007, 140–47 (cat. no. 12).

Denis 2009
Denis, Isabelle. "Symboles et allégories dans les bordures de la tenture des *Actes des Apôtres* de Charles Ier d'Angleterre." In *Rencontre avec la Patrimoine Religieux (Association)* 2009, 15–27.

Denis 2010
Denis, Isabelle. "A New Look at the *Story of Coriolanus*." In Campbell and Cleland 2010, 34–55.

De Strobel 2010
De Strobel, Anna Maria. "The Popes and Their Tapestries: The History of the Papal Collection." In London 2010, 37–43.

De Strobel forthcoming
De Strobel, Anna Maria, ed. *Raffaello in Cappella Sistina: Gli arazzi degli Atti degli Apostoli della Scuola Vecchia*.

Detroit–Fort Worth–Florence 1986
Darr, Alan Phipps, and Giorgio Bonsanti. *Donatello e i suoi: Scultura fiorentina del primo Rinascimento*. Exh. cat. Detroit: Detroit Institute of Arts; Fort Worth: Kimball Art Museum; Florence: Forte di Belvedere, 1986.

Dijon–Luxembourg 1998–99
Starcky, Émmanuel, Hélène Meyer, and Laure Starcky. *À la gloire du roi: Van der Meulen, peintre des conquêtes de Louis XIV*. Exh. cat. Dijon: Musée des Beaux-Arts de Dijon; Luxembourg: Musée d'Histoire de la Ville de Luxembourg, 1998.

DuBon 1964
DuBon, David. *Tapestries from the Samuel H. Kress Collection at the Philadelphia Museum of Art: The History of Constantine the Great Designed by Peter Paul Rubens and Pietro da Cortona*. Aylesbury: Phaidon, 1964.

Ducéré 1903
Ducéré, É[douard]. *Bayonne sous l'ancien régime: Le marriage de Louis XIV d'après les contemporains et des documents inédits*. Bayonne: A. Lamaignère, 1903.

Dumonthier 1910?
Dumonthier, Ernest. *Le Mobilier national: Étoffes et tapisseries d'ameublement des XVIIe et XVIIIe siècles*. Paris: Massin, [1910?].

Duportal 1925
Duportal, Jeanne. "Le livre du sacre de Louis XIV." *L'amateur d'estampes* 4 (1925): 161–69.

Duportal 1926
Duportal, Jeanne. "Le livre du sacre de Louis XIV." *L'amateur d'estampes* 5 (1926): 19–28.

Dussieux et al. 1854
Dussieux, L[ouis], et al. *Mémoires inédits sur la vie et les ouvrages des membres de l'Académie royale de peinture et de sculpture*. 2 vols. Paris: J.B. Dumoulin, 1854.

Ehrmann 1986
Ehrmann, Jean. *Antoine Caron: Peintre des fêtes et des massacres*. Paris: Flammarion, 1986.

Engerand and Bailly 1899
Engerand, Fernand, and Nicolas Bailly. *Inventaire des tableaux du roy: Rédigé en 1709 et 1710*. Paris: E. Leroux, 1899.

Erkelens 1962
Erkelens, A. M. Louise E. "Rafaëleske grotesken op enige Brusselse wandtapijtseries." *Bulletin van het Rijksmuseum* 4 (1962): 115–38.

Favreau 2005
Favreau, Marc. "'Description des sujets de tapisseries': Un inventaire iconographique partiel des tapisseries de la Couronne sous le règne de Louis XIV." *Bulletin de la Société de l'histoire de l'art français* (2005): 47–67.

Favreau 2011
Favreau, Marc. "L'avant-Gobelins' à la cour du soleil: "Le fonds ancient de la collection royale de tapisseries sous le règne du Louis XIV." In Brejon de Lavergnée and Vittet 2011b, 83–93.

Félibien 1663
Félibien, André. *Les reines de perse aux pieds d'Alexandre: Peinture du cabinet du roy*. Paris: Pierre Le Petit, 1663.

Félibien 1665
Félibien, André. *Les quatre élémens peints par M. Lebrun et mis en tappisseries pour sa majesté*. Paris: Pierre Le Petit, 1665.

Félibien (1666–85) 1972
Félibien, André. *Entretiens sur les vies et sur les ouvrages des plus excellents peintres anciens et modernes*. 4 vols. Paris: Pierre Le Petit, 1666, 1672, 1679, and 1685. Reprint, Geneva: Minkoff, 1972. Citations in the catalogue refer to the Minkoff edition.

Félibien 1670
Félibien, André. *Tapisseries du roi, où sont representez les quatre éléments et les quatre saisons*. Paris: L'Imprimerie Royale, par Sebastien Cramoisy, 1670.

Félibien 1690
Félibien, André. *Tapisseries du roy, où sont representez les quatre éléments et les quatre saisons: Avec les devises qui les accompagnent et leur explication*. Augsburg: Johann Ulrich Kraussen, 1690. https://archive.org/details/tapisseriesduroyoofeli.

Fenaille 1903–23
Fenaille, Maurice. *État général de la Manufacture des Gobelins depuis son origine jusqu'à nos jours, 1600–1900*. 6 vols. Vol. 1, *Les ateliers parisiens au dix-septième siècle depuis l'installation de Marc de Comans et de François de La Planche au Faubourg Saint-Marcel en 1601 jusqu'à la fondation de la Manufacture royale des meubles de la Couronne en 1662* (1923). Vol. 2, *Période de la fondation de la Manufacture royale des meubles de la Couronne sous Louis XIV, en 1662, jusqu'en 1699, date de la réouverture des ateliers* (1903). Vol. 3, *Période du dix-huitième siècle*, pt. 1, *Depuis la réouverture des ateliers en 1699 jusqu'à la mort du duc d'Antin en 1736* (1904). Vol. 4, *Période du dix-huitième siècle*, pt. 2 [1737–93] (1907). Vol. 5. *Période du dix-neuvième siècle, 1794–1900* (1912). [Vol. 6], *Table* (1923). Paris: Hachette, 1903–23.

Fermor 1996
Fermor, Sharon. *The Raphael Tapestry Cartoons: Narrative, Decoration, Design*. London: Scala; London: Victoria & Albert Museum, 1996.

Ffolliott 1986
Ffolliott, Sheila. "Catherine de' Medici as Artemisia: Figuring the Powerful Widow." In *Rewriting the Renaissance: The Discourses of Sexual Difference in Early Modern Europe*, edited by Margaret W. Ferguson, Maureen Quilligan, and Nancy J. Vickers, 227–41. Chicago: University of Chicago Press, 1986.

Florence 1986
Gallo, Daniela. *Iacopo Sansovino: Il Bacco e la sua fortuna*. Mostre del Museo Nazionale del Bargello 7. Exh. cat. Florence: Museo Nazionale del Bargello, 1986.

Florence 2008
Innocenti, Clarice, ed. *Women in Power: Caterina and Maria de' Medici: The Return to Florence of Two Queens of France*. Exh. cat. Florence: Palazzo Strozzi, 2008.

Forti Grazzini 1989
Forti Grazzini, Nello. "Arazzi." In Mantua 1989, 466–79.

Forti Grazzini 1994
Forti Grazzini, Nello. *Il patrimonio artistico del Quirinale: Gli arazzi*. 2 vols. Rome: Editoriale Lavoro; Milan: Electa, 1994.

Forti Grazzini 2003
Forti Grazzini, Nello. *Gli arazzi della Fondazione Giorgio Cini*. Venice: Marsilio, 2003.

Forti Grazzini 2007
Forti Grazzini, Nello. "*The Triumph of Venus*." In New York 2007, 397–405 (cat. no. 49).

Foucart-Walter 2001
Foucart-Walter, Élisabeth. *Pieter Boel, 1622–1674: Peintre des animaux de Louis XIV; Le fonds des études peintes des Gobelins*. Les dossiers du Musée du Louvre. Paris: Réunion des Musées Nationaux, 2001.

Foucart-Walter and Pinault-Sørensen 2001
Foucart-Walter, Élisabeth, and Madeleine Pinault-Sørensen. "Pieter Boel: Peintre des animaux de Louis XIV." *L'estampille / L'objet d'art* 363 (November 2001): 51–57.

Franses 2015
Franses, Simon. "Southern Netherlands, Brussels: The Battle of Zama." http://www.franses.com/tapestries /brusselssouthern-netherlands/.

Fumaroli 1995
Fumaroli, Marc. "Cross, Crown, and Tiara: The Constantine Myth between Paris and Rome (1590–1690)." In *Piero della Francesca and His Legacy*, edited by Marilyn Aronberg Lavin, 89–102. Studies in the History of Art 48, Symposium Papers 28. Washington, D.C.: National Gallery of Art, 1995.

Gady 2010
Gady, Bénédicte. *L'ascension de Charles Le Brun: Liens sociaux et production artistique.* Passages / Passagen 29. Paris: Éditions de la Maison des Sciences de l'Homme, 2010.

Gady 2013
Gady, Bénédicte. "François Bellin: Un paysagiste de seconds plans?" In Lemoine and Sjöholm 2013, 131–47.

Gaehtgens 2008
Gaehtgens, Barbara. "Artemisia: An Iconographic Programme for a Regent." In Florence 2008, 109–15.

Gastinel-Coural 1998a
Gastinel-Coural, Chantal. "Les tapisseries du sacre: Le voyage à Reims." *L'estampille / L'objet d'art* 320 (January 1998): 54–82, 89.

Gastinel-Coural 1998b
Gastinel-Coural, Chantal. "Van der Meulen et la Manufacture royale des Gobelins." In Dijon-Luxembourg 1998–99, 110–25.

Geerts, Caciorgna, and Bossu 2014
Geerts, Walter, Marilena Caciorgna, and Charles Bossu, eds. *Scipione l'Africano: Un eroe tra Rinascimento e barocco. Atti del convegno di studi, Roma, Academia Belgica, 24–25 maggio 2012.* Translated by Marilena Caciorgna. Milan: Jaca, 2014.

Ghent 1987
Hennel-Bernasikowa, Maria, Erik Duverger, Ryszard Szmydki, and Guy Delmarcel. *Tapisseries flamandes du château du Wawel à Cracovie et d'autres collections européennes.* Exh. cat. Ghent: Stad Gent; Sint-Pietersabdij: Centrum voor Kunst en Cultuur, 1987.

Göbel 1933–34
Göbel, Heinrich. *Die germanischen und slawischen Länder.* Vol. 3 of *Wandteppiche.* 2 parts. Berlin: Klinkhardt & Biermann, 1933–34.

Godefroy 1649
Godefroy, Théodore, and Denis Godefroy. *Le cérémonial François: Contenant les ceremonies observées en France aux sacres et couronnemens de roys et reynes…*2 vols. Paris: Sébastien Cramoisy, 1649.

González-Palacios 1993
González-Palacios, Alvar. *Il Gusto dei principi: Arte di corte del XVII e del XVIII secolo.* 2 vols. Mami 162. Milan: Longanesi, 1993.

Grivel and Fumaroli 1988
Grivel, Marianne, and Marc Fumaroli. *Devises pour les tapisseries du roi.* Paris: Herscher, 1988.

Grivel, Leproux, and Nassieu Maupas 2014
Grivel, Marianne, Guy-Michel Leproux, and Audrey Nassieu Maupas. "Baptiste Pellerin: Cartonnier." In *Baptiste Pellerin et l'art parisien de la Renaissance*, edited by Marianne Grivel, 127–59. Collection Art et Société. Rennes: Presses Universitaires de Rennes, 2014.

Guichard and Darcel 1881
Guichard, Édouard, and Alfred Darcel. *Les tapisseries décoratives du Garde-meuble (Mobilier national): Choix des plus beaux motifs.* 2 vols. Paris: J. Baudry, 1881.

Guiffrey 1878–84
Guiffrey, Jules. *France: Tapisseries françaises.* Vol. 1 of *Histoire générale de la tapisserie*, by Jules Guiffrey, Eugène Müntz, and Alexandre Pinchart. 3 vols. Paris: Société Anonyme de Publications Périodiques, 1878–84.

Guiffrey 1881–1901
Guiffrey, Jules. *Comptes des bâtiments du roi sous le règne de Louis XIV.* 5 vols. Paris: Imprimerie Nationale, 1881–1901.

Guiffrey 1885–86
Guiffrey, Jules. *Inventaire général du Mobilier de la Couronne sous Louis XIV (1663–1715).* 2 vols. Paris: La Société d'Encouragement pour la Propagation des Livres d'Art, 1885–86.

Guiffrey (1886) 1978
Guiffrey, Jules. *Histoire de la tapisserie depuis le moyen âge jusqu'à nos jours.* Tours: Alfred Mame & fils, 1886. Reprint, Osnabrück: O. Zeller, 1978.

Guiffrey 1887
Guiffrey, Jules. "Destruction des plus belles tentures du Mobilier de la Couronne en 1797." *Mémoires de la Société de l'histoire de Paris et de l'Île-de-France* 14 (1887): 265–98.

Guiffrey 1892a
Guiffrey, Jules. "Les manufactures parisiennes de tapisseries au XVIIe siècle. Hôpital de la Trinité—Grande galerie du Louvre—Savonnerie—Faubourg Saint-Marcel—Faubourg Saint-Germain—Gobelins." *Mémoires de la Société de l'histoire de Paris et de l'Île-de-France* 19 (1892): 43–287.

Guiffrey 1892b
Guiffrey, Jules. "Les tapisseries de la Couronne autrefois et aujourd'hui: Complément de l'inventaire du Mobilier de la Couronne sous le règne de Louis XIV." *Nouvelles archives de l'art français ancien et moderne* 8 (January–February 1892): 1–55. http://gallica.bnf.fr/ark:/12148 /bpt6k5823971k.image.langEN.

Guiffrey 1898
Guiffrey, Jules. "Nicolas Houel: Apothicaire parisien du XVIe siècle de la Maison de la charité chrétienne." Extracts from *Mémoires de la Société de l'histoire de Paris et de l'Île-de-France* 25 (1898). Nogent-le-Rotrou: Imprimerie de Daupeley-Gouverneur, 1899.

Guiffrey 1913
Guiffrey, Jules. *Inventaire descriptif et méthodique des tapisseries du Garde-meuble.* Vol. 4 of *Inventaire général des richesses d'art de la France: Paris, Monuments civils.* Paris: Mobilier National, 1913.

Halbturn 1981
Bauer, Rotraud, with Jan Karel Steppe. *Tapisserien der Renaissance nach entwürfen von Pieter Coecke van Aelst.* Exh. cat. Halbturn: Schloss Halbturn, 1981.

Hans 2012
Hans, Pierre-Xavier. "La tenture des *Quatre Saisons.*" In Versailles 2012, 238–39, 321.

Hartkamp-Jonxis 2008
Hartkamp-Jonxis, Ebeltje. "Een geschilderd patroon voor een wandtapijt met de *Landing van Scipio op de kust van Afrika* uit het midden van de 16de eeuw." *Bulletin van het Rijksmuseum* 56, no. 1/2 (2008): 82–101.

Hartkamp-Jonxis and Smit 2004
Hartkamp-Jonxis, Ebeltje, and Hillie Smit. *European Tapestries in the Rijksmuseum.* Amsterdam: Rijksmuseum; Zwolle: Waanders, 2004.

Havard and Vachon 1889
Havard, Henry, and Marius Vachon. *Les manufacture nationales: Les Gobelins, la Savonnerie, Sèvres, Beauvais.* Paris: G. Decaux, 1889.

Hefford 1986
Hefford, Wendy. "Another *Aeneas* Tapestry." *Artes Textiles* 11 (1986): 75–87.

Hefford 1999
Hefford, Wendy. "The Duke of Buckingham's Mortlake Tapestries of 1623." *Bulletin du CIETA* [Centre international d'étude des textiles anciens] 76 (1999): 90–103.

Hefford 2007a
Hefford, Wendy. "*Meeting at the Temple of Venus.*" In New York 2007, 190–95 (cat. no. 17).

Hefford 2007b
Hefford, Wendy. "*The Miraculous Draft of Fishes.*" In New York 2007, 184–89 (cat. no. 16).

Hefford 2007c
Hefford, Wendy. "The Mortlake Manufactory, 1619–49." In New York 2007, 170–83.

Herrero Carretero 2007
Herrero Carretero, Concha. "*Decius Mus Consults the Oracle*" and "*The Battle of Veseris and the Death of Decius Mus.*" In New York 2007, 95–105 (cat. nos. 10–11).

Herrero Carretero 2008
Herrero Carretero, Concha. *Rubens, 1577–1640: Colección de Tapices; Obras Maestras de Patrimonio Nacional.* Madrid: Patrimonio Nacional, 2008.

Houel 1563
Houel, Nicolas. *L'histoire de la Royne Arthemise.* Unpublished manuscript, 1563. Bibliothèque Nationale de France, Ms. Fr. 306. http://gallica.bnf.fr/ark:/12148/btv1b9058243m /f30.image.

Howarth 1994
Howarth, David. "William Trumbull and Art Collecting in Jacobean England." *British Library Journal* 20, no. 2 (Autumn 1994): 140–62.

Howarth 2011
Howarth, David. "The Southampton Album: A Newly Discovered Collection of Drawings by Francis Cleyn the Elder and His Associates." *Master Drawings* 69, no. 4 (2011): 435–78.

Hunter 1916
Hunter, George Leland. "*Scipio* Tapestries Now in America." *Burlington Magazine for Connoisseurs* 29, no. 158 (May 1916): 59–61, 64, 67.

Hunter 1925
Hunter, George Leland. *The Practical Book of Tapestries.* Philadelphia: J. B. Lippincott, 1925.

Janneau 1933
Janneau, Guillaume. "Nos tapisseries dans nos ambassades." *La Renaissance* 16, no. 4–5 (April–May 1933): 74–112.

Jolly 2002
Jolly, Anna. "Entwicklungsgeschichte des Naturalismus in Frankreich." In *Seidengewebe des 18. Jahrhunderts.* Vol. 2 of *Naturalismus*, 22–26, 375–78. Die Textilsammlung der Abegg-Stiftung 3. Riggisberg, Switzerland: Abegg-Stiftung, 2002.

Jombert 1774
Jombert, Charles-Antoine. *Catalogue raisonné de l'oeuvre de Sebastien le Clerc, chevalier romain, dessinateur et graveur du Cabinet du roi: Disposé par ordre historique, suivant l'année où chaque pièce a été gravée, depuis 1650 jusqu'en 1714. Avec la vie de ce celebre artiste.* 2 vols. Paris: Chez l'Auteur, 1774. https://ia601602.us.archive .org/32/items/catalogueraisonnoojomb /catalogueraisonnoojomb.pdf.

Jouin 1889
Jouin, Henri Auguste. *Charles Le Brun et les arts sous Louis XIV: Le premier peintre; Sa vie, son oeuvre, ses écrits, ses contemporains, son influence d'après le manuscript de Nivelon et de nombreuses pièces inédites.* Paris: Imprimerie Nationale, 1889.

Junquera de Vega and Herrero Carretero 1986
Junquera de Vega, Paulina, and Concha Herrero Carretero. *Catalogo de tapices del Patrimonio nacional.* 2 vols. Madrid: Editorial Patrimonio Nacional, 1986.

Karafel 2009
Karafel, Lorraine. "Le retour de l'âge d'or: Les tapisseries à l'antique de Raphaël pour le pape Léon X." In *Rencontre avec le Patrimoine Religieux (Association)*, 2009, 29–40.

Karafel 2013
Karafel, Lorraine. "Raphael's Tapestries: The *Grotesques of Leo X* and the Vatican's Sala dei Pontefici." In *Late Raphael: Proceedings of the International Symposium, Actas del Congreso Internacional, Madrid, Museo Nacional del Prado, October 2012*, edited by Miguel Falomir, 50–57. Madrid: Museo Nacional del Prado, 2013.

Karafel forthcoming [2015]
Karafel, Lorraine. *Raphael's Tapestries: The Grotesques for the Vatican Palace.* New Haven: Yale University Press, forthcoming [2015].

Kastner 2000
Kastner, Victoria. *Hearst Castle: The Biography of a Country House.* New York: Harry N. Abrams, 2000.

Kirchner 2008
Kirchner, Thomas. *Le héros épique: Peinture d'histoire et politique artistique dans la France du XVIIe siècle.* Translated by Aude Virey-Wallon and Jean-Léon Muller. Passages / Passagen 20. Paris: Éditions de la Maison des Sciences de l'Homme, 2008.

Kirchner 2013
Kirchner, Thomas. *"Les reines de Perse aux pieds d'Alexandre" de Charles Le Brun: Tableau-manifeste du XVIIe siècle.* Translated by Aude Virey-Wallon. Passerelles, Centre Allemand d'Histoire de l'Art / Deutsches Forum für Kunstgeschichte. Paris: Éditions de la Maison des Sciences de l'Homme, 2013.

Knauer 2005
Knauer, Elfriede R. "*The Battle of Zama* after Giulio Romano: A Tapestry in the American Academy in Rome, Part I." *Memoirs of the American Academy in Rome* 50 (2005): 221–65.

Knauer 2006–7
Knauer, Elfriede R. "*The Battle of Zama* after Giulio Romano: A Tapestry in the American Academy in Rome, Part II." *Memoirs of the American Academy in Rome* 51/52 (2006–7): 239–76.

Knothe 2007a
Knothe, Florian. "*The Battle of Granicus*." In New York 2007, 365–73 (cat. no. 40).

Knothe 2007b
Knothe, Florian. "*Water.*" In New York 2007, 356–64 (cat. no. 39).

Knothe 2008
Knothe, Florian. "*Pierres Fines: The Manufacture of Hardstone Works at the Gobelins under Louis XIV.*" In New York 2008, 40–53.

Knothe 2010
Knothe, Florian. "Tapestry as a Medium of Propaganda at the Court of Louis XIV: Display and Audience." In Campbell and Cleland 2010, 342–59.

Knothe forthcoming [2015]
Knothe, Florian. *The Manufacture des Meubles de la Couronne aux Gobelins under Louis XIV: A Social, Political, and Cultural History.* Studies in Western Tapestry 8. Turnhout: Brepols, forthcoming [2015].

Kopp 2015
Kopp, Edouard. "*The Coronation of the King.*" In Los Angeles–Paris 2015, 58–59 (cat. no. 2).

La Fontaine and Titcomb 1967
La Fontaine, Jean de, and Eleanor Titcomb. *Le songe de vaux.* Geneva: Droz, 1967.

Lafréry 1544?–1602
Lafréry, Antoine, et al. *Speculum Romanae magnificentiae.* Rome: n.p., 1544?–1602.

La Motte Le Noble 1673
La Motte Le Noble, [François] de. *Histoire panégyrique de Louis XIV: Roy de France; Sous le nom de héros incomparable.* Rouen: Antoine Maurry, 1673.

Lavalle 1990–91
Lavalle, Denis. "Vouet et la tapisserie." In Paris 1990–91, 489–525.

Lefébure 1993
Lefébure, Amaury. "La tenture de *L'histoire de Scipion*: Un nouveau regard." *Revue du Louvre* 43, no. 5/6 (December 1993): 81–87.

Lefébure 1996
Lefébure, Amaury. *La galerie de Scipion.* Louvre Feuillets 6/27. Paris: Musée du Louvre, Département des Objets d'Art, 1996.

Lemoine and Sjöholm 2013
Lemoine, Annick, and Olivia Savatier Sjöholm. *Le beau langage de la nature: L'art du paysage au temps de Mazarin.* Rennes: Presses Universitaires de Rennes; Rennes: Musée des Beaux-Arts de Rennes, 2013.

Leutrat 2007
Leutrat, Estelle. *Les débuts de la gravure sur cuivre en France: Lyon, 1520–1565.* Geneva: Droz, 2007.

Leuven 2013
Jonckheere, Koenraad, ed. *Michiel Coxcie, 1499–1592, and the Giants of His Age.* Exh. cat. Leuven: M—Museum Leuven; London: Harvey Miller Publishers, 2013.

Lévêque 1984
Lévêque, Jean-Jacques. *L'école de Fontainebleau.* Neuchâtel: Éditions Ides et Calendes, 1984.

Lichtenstein and Michel 2008
Lichtenstein, Jacqueline, and Christian Michel. *Les conférences de l'Académie royale de peinture et de sculpture. Tome 2:2. Les conférences au temps de Guillet de Saint-Georges, 1682–1699.* Paris: École Nationale Supérieure des Beaux-Arts, 2008.

Lichtenstein et al. 2009
Lichtenstein, Jacqueline, Christian Michel, Jean-Gérald Castex, et al. *Les conférences de l'Académie royale de peinture et de sculpture. Tome 3. Les conférences au temps de Jules Hardouin-Mansart, 1699–1711.* Paris: École Nationale Supérieure des Beaux-Arts, 2009.

Lille 2004
Brejon de Lavergnée, Arnauld, with Alexis Merle du Bourg. *Rubens.* Exh. cat. Lille: Palais des Beaux-Arts, 2004.

Lister 1873
Lister, Martin. *Voyage de Lister à Paris en 1698.* Edited by Ernest de Sermizelles. Paris: Bibliophiles François, 1873.

Livy / Edmonds 1850
Titus Livius. *The History of Rome: Literally Translated, with Notes and Illustrations by D. Spillan and Cyrus Edmonds.* Vol. 3. Translated by Cyrus Edmonds. London: Henry G. Bohn, 1850.

London 2010
Evans, Mark, and Clare Browne with Arnold Nesselrath, eds. *Raphael: Cartoons and Tapestries for the Sistine Chapel.* London: V&A Publishing, 2010.

Los Angeles 2010
Marchesano, Louis, and Christian Michel. *Printing the Grand Manner: Charles Le Brun and Monumental Prints in the Age of Louis XIV.* Exh. cat. Los Angeles: Getty Research Institute, 2010.

Los Angeles–Paris 2015
Fuhring, Peter, Louis Marchesano, Rémi Mathis, and Vanessa Selbach, eds. *A Kingdom of Images: French Prints in the Age of Louis XIV, 1660–1715.* Exh. cat. Los Angeles: Getty Research Institute; Paris: Bibliothèque Nationale de France, 2015.

Loudet 1961
Loudet, Simone. "Le livre du sacre de Louis XV." *Gazette des Beaux-Arts* 58 (February 1961): 105–16.

Louvois 2007
Louvois, François-Michel Le Tellier, marquis de. *Architecture et beaux-arts à l'apogée du règne de Louis XIV: Édition critique de la correspondance du marquis de Louvois, surintendant des bâtiments du roi, arts et manufactures de France, 1683–1691, conservée au Service historique de la défense.* Vol. 1: *Années 1683 et 1684, Collection de documents inédits sur l'histoire de France,* edited by Thierry Sarmant, Raphaël Masson, Agnès Beylot. Série in-80; v. 43, no. 49. Paris: CTHS [Le comité des travaux historiques et scientifiques], 2007.

Lugt 1949
Lugt, Frits. *Inventaire général des dessins des écoles du nord: École flamande.* 2 vols. Musée du Louvre, Département des Peintures, des Dessins et de la Chalcographie. Paris: Musée Nationaux, Palais du Louvre, 1949.

Mabille 2004
Mabille, Gérard. "Le grand buffet d'argenterie de Louis XIV et la tenture des *Maisons royales.*" In Alcouffe 2004, 180–91.

Mabille 2007
Mabille, Gérard. "Le mobilier d'argent de Louis XIV." In Versailles 2007, 60–83.

Mabille and Pieragnoli 2010
Mabille, Gérard, and Joan Pieragnoli. *La ménagerie de Versailles.* Arles: Éditions Honoré Clair; Versailles: Château de Versailles, 2010.

Magalotti 1991
Magalotti, Lorenzo. *Diario di Francia dell'anno 1668.* Edited by Maria Luisa Doglio. Italia 3. Palermo: Sellerio, 1991.

Mailho-Daboussi 2012
Mailho-Daboussi, Lorraine. *Les tapisseries: Étude d'une collection publique.* Ministère de la Culture et de la Communication, Direction Générale des Patrimoines, 2012. *In situ: Revues des patrimoines* 13 (2010). http://insitu.revues.org/6960.

Malgouyres 2008
Malgouyres, Philippe. "Le Jardin des Plantes: Une pièce de la tenture des *Maisons royales.*" *Actualité du départment des objets d'art* 36 (February 20–June 20, 2008).

Mamone 2008
Mamone, Sara. "Caterina and Maria: Two Artemisias on the French Throne." In Florence 2008, 31–41.

Mansuelli 1958
Mansuelli, Guido A. *Galleria degli Uffizi: Le sculture.* Part 1 of *Cataloghi dei Musei e Gallerie d'Italia.* Rome: Instituto Poligrafico dello Stato, 1958.

Mantua 1989
Gombrich, Ernst H., Manfredo Tafuri, Sylvia Ferino Pagden, Christoph L. Frommel, Konrad Oberhuber, Amedeo Belluzzi and Kurt W. Forster, and Howard Burns. *Giulio Romano.* Exh. cat. Mantua: Palazzo del Te; Mantua: Palazzo Ducale, 1989.

Marchesano 2010
Marchesano, Louis. "Charles Le Brun and Monumental Prints in the Grand Manner." In Los Angeles 2010, 1–37.

Marchesano 2015a
Marchesano, Louis. "*Allegory of Fire.*" In Los Angeles–Paris 2015, 176–77 (cat. no. 57).

Marchesano 2015b
Marchesano, Louis. "*Triumphal Entry of Alexander into Babylon.*" In Los Angeles–Paris 2015, 66–7 (cat. no. 6).

Martinez and Martinez 2005
Martinez, Michel, and Gilles Martinez. *Saint-Cloud: Le château, le parc, la fête.* Saint-Cyr-sur-Loire: A. Sutton, 2005.

Mazière de Monville 1731
Mazière de Monville, Simon-Philippe. *La vie de Pierre Mignard: Premier peintre du roy.* Amsterdam: Aux Dépens de la Compagnie, 1731.

Meiss with Smith and Beatson 1974
Meiss, Millard, with Sharon Off Dunlap Smith and Elizabeth Home Beatson. *French Painting in the Time of Jean de Berry: The Limbourgs and Their Contemporaries.* 2 vols. New York: Pierpont Morgan Library; New York: George Braziller, 1974.

Merle du Bourg 2004
Merle du Bourg, Alexis. "La tenture de la *Vie de Constantin:* Esquisses, cartons et tapisseries." In *Rubens au Grand Siècle: Sa réception en France, 1640–1715,* 15–18. Collection "Art & Société." Rennes: Presses Universitaires de Rennes, 2004.

Mérot 1992
Mérot, Alain. "Simon Vouet et la grotesque: Un langage ornemental." In *Simon Vouet: Actes du colloque international: Galeries nationales du Grand Palais, February 5–7, 1981,* edited by Stéphane Loire, 563–72. Paris: Documentation Française, 1992.

Meyer 1980
Meyer, Daniel. *L'histoire du roy.* Paris: Réunion des Musées Nationaux, 1980.

Meyer 1989
Meyer, Daniel. "Les tapisseries des appartements royaux à Versailles et la Révolution." In Paris 1989a, 131–38.

Meyer 1996
Meyer, Daniel. "Les maisons royales dans la tapisserie." *Dossier de l'art* 32 (September 1996): 48–55.

Michel, Christian 2010
Michel, Christian. "Charles Le Brun and the Diffusion of His Oeuvre through Prints." In Los Angeles 2010, 39–47.

Michel, Patrick 1999
Michel, Patrick. *Mazarin, prince des collectionneurs: Les collections et l'ameublement du cardinal Mazarin, 1602–1661.* Notes et Documents des musées de France 24. Paris: Réunion des Musées Nationaux, 1999.

Milovanovic 2009a
Milovanovic, Nicolas. "Le Roi-Soleil." In Versailles 2009, 179–84.

Milovanovic 2009b
Milovanovic, Nicolas. "Les métamorphoses de l'image royale." In Versailles 2009, 34–41.

Milovanovic 2010
Milovanovic, Nicolas, ed. *L'antichambre du grand couvert: Fastes de la table et du décor à Versailles.* Montreuil: Gourcuff Gradenigo, 2010.

Milovanovic 2012
Milovanovic, Nicolas. "Les sources textuelles des peintures." In Versailles 2012, 169–75.

Montagu 1962
Montagu, Jennifer. "The Tapestries of Maincy and the Origin of the Gobelins." *Apollo* 76, no. 7 (September 1962): 530–35.

Motte Masselink, Masselink, and Drelon 2013
Motte Masselink, Nathalie, Reid Masselink, and Klara Drelon. *25 dessins anciens.* Paris: Galerie Nathalie Motte Masselink, 2013.

Mulherron 2012
Mulherron, Jamie. "A Mortlake Tapestry after Titian: The Importance of the Supper at Emmaus at Hardwick." *National Trust, Arts, Buildings, Collections Bulletin* (February 2012): 11–12. http://www.nationaltrust.org.uk /document-1355767022-416/.

Müntz 1878–84
Müntz, Eugène. *Histoire de la tapisserie en Italie, en Allemagne, en Angleterre, en Espagne, en Danemark, en Hongrie, en Pologne, en Russie et en Turquie.* Vol. 2 of *Histoire générale de la tapisserie,* by Jules Guiffrey, Eugène Müntz, and Alexandre Pinchart. 3 vols. Paris: Société Anonyme de Publications Périodiques, 1878–84.

Müntz 1897
Müntz, Eugène. *Les tapisseries de Raphaël au Vatican et dans les principaux musées ou collections de l'Europe: Étude historique et critique.* Paris: J. Rothschild, 1897.

Musée du Louvre (Paris) and Balis et al. 1993
Musée du Louvre, Département des objets d'art, Arnout Balis, Krista De Jonge, Guy Delmarcel, and Amaury Lefébure. *Les chasses de Maximilien.* Paris: Réunion des Musées Nationaux, 1993.

Néraudau 1986
Néraudau, Jean-Pierre. *L'Olympe du Roi-Soleil: Mythologie et idéologie au Grand Siècle.* Nouveaux Confluents. Paris: Société d'Édition "Les Belles Lettres," 1986.

New York 2002
Campbell, Thomas P. *Tapestry in the Renaissance: Art and Magnificence.* Exh. cat. New York: Metropolitan Museum of Art; New Haven: Yale University Press, 2002.

New York 2007
Campbell, Thomas P., ed. *Tapestry in the Baroque: Threads of Splendor.* Exh. cat. New York: Metropolitan Museum of Art; New Haven: Yale University Press, 2007.

New York 2008
Koeppe, Wolfram, and Anna Maria Giusti, eds. *Art of the Royal Court: Treasures in Pietre Dure from the Palaces of Europe.* Exh. cat. New York: Metropolitan Museum of Art; New Haven: Yale University Press, 2008.

New York 2014
Cleland, Elizabeth, with Maryan W. Ainsworth, Stijn Alsteens, and Nadine M. Orenstein. *Grand Design: Pieter Coecke van Aelst and Renaissance Tapestry.* Exh. cat. New York: Metropolitan Museum of Art; New Haven: Yale University Press, 2014.

Nivelon and Pericolo 2004
Nivelon, Claude, and Lorenzo Pericolo. *Vie de Charles Le Brun et description détaillée de ses ouvrages.* Hautes études médiévales et modernes 86. Geneva: Droz, 2004.

Ordre du Sacre 1515
L'ordre du Sacre et couronnement du roy tres chrestien notre sire Francoys de valoys, premier de ce nom. Paris: Jean Jehannot, 1515.

Ormesson 1860–61
Ormesson, Olivier Lefèvre d', and André Lefèvre d'Ormesson. *Journal d'Olivier Lefèvre d'Ormesson: Et extraits des Mémoires d'André Lefèvre d'Ormesson.* Edited by Adolphe Chéruel. Collection de documents inédits sur l'histoire de France. 2 vols. Paris: Imprimerie Impériale, 1860–61.

Paradin 1553
Paradin, Claude. *Quadrins historiques de la Bible.* Lyon: Jean de Tournes, 1553.

Paris 1962
Charles Le Brun, premier directeur de la Manufacture royale des Gobelins: Exposition organisée à l'occasion du troisième centenaire de la fondation des Gobelins. Exh. cat. Paris: Musée des Gobelins, 1962.

Paris 1965
Viatte, Germain. *Le XVIe siècle européen: Tapisseries.* Exh. cat. Paris: Mobilier National, 1965.

Paris 1972
Laclotte, Michel, and Sylvie Béguin. *L'école de Fontainebleau.* Exh. cat. Paris: Grand Palais, 1972.

Paris 1978
Jestaz, Bertrand, and Roseline Bacou. *Jules Romain: L'histoire de Scipion; Tapisseries et dessins.* Exh. cat. Paris: Galeries Nationales du Grand Palais, 1978.

Paris 1983–84a
Béguin, Sylvie, Jean Coural, Roseline Bacou, Ségolène Bergeon, Lola Faillant-Dumas, Pierrette Jean-Richard, Michel Laclotte, Catherine Monbeig-Goguel, and Françoise Viatte. *Hommage à Raphaël: Raphaël dans les collections françaises.* Exh. cat. Paris: Galeries Nationales du Grand Palais, 1983.

Paris 1983–84b
Cuzin, Jean-Pierre, and Dominique Cordellier. *Hommage à Raphaël: Raphaël et l'art français.* Exh. cat. Paris: Galeries Nationales du Grand Palais, 1983.

Paris 1984
Dessins français du XVIIe siècle: 83e exposition du Cabinet des dessins. Exh. cat. Paris: Musée du Louvre, 1984.

Paris 1985
Walton, Guy, and Mogens Bencard. *Versailles à Stockholm: Dessins du Nationalmusem; Peintures, meubles et arts décoratifs des collections suédoises et danoises.* National-museums Skriftserie NS 5. Exh. cat. Paris: Institut Culturel Suédois Hôtel de Marle; Stockholm: Nationalmuseum, 1985.

Paris 1989a
De Versailles à Paris: Le destin des collections royales. Exh. cat. Paris: Centre culturel du Panthéon, 1989.

Paris 1989b
Boyer, Jean-Claude, with Jean Habert. *Le Peintre, le roi, le héros: L'Andromède de Pierre Mignard.* Les dossiers du Département des peintures 37. Exh. cat. Paris: Musée du Louvre, 1989.

Paris 1990–91
Thuillier, Jacques, and Barbara Brejon de Lavergnée. *Vouet.* Exh. cat. Paris: Galeries Nationales du Grand Palais, 1990.

Paris 1995
Lesage, Claire, ed. *Jean de La Fontaine.* Exh. cat. Paris: Bibliothèque Nationale de France, 1995.

Paris 2001
Brugerolles, Émmanuelle, and David Guillet. *Le dessin en France au XVIIe siècle dans les collections de l'école des Beaux-Arts.* Exh. cat. Paris: École Nationale Supérieure des Beaux-Arts, 2001.

Paris 2002
Alcouffe, Daniel, Emmanuel Coquery, Gérard Mabille, Marie-Laure de Rochebrune et al. *Un temps d'exubérance: Les arts décoratifs sous Louis XIII et Anne d'Autriche.* Exh. cat. Paris: Galeries Nationales du Grand Palais, 2002.

Paris 2003
Avril, François. *Jean Fouquet: Peintre et enlumineur du XVe siècle.* Exh. cat. Paris: Bibliothèque Nationale de France, 2003.

Paris 2004
Cordellier, Dominique, with Bernadette Py. *Primatice: Maître de Fontainebleau.* Exh. cat. Paris: Musée du Louvre; Paris: Réunion des Musées Nationaux, 2004.

Paris 2007
Brejon de Lavergnée, Arnauld, and Jean Vittet, eds. *À l'origine des Gobelins: La tenture d'Artémise; La redécouvert d'un tissage royal.* Exh. cat. Paris: Collections du Mobilier National, Galerie des Gobelins; Paris: Réunion des Musées Nationaux, 2007.

Paris 2008
Jean Vittet, ed. *Le tenture de l'histoire d'Alexandre le Grand.* Exh. cat. Paris: Collections du Mobilier National, Galerie des Gobelins; Paris: Réunion des Musées Nationaux, 2008.

Paris 2012–13a
Cordellier, Dominique. *Luca Penni: Un disciple de Raphaël à Fontainebleau.* Exh. cat. Paris: Musée du Louvre / Louvre Éditions; Paris: Somogy Éditions d'Art, 2012.

Paris 2012–13b
Henry, Tom, and Paul Joannides. *Raphaël: Les dernières années.* Exh. cat. Paris: Musée du Louvre / Louvre Éditions; Paris: Hazan, 2012.

Paris-Bergues 2012
Brugerolles, Émmanuelle, and Patrick Descamps. *De Heemskerck à Le Brun: Les plus beaux dessins du Musée de Mont-de-Piété de Bergues.* Exh. cat. Paris: Salon du Dessin; Bergues: Musée du Mont-de-Piété, 2012.

Parsons 1704
Parsons, Colonel. *The Tent of Darius Explained; or, The Queens of Persia at the Feet of Alexander.* London: printed by W. R. for the author, 1704. http://find.galegroup.com/ecco/infomark.do?contentSet=ECCOArticles&docType=ECCOArticles&bookId=1264500500&type=getFullCitation&tabID=T001&prodId=ECCO&docLevel=TEXT_GRAPHICS&version=1.0&source=library&userGroupName=gri_wbis.

Patrizi 2014
Patrizi, Florence. "Dal Grand Scipion alla Storia della regina Artemisia: La scuola di Raffaello e la cultura visual di Nicolas Houel." In Geerts, Caciorgna, and Bossu 2014, 97–110.

Percier and Fontaine 1810
Percier, Charles, and Pierre-François-Léonard Fontaine. *Description des cérémonies et des fêtes qui ont eu lieu pour le marriage de S. M. l'empereur Napoléon avec S.A.I. madame l'archduchesse Marie-Louis d'Autriche.* Paris: P. Didot, 1810.

Perrault 1909
Perrault, Charles. *Mémoires de ma vie.* Écrits d'amateurs et d'artistes. Paris: H. Laurens, 1909.

Philadelphia 1964
DuBon, David. *Catalogue of the Exhibition "Constantine the Great: The Tapestries, The Designs."* Exh. cat. Philadelphia: Philadelphia Museum of Art, 1964.

Pichart 1878–84
Pichart, Alexandre. *Pays-Bas—Tapisseries flamandes.* Vol. 3 of *Histoire générale de la tapisserie,* edited by Jules Guiffrey, Eugène Müntz, and Alexandre Pinchart. Paris: Société Anonyme de Publications Périodiques, 1878–84.

Pichon 1880
Pichon, Jérôme. *Vie de Charles-Henry, comte de Hoym, ambasssadeur de Saxe-Pologne en France, 1694–1736.* 2 vols. Paris: Société des Bibliophiles François, 1880.

Pinoteau 1978
Pinoteau, Hervé. "Luigi Bader: Les Bourbons de France en exil à Gorizia." In *Itinéraires* 220 (February 1978): 154–58.

Pope-Hennessy 2000
Pope-Hennessy, John. *An Introduction to Italian Sculpture.* Vol. 3 of *Italian High Renaissance and Baroque Sculpture.* London: Phaidon, 2000.

Posner 1959
Posner, Donald. "Charles Le Brun's *Triumphs of Alexander.*" *Art Bulletin* 41, no. 3 (September 1959): 237–48.

Préaud 1980
Préaud, Maxime. *Sébastien Leclerc II.* Vol. 9 of *Inventaire du fonds français: Graveurs du XVIIe siècle.* Paris: Bibliothèque Nationale, Département des Estampes, 1980.

Préaud 1993
Préaud, Maxime. *Antoine Lepautre, Jacques Lepautre, et Jean Lepautre,* part 1. Vol. 11 of *Inventaire du fonds français: Graveurs du XVIIe siècle* Paris: Bibliothèque Nationale, Département des Estampes, 1993.

Puhlmann 1996/97
Puhlmann, Helga. "Nicht ohne Anmuth und selbst in der Erfindung bobenswerth." *Die Dresdner Bildteppiche nach Kartons von Raffael und ihre Bordüren. Jahrbuch der Staatlichen Kunstsammlungen Dresden* 26 (1996/97): 55–68.

Reims 2014
Lacaille, Frédéric, Alexandre Maral, and Benoît-Henry Papounaud, eds. *Sacres royaux de Louis XIII à Charles X.* Exh. cat. Reims: Musée du Tau; Paris: Éditions du Patrimoine, Centre des Monuments Nationaux, 2014.

Reiset 1866
Reiset, Marie Frédéric de. *Notice des dessins, cartons, pastels, miniatures et émaux exposés dans les salles du 1er [et du 2e] étage au Musée national du Louvre.* Part 1 of *Écoles d'Italie, écoles allemande, flamande et hollandaise.* Paris: Imprimeries Réunies, 1866.

***Rencontre avec la Patrimoine Religieux (Association)* 2009**
Tapisseries et broderies: Relectures des mythes antiques et iconographie chrétienne. Actes du colloque d'Angers, 4–6 October 2007. Art sacré 27. Limoges: Cahiers de Rencontre avec le Patrimoine Religieux, 2009.

Reyniès 1999
Reyniès, Nicole de. "*Le Pastor Fido* et la tapisserie française de la première moitié du XVIIe siècle." In Arminjon and Reyniès 1999, 14–32.

Reyniès 2010a
Reyniès, Nicole de. "The Camel (*Le Dromadaire*) from the series *Grostesques with a Yellow Ground.*" In Delmarcel, Reyniès, and Hefford 2010, 190–94.

Reyniès 2010b
Reyniès, Nicole de. "Small Stag Hunt with Horses and Hounds from the series *Petites Chasses et Verdures.*" In Delmarcel, Reyniès, and Hefford 2010, 184–89.

Reyniès 2014
Reyniès, Nicole de. "*Jeux d'enfants:* Une tenture du XVIIe siècle." In *Beauvais 350 ans: Portraits d'une manufacture; Dossier de l'art* 218 (May 2014): 21–29.

Ribou 2014
Ribou, Marie-Hélène de. "Tapestry of *Chambres du Vatican: Le Parnasse.*" In *Decorative Furnshings and Objets d'Art in the Louvre from Louis XIV to Marie-Antoinette,* by Jannic Durand, Michèle Bimbenet-Privat, and Frédéric Dassas with Catherine Voiriot, 116–17. Paris: Musée du Louvre / Louvre Éditions, 2014.

Richefort 2004
Richefort, Isabelle. *Adam-François Van der Meulen, 1632–1690: Peintre flamand au service de Louis XIV.* Rennes: Presses Universitaires de Rennes, 2004.

Rome-Bordeaux-Paris 2011–12
Bayard, Marc, Arnauld Brejon de Lavergnée, and Éric de Chassey. *Poussin et Moïse: Du dessin à la tapisserie.* 2 vols. Exh. cat. Rome: Académie de France à Rome, Villa Medici; Bordeaux: Galerie des Beaux-Arts; Paris: Galerie des Gobelins; Rome: Drago, 2011.

Romier 1909
Romier, Lucien. *La carrière d'un favori: Jacques d'Albon de Saint-André, maréchal de France (1512–1562).* Paris: Perrin & Cie, 1909.

Rooses and Ruelens 1898
Rooses, Max, and Charles Ruelens. *Codex diplomaticus Rubenianus: Correspondance de Rubens et documents épistolaires concernant sa vie et ses œuvres.* Vol. 2. Antwerp: Jos. Maes, 1898. http://babel.hathitrust.org/cgi/pt?id=wu.89054771522#view=1up;seq=420.

Russel 2005
Russel, Daniel. "Wives and Widows: The Emblematics of Marriages and Mourning in France at the End of the Renaissance (1560–1630)." In *Visual Words and Verbal Pictures: Essays in Honor of Michael Bath,* edited by Alison Saunders, Peter Davidson, and Michael Bath, 141–60. Glasgow Emblem Studies Special Number. Glasgow: Department of French, University of Glasgow, 2005.

Sabatier 1999
Sabatier, Gérard. *Versailles; ou, La figure du roi.* Paris: Albin Michel, 1999.

Sabatier 2010
Sabatier, Gérard. *Le Prince et les arts: Stratégies figuratives de la monarchie française, de la Renaissance aux lumières.* Seyssel, France: Champ Vallon, 2010.

***Sacre des rois* 1985**
Le sacre des rois: Actes du colloque international d'histoire sur les sacres et couronnements royaux, Reims 1975. Paris: Belles Lettres, 1985.

Saint-Sulpice-le-Verdon 2000
Levesque, Richard. *La vendée au temps de la Renaissance.* Exh. cat. Saint-Sulpice-le-Verdon: Logis de la Chabotterie, 2000.

Salmon 2011
Salmon, Xavier. *"Le Triomphe de Vénus" par Noël Coypel: Un cartoon de tapisserie redécouvert.* Dijon: Faton, 2011.

San Francisco 1976–77
Bennett, Anna Gray. *Five Centuries of Tapestry from the Fine Arts Museums of San Francisco.* Exh. cat. San Francisco: Fine Arts Museums of San Francisco; Rutland, VT: Charles E. Tuttle, 1976–77.

Sauvel 1961
Sauvel, Tony. "Recherches sur la tenture dite des '*Mois*' ou des '*Maisons royales.*'" *Bulletin de la Société de l'histoire de l'art français* (1961): 59–64.

Sauvel 1963
Sauvel, Tony. "La tenture des Gobelins dite des *Saisons.*" *Bulletin de la Société de l'histoire de l'art français* (1963): 61–68.

Saward 1982
Saward, Susan. *The Golden Arts of Marie de' Medici.* Studies in Baroque Art 2. Ann Arbor: UMI Research Press, 1982.

Saxy 1623
Saxy, Pierre. *Entrée de Loys XIII: Roy de France et de Navarre dans sa ville d'Arles, le XXIX Octobre M.DC.XXII. Estans consuls et gouverneurs de ladicte Ville Pierre de Boches et Nicolas Dycard de l'estat des nobles, et Gauchier Peint et Claude Janim de celuy des bourgeois.* Avignon: Imprimerie de I. Bramereau, 1623. https://archive.org/stream/entreedeloysxiiioosaxy#page/20/mode/2up.

Schmitz-von Ledebur 2014
Schmitz-von Ledebur, Katja. "Jehovah Orders Joshua to Cross the Jordan into the Promised Land." In New York 2014, 222–24 (cat. no. 54).

Schnapper 1987
Schnapper, Antoine. "Préface." In Brejon de Lavergnée 1987, 5–10.

Schnapper 1993
Schnapper, Antoine. "Trésors sans toit: Sur les débuts de Louis XIV collectioneur." *Revue de l'art* 99 (1993): 53–59.

Schnapper 1994
Schnapper, Antoine. *Curieux du Grand Siècle.* Collections et collectionneurs dans la France du XVIIe siècle II—Œuvres d'art. Paris: Flammarion, 1994.

Schotter et al. 2012
Schotter, Bernard, Matthieu Somon, Arnauld Brejon de Lavergnée, and Christoph Henry. *Poussin et Moïse: Histoires tissées; Exposition à la Galerie des Gobelins.* Dijon: Faton, 2012

Sharratt 2005
Sharratt, Peter. *Bernard Salomon: Illustrateur Lyonnais.* Geneva: Droz, 2005.

Shearman 1972
Shearman, John. *Raphael's Cartoons in the Collection of Her Majesty the Queen and the Tapestries for the Sistine Chapel.* London: Phaidon, 1972.

Siple 1938
Siple, Ella S. "A Flemish Set of Venus and Vulcan Tapestries I—Their Origin and Design." *Burlington Magazine* 73, no. 428 (November 1938): 212–13, 216–21.

Siple 1939
Siple, Ella S. "A Flemish Set of Venus and Vulcan Tapestries II—Their Influence on English Tapestry Design." *Burlington Magazine* 74, no. 435 (June 1939): 268, 272–75, 277–79.

Standen 1985
Standen, Edith Appleton. *European Post-Medieval Tapestries and Related Hangings in the Metropolitan Museum of Art.* 2 vols. New York: Metropolitan Museum of Art, 1985.

Standen 1990
Standen, Edith A., "The *Jardin des Plantes*: An *Entrefenêtre* for the *Maisons Royales* Gobelins Tapestry Series." *Bulletin du CIETA* [Centre international d'étude des textiles anciens] 68 (1990): 49–52.

Standen 1992/93
Standen, Edith A. "The Garden of the Sun-King: A Gobelins Tapestry in the Virginia Museum of Fine Arts." *Arts in Virginia* 30, nos. 2–3 (1992/93): 2–9.

Standen 1999
Standen, Edith. "For Minister or for King: Two Seventeenth-Century Gobelins Tapestries after Charles Le Brun." *Metropolitan Museum Journal* 34 (1999): 125–34.

Stockholm 2002
Sjöberg, Ursula. *Krig och Kärlek På Tapeter: En unik samling vävda tapeter från 1500- och 1600-talet.* Exh. cat. Stockholm: Royal Palace, 2002.

Szanto 2008
Szanto, Mickaël. *Le dessin ou la couleur? Une exposition de peinture sous le règne de Louis XIV.* Hautes études médiévales et modernes 91. Geneva: Droz, 2008.

Szmydki 1987
Szmydki, Ryszard. "Tapisseries flamandes dans la collection de Jean-Casimir Vasa (1609–1672)." In Ghent 1987, 122–35.

Szmydki 1995
Szmydki, Ryszard. *Vente du mobilier de Jean-Casimir en 1673.* Warsaw: Wydawnictwo Neriton, 1995.

Tauss 2000
Tauss, Susanne. *Dulce et decorum? Der Decius-Mus-Zyklus von Peter Paul Rubens.* Osnabrück: Universitätsverlag Rasch, 2000.

Tauss 2012
Tauss, Susanne. "'Nicht allein Maler, sondern hoch bewandert in Historien und politischen Dingen' Der Decius Mus-Zyklus von Peter Paul Rubens." In Wuppertal 2012, 67–87.

Tessin 1717
Tessin, Nicodemus. *Traictè dela [sic] decoration interieure 1717 (Nicodemus Tessin the Younger: Sources, Works, Collections).* Edited by Patricia Waddy with Bo Vahlne, Guy Walton, and Jan von Gerber. Stockholm: Nationalmuseum, 2002.

Thomson 1914
Thomson, William George. *Tapestry Weaving in England from the Earliest Times to the End of the XVIIIth Century.* London: B. T. Batsford; New York: C. Scribner's Sons, 1914.

Thomson 1930
Thomson, William George. *A History of Tapestry Weaving from the Earliest Times to the Present Day.* London: Hodder & Stoughton, 1930.

Thou 1594
Thou, Nicolas de. *Cérémonies observées au sacre et couronnement du très chrétien et très valeureux Henri IV, roi de France et de Navarre.* Paris: Jamet Mettayer & Pierre L'Huillier, 1594.

Thuillier and Foucart 1967
Thuillier, Jacques, and Jacques Foucart. *Rubens' Life of Marie de' Medici.* New York: Harry N. Abrams, 1967.

Tillet 1580
Tillet, Jean du. *Recueil des roys de France: Leurs couronne et maison.* Paris: Jacques du Puys, 1580.

Vallery-Radot 1953
Vallery-Radot, Jean. *Le dessin français au XVIIe siècle.* Lausanne: Mermod, 1953.

Vandenbroeck 2009
Vandenbroeck, Paul. "Meaningful Caprices: Folk Culture, Middle-Class Ideology (ca. 1480–1510) and Aristocractic Recuperation (ca. 1530–1570): A Series of Brussels Tapestries after Hieronymus Bosch." In *Jaarboek / Koninklijk Museum voor Schone Kunsten Antwerpen = Antwerp Royal Museum Annual 2009* (2009): 212–69.

Van Tichelen 1997
Van Tichelen, Isabelle. "The History of Constantine." In Antwerp 1997, 58–77.

Vasari (1550, 1568) 1966–87
Vasari, Giorgio. *Le vite de' più eccellenti pittori, scultori e architettori, nelle redazioni del 1550 e 1568.* Edited by Rosanna Bettarini, with commentary by Paola Barrochi. 6 vols. Florence: Sansoni; Florence: Studio per Edizioni Scelte, 1966–87.

Verlet 1982
Verlet, Pierre. *The Savonnerie: Its History, the Waddesdon Collection.* The James A. de Rothschild Collection at Waddesdon Manor. London: The National Trust; Fribourg: Office du Livre, 1982.

Versailles 1951
Dessins du Nationalmuseum de Stockholm: Versailles et les Maisons royales. Exh. cat. Versailles: Château de Versailles, 1951.

Versailles 1967
Coural, Jean, with Jacques Thuillier. *Chefs-d'œuvre de la tapisserie Parisienne, 1597–1662.* Exh. cat. Versailles: Orangerie de Versailles, 1967.

Versailles 2006
Vittet, Jean. *Tapis de la Savonnerie pour la chapelle royale de Versailles.* Exh. cat. Versailles: L'Etablissement Public du Musée et du Domaine National de Versailles; Paris: Mobilier National, 2006.

Versailles 2007
Arminjon, Catherine, ed. *Quand Versailles était meublé d'argent.* Exh. cat. Versailles: L'Etablissement Public du Musée et Domaine National des Châteaux de Versailles et de Trianon, 2007.

Versailles 2009
Milovanovic, Nicolas, and Alexandre Maral. *Louis XIV: L'homme and le roi.* Exh. cat. Versailles: L'Etablissement Public du Musée et Domaine National des Châteaux de Versailles et de Trianon, 2009.

Versailles 2011
Gautier, Jean-Jacques, and Bertrand Rondot. *Le château de Versailles raconte le Mobilier national: Quatre siècles de création.* Exh. cat. Versailles: L'Etablissement Public du Musée et Domaine National des Châteaux de Versailles et de Trianon, 2011.

Versailles 2012
Maral, Alexandre, and Nicolas Milovanovic. *Versailles et l'antique.* Exh. cat. Versailles: L'Etablissement Public du Musée et Domaine National des Châteaux de Versailles et de Trianon; Paris: Artlys, 2012.

Vittet 2004
Vittet, Jean. "Les tapisseries de Michel Particelli d'Hémery et de son gendre Louis Phélypeaux de La Vrillière." In Alcouffe 2004, 171–79.

Vittet 2007a
Vittet, Jean. "*The King's Entry into Dunkirk, The Audience with Cardinal Chigi, The Siege of Douai,*" and "*The King Visits the Gobelins.*" In New York 2007, 374–89 (cat. nos. 41–47).

Vittet 2007b
Vittet, Jean. "*Moses Rescued from the Nile.*" In New York 2007, 163–69 (cat. no. 15).

Vittet 2007c
Vittet, Jean. "Les tapisseries de la Couronne à l'époque de Louis XIV: Du nouveau sur les achats effectués sous Colbert." *Versalia* 10 (2007): 182–201.

Vittet 2008
Vittet, Jean. "Un chef-d'œuvre des Gobelins: La tenture de *l'Histoire d'Alexandre le Grand* par Charles Le Brun." *L'estampille / L'objet d'art* 440 (November 2008): 66–75.

Vittet 2010
Vittet, Jean. "Charles de Coman's Posthumous Inventory, 1635." In Campbell and Cleland 2010, 56–83.

Vittet 2011a
Vittet, Jean. "Exemple d'un ameublement: Décor textile de l'antichambre du Grand Couvert, tenture de la galerie de Saint-Cloud." In Versailles 2011, 126–31.

Vittet 2011b
Vittet, Jean. "Poussin et la tapisserie: Dernières découvertes, nouvelles observations." In Rome-Bordeaux-Paris 2011–12, 86–94.

Vittet 2011c
Vittet, Jean. "Les tapisseries de la Couronne à Versailles sous Louis XIV." *Versalia* 14 (2011): 177–97.

Vittet 2012a
Vittet, Jean. "Un chef-d'œuvre inconnu: La tenture des *Grotesques* du cardinal de Richelieu." Special issue, "La tapisserie en France du moyen âge à nos jours," *L'Archéothema: Revue d'archéologie et d'histoire* 20 (April 2012): 68–73.

Vittet 2012b
Vittet, Jean. "*Le Colosse de Rhodes.*" In Versailles 2012, 310–11, 322.

Vittet 2012c
Vittet, Jean. "Tapisserie de la manufacture des Gobelins, atelier de Jean-Baptiste Mozin (1667–1693) d'après Jules Romain Tenture de *L'Histoire de Scipion* (1499–1546): *Les Repas chez Syphax*." In Blois 2012, 257–58 (cat. no. 192).

Vittet 2012d
Vittet, Jean. "Les tapisseries d'Henri IV: I. L'héritage des rois de Navarre." *La Lettre de la Société Henri IV* 26 (December 2012): 3–9.

Vittet 2012e
Vittet, Jean. "*Le triomphe d'Alexandre* ou *L'entrée dans Babylone*." In Versailles 2012, 312–13, 322.

Vittet 2013
Vittet, Jean. "La tenture de *L'histoire de Constantin* de Rubens et la Bataille de l'Île de Rié." In Avrillas 2013, 12–13.

Vittet 2014
Vittet, Jean. *Les Gobelins au siècle des Lumières: Un âge d'or de la manufacture royale*. Paris: Swan Éditeur, 2014.

Vittet forthcoming [2015]
Vittet, Jean. "La tenture de *l'histoire du roi* de Charles Le Brun: Le portrait entre vérité et propagande." In Bertrand and Delmarcel forthcoming [2015]: 87–95.

Vittet and Brejon de Lavergnée 2014
Vittet, Jean, and Arnauld Brejon de Lavergnée. "Louis XIV et son gout pour la tapisserie." In Da Vinha, Maral, and Milovanovic 2014, 143–51.

Vittet and Brejon de Lavergnée with de Savignac 2010
Vittet, Jean, and Arnauld Brejon de Lavergnée in collaboration with Monique de Savignac. *La collection de tapisseries de Louis XIV*. Dijon: Faton, 2010.

Vittet and Merle du Bourg 2004
Vittet, Jean, and Alexis Merle du Bourg. "*L'histoire de Constantin*." In Lille 2004, 278–85.

Weigert and Hernmarck 1964
Weigert, Roger-Armand, and Carl Hernmarck, eds. *Les relations artistiques entrée la France et la Suède, 1693–1718: Nicodème Tessin le jeune et Daniel Cronström correspondance (extraits)*. Stockholm: AB Engellska Boktryckeriet, 1964.

Wilson and Hess 2001
Wilson, Gillian, and Catherine Hess. *Summary Catalogue of European Decorative Arts in the J. Paul Getty Museum*. Los Angeles: J. Paul Getty Museum, 2001.

Wuppertal 2012
Finckh, Gerhard, and Nicole Hartje-Grave, eds. *Peter Paul Rubens*. Exh. cat. Wuppertal: Von der Heydt-Museum, 2012.

Zerner and Bayard 2009
Zerner, Henri, and Marc Bayard, eds. *Renaissance en France, Renaissance française? Actes du colloque: Les arts visuels de la Renaissance en France (XVe–XVIe siècles), Rome, Villa Medici, 7–9 June 2007*. Collection d'histoire de l'art de l'Académie de France à Rome 10. Paris: Somogy; Rome: Académie de France à Rome, 2009.

Ziegler 2010
Ziegler, Hendrik. *Der Sonnenkönig und seine Feinde: Die Bildpropaganda Ludwigs XIV; In der Kritik*. Petersberg, Germany: Michael Imhof, 2010.

Index

Note: Page numbers in *italics* refer to figures; those in **boldface** refer to the catalogue and the checklist entries for a work; those followed by *n* refer to notes, with note number.

Illustration Credits

Every effort has been made to contact the owners and photographers of objects reproduced here whose names do not appear in the captions or in the illustration credits listed below. Anyone having further information concerning copyright holders is asked to contact Getty Publications so this information can be included in future printings.

Figs. 1, 8, 14, 15, 16, 22, 29, 35, 38, 39, 41, 42, 43, 56, 59, 60, 65, and plates 10b, 10c, 10f, 10g, 11a: © RMN-Grand Palais / Art Resource, NY; *figs. 2, 19, 20:* Image © Le Mobilier National; *fig. 3:* V & A Images / Art Resource, NY; *fig. 5:* © The State Hermitage Museum. Photo by Alexander Lavrentiev; *figs. 6, 51:* © Patrimonio Nacional; *figs. 7, 11, 12, 23, 48, 61:* Image © Le Mobilier National. Photo by Philippe Sébert; *fig. 9:* S.S.P.S.A.E e per il Polo Museale della città di Firenze—Gabinetto Fotografico; *figs. 10, 21, 25, 26, 53, and plates 1a, 2a, 3a, 5a, 6a, 7a, 9a, 10a, 10d, 10e, 10h, 10i, 11b, 12a:* Image © Le Mobilier National. Photo by Lawrence Perquis; *fig. 13:* Philippe Sébert; *figs. 17, 18, 28, 32, 33, 45, 58:* Image © Le Mobilier National. Photo by Isabelle Bideau; *fig. 27:* Musées de Strasbourg, M. Bertola; *figs. 34, 37:* © Centre des Monuments Nationaux; *figs. 36, 44:* Musée du Louvre, Dist. RMN-Grand Palais / Martine Beck-Coppola / Art Resource, NY; *figs. 40, 55, and plate 5b:* Bibliothèque Nationale de France, Paris; *fig. 46:* V & A Images / The Royal Collection, on loan from HM The Queen / Art Resource, NY; *fig. 47:* Foto © Musei Vaticani; *fig. 49:* Museo Nazionale del Bargello, Florence, Italy / Bridgeman Images; *fig. 50:* Used with permission from the Biltmore Company, Asheville, North Carolina; *fig. 52:* Musée du Louvre, Dist. RMN-Grand Palais / Philippe Fuzeau / Art Resource, NY; *fig. 54:* Art Gallery of New South Wales, Sydney, Australia / Bridgeman Images; *fig. 57:* © Nationalmuseum, Stockholm; *fig. 62:* © Château de Versailles, Dist. RMN / © Christophe Fouin; *fig. 63:* De Wit Royal Manufacturers of Tapestry, Belgium; *fig. 64:* Musée du Louvre, Dist. RMN-Grand Palais / Thierry Ollivier / Art Resource, NY; *plate 4a:* Photo by Victoria Garagliano / © Hearst Castle® / CA State Parks

Contributors

Charissa Bremer-David is Curator in the Department of Sculpture and Decorative Arts at the
J. Paul Getty Museum, author of *French Tapestries and Textiles in the J. Paul Getty Museum* (1997),
and has published extensively on French tapestries.

Pascal-François Bertrand is Professor of Art History at the Université Bordeaux Montaigne,
the academic lead for the French national research database on tapestry known as ARACHNE, and
the author of several books and articles on tapestry.

Arnauld Brejon de Lavergnée is Senior Curator Emeritus, former Director of Collections at
the Mobilier National, and a respected specialist on French and Italian art of the Baroque. Currently,
he is preparing the catalogue raisonné on the artist Simon Vouet.

Jean Vittet, Chief Curator, Musée National du Château de Fontainebleau, and former Inspector
of Collections at the Mobilier National, is the leading researcher on the French royal collection of
tapestries. He has published widely on the subject.